# THE SLIP

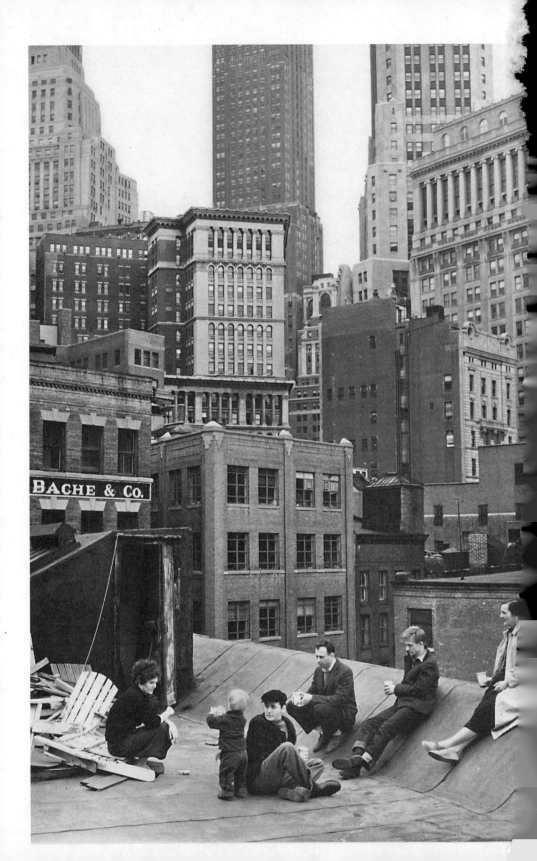

# THE SLIP

## The New York City Street That Changed American Art Forever

## PRUDENCE PEIFFER

HARPER

*An Imprint of* HarperCollins*Publishers*

HarperCollins books may be purchased for educational, business, or sales promotional use. For information, please email the Special Markets Department at SPsales@harpercollins.com.

FIRST EDITION

*Designed by Bonni Leon-Berman*

Library of Congress Cataloging-in-Publication Data has been applied for.

ISBN 978-0-06-309720-9

23 24 25 26 27 LBC 5 4 3 2 1

*Page iii:* Delphine Seyrig, Duncan Youngerman, Robert Indiana, Ellsworth Kelly, Jack Youngerman, and Agnes Martin on the roof of 3–5 Coenties Slip, New York, 1958. Photograph by Hans Namuth. *(Courtesy Center for Creative Photography, University of Arizona. © 1991 Hans Namuth Estate.)*

*Page v:* Street map depicting New York slips, ca. 1855. *(Courtesy New York Public Library Digital Collections, Lionel Pincus and Princess Firyal Map Division.)*

To Jack, and to Charles

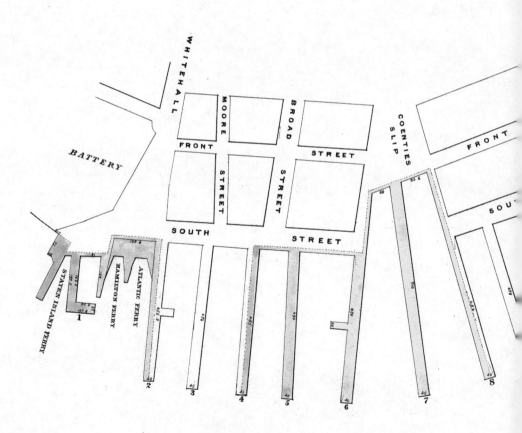

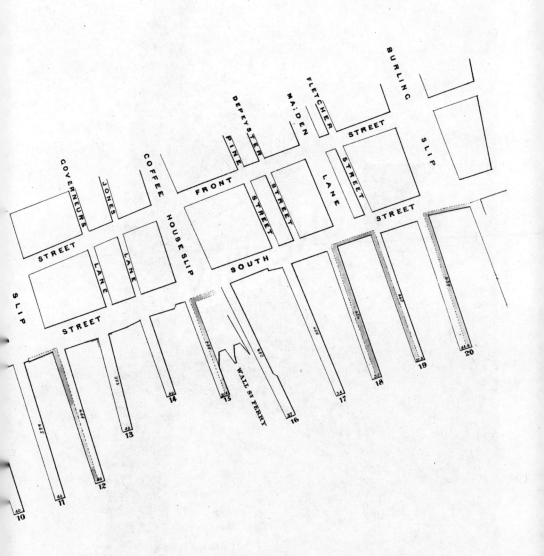

**Intersection of Coenties Slip and South Street, New York, ca. 1958. Photograph by Jack Youngerman.**

*(Courtesy Duncan Youngerman/Jack Youngerman Archive.)*

# CONTENTS

# INTRODUCTION

THEY GATHER ON THE ROOF of 3–5 Coenties Slip at the southern tip of Manhattan, enjoying coffee and cigarettes one brisk, gray, early March morning in 1958. The artists fall naturally into the triangular composition of a grand nineteenth-century painting, as if on the prow of a ship. At the far left, Delphine Seyrig perches atop the ruins of several Adirondack chairs; clustered in the center, Robert Clark (who was just reinventing himself as Robert Indiana) squats in a black beret next to Duncan Youngerman, one and a half years old and dressed in cuffed jeans, a mini version of his father, Jack, who sits on the sloped roof with his rescue dog Orange, the unofficial mascot of the Slip. Ellsworth Kelly stands just behind near the open door to the stairs, forming the peak of the triangle, and Agnes Martin is off to the far right, sitting above everyone on a tar-paper roof peak, her hand pocketed in her khaki trench coat (a contrast to the dark clothes everyone else is wearing). As always, she's in sensible shoes. Not pictured but a core part of this story are the artists Lenore Tawney, already living at the Slip, and James Rosenquist, who would arrive several years later.

The same day this picture was taken, its photographer, Hans Namuth, who was on assignment to shoot Kelly as part of a photo essay about American artists participating in the 1958 Brussels World's Fair, also photographed the artists having a simple lunch in Kelly's apartment, Youngerman's attic-loft studio, and Kelly, Indiana, and Martin riding bikes around Lower Manhattan's narrow lanes. (Ironically Tawney, though not part of this shoot, was the other artist on the Slip who was exhibiting her work in Brussels,

in the *American Artists and Craftsmen* exhibition at the American Pavilion.) Some eight years earlier, Namuth had helped launch the mythic reception of Abstract Expressionism, photographing and filming Jackson Pollock's balletic paint-flinging at Pollock and Lee Krasner's studio home on the East End of Long Island, also just a stone's throw from the water. Now he was photographing the group at Coenties for the next chapter of American art.

Today, though, the Slip shows up more readily as a footnote in that history, with this photograph as its best-known document. Modern Western art history has traditionally been understood and categorized through a progression of influential movements and the artists who reacted against them or in productive friction with them to form, in turn, new movements. In its most simplified version, the postwar American story reads something like this: In the decades following World War II in the United States, Abstract Expressionism's embodied gestures and defiant abstract mark-making, which had wrested the center of the art world from Paris to New York, give way to Pop's brazen cultural and consumer references, the protest and experimentation of Happenings, performance, and dance, and the pared-down repetition and austerity of Minimalism. This cycle allows for some connective outliers—Ad Reinhardt's reticent black squares, Robert Rauschenberg's big combines hanging with real things. But its forward motion is defined by movements in the form of "isms," composed of and defined by men.

If you were to stumble on Namuth's roof photo without knowing about this short-lived community in New York in the 1950s and '60s, you might be surprised to see such different artists together in a single image. Each would go on to have a crucial impact, whether seismic or subtle, on twentieth-century art, even if their work was often difficult to fit into any one movement, and its reach not always equal: Seyrig would star in the quintessential Beat Generation film

in New York, though not a part of that crowd, and then become one of the most acclaimed actresses and feminist activists in France over the next three decades; just a few years later, Indiana's iconic stacked *LOVE* sculpture would become so ubiquitous as to set off decades of litigation; Kelly would be hailed as a giant of American abstract painting; Youngerman would show at the Museum of Modern Art a year after this photo was taken; and Martin's pure abstract canvases would be among the most transcendent and hallmark work of the postwar period. And as for those not present: Tawney would bring textile and fabric art into the hallowed realms of painting and sculpture, and Rosenquist would take his background as a commercial sign painter to make mural-scale mash-ups of American culture whose surfaces bounced light and interpretation off of them as much as their Ab Ex forebears absorbed it.

*The Slip* is the story of a group of artists at the start of their careers, before influence and success or even stability was assured—experimenting in their illegal warehouse studios. The artists never formed a movement or a school or even a mythic following en masse. This is a group biography that questions the very concept of a "group" or "movement," in the Slip's eclectic mix of gender and sexual orientation, abstract and representative painting, drawing and sculpture and assemblage and textile works, theater and film, that emerged from its sail-making lofts.

Coenties Slip is a street that is at once center and edge. Its inhabitants talked about "leaving Manhattan" to return home, and yet it was, for hundreds of years, the economic and industrial hub of the new metropolis, and one of the key grounds of real estate development for the likes of Robert Moses and David Rockefeller at the very time the artists lived there. Nikita S. Khrushchev's armored motorcade drove down the Slip in his state visit to New York City in September 1959 as chairman of the Council of Ministers of the USSR, at

the height of the Cold War. A 1960 tongue-in-cheek feature in *Esquire* magazine named Coenties Slip as number one of the "Ten Most In Places to Live" in New York, *because* it was "obscure"; in 1965, a reporter couldn't find it when she ventured downtown to profile some crazy artists she'd heard were squatting by the river. The Slip hosted a cross section of the city's cultural engine from 1956 to 1967; Frank O'Hara and Andy Warhol dropped in and others—John Cage, Merce Cunningham, Chryssa, Mark di Suvero, Jasper Johns, Ray Johnson, Malcolm Morley, Larry Poons, Robert Rauschenberg, and Cy Twombly, to name a few—lived nearby. But the core group of artists at the Slip felt apart from the city's art scene. As Indiana would later insist, "Johns and Rauschenberg were not in fact a part of Coenties Slip. They were a block away, and we had nothing to do with them—they were too successful."

The artists of the Slip were just finding themselves, even if they ranged in age from twenty-four to fifty. Robert Indiana literally *became* Indiana while at the Slip, changing his last name from Clark in perhaps the most emphatic gesture of place—adding his home state to his present identity. Many were just discovering their métier: Martin experimented with sculpture, which she ultimately abandoned for pure painting, destroying most of the constructions she made during this period, and Rosenquist spent days sitting in his studio waiting for something to float through the window and spark his creativity, before he figured out how he wanted to build his large scenes with paint.

It's a group brought together not by the tenets of composition or technique or even philosophy—as with Abstract Expressionism—or by a particular way of reacting or synthesizing the cultural moment, as with Pop art. To look at Namuth's photograph is to ask, what if we thought about groups in art history based instead on shared places? What if, rather than technique or style, it's a spirit of place that defines a crucial moment?

···

PLACE IS AN undervalued determinant in creative output: a place to be and a place apart and a place always changing and thus encouraging change. To think of an artistic group in terms of place is to write a different history of art, one that can be more inclusive, more open to serendipitous interaction, and can also explain more of the cultural, emotional, and financial context behind any art object. To focus on place allows us to bring in the small details around the conditions and materials of working, too often lost to the archive, that help uncover why anything even gets made at all.

The vocation of art, whatever the medium, is inherently a strange one within modern capitalist society—creative output's labor (however much it is now branded and celebrated) has long had an anxious relationship to more traditional jobs. Place helps us see a broader picture of how creativity happens in that daily matrix. And how it is constantly threatened—Virginia Woolf's 1929 essay "A Room of One's Own" only underscores the economic privilege of having a space to work. Scholars such as George Chauncey have helped us understand how place can define a whole world of identity—in this case, that of the gay male in New York City—and the myths and threats that surround its cultural impact and creative community.

To think more carefully about place is also to think beyond New York as "the postwar art capital of the world." The Slip artists all came from outside the city, believing that it was here that something could happen; they could not have known, though, how much what happened depended on the unique situation of their new surrounds.

A slip, in nautical terms, is a ramp or water space between piers for landing or repairing boats, and Manhattan once had a dozen running up its southeastern shoreline. Coenties Slip was among the busiest; it was bounded to the north by Pearl, the oldest street in Manhattan,

and led out like a widening funnel or a bell to the East River, passing Water Street, Front Street, and South Street along the way.

A detailed map of downtown Manhattan from 1857 carefully diagrams every building along Coenties Slip, including those crucial to our story. At the northwestern side of the Slip, just around the corner from Pearl Street, was 3–5 Coenties, two buildings joined internally by a central staircase (still standing today, and where Kelly and Rosenquist lived, along with Martin and the artist Ann Wilson for a time); and then moving south along the same side of the Slip, past Front Street but before South Street, came 25 (Indiana's second loft), 27 (where Seyrig, Youngerman, Tawney, and Martin lived for a time), and 31 Coenties Slip (where Indiana first lived before it was torn down), a row of nearly identical, modest four-story brick buildings erected in the nineteenth century as warehouses that served the sea. Unlike the typical house setup of that period—small rooms connected by narrow hallways and doors that could conserve heat in harsh winters—the floor plan inside these buildings was open to allow enough space for bolts of cotton duck to be unrolled, cut, and hoisted for a ship's sail and then hand-sewn together. A few years after the community of the Slip was disbanded because its buildings were razed, the Artist-in-Residence zoning amendments made it possible for artists to live legally in commercial loft buildings in SoHo and Tribeca. Before the concept of the loft became a cliché of artistic life in New York, these raw warehouses down by the water offered a cheap if illicit way to have enough room to live and work.

New York in the mid-1950s felt almost empty; returning army vets had moved out to Levittown and other suburban tracts and the city's population dipped. Even the waterways were changing, with the passage of a law by the Interstate Commerce Commission in 1948 allowing barges to charge fees between railroads in New Jersey and Manhattan piers, leading to the decline of working ports in Lower

Manhattan. This, despite the fact that at the time it was the largest harbor in the world; bigger than "the next six largest harbors put together." The writer Joseph Mitchell described New York Harbor as "oily, dirty, and germy" in 1951. "Nevertheless, there is considerable marine life in the harbor water and on the harbor bottom. Under the paths of liners and tankers and ferries and tugs, fish school and oysters spawn and lobsters nest." By the time Kelly, Indiana, Youngerman, Seyrig, Martin, Rosenquist, and Tawney moved to the Slip, the water alley had been filled in with dirt, and a park lined with sycamore and ginkgo trees occupied the site where huge ships used to dock. But at the far end of the Slip, just before the river's rickety piers, the Seamen's Church Institute, known as the "Doghouse," stood as a reminder of the still vibrant marine community: a place for sailors to stay while in port, and a welcome source of hot showers and hot cafeteria food for the artists.

On the roof, the group in Namuth's photo is both in the city and apart from it, silhouetted against the buildings—the "towers of Babylon," as Kelly described them. Lettering for the venerable Wall Street securities firm Bache & Co. is painted on the bricks just behind Martin, alluding to the business of the streets below. In the far right of the photograph, the commanding presence of the Standard Oil Building, originally built by John D. Rockefeller, is just visible. But five stories up on the illegal roof deck, the artists of 3–5, 25, and 27 Coenties Slip seem to be the only people in the city. The taller towers rise in uneven layers like teetering blocks against a blank sky. There's a clean minimalism about them; the repetition of windows and bricks and cornices offers a serene pattern above the fray of the messy bustle, the dark, colonial intersections and loud cobblestones clogged with homeless sailors and the brisk gait of a new business class keen to make more efficient use of Manhattan's limited grounds.

The scene tells a story of the art made at the Slip by those perched

on the roof: that same mix of quiet, Minimalist line and noisy, commercial Pop and sculpture from the found wreckage of the city's many former lives. Within a decade, the Slip, too, would be a past life; all but one of the artists' stocky old maritime warehouses pulled down, glass and concrete skyscrapers rising in their place.

...

*THE SLIP* IS also, then, a story of another character, New York, at a pivotal time in its development, when development itself spread at an unprecedented pace through the oldest corridors of the city. This brief period marks an emblematic shift in the cultural topography of Manhattan—the end of old New York. The Slip was a modest, almost forgotten place, an alley dead-ending in shipworm- and gribbles-infested piers. And yet it hosts the entire history of the island in its cobblestones—one of the first streets and essential markets of the new colony, built by enslaved people, with revolutionary meetings at the tavern just down Pearl Street (which was also the inaugural block with electricity); named by Herman Melville in *Moby-Dick; or The Whale* and site of the boom and bust and boom and bust of maritime and light industries, like so many tides rising and falling along the coastline.

The artists of the Slip were drawing from a cultural well that had fed centuries of immigrants and artists before them, running like the actual tributaries deep below the streets of Manhattan and the landfilled edges of the city: the promise that New York not only had the space for creative freedom (however illegally zoned) but also the stuff to help generate and protect it. This well was running dry; it was more and more difficult to find affordable housing. Something new and brash was coming. Not just the glass skyscrapers of financial firms that literally supplanted the warehouses and nautical chandleries. But also a new burgeoning gallery scene and the artistic communities of SoHo and Tribeca that rose around it; an art scene that

became that much more transparent to the publicity and fame and money channels of the city's latest thriving industry: art itself.

Above all, this is a book about a theory of making that transcends any nostalgia for a past moment in time: the productive space of what I'm calling collective solitude that this particular place afforded these artists. Collective solitude channels a larger phenomenon of New York's creative energy, one of the greatest gifts and curses it bestows on the individual: the ability to be alone working amid so much churning, crowded civilization. Writing a few years before the artists' arrival, in 1949, E. B. White famously celebrated the city's "gift of privacy and excitement of participation," in which at any moment you can feel the "emanations" in the air of its history and storied former citizens. But I'm thinking of a more specific individualism within the crowd, a creative practice particular to the economic and cultural conditions of the artists of Coenties Slip. All were just starting out in their careers. In a period in New York that also saw the harshest crackdown on homosexuality and a retrenched stigma against living alone—unmarried—after decades of progress, the Slip was something else entirely: a safe harbor, as Martin titled one of her works, for its predominantly gay artists. Collective solitude was necessary because it allowed each person some protected insularity to withstand the anxiety of not knowing if they *would* figure out what path they wanted to take in art, or if that path was sustainable, but also the company to make that struggle less lonely.

The geography of Coenties Slip allowed for this collective solitude; the street was "completely apart from the New York art scene" and, it seemed at times, New York itself, yet the city's tastemakers could still find their way to visit. As Youngerman put it, "One of the things we were very conscious of, without talking that much about it, was the fact that we all knew that we weren't part of the de Kooning/Pollock legacy in art which was centered around Tenth Street." Even in the late 1950s, Abstract Expressionism and its second generation were

still the reigning idea. "This was the first time that American art had made an impact beyond the local . . . and this colored the air."

None of the artists who settled at the Slip grew up in New York City. Most had been elsewhere for Abstract Expressionism's ascendancy there. Kelly and Youngerman were visiting the very studios and institutions of modern art history in Paris that the American Expressionists were rejecting. Martin was in New Mexico; Tawney in Chicago, North Carolina, North Africa, the Middle East, and Europe. Indiana was in Chicago and Europe too; Rosenquist was in the Midwest. And for those who went in search of that scene, its trappings of success proved illusory. From Rosenquist's vantage point, "There wasn't any art world. There were respected painters, like Willem de Kooning and Franz Kline, men who certainly knew how to paint, but they looked like ne'er-do-wells and acted like underground talent . . . Fine art never appeared to be remunerative. It was a personal, private achievement."

And though the artists helped one another find apartments and studios and jobs and galleries and shows, though they ran art workshops together, though they talked every day on the phone or over breakfast or on long walks along the Battery, though they commented on each other's art and swapped materials and spaces and stopped doing one thing or started doing another because of what they were seeing in their friends' lofts, though they became lovers and broke up, they could retreat to the solitary work and discipline of art making without any need for explanation or excuse. And what they all found, individually, was steeped in the place they were working: the open space and wood, brass, and rope materials of their old sail warehouses, the colors of the river and the tugboats and the rotting piers, the legacy of rich language and literature that directly cited Coenties Slip, the promise of arrival that had been blowing down the Slip from the river since the founding of New York.

# PART I
# BEFORE

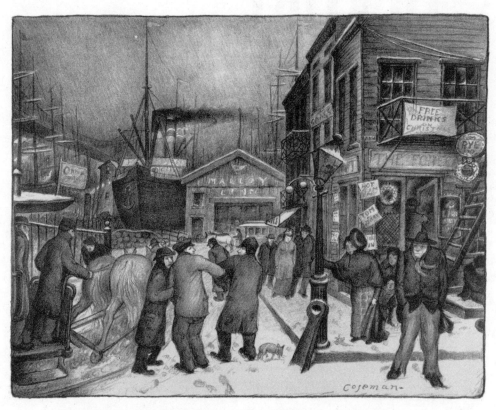

Glenn O. Coleman, *Coenties Slip*, 1928, lithograph on paper, image: 13¼ x 16⅞".

*(Smithsonian American Art Museum, Gift of Nathaly C. Baum in memory of Jacob J. Lehrman.)*

# 1

## THE SLIP

THEY COME BY BOAT. Some of the first humans to New York City arrive in canoes in 1000 B.C.E., paddling across the wide river from another island (and the region that is now Brooklyn), through thick reeds to "Manahatta," or "hilly island," and its verdant forest of oaks, nut trees, spruces, cedars, and pines, with tangles of blackberry, raspberry, and strawberries growing at their trunks. The local Native Americans, the Lenape, hunt deer, bear, mink, turkeys. In the water, they spear fish and haul handfuls of oysters, mussels, and clams into milkweed nets. Frogs create a racket in the trees. The Lenape farm the land.

In 1624, they come by boat too. The *Orange Tree*, the *Eagle*, and the *Love*, small ships from the Netherlands carrying religious refugees and young couples still in their teens (some married on the decks of the ships on the way over) and dozens of livestock. They make their homes on the east side of Lower Manhattan, where the wind is milder and spring water runs freely for their animals. Some 350 years later, painting in a room on the same grounds by the East River, a space once used to sew together ships' sails, and before that to graze cows, Agnes Martin titles her paintings *Water, The Tree*, and *Faraway Love*.

In 1626, eleven enslaved people arrive in New Amsterdam, imported by the Dutch West India Company from Africa. One West

India Company market report lists the price of wheat at three florins, pork seven florins, a keg of butter twenty-five florins, and a "negro" at forty florins. The enslaved people construct forts and roads, cut firewood and clear land, make lime from limestone and oysters, and work the farms on the outskirts of the settlement. They build New York.

The Dutch colonists' first order of business is to buy Manahatta from the Lenape for "60 guilders' worth of cloth, beads, hatchets, and other trinkets" (approximately $40 by 1960s standards). The Lenape mistake this as a gesture of sharing and an acknowledgment of the land and sea's richness, not a final transaction. The concept of owning land does not exist. They serve as guides for the settlers, taking them north (to what is now Midtown) where wild strawberries grow along the river "so plentifully," as a settler described, "that one can lie down and eat them."

Soon streets arrive. Pearl is the first, an old cow path along the shore named for the iridescent color of the oyster shells found there and ground into glittering dust, and sometimes the prize found within—at what becomes the head of Coenties Slip. And then the buildings: a five-story tavern is erected on Pearl Street in 1642.

The slips arrive next. Starting in the first quarter of the seventeenth century, a dozen slips run up the southeastern edge of Manhattan, their names a poem of prominent neighborhood families and trade: Whitehall Slip, Exchange Slip, Coenties Slip, Old Slip, Coffeehouse Slip, Fly Market Slip, Burling Slip, Peck Slip, James Slip, Market Slip, Pike Slip, and Rutgers Slip. Some 350 years later, Robert Indiana will stencil these names as if ring buoys in oil onto a long, vertical piece of insulation board in his work *The Slips*, 1959–60, with Coenties at the upper left.

Because this is where ships come in to dock with their cargo, markets often dot the end of each of the waterways. At their peak, Man-

hattan's slips are busier than any of its streets, and Coenties the most so. It is the hub of the city.

Coenties Slip is almost certainly named after an early colonial settler: Coenraedt Ten Eyck, a shoemaker and tanner who comes to the New World in 1651 with his second wife, Annetje. (One of the first zoning ordinances of Manhattan forces cobblers out of downtown in the 1640s due to their noxious fumes and dyes polluting the precious fresh water.) Coenraedt and Annetje have ten children. (In the nineteenth century, property on the Slip is still in the family.) According to a Dutch West India Company map, Coenraedt's original village plot is northwest, just off the central marsh and sheep's pasture, but they move east to the area around the Slip, which then becomes known as "Coentje's"—a casual contraction of "Coenraedt and Annetje's." Everyone pronounces it "Co-en-tees," but the artist Willem de Kooning once told Jack Youngerman that in Dutch, the name would be pronounced "Coonties."

In one of the city's first engineering projects, the Dutch use landfill to extend the shores of narrow downtown Manhattan—the constant story of adding to coastline even as it is eaten away. The names of consecutive southeastern streets illustrate this creep of land: Water Street (once on the water), then Front Street (once waterfront), and then South Street.

The first pier on the East River is built at Pearl and Broad Streets in 1648, and the Slip appears, like a small paper cut, on some of the earliest maps of the New Amsterdam settlement. Coenties is one of the deepest slips, the water slicing all the way to the boundary of Front Street, whereas the surrounding slips and piers go only as far west as South Street.

Coenties Slip Market is first mentioned in the City Hall records on July 15, 1691. In the beginning, it is an open-air space of a few stands that sell fish (it's commonly and a little misleadingly called the Great

Fish Market). One can procure clams "which bear some resemblance to the human ear," codfish, mackerel, sheephead, and dried herring. Early accounts mention six-foot lobsters and a harbor so quiet "that whales came up to the city and visited both the East and North Rivers." Later, it's best known for selling sugar and Lisbon wines, and it's so busy that money is raised to build a roof over the stalls. During the Revolutionary War, Coenties Slip Market is taken over by the military as a barracks and storehouse: the 64th Regimental Store. In 1691, the sheriff also has a ducking stool built and kept at Coenties Slip. This wooden contraption on wheels, with a long fulcrum arm ending in a chair, is used to dunk "ladies" in the Slip who can't "restrain their tongues."

...

ANOTHER MARKET IS established along the waterfront between Pearl and Water Streets, this one to sell people. Twenty years after the market is established, almost half of the population on Manhattan owns enslaved people, who make up one in five inhabitants of the island. (In *The New York Gazette*, May 25, 1778, an announcement: "A negro woman to be sold in Dock Street, between Coenties and [Old] Slip Markets.")

The city grows, the settlement more restless of its connections to Britain. War arrives in Lower Manhattan. Badly beaten in the Battle of Brooklyn during the Revolutionary War in 1776, George Washington smuggles his ten thousand troops over the river to Peck's Slip, just north of Coenties, in the haze of a late August night, on "scows, barges, and rowboats; anything that floated." They hide there for the night. At Fraunces Tavern on Pearl Street, Washington bids an emotional farewell and departs for Mount Vernon on December 4, 1783, following his victorious ousting of the British. In the new United States, a priority becomes power on the seas, and when the First Con-

gress meets in New York in 1789, "the first real legislation" is "to encourage shipping" and protect shipbuilding.

Coenties Marketplace becomes a "grand depot" for boats bringing farm produce and livestock down the East River. By 1796, New York is the busiest American port, outpacing Philadelphia, and the center of shipbuilding shifts from Philadelphia to New York as well; twenty years later, the Erie Canal opens, and barges and canal boats from its route start to clutter Coenties Slip.

By the mid-nineteenth century, South Street is known as "Street o' Ships" and the neighborhood as Sailortown—the dirty stretch along the southeastern piers of the island crowded with grog shops, shipjoiners, blockmakers, and dance houses. On any given day, two thousand sailors embark from ships berthed in the slips. Most of the men are penniless and at the mercy of racketeering creditors, as they won't be paid for at least a week after setting foot on shore. This is the area "where the lanes were the darkest and filthiest, where the dens were the deepest and foulest, where the low bar-rooms, groggeries, and dance-houses were the most numerous, where the vilest women and men abided, in the black sea of drunkenness, lewdness, and sin."

...

FROM THIS MIRE rises the Seamen's Church Institute, founded in 1834 by a group of Protestant men as a floating church service in the East River off Pike Street. It begins as a temporary tent out at the pier for Sunday services.

Water-adjacent is not a desired location in Manhattan. Fifth and Park Avenues are built on the premise of getting as far away from the murky, smelly, crime-ridden ports as possible. As Lucy Sante describes, "New York never had a particularly modern or well-organized waterfront, its piers being for the most part wooden, irregular, and in various states of dilapidation. The streets near the water were

usually among the dirtiest and most vice-ridden." Ships are often quarantined at port with highly contagious diseases such as yellow fever, typhoid, and bilious fever. The area around the slips is particularly susceptible to contamination; Fly Slip had been built over a sewer, and the Board of Health frequently evacuates residents living at the slips, scrubbing, whitewashing, and sometimes acid-washing the infected buildings.

A terrible fire rips through the neighborhood in 1835. One bitter December night, "shortly before nine o'clock [the] fire-alarm first sound[ed]." A gas pipe had burst at Pearl and Beaver Streets, and flames sweep through thirteen acres of downtown Manhattan. Nineteen blocks burn, from Merchant Street to Wall Street and south to Coenties Slip.

John Henry Bufford's lithograph *View of the Great Conflagration of Dec. 16 and 17th, 1835; from Coenties Slip* captures some of the night's drama. Every building along the water is on fire with great billows of black smoke, and even the river, reflecting the flames, seems to be alight and clotted in soot. Figures desperately stand on the roofs of the enflamed warehouses, tall ladders reach up to a row of windows several stories below, a fire brigade is lined up like an army in the Slip, sending thin plumes of water into the morass, and people on barges in the water pick up crates, barrels, and goods thrown down or falling there.

The night is so cold that water freezes in the hydrants. In his diary, New York resident Philip Hone describes the flames as "flashes of lightning." The fire, which rages for two days, leaves the area, in the words of one witness, "a smoldering mass of ruins." Hundreds of storehouses are destroyed: "So vast was the barren waste, that an uninterrupted view was afforded from Wall Street to the East River, and thence to Coenties Slip; a prospect of awful grandeur, as far as the eye could reach." The ruined merchandise is immense: cloths, silks, laces, prints, and "a mountain of coffee" lie at the corner of Old Slip

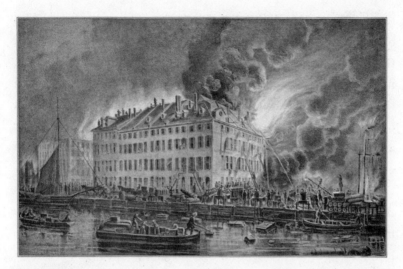

1974 calendar reproduction of an 1836 print depicting the Coenties Slip fire of 1835.

*(Courtesy Columbia University Libraries, Seymour B. Durst Old York Library Collection.)*

and South Street. Three thousand clerks, porters, and car men immediately fall into unemployment, and the insurance companies of New York City are bankrupted. The market, warehouses, and goods are necessary for the city to function, and Coenties Slip is quickly rebuilt.

Two years later, with the prices of goods rising ever higher, a riot begins in a warehouse on Washington Street just around the corner from the Slip, with looters throwing five hundred barrels of flour and one thousand bushel sacks of wheat out the windows. When the police arrive, the mob heads to a warehouse on Coenties Slip, where they do the same to thirty barrels of flour and a hundred bushels of wheat.

...

IN 1852, HERMAN MELVILLE publishes *Moby-Dick; or The Whale.* On its opening page, he cites the Slip as a stop along one's Sunday stroll

through the metropolis, so that even in the city, our fate is to dream of the sea: "Circumambulate the city of a dreamy Sabbath afternoon. Go from Corlears Hook to Coenties Slip, and from there, by Whitehall, northward. What do you see? Posted like distant sentinels all around the town, stand thousands upon thousands of mortal men fixed in ocean reveries." Two years later, a former journalist now carpenter and freelance writer in Brooklyn, Walt Whitman, begins a collection of poems, which he would publish the next year (in three consecutive, revised editions through 1860) as *Leaves of Grass*. He rediscovers the Lenape name for his home, Mannahatta, "my city's fit and noble name," calling the word "liquid, sane, unruly/musical, self-sufficient... hemm'd thick all around with sailships and steamships." With this collection, he becomes the city's unofficial poet, tangling his own sexual assignations with his love for the strangers on the crowded sidewalks—so much so that one contemporary critic burns his review copy and calls Whitman "a frequenter of low places, a friend of cab drivers!"

In Civil War New York, from 1861 to 1865, more than 50 percent of the nation's imports and exports flow through the city and its Wall Street Custom House, which is the main source of revenue for the federal government. Melville serves as a customs inspector there (he cannot afford to live on his book sales), constantly dodging bribes as he supervises goods being unloaded and delivered from ships. He often walks the city before or after his shift, sometimes passing by where he was born in 1819 at 6 Pearl Street, around the corner from the Slip. One hundred years later, the artists on the Slip would walk the same routes, looking for inspiration or escape from the daily routines that blocked creative flow. At the end of the war, walking downtown near the area around Coenties Slip, Melville observes destitute Confederate soldiers just released from northern prisons waiting to travel south, "wandering penniless" or "lying in their worn and patched gray uniforms under the trees of the Battery, near the barracks where they were lodged and fed."

The Slip remains one of the busiest spots in the city, though the city continues to push north. In 1879, the journalist Charles H. Farnham describes a carriage ride around the downtown waterfront of New York, clogged with wagons and horses hauling "thousands of tons of freight and thousands of people" a day, including bales of cotton, hogsheads of tobacco, and barrels of flour and sugar. He travels up South Street—where the flour trade fills the warehouses and one could see "loads of oranges, boxes of tea, four-bushel bags of peanuts, cases of silk and Indian shawls, a steam-boiler, and coops of geese"—to Coenties Slip, "one of the oldest parts of the docks." The view down this street, Farnham writes, is "quite picturesque, with the converging rows of old houses, and here and there a dormer-window above the pinched and faded fronts." And just north of this is "the finest view of ships in the port of New York."

Pearl Street is dotted with warehouses making one-masted sloops and two-masted ketches. And Market Street is the center of nautical supply. "The houses are full of ship-chandlery—great cables, anchors and wheels; the signs of sail-lofts flap from upper stories," Farnham writes. "Boats run their bows out-of-doors, spar-yards are full of men hewing great timbers, and shipsmith shops glow with forges and echo with blows on the anvil." At the end of Coenties Slip, a thick glade of ship masts grows. Farnham captures the strange nature of the slips, which let huge ships sidle into the city streets: "You can put your hand on their anchors, their figure-heads, and their shapely bows. They seem almost human in their confident intimacy."

Seven years later, a slightly less romantic view of the Slip is recounted in a detailed *New York Times* survey of its buildings and inhabitants, which mentions the numerous "trucks" (large carts pulled by teams of horses) lined up to load and unload goods from the ships and warehouses, whose drivers, including "colored men," wear old navy and army coats and stand about in clusters on the street and sidewalk, waiting. The Slip's plentiful barrooms are filled

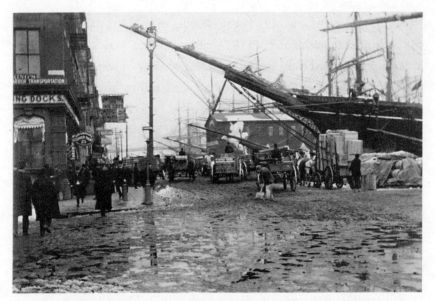

**Alfred Stieglitz, *Coenties Slip, South Street, New York*, 1896–97, gelatin silver print, 3½ x 4⅝".**

*(Philadelphia Museum of Art, From the collection of Dorothy Norman, 1997.)*

with sailors drinking rum; several of these spots would survive into the 1950s. Slender stairways lead up to businesses on the upper floors: washers, sailmakers, and shipping masters.

The building committee of the Seamen's Church Institute acquires a site at South Street and Coenties Slip in 1906, and on April 15, 1912, the cornerstone for a new building is laid. A year later, on a May day thick with sea fog that "poured heavily at intervals," the new institute is officially opened at 25 South Street. Several flags are unfurled from the roof: the U.S. flag, the blue flag of the institute, and semaphore flags that spell out "Welcome."

By September, the institute accepts lodgers. As described in the SCI's periodical, *The Lookout*, a seaman can get his key, "take the elevator to his room and go to sleep that night secure in the conviction that he will neither be aroused by a drunken quarrel nor be robbed in the darkness." The hotel sleeps just under six hundred, with pri-

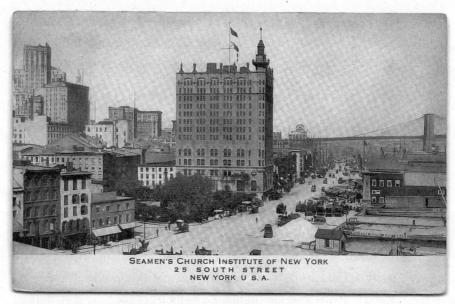

SEAMEN'S CHURCH INSTITUTE OF NEW YORK
25 SOUTH STREET
NEW YORK U S.A.

Seamen's Church Institute of New York postcard, 1917.

vate rooms costing twenty-five cents and the dormitory beds fifteen. A seaman will "enter this port with the knowledge that he is to be welcomed, to be treated with consideration," *The Lookout* states. "He will know that a clean bed in attractive surroundings awaits him; that his luggage will be cared for, his mail received for him; that he will find amusement; that . . . he will be living in a place where people care about him as an individual, where people want him to be happy."

Two hundred sixteen feet above the river, a lighthouse is erected on the roof of the Seamen's Institute, and dedicated to the memory of RMS *Titanic* on April 15, 1913, the one-year anniversary of the passenger liner hitting an iceberg and sinking, with more than 1,500 lives lost, en route to New York from England.

A *Harper's* article describes the "deep phosphorescent glow" of the lighthouse—which is a key on nautical charts until 1968: "In the gloom of a rainy evening, as the Staten Island ferry-boat creeps on through mists to its slip on the south tip of Manhattan Island, the veil

ahead is suddenly pierced as if by a huge green eye. Glowing in pure aquamarine, like an enormous jewel, it points the way until the gray veil lifts." Ten years later, F. Scott Fitzgerald would write a different green light into the watery horizon of *The Great Gatsby*.

The Seamen's Church Institute is a world unto itself. It has its own post office. Letters arrive addressed to (and delivered to) sailors c/o "Sailors Home with the green light, New York."

A saloon on the corner of Front Street and Coenties Slip that had "fattened on the weaknesses of seamen" for fifty years is torn down as part of an expansion plan of the SCI. The annex requires that buildings along Front Street from Coenties Slip to Cuyler's Alley be razed. By the 1930s, twenty thousand merchant seamen arrive daily in the port of New York, and the institute is visited every day by eight to ten thousand of them. The figure of the sailor, "young and manly, unattached, and unconstrained by contemporary morality," as George Chauncey describes, "epitomized the bachelor subculture in the gay cultural imagination." This association would persist from the turn of the twentieth century through the artists' arrival at the Slip; and concurrently, the waterfront was seen as a neighborhood to find gay men.

The voice of this generation of artists, the critic Paul Rosenfeld, pens his manifesto *Port of New York: Essays on Fourteen American Moderns* in 1924. He discusses New York's harbor and the transatlantic ocean liners as the influence and training of European artistic practice, before Americans return home to their native soil to establish a unique tradition in arts and letters. The "creators" he highlights, among them the photographer and gallerist Alfred Stieglitz, and the painters Arthur Dove and Georgia O'Keeffe, give him "the sensation one has when, at the close of a prolonged journey by boat, the watergate comes by, and one steps forth and stands with solid underfoot." His essay is a stake in the ground: American art has arrived.

This awakening of a pioneering and uniquely American creativ-

ity is rooted in a post–World War I nationalism and a kind of colonial manifest destiny, hammered into the piers of New York Harbor and its gritty, democratic openness to the sea: "Perhaps," Rosenfeld muses in his epilogue, "the tradition of life imported over the Atlantic has commenced expressing itself in terms of the new environment, giving the Port of New York a sense at last, and the entire land the sense of the port of New York . . . through words, lights, colors, the new world has been reached at last."

More than 900,000 New Yorkers fight in World War II, many of them embarking overseas from the city's harbor. At the Brooklyn Navy Yard across the river from the Slip, a massive shipbuilding operation is soon under way—the largest in the country—and by 1942, more than five hundred factories in the city are producing supplies for the war. New York's port becomes the base of the war's shipping efforts. More than half of the men and supplies transported overseas leave from here; more than 3 million men and 63 million tons of supplies. New York becomes once again the busiest harbor in the world. A naval officer leases the third floor of 27 Coenties Slip, and converts the space into a kind of apartment.

And then, on August 14, 1945, the news comes in at 7:03 p.m. across Times Square's sign: "Official—Truman announces Japanese surrender." Sailors and staff scramble up to the roof of the Seamen's Church Institute to celebrate V-J Day. "Pennants flew from all the ships in the New York Harbor. Tankers, freighters, and tugs blasted their whistles in a thrilling cacophony of victory. Rocket flares shoot up into the sky." Sailors wave white handkerchiefs from gunneries.

Artists start arriving at the Slip. Just after the war, Oscar Williams, dubbed a "poetry entrepreneur-cum-anthologist" by the poet Anthony Hecht, settles in the cold-water penthouse of an office building at 35 Water Street, adjoining Coenties Slip, with his wife, Gene Derwood, a poet and painter. Williams works on his own poems and more than thirty essential paperback anthologies of poetry,

and Derwood writes and paints. To be included in his affordable Little Treasury series of modern or American poets is to have arrived on the scene, and in his bow-tied, bespectacled nerdiness he holds a quiet power. Their unconventional location as early as the 1940s was perhaps inspired not only by cheap rent, but by two poets Williams most championed and helped build into an essential American canon through his anthologies: Walt Whitman and Hart Crane. Whitman and Crane both lived in Brooklyn, but they wrote often of the East River, the downtown city skyline, the Brooklyn Bridge, and the ferries crossing from their borough to Manhattan. In their "run-down neighborhood," the Williamses host salons and parties for poets, where they once served only mashed potatoes for dinner. They are close with Dylan Thomas, who sometimes stays with them when in New York (he described Williams in a letter to his wife as "a very odd, but kind, little man"), and W. H. Auden, among others, though the poet James Merrill said that in person, Williams could be "rather a creep." Ted Hughes and Sylvia Plath drink Drambuie at a party at 35 Water Street in 1958; she describes Williams as a "queer, bird-like little man," and their penthouse as "a tiny rooftop studio" filled with art (Derwood's) and "a fine little tar-roof porch overlooking the gulls and boats." "Visiting the Williamses," the writer John Gruen remembered, "was something of a trauma" (he mentions the neighborhood's "seedy bars all around and dozens of woebegone drunks"), but the worst offense was having to wait "several long minutes before Gene Derwood made her way down in the manually operated elevator to unlock the front doors of the building."

After serving in the army, a young artist from Mississippi named Fred Mitchell wins a Pepsi Cola–sponsored painting prize and sails for Rome in 1947. He had grown up without art museums, so he finds Europe to be an explosive revelation. He returns to New York three years later, in 1951, and moves downtown to Bleecker Street,

where he often hangs out with artists he met in Italy, including Angelo Ippolito, Charles Cajori, Lois Dodd, and William King. They talk about Rome and the terrible lack of cafés in New York. (A lament that Kelly and Youngerman would soon take up on their arrival from Paris.) Mitchell and Ippolito have been trudging uptown to the Fifty-seventh Street galleries, trying to get them interested in their paintings without success. So naturally their next thought is, Why don't we open our own gallery? (They also considered opening a café.) One day in 1952 they pass a tiny vacant barbershop downtown with a "For Rent" sign, and the cooperative Tanager Gallery is founded: a gallery by artists for artists, not so much to sell work (though that would be nice) as "to show what was going on."

Mitchell settles at 26 Water Street, and then moves to 128 Front Street (where Robert Rauschenberg and Jasper Johns lived for a time). Two years later, Mitchell makes a studio in a cheap, old sail-making loft at 31 Coenties Slip, where he soon sets up a small painting class, called, alternatively, the Battery School and the Coenties Slip School, charging $1 per hour for figurative and abstract drawing and painting classes. After pining for Rome, the Slip gives him a renewed interest in living in New York. He loves the site's surprising intimacy, and the "marvelous hunk of space which filled the gaze outward." "On the edge of New York City," he is invigorated, "feeling the sea wind, seeing the movement of tides and ships, and sensing the organic growth of the city from its earliest days." Soon he becomes the art director at the Seamen's Church Institute, and invites his friend Ellsworth Kelly to join him on the Slip.

# 2

## THE FRENCH PRELUDE

IN OCTOBER 1947, A DUTCH liner from New York arrived in northern France, some three years after the same beaches had been stormed by a million Allied troops. Disembarking for the first time on European soil, Jack Youngerman, a twenty-one-year-old from Louisville, Kentucky, looked around in great anticipation and a little awe. At the time he was "a rare combination of nonchalance and intensity," in the words of his good friend Richard Seaver, who would soon join him in France, a personality encapsulated by sharp cheekbones and piercing blue eyes that were open wide to observe and absorb the world, but also focused on what lay ahead. Or, as Youngerman described himself, he was "a skinny country boy from Kentucky."

Youngerman was heading to Paris because all the art schools in the States were full—he had tried to get into the Art Students League, Wooster, and Black Mountain College. He had decided, halfway through a degree in journalism at the University of Missouri, and having gone to one art class, that he would rather be studying art. Either pursuit was a world away from his childhood in St. Louis and Louisville, and that was the point. After serving in the navy's V-12 premidshipman academic program at the University of North Carolina, where he met Seaver, he enrolled at the École des Beaux-Arts under the GI Bill. (At eighteen, he'd chosen the navy over the army because he liked the uniforms more, and maybe, he thought, he'd have less of

a chance of getting shot.) And now, as his train made its way through Normandy to Paris, he looked out the window, through the green streaks of hedgerows whirring by, and saw the bombed-out shells of abandoned, charred tanks still not cleared away from the farm fields.

World War II broke Paris into bright slivers of austerity and anxiety, with existential reckoning everywhere. The city had been the seat of refined culture since its seventeenth-century academies and salons defined "fine art" and the tenets of history painting, and had been the center of modernism since the middle of the nineteenth century's breakthroughs in vision and representation. Its modernism had been categorized through a succession of "isms" in which artists pushed the psychological and perceptual line between art and lived reality even further: Realism, Impressionism, Neo-Impressionism, Symbolism, Fauvism, Cubism. Now that innocuous still life object, broken open and reimagined on the picture plane by Edouard Manet, Paul Cézanne, Pablo Picasso, took on a new value: Parisians were suddenly grappling with the reality that a grapefruit cost "the equivalent of four days' pay for a skilled worker."

The contradictions of Reconstruction Paris, as the art historian Yve-Alain Bois points out, encompassed "a frantic race for modernization clashing with Old War customs." There was a certain level of shame at the Nazis' brazen occupation of one of democracy's symbolic centers of culture, the existence of the cooperating Vichy government, and now the American bailout in the form of the Marshall Plan. Writers, philosophers, and artists who had gone underground during the war, fled and then returned, led the resistance, joined the Communist Party, sat idle, or even collaborated with the Vichy government now debated what could be done in the face of a new reality, exposed so recently through the Holocaust, Hiroshima, and the brutal theater of war. And there was a growing anxiety that Paris was losing its grip on cultural dominance to New York, particularly as the Nazi flag had just recently flown from the Paris Opera and other art centers of the city.

Youngerman had grown up poor in an unhappy home in Louisville, with an alcoholic father and "warring parents." After his parents' bitter divorce, he lived in an even more extreme situation with his mother and brother, who was a year and a half older. Several years after the divorce, his father had a breakdown and was institutionalized. Youngerman never saw him again; his father spent the next twenty years of his life in a veterans' mental hospital in Mississippi, where he died. The only escape from the claustrophobic negativity of Youngerman's situation seemed to be work, a constant striving toward more open spaces and possibilities. He knew there was an elsewhere, but where?

Art didn't at first seem the answer; Youngerman hadn't experienced any in person until, on leave from the navy, he went to the National Gallery in Washington, D.C., and then, on his way to Paris in 1947, stopped by the Museum of Modern Art in New York, which was less than two decades old. As a kid, he'd seen a few black-and-white reproductions of Rembrandt in a schoolbook, Norman Rockwell *Saturday Evening Post* covers, and images of regional painters in random magazines at friends' houses (his mother only got Christian Science publications). "Being an artist wasn't among the human possibilities for me. Artists were people who lived in Europe 300 years ago." But he felt a sense of art's promise to deliver one to another place, another situation, and he followed that instinct all the way to the center of Western culture—the city of Balzac and the Human Comedy, the city of Monet and Impressionism. "I borrowed some money for the ship and left. That was my great escape into the outside world."

Embarking from the train at Gare Saint-Lazare, he took a bus to the Pont du Louvre, where he got off with his meager luggage. He just stood there, in the middle of the bridge on that beautiful fall day, looking toward the Île de la Cité and Notre-Dame. He couldn't believe he was there.

Attending the École des Beaux-Arts was like walking into the nine-

teenth century. In his first weeks of class in Paris, he was suddenly "very close to things in art history." Henri de Toulouse Lautrec and Vincent van Gogh had been students there. This 180-degree change in his situation was almost too much, but the chilly reception of most French students to the American GI interlopers helped anchor him to reality. He brought his first attempts at painting, little still lifes made from available objects in his hotel room, to his professor, who said, "Not bad for an American." In 1948, as Youngerman soon realized, "art was still French in everybody's minds. It was a French province."

One of the students in Youngerman's class at the École was an Alsatian his age who had been drafted into the German army after the fall of France in 1940, and had been in the Battle of Stalingrad. He considered himself French; he grew up speaking the language in Alsace, and then didn't have a choice but to fight with the Nazis. Youngerman realized that everyone's life in Europe was wholly changed by the war.

He got along best with art students who also came from humble beginnings. "The ones who came from the bourgeoisie were a little bit standoffish if not contemptuous." The French defeat in the war had softened some of those attitudes, but for others, it only calcified them. "They owned art while we were just full of dollars."

The dollar went a long way in postwar Paris. The GI Bill awarded seventy-five dollars for nine months of the year. "Thirty cents a day would get you a hotel room" with bed, basin, table, and chair. This was de rigueur for young students, but also for the French intellectuals of the time who looked to cast off bourgeois trappings. "The choice in Paris in the late forties was usually either renting a decrepit small flat with ancient bathroom and kitchen facilities or living in a hotel out of a suitcase," Agnès Poirier writes. "When one was young, intellectual, and unattached, the second solution was by far the preferred option."

Youngerman lived in the heart of Paris, on the top floor of a tiny hotel overlooking the Seine on Île Saint-Louis, an enclave of buildings

that still felt of a piece with their seventeenth-century history. Hô-
tel de Bourgogne had a set configuration: six stories, with a winding
staircase and one public water outlet for the whole building, which
was also the one toilet (and that toilet did not have a seat). Madame
Dongne ran the hotel—Madame Dangles, Youngerman, and later
Kelly, called her.

His room, a former maid's quarters, wasn't big enough for an ea-
sel, but he painted on small canvases and paper. He had a single bed,
a tiny table, a compact dresser, and a garret window: "the ultimate
romantic thing." On the top of the dresser was a large bowl with a
pitcher of water and a glass—"a standard accessory of inexpensive
lodgings," which explains its ubiquity in Cubist works made in Paris
a few decades before.

There was an electric hot plate with two burners, but Youngerman
mainly ate out at inexpensive mom-and-pop restaurants, the student
cafeteria, and canteens serving working-class menus. He thought
it was terrific. The hotel also had chicory coffee for three centimes.
Many meals were served family style—steaming platters of meat and
potatoes. He would save bread (which was rationed) from the student
canteens; he always had a piece of baguette in his pockets just in case.
Vegetables were most common. Youngerman learned the joy of mak-
ing a single tomato become an entire meal: cutting it thinly and pour-
ing vinaigrette over the pieces. It was almost like painting: a slice of
red amid the gray and brown. This kind of asceticism appealed to
him. He was young, he had grown up without much, and most of what
he wanted to do in Paris didn't cost money anyway—walking the
streets, going to museums (thanks to his Beaux-Arts student card),
visiting churches. To learn the language, he read Balzac in French,
marking the words he didn't know and looking them up in a little dic-
tionary he carried around.

One day, taking the bus from his room on the Île Saint-Louis to the

Beaux-Arts, holding his art box, Youngerman got to talking with an older Parisian. "Paris is so beautiful," he mused.

"Ahh, mais avant la guerre, avant la guerre," the old man answered.

It was such a common refrain in Paris at the time that it became one of the first French phrases Youngerman learned—"Ah, but before the war, before the war," that wistful nostalgia for a time when Nazi occupation of the city was unfathomable.

•••

YOUNGERMAN WAS EAGER to learn French and wary of socializing only with expats. One of the first Americans that he met at the Beaux-Arts was Ellsworth Kelly, tall and thin, with a reedy curve to his posture and a shy smile. They met at the student restaurant, where you could eat for around ten cents. In 1948, Kelly arrived back in the city where he had served during World War II. Youngerman's first impression of Kelly remained constant throughout his life: Ellsworth was an "impeccable poet," in his work, his life, and his conversation. He spoke carefully, deliberately—as a child he had been a self-described "loner" and had a stammer—and Youngerman found that even his manner of speaking had parallels to qualities of his work. "Part of Ellsworth's likeability was the fact that he spoke, in my memory, not carefully but he chose his words always, and well. And that's part of his work too."

Kelly grew up in New Jersey and moved often, but his fondest childhood memories were of when he lived near a reservoir and could watch birds. During the war, Kelly participated in the secret ghost army 603rd Engineers Camouflage Battalion; first, working in the United States, silk-screening posters with camouflage techniques, and then, in a directly opposed strategy in Britain, France, and Germany, working to trick perception *through* visibility: helping create

fake army props including airfields, and inflatable trucks and tanks, to confuse the German troops during D-Day operations. He had a nervous reaction to his time in the army, which manifested as a rash on his face.

Kelly had been studying art at Pratt Institute in Brooklyn before enlisting and, just after the war, at the School of the Museum of Fine Arts, Boston, on the GI Bill. But he wasn't satisfied in Boston, where all the focus was on painting the traditional nude. He wanted to study color. He enrolled at the École des Beaux-Arts in order to qualify for the government stipend. "I didn't go to Paris to go to school . . . the Beaux-Arts was the only place that didn't care about attendance," giving him time to really look at art. He was plagued by a domineering mother; just before he left for Europe, he visited a faith healer in New York who hypnotized him and helped him work through his mother's hold on him. The break was complete: she never attended any of his exhibitions.

Kelly knew exactly what he wanted to see. He came to France with a notebook already full—pages and pages listing artworks to visit in the city, and nearby museums and cathedrals. He liked "being a stranger" in Paris, and in some ways never felt that he fit in. But he was also uncertain of his next step. His immediate thought on arrival was "What am I doing here? What am I going to be? A tenth-rate Picasso?"

In April 1949, Youngerman gave his room to his new friend, Kelly, and moved to live closer to the Beaux-Arts, though he immediately regretted leaving that little hotel. Kelly would in turn stay there for three years.

It was always cold in the building during the winter. The ground-floor heat was turned off in hotels on March 1, no matter the prevailing temperature. And Youngerman or Kelly never had a fireplace or heater in his top-floor room, just the residual rising heat. Kelly's friend and fellow artist Ralph Coburn watched the damp spread up

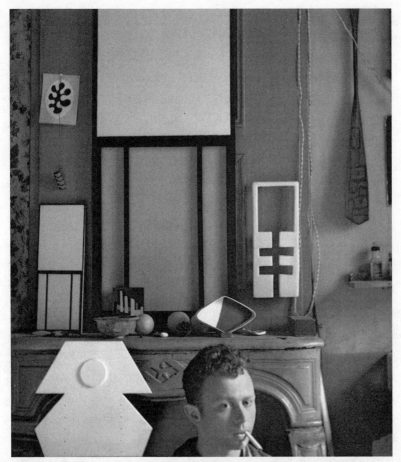

Ellsworth Kelly in his Hôtel de Bourgogne studio, Paris, 1950.
(Courtesy Ellsworth Kelly Studio.)

the wall. The American writer Norman Mailer described his time in Paris in December 1947 as "a long leaky French winter." For the American playwright Arthur Miller that same winter, "The sun never seemed to rise over Paris, the winter sky like a lid of iron graying the skin of one's hands and making faces wan." "Paris looks sadder and sadder every day," the French philosopher Simone de Beauvoir wrote in the winter of 1948. "Dark, cold, damp, empty." Even the Beaux-Arts never had central heating, just a stove next to the model. Harvard's

Byzantine Institute in Paris was well heated; Kelly began research-
ing specimens in the library twice a week. That was the way that it
was for so many—being poor, "not having comfort much less luxury,"
as Youngerman put it. Even the artist Constantin Brancusi worked in
a cold, cavernous studio in Paris. "He had about four layers on, even
with the stove" in his studio. "He was the best-known sculptor any-
where! And that was the way he was living."

...

IN PARIS, KELLY and Youngerman could avoid the debates and ma-
cho posturing around Abstract Expressionism then overtaking post-
war New York. A major spread on Jackson Pollock in *Life* magazine
in August 1949 famously asked, "Is he the greatest living painter in
the United States?" The thirty-seven-year-old Pollock, arms crossed
and leaning against a painting, reluctantly takes on the question's
challenge. And even as the article seems to answer its question in the
affirmative, it also raises the specter of criticism about Ab Ex: that it
might just be decoration, that its painters don't know what they are
doing but only intuit some inner state onto the canvas through in-
tense struggle, or most damningly, that it is as "unpalatable as yes-
terday's macaroni."

But with this spread, the mainstream publication *Life* also intro-
duced an audience outside of the art world to a certain assurance in
American painting that had not been documented so openly before.
Pollock is independent, energetic, driven. His origins seem to be the
American regionalism and intensity of Thomas Hart Benton and
José Clemente Orozco. Pollock was not talking about Pablo Picasso or
Georges Braque (though Cubism was a huge influence on his work); he
was not engaging directly with the abstract tendencies of Cézanne or
Henri Matisse, Manet, Hans Arp, or Fernand Léger. The dominance
of Paris in shaping the history of modernism seems far from his mind.

He was even rejecting a centuries-old tradition of easel painting, instead tacking his unstretched canvas to the floor of the studio, and letting dirt, cigarettes, and nails mix in with the paint that he flung down. He talked about being "literally in the painting" himself—a line that begins to equate Ab Ex paintings directly with their makers. Mark Rothko would also connect his expanded fields with a certain release of control and presence of the artist: "However you paint the larger picture, you are in it. It isn't something you command."

This is not to say that Ab Ex had shaken off all European influence. Pollock was deeply immersed in the work of the Surrealists who fled Europe just before or during World War II—among them André Breton, Max Ernst, and Salvador Dalí—artists who carried to New York an interest in the unconscious, in drawing practices around automatism and dreams, and in exploring "primitive" mark-making, and who showed their work at many of the same galleries as the young Americans. For Pollock, this meant a connection back to Native American practices of drawing with sticks directly on the ground and, like his fellow Americans Rothko, Robert Motherwell, and Barnett Newman, an interest in a deeper layer of universal myth and tragedy that World War II had exposed. The scale of the works, with their fields of color reaching for an American sublime, was embraced as an indication of the United States' postwar economic and cultural ascendance.

No small influence on Pollock's public rise was the art and culture critic Clement Greenberg, who became his champion. As early as 1946, Greenberg puzzled out through a review in *The Nation* what he saw in Pollock's "ugly" painting, work that would, the critic asserted, "become a new standard of beauty." Greenberg was excited by the raw assertiveness of Pollock's pictures, which didn't really look or feel like anything else. In some ways, they upended how critics typically contextualized an artist's work—particularly an American artist's work—within the long tradition of the European avant-garde.

Pollock was an "original." And, Greenberg wrote in that same review, "It is precisely because I am . . . still learning from Pollock that I hesitate to attempt a more thorough analysis of his art."

Kelly and Youngerman pored over the Pollock *Life* article at a Paris café. The two were impressed by Pollock but felt that the scene in New York was far away; they had no real contact with it or with what artists were doing there. When Youngerman started painting in Paris, "I hadn't seen anything that was happening in America." And for Kelly, to be an American in France offered a certain level of anonymity to explore his own kind of composing, and to visit artists whose own experiments in abstraction might offer insights into the way forward. Both Youngerman and Kelly were already seeking "an economy of means," a reduction to the simplest expression, that seemed in direct opposition to Abstract Expressionist painting and ethos. And for Youngerman, shape would become central to his ideas around composing a painting—the very thing that Pollock's abstraction eradicated, or took to its most extreme form in his tangled lines.

The two young artists instead looked elsewhere. Kelly would wander home from his museum visits along the quais of the Seine at night, watching the lights reflect on the surface of the water, a motif that he would soon paint. His notebooks turned from lists of art to see, to ideas for paintings. He made many sketches in and of his room; he painted the hotel's floor toilet in black and white in 1949—he considered this his first "object-oriented work," in which he was no longer inventing content to paint. "I think that if you can turn off the mind and look only with the eyes," he said, "ultimately everything becomes abstract." He became fascinated by the windows in the hotel. *Open Window, Hotel de Bourgogne,* 1949, and *Broken Window, Hotel de Bourgogne,* 1949, mark some of his first drawings in which the absolute simplest aspects of the thing observed are conveyed on the page, like an abstracted skeleton of its structure. Kelly would take this idea back to New York and shape it into a lifelong strategy for composing

pictures through patterns, colors, light, and lines already existing in the world. As he later said, "I think those six years in Paris I had of freedom is really what allowed me to keep my original ideas." In work such as *Black and White on Red*, 1949, Youngerman used thin lines to form poles from which black and white shapes emerge like flags and triangular pennants, evoking Paul Klee's delicate fields of abstract figures that seem to make up a landscape or hieroglyphic picture. But he was soon loosening things up, filling the whole surface with a maze of lines, and then, by 1953, finding the start of the jagged forms that would be his later trademark, across colorful oil compositions that seem to be derived from collages of torn paper.

Though he qualified for three years at the Beaux-Arts, after the first year and a half, Youngerman, like Kelly, stopped attending class regularly. His education was on the streets, learning French, going to see all the art in the Paris museums, and spending "days learning by copying old masters," drawing "incessantly." Kelly and Youngerman visited the Louvre, the Musée de Cluny, and the Guimet and Cernuschi Asian art museums. They traveled by bike and train (third class) to see Romanesque churches in surrounding towns.

In September 1952, Kelly visited Claude Monet's studio in Giverny, an hour's train ride from Paris, with the South African painter Alain Naudé, who he was seeing. Today, Monet is heralded as among the most famous artists in history, and the series of massive *Water Lily* canvases he painted of his carefully cultivated garden and pond (and continuously reworked from 1914 until his death in 1926) are among the most recognized artworks in the world. Monet's studio and home opened in 1980 to the public, immediately becoming a major tourist destination. But when Kelly and Naudé set out on their pilgrimage, the artist had been dead for twenty-six years and his work was only just being rediscovered, in part thanks to contemporary artists' new interest in fields of color and large-scale canvases. Kelly had written to Monet's stepson, Jean-Pierre Hoschedé, who showed them around

the property. The two were "shocked" by the conditions: Monet's abandoned studio, wild garden, and ill-kept work. (During his lifetime, Monet was fastidious: he instructed his gardener to row out and dust off the lily pads in the pond before he went out to paint.) "Windows blown out during the war had not been replaced; huge paintings from the 1920s were carelessly stacked and in some cases, had been rained upon." But Kelly was also shocked by the scale, color, and relative abstraction of the *Water Lily* canvases, some of which stretched over forty feet. "It was fantastic. All the late paintings were still there." The studio was full of fifteen large canvases, some half-finished and unsigned. He rushed back to his room in Paris and got to work. "On the first day after I went there I painted a picture and it was solid green." This was Kelly's first "monochrome," an oil on wood that he called *Tableau Vert*.

Youngerman visited the windows of Notre-Dame and Sainte-Chapelle, just around the corner from his apartment. "Anyone who has really looked at the windows of the Sainte Chappelle, or at Arabic Art, knows that the meaning of 'decoration' is not easily defined," Youngerman would later explain. He saw the full range of the Western canon all at once. "I was open to everything on the one hand, and how naïve I was about art education and about contemporary art." He was like a "child"—up for anything because he had no preconceptions. He learned to look. "I saw the work before I read about it." He made small painted facsimiles of the art he saw and sent them home to his mother, who had never been able to travel. He studied Romanesque art, taking day trips to Vézelay to visit the grand basilica there. In the summer of 1953, he spent a night at Lascaux to see the caves; his guide was one of the boys who had discovered the ancient drawings when his dog went down a hole in 1940. Youngerman would later tell the critic Barbara Rose, "Perhaps this sounds romantic, but the Lascaux grottos had a bigger effect on me than Abstract Expressionism, more immediate at any rate." He was in a state of perpetual

wonder that he was not just reading about art historical landmarks but having the chance to see them in person, and in intimate, direct circumstances.

Youngerman bought "a little two-seater used car in Paris that didn't last very long," a Peugeot. One beautiful June day, he and Kelly drove to Auvers-sur-Oise, an hour from Paris at the speed of their slow automobile, to the town where Van Gogh lived at the end of his life (and where he died by suicide). The village looked exactly like Van Gogh's scenes. They kept rounding corners and stumbling into one of his paintings, as if the artist had himself invented what the town looked like, and not represented what he saw with his brush.

Vincent had written to his brother Theo, "Auvers is decidedly very beautiful. So much so that I think it'll be more advantageous to work than not to work, despite all the bad luck that's to be foreseen with paintings." In the same letter, he asked his brother to send "ten meters of canvas" or at least some sheets of Ingres drawing paper. "There's a lot to draw here."

Kelly and Youngerman stopped to pick poppies and cornflowers growing wild on the edges of the country road, and went to the cemetery where both Van Goghs were buried side by side, a little plot directly across from a wheat field "straight out of a Van Gogh painting." They laid their bouquets on the two graves.

That idea of conjuring a new language for seeing—inventing what we apprehend rather than depicting it—stayed with Youngerman, even if he himself would not put it into practice until he moved to Coenties Slip. And this pilgrimage underscored the importance of Van Gogh for Kelly—an unexpected influence, though not if one thinks about color.

Youngerman and Kelly's trip was a tribute to an artist who meant so much to them, but also, perhaps unwittingly, a tribute to a place that for a time allowed the artist to work productively, and to the supportive connection between artistic people, in the form of Vincent

and Theo's relationship. Theo died just six months after Vincent. For Youngerman, the hundreds of letters between Vincent and Theo are "among the things that we learn about art that are the most moving." Kelly and Youngerman yearned for their own local community—but they would have to wait until Coenties Slip for its full blossoming.

For a time, Youngerman and Kelly found some notion of community in Paris cafés. It was difficult to connect with their fellow students but Youngerman and Kelly spent hours sitting at cafés absorbing the conversations around them, sometimes rubbing elbows with famous intellectuals and artists, and debating what had happened to Europe.

Paris in the 1950s was filled with "a popular street intellectual that you couldn't avoid if you wanted to." Youngerman remembered that everyone talked politics in the cafés, and leftist politics often bent toward communism. Since the supposed march of progress proposed by Germany—a capitalist country—had turned so horrific, and since Russia, a Communist country, had allied with America, there was a sense that perhaps the Allies should share more than sides in the war. Some of the Communist thinkers that Youngerman knew in Paris were the most "dedicated, free-thinking, uncorrupt people you can imagine." But there was a certain naiveté around the conversation at the time, too, because no one knew the enormous deception of the Soviet Union. Later, when the truths came out about Russian policy during this period under Stalin, it was "the most horrific enlightening . . . imaginable."

The central construct of café life in daily Paris introduced Youngerman to contemporary political and cultural debates. He would take with him to New York this particular way of being alone but with people. It would infuse Coenties Slip with its unique template of influence by osmosis; the collective solitude model unique to the geographic makeup of that corner of New York. In Paris, "at any time, you can go out and be part of the city, you can see passersby, you can

get out of your personal loneliness, without having to make conversation with another person. That's something I want to do almost every day." For Youngerman, it felt vital for art making.

...

KELLY AND YOUNGERMAN set out to visit the artists whose early twentieth-century experiments with abstraction and materials had forged a new understanding of modernism. In February 1950, Kelly, Youngerman, and Coburn visited Jean Arp's studio in Meudon-Val-Fleury, just outside Paris. The Alsatian artist was one of the early trailblazers of abstraction in Europe, and had experimented with a number of noncompositional strategies in painting, sculpture, and printmaking with works that were central to the Dadaist and Surrealist experiments with form. His monochrome wood reliefs would be a holy grail for Kelly, who made his own for the first time in Paris; for Youngerman, it was Arp's woodcuts that demonstrated how edges could melt away and new shapes could be invented.

The war had not been kind to Arp. He and his wife, the artist Sophie Taeuber-Arp, had fled Meudon in 1940, when Paris was occupied by the Nazis, and settled for several years in Grasse, Switzerland, with friends; they planned to travel on to the United States. The two collaborated on multiple projects; Arp believed that "creative activity should be a shared rather than a solitary process." Despite the "horrors of those years" living in exile, Arp looked back on this period in Switzerland as one of great productivity and "one of the finest experiences of my life." They lived "surrounded by trembling crowns of light, gliding flower wings, ringing clouds, and tried to forget the horror of the world. We did drawings, watercolors, and lithographs together, and so produced one of the most beautiful of books . . ." But it was not to last. In 1943, spending the night at the artist Max Bill's house in Zurich to sign some lithographs, Taeuber-Arp died in her

sleep of accidental carbon monoxide poisoning from a broken stove in her bedroom.

Devastated, Arp returned to Meudon in 1946. At the time of Youngerman, Kelly, and Coburn's visit, he was still grieving his wife's death some seven years earlier. Youngerman remembers a studio filled with sculpture and an elderly assistant working. They talked politics more than art—Arp, speaking in English, was skeptical of real change.

Later, Kelly and Youngerman visited the aging god of modern sculpture, Brancusi, with their fellow artist Alain Naudé. The Romanian artist had also attended the École des Beaux-Arts (in 1905), and quickly honed his carving skills, working directly in wood or stone to make simple figures and geometric forms. He worked on the left bank in Montparnasse at 11 Impasse Ronsin, an alley that became, not unlike Coenties Slip, a kind of secret art community, with a number of artists working there over the years, including Max Ernst, Jean Tinguely, and Niki de Saint Phalle. For Kelly, the visit "strengthened my intention to make art that is spiritual in content." All this despite the fact that the trip had a few distractions: Brancusi was otherwise occupied getting "one of the college girls present to sit on his lap." But still, Kelly remembered "the extraordinary experience of moving among great sculptures that he had known only from photographs and of the effect of the lame old man with his parted beard, his pointed cap, and his white duck pajamas." Youngerman remembers it being extremely cold—it must have been early spring—and seeing Brancusi's sculptures everywhere (just as in the famous photographs that he took of them in situ). The sculptor also made his own furniture. Brancusi's studio had become a kind of work of art in itself.

Another artist often sighted in the evenings in Montparnasse was Alberto Giacometti. During this period, Simone de Beauvoir described "Giaco" as always being covered in gray plaster: "on his clothes, his hands, and his rich dirty hair. He works in the cold with

hands freezing, he does not care." Giacometti had first made a name for himself loosely associated with the Surrealist movement in Paris, with hybrid sculptures of shapes and animals that threatened to trap or entomb the viewer. After World War II, he began making sculptures that stretched and twisted the human figure into lines of compressed gesture—exclamation points of pain and distorted presence that perfectly fit with the existential reckoning of the postwar world.

In 1951, Giacometti stopped into Kelly's opening at Galerie Maeght and, looking at the young artist's paintings, told him, "That's exactly what I do." Visiting his big, drafty studio at 46 Rue Hippolyte Maindron, where he worked alone, fifteen hours a day and often at night, Kelly felt a great affinity for the artist who created, in the words of Sartre, "an indistinct figure of a man walking on the horizon." Sensing that the artist wanted to be alone while he was working, Kelly stayed only a few minutes. "But what he and I did was exactly the same: I mean the spirit of it. His figures were surrounded by emptiness; I lost the figure altogether."

Little by little, aided by the art and artists they were seeing, that loss of the figure overtook Kelly and Youngerman. Kelly began making small wooden reliefs, "painting objects," based on drawings and stencils in his hotel room in Paris, sometimes laced with string—work that reflected his engagement with Arp, but also his time in the navy as a stencil cutter for posters. For Youngerman, Paul Klee's first museum show in France—the outlier artist, who worked and taught mainly in Germany, had died a decade earlier—was "quite a revelation" for how it slipped into musical registers of color and pattern outside of the figures and landscape that Klee also depicted.

Youngerman and Kelly went religiously to the Salon de Mai, where artists showed their recent work. Here they saw Matisse's first big cutouts, a technique that the artist had invented in which he cut shapes out of paper he had painted with gouache, and arranged them on the page. The master was still alive at the time, though confined

to his bed and wheelchair, from which he cut paper and directed assistants in pinning up his compositions on the walls of his bedroom and living room in southern France. The more sedentary the artist became, the more his shapes seemed to tumble and twist through space. Seeing these works was a "visual shock." The two young artists were astounded by how close these veered into a feeling of form rather than representative form itself. Youngerman, in particular, marveled at how Matisse was, at the end of his life, still pushing his work to new places. Here was the master of elegance making strange, even awkward shapes. Youngerman realized that "an artist can make something almost deliberately . . . not ugly . . . but also not pretty, not appealing. He can make something that's not easy to bear." Youngerman was also struck by Matisse's use of color in his *Jazz* prints, made from cutouts, in 1947. "I realized that even though every plate had black or white or both in them, you don't think of black and white at all, but of the other colors." For Youngerman, this was an epiphany that he stored up until he began painting at Coenties Slip, and discovered "I almost always need black or white, often both, as components of 2 or 3-color paintings."

...

IN APRIL 1950, Youngerman was sitting with Richard Seaver at a café when a beautiful girl came running across Rue de Rennes, dodging cars and bicycles, to say hello. Her name was Delphine.

Delphine Seyrig spoke perfect English with an "American" accent; you would never guess she was European. She was a vivacious seventeen-year-old actress and student with a pouf of dark hair. Seaver had met her while teaching at a secondary school, Le College Cevenol, and they became friends, going regularly to the theater. She made an impression on everyone. Seaver described Seyrig as a

"Garbo-look-alike." In 1969, the novelist Marguerite Duras mentioned her "very, very blue eyes," "radiant complexion," and "brilliant teeth, slightly irregular, which she bares fully when she laughs."

Born in Lebanon "in the most beautiful light in the world," as she once told Duras, where her father, Henri Seyrig, was the director of the Institut Français d'Archéologie, she had grown up in Beirut until the age of eight, when her family moved to New York. Henri had been sent there by General Charles de Gaulle during World War II as cultural attaché and representative of the Free French government. Henri's mandate was to contact the French embassies in North and South America and win them to the Free French cause. Henri would go on to become director of all the museums of France from 1960 to 1962, appointed by André Malraux. Seyrig's mother, Hermine, known as Miette, was also an anthropologist who came from a distinguished intellectual background. (Her uncle was the great linguist Ferdinand de Saussure.)

In the States, Seyrig went to a girl's boarding school across the river in New Jersey, where she first heard Frank Sinatra and Glenn Miller's big band and was immediately infatuated. She had grown up in a roving, international house of high culture and utter lack of pretension, but she had never heard pop radio. This experience was an intellectual breakthrough, a "revelation." Those radio programs and the announcer were, despite their public nature, somehow addressed to *her*. It was a moment that would later inform her career and artistic pursuit: understanding how the entertaining arts—making music, acting in front of people—could be at once a very public and very intimate performance.

Seyrig carried her teenage love of American culture back to Paris, and it helped her immediately fall for the blond, slightly aloof American painter sitting next to her friend at the café. (As Youngerman later said, had Seyrig never spent time in New York, the two would

probably not have gotten together. "The fact that I was an American was a plus.")

The two began to spend all their time together.

Their whirlwind love affair proved enriching for Kelly too. He and Seyrig loved to talk books and art, and her parents became some of Kelly's greatest and most influential early champions. Henri Seyrig bought *Antibes*, a white monochrome oil-on-cardboard relief, the only sale Kelly made during his almost seven years in France.

Kelly met the American sculptor Alexander Calder in Paris in May 1950 through Youngerman and Seyrig—the artist had become fast friends with Henri and Miette Seyrig, visiting them often in Beirut. Kelly described Calder in a postcard as "very jovial" and, perhaps a comment on Calder's boisterous, ruddy presence, "a farmer."

Calder was an artist everyone loved. He would rent out whole restaurants after his exhibition openings and, as the Museum of Modern Art curator Dorothy C. Miller reminisced, everyone would get very drunk on red wine and dance to the accordion. "He was like a bear but he was the most perfect dancer." Born into an artistic family in rural Pennsylvania and trained at the Art Students League in New York, Calder moved to Paris in 1926. There he continued to develop the whimsical wire sculptures that he had first begun in New York, culminating in a full cast of animals and props for his *Cirque Calder*—a circus that he would activate in evening performances. In Paris, Calder seemed to meet and befriend everyone—the artists Joan Miró, Frederick Kiesler, Fernand Léger, and Piet Mondrian, as well as James Johnson Sweeney, who would become the director of the Guggenheim Museum in New York. He continued to experiment with sculpture, turning next to what he called "mobiles" (works that moved) and "stabiles" (works that were stationary). Back in New York, he became a kind of house artist for the Museum of Modern Art, designing elaborate candelabra for its tenth-anniversary dinner; in 1943, the museum hosted a major survey of his work. Calder

would be vital to Kelly, and to his leaving Paris for New York. "I loved him and thought of him as a father figure, though he wasn't that much older."

Youngerman and Seyrig wed three months after their café meeting, on July 3, 1950, in a daytime ceremony eight miles from Paris in the town of Marnes-la-Coquette, best known for its famous inhabitant, the actor and singer Maurice Chevalier. They were spurred in part by the fact that the Seyrigs didn't want their daughter living with Youngerman without being married.

Seyrig was late to the ceremony. On their wedding night, she went off to an audition. (Youngerman waited for her outside their hotel at Saint-Germain-des-Prés on a park bench.) Looking back, Youngerman saw that not only then but throughout her life as an independent feminist, Seyrig was "one of the least marriage-oriented people I've ever met." Following the small ceremony, they moved to Rue Maublanc in the Fifteenth Arrondissement, at the time a very modest, lower-middle-class neighborhood. Just down the block from their apartment were open vegetable markets where they would see Samuel Beckett, who lived just a few blocks away on Rue des Favorites, shopping with his net bag full of leeks.

The couple felt entirely compatible despite the vast difference between Youngerman's own family background—his broken household and being raised very poor with an alcoholic, raging father who was by then in a mental hospital—and that of Seyrig—her parents were open, welcoming, and "extremely modest." Henri had slept in trees during World War I; Miette, the daughter of a naval officer, was an avid sailor and had crewed several voyages with Ella Maillart, who would go on to become a famous explorer and travel writer. (Henri could be a commanding presence, though, with powerful silences; after seeing the film *The Godfather* in 1972, Delphine commented that Marlon Brando's character reminded her so much of her father.) At the time, the Seyrigs were still living in Beirut, and they invited Kelly

to join Youngerman and their daughter in August at their family's summer home, Villa La Combe, in Meschers-sur-Gironde, France.

...

MESCHERS WAS A wonderful complement to Paris. A sleepy port town on the southwestern coast, its shoreline was framed by chalky cliffs and ancient caves; little fishing huts perched on piers like stilts dotted the rocks at the beach. Maritime sunflowers grew along the path to the beach and restaurants served local fish and oysters on spindly outdoor tables. To get there, you took the train from Paris and biked from the station one town over. Youngerman remembers arriving late at night and cycling in the dark to La Combe. The house was a former wine storage cellar that had been converted into a modest home. Its location and grounds were a place almost to hide—outside the village in thick pine woods, about five minutes from the water, a poetic place "removed from the world." Miette had a boat tied up at the downtown dock.

It was a languid August. Youngerman and Kelly spent their days working separately, sketching on paper. Miette lent Kelly her Leica camera, and he took photographs: of the striped beach cabanas, of a shadow of a balcony against the wall of La Combe, leaves framed against the sky, a metal stairway railing, trapeze swings in a playground, a brick wall. During these weeks he wandered off alone to do automatic drawing exercises with specific challenging limits meant to reduce his personal agency in their creation, and thus push himself to a more natural abstraction. He would not look down at the page while drawing a scene, or blindfold himself to draw coat hangers, pine branches, and the reinforced rods that still dotted the beachfront from the war. Youngerman, too, influenced by Matisse's teaching practice of having his students not look at their paper when drawing from a life model, experimented with automatism.

Jack Youngerman in Meschers, southwest France, 1950. Photograph by Ellsworth Kelly.

(Courtesy Duncan Youngerman/Jack Youngerman Archive. © Ellsworth Kelly Foundation.)

They weren't talking very much about art by this point in their friendship. Youngerman and Kelly had already arrived at a silent understanding, "a sense of who the other person is and what their art thinking is." Youngerman was always impressed by how much art history Kelly absorbed, and also how he noticed things in his environment that he could directly use in his abstractions. "He's the nonfigurative artist who in a lot of important cases, the work came from what he saw directly. I noticed the fact that he noticed everything."

Through this noticing, Kelly experienced a major epiphany in his approach to art making—as Bois has noted, this summer generated an "ebullient confidence" in Kelly's art. It was here, at the beach and at the Seyrigs' home, that Kelly produced a series of shadow studies that provided a breakthrough for his found compositions, what Bois, quoting the artist himself, has called the "aesthetic of the found object . . . the already-made."

For Kelly, this was a way of avoiding *composing* pictures. Instead, he wanted to *find* them: "I felt that my vision was choosing things out there in the world and presenting them. To me the investigation of perception was of the greatest interest. There was so much to see, and it all looked fantastic to me." As Kelly put it, "I always wanted to make things out of what I saw." Or, as Youngerman framed it, "I was impressed by the fact that he could do what figurative artists do but with the end result being total nonfiguration." For Kelly, place became his art. Kelly's early exposure to methods of seeing, experimenting with form and shadows in the army, would influence his greatest work, and he took the breakthroughs he made in Meschers with him to Coenties Slip, where he could fully realize their implications.

Kelly's euphoria over the expanded potential for finding compositions in his daily life was palpable in Meschers. "Everywhere I looked, everything I saw became something to be made, and it had to be exactly as it was, with nothing added. It was a new freedom: there was

no longer the need to compose. The subject was there already made, and I could take from everything. It all belonged to me: a glass roof of a factory with its broken and patched panels, lines on a road map . . . paper fragments in the street. It was all the same: anything goes."

Kelly suddenly drew everything. His sketches of the beach cabanas include copious notes about the color and shadows on the awnings, with elaborate diagrams highlighting the degree of pale yellow, dull orange, and violet. "Can you see the stripes?" Kelly wrote in a postcard to Ralph Coburn on August 16, referring to the photograph on the front of the card, of the Nonnes beach at sunset, not able to conceal his excitement at the very simple found pattern that, in its wear and tear, formed natural variations of shape and color up and down the beach. It was almost as if he were asking, "Can you see what I see? Can you see how I can use this?"

In his paintings *La Combe I* and *III* and folded screen *La Combe II*, the shadows of a railing on the stairway of the Seyrig villa, seen from above, became an already-made motif to transfer. Kelly was obsessed with the shadows on those stairs, and made numerous drawings and paintings of them. (Writing to Kelly a few years later from Meschers, Youngerman refers to "the Kelly stairs.") Kelly's preoccupation allowed him to incorporate chance into his compositions, and evacuate any free compositional agency—how he learned to *see* abstraction in the world around him, and carry it over into a drawing, collage, and painting.

Flush with excitement, Kelly returned to Paris in September 1950. He was desperate for money, as his GI Bill funding was dwindling. He took a job teaching children at the American School; to every class he wore the same suit because it was all he had. Like the pattern on the beach umbrellas and the long summer shadows at Meschers, the sixth graders Kelly taught provided him with great inspiration. Kelly dreamed that he was working "very large on a spatter-work" in the method of two of his students, as he wrote to

Coburn, "when suddenly there came to me an idea for a very grand work, something to be used with architecture." The dream, Kelly wrote, "is something I have been waiting for." The subsequent achievements *Cité* and *Colors for a Large Wall* from 1951, with their monumental execution of chance strategies and formal arrangement of abstract patterns, were from lessons learned at Meschers.

...

WHILE KELLY AND YOUNGERMAN were discovering so much in France, they were making art daily and it was not being seen. There was only so much time ambitious artists could spend creating art without having anyone engage with it, particularly when they knew that back in the United States, artist-run galleries were cropping up along the edges of Abstract Expressionism and there was a propulsive energy around a new generation of painters doing things their own way.

Early on in their time in Paris, Kelly and Youngerman met the American artist William Klein. He had fought in World War II and stayed on in Paris after the war, becoming an assistant in Léger's studio, where he trained as a painter with the great abstract master. (Kelly and Youngerman visited Léger's studio too.) Klein remembers Léger telling all his assistants, "You guys are all obsessed with collectors and museums and galleries, but all that's bullshit. What you should do is take a look at what painters did in the fifteenth century in Italy." Klein and the other assistants couldn't afford the books on the quattrocento, so they stole them. "We took what Léger told us seriously." One day he picked up a 35mm camera to take a picture of a mural painting moving, and he found the resulting blurred abstraction compelling; this was the beginning of his turn to photography and film. Klein would travel between New York and Paris and ended up being the friend who brought Alain

Resnais into Seyrig and Youngerman's life, a fateful introduction. Kelly and Youngerman met other young artists: the charming Almir Mavignier, who had moved from Rio to Paris in 1951; François Morellet, who had met Mavignier in Brazil in 1950 and encouraged his cross-Atlantic move; Edgar Negret, a Colombian sculptor whom they would later reconnect with in New York; Robert Breer, a young American painter who would shortly shift from painting toward experimental film. Along with Klein, they were all trying on different modes of abstraction, and frustrated by the difficulties in showing their work anywhere in Paris.

Kelly met the composer John Cage and his partner, the choreographer and dancer Merce Cunningham, when they stayed for a time at the same Hôtel de Bourgogne in Paris. Kelly was headed to the metro and Cage yelled out to him, "I saw you coming out of the hotel and you look like an American—what do you do?" Kelly answered, "Well, I'm a painter." Cage had come by Kelly's room to look at his paintings, and the two kept up a correspondence. Cage and Cunningham gave Kelly "a great feeling that I was doing something that could be important." It made Kelly impatient to share his new ideas about composition with other artists interested in the same thing. The great paradox of Paris at the time was that the extreme access it offered to artists' studios was in direct opposition to the insular world of its gallery and museum system.

Kelly and Youngerman finally got a break with the fortuitous renovation of an unused basement in Jean-Robert Arnaud's bookshop at 34 Rue du Four. In April 1951, the artist John-Franklin Koenig and the bookseller Arnaud turned the space into a cooperative art gallery. Youngerman helped whitewash the cellar walls; the room had little windows near the top that let some light in from the street. The inaugural two-week show included about a dozen works by Youngerman— some cut paper collages and a few modest-size paintings—followed by a show of thirty-one works by Kelly in May. For both, it was their

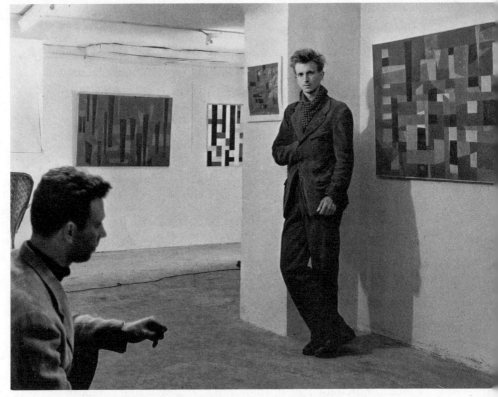

**Ellsworth Kelly and Jack Youngerman at Youngerman's first show, Galerie Arnaud, Paris, April 1951.**

*(Courtesy Duncan Youngerman/Jack Youngerman Archive.)*

first solo exhibition in Paris, or anywhere for that matter, and their first opportunity to publicly show their experiments in abstraction.

But what might have been a triumph for the young expat artists in the center of Paris felt hollow for Youngerman. The show only brought him a renewed sense of inadequacy, of how much he still had to learn, and how much he still had to find his own voice. Kelly, whose exhibited work incorporated some of his studies from the previous summer at La Combe, had two momentous visitors to his show: Georges Braque was deeply impressed by the young artist's painting

*Meschers*. And when the American School's director visited the show, perhaps scandalized by the spare unadornment of what he saw, he promptly fired Kelly from his teaching post.

Kelly returned to Meschers for the month of July, and then started working as a night watchman in Paris, a position that freed his days for painting but seems hard to square with his demeanor. The job didn't last long.

In the summer of 1952, Youngerman visited Meschers alone. Writing to Kelly from La Combe, he felt "grateful of the sun and respite." He woke up early and biked down to the beach to gather oysters at low tide. "But the tide hasn't gone out enough yet so I've a wait. But that beach this morning—quiet, quiet, quiet, with the water just slithering in like oil. Like the Beginning. Everything new. And Silent." The artists' letters seem to acknowledge the turning point that they faced in their lives—the suspended reality of postwar Paris, the waiting-for-something-to-happen, the traveling back to their cramped rooms to make something of all the art history they were seeing, the feeling of ambition that welled up in their chests just like desire. They were at the beginning of something, but what?

"The war years," as James Knowlson wrote, "had revealed the concrete reality of waiting." It was in this environment, in late 1948 and early 1949, that Samuel Beckett wrote *En Attendant Godot* (later translated into English by Beckett as *Waiting for Godot*). The existential parrying of the play's two central characters as they wait for someone who never arrives came right out of Beckett's own street life and experience in Paris. *Godot* was finally produced in full in 1953, at Théâtre de Babylone in Paris, directed by Delphine Seyrig's acting teacher, Roger Blin.

The production went up thanks to the support of Seyrig, who staked an inheritance from her aunt at a moment when she and Youngerman were living hand-to-mouth in Paris, just down the

street from where Beckett wrote most of the play. Youngerman didn't question his wife's decision. When Miette worried over the use of this money, her daughter replied, "You simply have to read the script," which she found stunning, bleak, funny, and unlike anything she'd heard before. Her commitment to acting and supporting art transcended superficial comforts—a commitment that would help buoy her and Youngerman when they first moved to New York and were setting up their bare-bones apartment at the Slip.

Opening night was January 3, 1953. *Godot* went from avant-garde word of mouth to a cultural sensation for the forty-year-old writer; it was a complete game changer, signaling both "the end of his anonymity and the beginning of his theatrical and financial success." The "talk of theatrical Paris," *Godot* seemed to channel the absurd and complex condition of the city after the war.

Kelly and Youngerman were waiting for their next step too. Youngerman hadn't shown since a rare 1952 gallery exhibit at Denise René's. He felt "increasingly unrelated to what was happening in Paris art." In November 1953, Kelly was kicked out of his Paris studio and forced to move into the maid's quarters in the home of the parents of the artist Morellet. "This," Bois writes, "marks the beginning of the end of his love affair with Paris. He is depressed, despite the encouragement he receives from his friends and from Alexander Calder." Gray days stretched on. In his notebook, Kelly made a sketch for an abstract painting whose colors were taken from the city landscape; the bottom panel color he labeled "cement" and the top panel "sky." Underscored above the drawing is a further note: "Blue sky needed." He saw a reproduction of a painting from Ad Reinhardt's exhibition at Betty Parsons Gallery in New York in the December 1953 issue of *ArtNews*, found at a bookstore on Rue de Rivoli, a work that in its straightforward, stripped-down simplicity made him believe he might have some compatriot artists in New York after all. He developed jaundice and was treated at the Amer-

ican Hospital in February 1954, where he remained for five weeks. His nurse would bring him colored paper to work on collages in bed. Youngerman picked him up at the hospital when he was discharged and took him back to his and Seyrig's apartment for a few days. Kelly was still shaky. By early summer of 1954, Kelly was ready to leave Paris and try his luck in New York. He was frustrated and broke, but grateful. "If I didn't have those years in France, I don't know what I could have done."

Youngerman missed Kelly immediately, and he, too, wondered about opportunities in the United States. It was as if he had absorbed all of the art history he could. Paris was not supporting or feeding his kind of contemporary art, as he had seen from the bookstore basement exhibition. He traveled to visit his father-in-law at the Institut Français d'Archéologie in Beirut, and eagerly visited sites throughout the Middle East, in Syria, Iraq, Turkey, and Jordan, where a different lineage of abstract decoration fascinated him. The Seyrigs' home in Beirut was dramatic, filled with Calder mobiles (he, too, had visited that same year) and a beautiful stained-glass window much admired by Calder. Youngerman met the filmmaker and art teacher Maryette Charlton, who had come from Chicago and established an important art school at the American Institute of Beirut; like Calder before him, Youngerman was brought in as a visiting artist for a short stint. Charlton would return to the States in 1956; she was one of the figures from these early years abroad who would end up living down near the Slip in New York, and became a close friend to Seyrig, Youngerman, Kelly, and Tawney.

Youngerman isolated himself more and more, unable to relate to the contemporary art scene in Paris, with its emphasis on tachisme, a movement of abstraction that seemed to abandon form for messy color. He found himself thinking increasingly of America. On September 17, 1955, he wrote to Calder: ". . . I'm homesick for American space, for an American automn [*sic*]."

And on November 18, Youngerman wrote to Kelly in New York:

*Henri had a heart attack this past winter, but is perfectly recov-*
*ered. Your white relief (sailboat) looks nice on the rose wall of his*
*room. Delphine is with child for this Spring.... I hope that things*
*are going well for you, & that your work is being appreciated in*
*America. I've put off my visit—maybe next fall. Painting in Paris*
*is DEAD. I only like my own recent paintings. I saw chez Henri*
*two little things you sent him—very beautiful: And very close to*
*motifs in Arab art! Well, salut! Jack*

And then, as a kind of postscript below, a scribbled query full of
hope—"Is there any American painting?"

# PART II
# ARRIVALS

# 3

## ELLSWORTH KELLY

HE CAME BY BOAT.

Ellsworth Kelly arrived from Paris on the *Queen Mary*, a $200 ticket his parents had paid for.

It was June 22, 1954, the second day of summer (and a hot one, well into the eighties). He was just thirty-one, extremely thin, and barely recovered from that serious bout of jaundice. But he was still arresting, with "button blue eyes," as the artist Ann Wilson described. His art was on board too, shipped on credit; he was bringing home six years of work, including more than eighty-five paintings and reliefs, as well as sketchbooks.

Kelly came to New York because he could not find a way to make a living in Paris. (He had also never felt fully at ease speaking French.) "In France, they thought I was too American. And when I came back, people said, 'You're too French.' I just stuck to my guns and continued painting. I thought I had something really important that came to me in France. That was hard, though, because it was right at the moment of the breakthrough of the Abstract Expressionists."

Manhattan in the 1950s was the height of Abstract Expressionism's reception and renown, putting the New York School on the world map, and in particular the enclave clustered around the Tenth Street Studios, stretching between Eighth and Twelfth Streets and First and Sixth Avenues in the Village, and the Club on Eighth Street,

where painters would come to drink cans of Ballantine and pass bottles of whiskey and talk shop. This community, like Coenties Slip, was born from economic necessity: munitions factories during World War II, the buildings had been recently vacated and were cheap.

Kelly's friend who he had met in Paris, the expressionist painter Fred Mitchell, had found him a loft space at 109 Broad Street in the financial district, around the corner from Mitchell's own. Mitchell, who called him "Ellsworthy," was Kelly's only real contact in New York.

Kelly got a job sorting mail at night in the main branch of the post office; he wanted to keep days and the light for his real work. A notebook from 1955 records sketches of the specific folds and angles of envelopes. In a gesture typical of Kelly's discerning eye, he was most drawn to envelopes with transparent "windows" that offered a glimpse of a letter or paper, often askew. His stark white room was a former office on the top floor of an old four-story building, with high ceilings—"Quite large enough to begin working in"—as he put it in a letter to his friend Coburn. An office building was opposite his window, and beyond that, the East River docks and the battery, where all the sightseeing boats were tied up. He had not yet moved to the Slip but admired its features: "The promenade is especially agreeable at night, with the lapping of the waves, looking out to the Statue of Liberty, (all lit up) + to my loft, one block, God's Lighthouse where they give sermons every evening at 8 o'clock, + across the square lined with trees (the closest thing to a Piazza in New York—Coenties Slip) is the Seamen's Institute ('Dog House') where all Seamen live between voyages—where one can get a shower (if you look enough like a seaman, though I have a bath here annexed to my room + have not yet gone for a shower); but I have eaten at the cafeteria."

Kelly had a door to the roof, which had a little terrace with a table and benches. "Looking back one gets magnificent views of the downtown skyscrapers—on Saturdays + Sundays the district is deserted (only the drunk seamen) + is very quiet + would be nice then for a roof

party." Kelly always took from his environment. What he saw, and the way it came into view, influenced his work. His time in France also framed his perspective in New York: "From each of the windows of this building is a fragment from one of Monet's Rouen cathedrals. The sky is very often blue here + this pleases me." He was ready to get back to work, even as he was a little nostalgic for Paris.

Barnett Newman, the monocle-and-mustache-sporting outlier of Parsons's older New York painting guard, worked in the neighborhood, with a studio at 110 Front Street (and one on Wall Street just before). In a coffee shop, Kelly was asking about apartments and the proprietor told him an artist lived upstairs. "I went up and managed to see into a studio, and there was a white-on-white painting, though no one seemed to be at home." He was thrilled to view work that seemed to be in line with his own. But Newman would not provide the community Kelly hoped to find. "Later I discovered it was Newman's studio, but I also heard that he thought I'd been spying on him." The two never hit it off.

At the time, Newman had troubles of his own and had become increasingly isolated. He did not exhibit between 1951 and 1955, and had a major falling-out with his former friend and fellow Parsons Gallery artist Ad Reinhardt in 1954 when Reinhardt described Newman in a tongue-in-cheek article as a "traveling-design-salesman," and "avant-garde-huckster-handicraftsman." Newman sued Reinhardt for $100,000 in libel.

•••

THERE WERE, OF COURSE, other artists besides Kelly looking to "move out" from the influence of Abstract Expressionism, as Rauschenberg put it, and several lived scattered around the downtown neighborhoods. The composer John Cage occupied a once-derelict tenement building on the Lower East Side, near the Manhattan

Bridge, which he had renovated to such beautiful minimalist appeal (marble table, straw mats, and a grand piano with plants around its base) that *Harper's Bazaar* used it for fashion shoots. "It was comfortable there. Even though we were poor, we lived with such a view—from Brooklyn and Queens across to the Statue of Liberty—that life was enjoyable and not oppressive."

Kelly had kept in touch with Cage and Cunningham after Paris, and sent along a contact sheet of photos of his paintings. Cage mentioned "an interesting young painter," Robert Rauschenberg, he had met in 1951, and with whom he'd spent several important summers working together at Black Mountain College. Finally in New York, Kelly looked him up.

Rauschenberg had returned from an extended stay in Rome in 1952 "with five dollars in cash," living, as the writer Calvin Tomkins describes, "on the far edge of poverty." He found a loft at 61 Fulton Street around the corner from the Fish Market, and bargained the rent down to ten dollars a month. A hose and a bucket were his only plumbing. The following year, Rauschenberg created an artwork that was an audacious announcement of his position vis-à-vis Abstract Expressionism. He asked Willem de Kooning, whom he greatly admired, to give him a drawing that he would erase as an act of art. Amazingly de Kooning agreed, although he made sure to choose one that would be a challenge, as it included both charcoal and pencil. (It purportedly took Rauschenberg a month to complete his erasure.) Not only did Rauschenberg's *Erased de Kooning Drawing*, 1953, directly challenge the accrued and assertive mark-making that embodied Abstract Expressionism, but it literally disappeared the work of one of the artists identified so closely with it. It was a bold and confident announcement of a new guard.

Rauschenberg and Kelly traced similar routes in Lower Manhattan that influenced their art to very different ends. Just a few blocks from his apartment, Kelly took the Staten Island Ferry (five cents)

to visit a friend, and from the ferry stop, a bus. As he tried to read a paperback, "black shadows from the lampposts and telephone poles kept breaking across the white pages" as it lay on his lap. He took out a pencil and furiously recorded the shadows' outlines. Back home, he copied these twenty images into a blank book that served as a catalyst for many paintings and future projects. As Kelly would later say, "a slight variation can be enough to change the picture."

Rauschenberg also took the ferry to Staten Island, a favorite boat destination for artists in the neighborhood, spending all day on the beach and finding "castoff clothes, pieces of wood or metal," buckets of physical stuff that he incorporated into his collages. His studio was "full of things he brought back from Staten Island," salvaged off the street, spotted in shopwindows, or bought at estate auctions. His fellow artist and partner Cy Twombly had a different take. He fashioned an ephemeral exhibition of plaster sculptures in the sand of a Staten Island beach.

After breaking up with Twombly, Rauschenberg met Jasper Johns in the late fall of 1953, and they soon became partners in life and work. To pay the bills, they began designing window displays at Tiffany's and Bonwit Teller under the name "Matson Jones." In 1955, Rauschenberg moved a block east, into the top-floor loft above Johns's at 278 Pearl Street, a narrow brick building that had once been a factory for American flags—the subject of Johns's most famous painting—and that was already condemned by the city. They lived there for three years until 278 Pearl was razed along with dozens of other buildings on their block to make room for car traffic once the Third Avenue El had been taken down. (In place of the buildings was "a new, narrow, triangular block filled mostly by a parking lot.")

Johns and Rauschenberg next moved six blocks south, to 128 Street, where they occupied the second and third floors of a fairly nondescript building over Marotta's Real Italian Hero Sandwiches, with white-painted bricks, low, stamped metal ceilings, and linoleum floors. (This

was the same building where Mitchell lived. In fact, Johns's first exhibition in New York was in 1955, in one of the huge group Christmas shows held every year at Tanager Gallery.) Rauschenberg moved out in 1961 when the two broke up, in part over the difficulties of both becoming better known in the art world in an era that was a "particularly hostile, prudish time" as Rauschenberg later put it. But their years together cemented a productive exchange of ideas that stayed with each of them for decades on.

When Kelly finally knocked on his studio door and met Rauschenberg in the summer of 1954, he was immediately drawn to one of his White Paintings propped on the floor. Rauschenberg remembers that Kelly "was furious I had stolen his idea." Kelly had planned a series of white monochromes in a sketchpad in Paris, and here was something akin to that—and already executed. Further salt in the wound: Rauschenberg had exhibited the series at Stable Gallery in New York the year before. Kelly remembers this studio visit differently; he immediately compared Rauschenberg's monochromes to a "four-panel white painting that his friend Alain Naudé had completed in France in 1952," and that "it was Rauschenberg" who was thrown by the idea of another work so similar.

No matter what happened exactly, the visit was shocking for Kelly. He "felt even more lonely after this encounter." Rauschenberg, like Newman, was not going to provide the community that he might have hoped to find and build in New York. (Kelly may have been even more disappointed to not find camaraderie with a fellow gay artist; the importance of such social circles to "find jobs, apartments, romance, and . . . close friendships" had long been central to life in gay New York, as George Chauncey has traced in the city's prewar life; and now the city was in a moment of even deeper repression.) But Kelly wasn't discouraged from pursuing his own spare abstractions. And he felt lucky to have Henri Seyrig and Calder as admirers and bene-

factors. Calder sent Kelly money that first winter to "relieve your sou-
cis about the rent," as he put it in his note.

Kelly continued to paint, introducing the curve into his repertoire of
shapes, which he called "a new direction for me in New York." He wrote
to Henri Seyrig on October 17, 1954, from his Broad Street studio:

> *My paintings look so beautiful on these white walls—the room
> alive with color—+ some new huge shapes in black + white, some
> new work that dwarfs me, like the towers outside. These have
> some curves in them—large open curves—they excite me very
> much, + I know you would like them too.*
>
> *I have a bath here, so I can keep clean (so necessary here, alas)
> + gas for a cooking stove, and always hot water, +heat too.*
>
> *I am so anxious to show my things. + to get to working on my
> new projects, which now progress slowly.*

Meanwhile, Calder continued to work tirelessly to connect Kelly
with some of the eminent art world figures he knew personally, in-
cluding James Johnson Sweeney, the director of the Guggenheim
Museum.

In a painting by Mitchell from 1954, *Figures in Battery Park/
Coenties Slip*, three forms dance in bright colors—the artist, Kelly,
and Mitchell's Swedish seaman boyfriend. But all was not light and
revelry. The transition back to New York was difficult for Kelly: "The
violence done to his psyche by New York nearly paralyzed him at
first," the curator Eugene Goossen noted. Despite his initial, optimis-
tic letters, Kelly grew discouraged by his loneliness and work situa-
tion. He trailed a cloud of quiet focus around with him. Calder's wife,
Louisa, invited Kelly to a Christmas party in 1954. "Do you like to
dance?" she wrote. "If you would like to come we can put you up—or
are you too serious for this sort of nonsense?"

A year later, Kelly wrote to Calder: "I hope soon to sell a painting. The Post Office has proved no solution for me + I have planned for quite a while to quit—+ just paint + hope for the best, since at present I am able to accomplish nothing in painting." He kept resigning from the post office and then starting work up again there when he needed the money. And again, writing to Coburn, he expressed his regret at leaving Paris. "Each day it gets worse. Really, there is nothing here for me."

...

IN THE MIDST of Kelly's period of self-doubt, another Paris transplant was searching for a way forward. Some eight years earlier, the artist Betty Parsons had decided to start a gallery in New York. It opened in September 1946 at 15 East Fifty-seventh Street, the city's original gallery neighborhood, in a small, brightly lit space stripped of all its decorative features and rugs, painted white, with big leaded-glass windows that looked out on a maze of fire escapes. As she later claimed, "The gallery was the first to be painted white and the first to

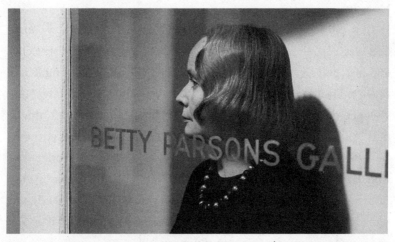

Betty Parsons at her gallery, New York, ca. 1960. Photograph by Gwyn Metz.

show really big pictures when Pollock broke away from easel painting."

Parsons's timing was fortuitous; another enterprising heiress, Peggy Guggenheim, had decided to close her gallery, Art of This Century, and return to Europe, and Parsons inherited many of her artists, including Pollock, Rothko, Newman, and Clyfford Still. As the gallerist Leo Castelli once said, "It was the beginning of a great moment in American art that started there at Betty Parsons's. For the first time a great original art movement took place in America." Parsons wasn't shy about her eye, which she also attributed to her own lifelong practice as an artist: "I was born with a gift for falling in love with the unfamiliar. Actually, being an artist gave me a jump on other dealers—I saw things before they did." She had great self-confidence, part of which came from class. She grew up wealthy (even if it was precarious and lost in the stock market crash), attended finishing school, got married to a man a decade older, got a divorce in Paris (the same city where she had honeymooned) two years later but kept his name, and spent the rest of the decade there. Brancusi cooked her eggs, decades before Kelly and Youngerman's studio visits, and Berenice Abbott photographed her; a brief stint in California included a job selecting wine (a skill honed in Paris) and parties with Marlene Dietrich. But after divorcing, she was disinherited. She lived with women for the rest of her life. Parsons once told Youngerman, without vanity, as if stating a historic fact: "All [my] sisters were beautiful, but I was the most beautiful." She enjoyed being mistaken for Greta Garbo, a friend and tennis partner, on the street. She had a deep voice, a thing for berets and pearls, and an aversion to makeup. She carried her watercolors, pens, a vial of corked water, and notebooks everywhere in a little wicker basket, and was constantly drawing or jotting notes or lines of poetry—even in the car. Well into her seventies, she would go skinny-dipping in the ocean on the North Fork of Long Island.

The critic Lawrence Alloway described her character as "aristo-cratic," with "a quizzical curiosity about people in which observation abruptly issues in firm assessment; and a readiness to be exalted and overwhelmed by works in the studio, or by intuitions about artists." For Alloway, her life and her gallery were run "with an unflagging zeal and the untidiest of desks."

Her first show that fall of 1946—Northwest Coast Indian art, with a particular emphasis on paintings and small sculptures—demonstrated both Newman's influence and her own ambitions for consistently expanding what a contemporary art gallery might show, what American art encompassed, and what a contemporary art audience might, or *should*, be interested in looking at. Newman and Parsons worked hard to secure loans, including from the American Museum of Natural History. Her next show was no less ambitious in its difficult abstraction: the square almost-monochromes of Reinhardt. She went on to exhibit Newman, Pollock, Rothko, and Still, although these artists were not satisfied with the number of shows she was able to give them (she often closed her gallery on a whim for trips or long summer breaks), or the prices she asked for the work. She let her artists hang one another's shows, but "no matter how good the paintings looked, the public was invariably depressed by what they saw" and finances were always tight. She thought of her main Ab Ex artists as the "four horsemen," calling Rothko the "Painter of the Sublime," Newman "The Great Statesman," Pollock "Nature," and Still "The Stallion and the Eagle." She even showed thirteen abstract canvases by the young Robert Rauschenberg in the spring of 1951—a financial flop, with no works selling; it was here that Cage first saw that work.

Parsons felt that the world didn't understand her artists' genius. She once described what she looked for in art, quoting the author Willa Cather: "What is any art but an effort to make a sheath, a mold, in which we imprison for a moment a shining elusive element which is life

itself." How could collectors see this work when modern art still meant the radical breakthroughs of Cézanne? Pollock had "exploded the easel painting, the wall painting. His paintings were walls—whole worlds." The Ab Ex artists' own internal competition didn't help things either. Parsons, unable to promise these artists an exclusive roster, or provide them with stipends or stable salaries, watched as they slowly defected to the dealer Sidney Janis, a former shirt manufacturer, whose gallery was literally across the hall from her own.

Parsons was never commercial and she didn't make a distinction between art and life. This was an "admirable" quality, as Youngerman later saw it, "but it also conflicts with not just the egos but a certain seriousness that people like." Rothko and Pollock were "working on the outer limits of themselves," and so they resented some of the people that Betty brought in because they were her friends, rather than important artists, art critics, collectors, or curators. Her sense of art was less focused and more accepting. Dorothy Miller once joked that Parsons lost interest in artists when they began to really sell. Parsons herself admitted that she wasn't a "natural businesswoman" and that the commercial side of things made her nervous. (Even so, Clement Greenberg credited her with American art's "triumph . . . no longer in tutelage to Europe.") She often forgot to follow up on potential sales. She was not mechanically inclined; a close friend remembered that she found radios "mind-boggling" and could barely turn one on. She had her own art career, painting and making sculptures on "weekends, at night, at any free moment," though she never showed her work at her gallery. Even if the city's major museum curators typically visited galleries on the weekend, Parsons would close hers to head out east to work on her art. Because she was not interested in the market, she also never offered advice for what her artists *should* do. ("Frankly, I think I could have used some advice," Youngerman later said.) She had an extreme modesty about her gallery as a business endeavor, even as she was certain of the greatness of her artists.

She signed letters to her artists with "love." As Greenberg wrote at the time, the Betty Parsons Gallery was a place "where art goes on and is not just shown and sold."

The crisis of the defection of her "Giants" to Sidney Janis was fortuitous for Kelly. It opened up a space for Parsons to look for new artists and new kinds of painting to support. She had first seen Kelly's and Youngerman's work in Paris when, ironically, she was looking for European artists to show; she was struck by their uncomplicated abstraction, how they were "free and had balance and light" and "had a purity in them."

Even back in New York, Kelly had to differentiate his process from the looming influence of Parsons's original Ab Ex crew: "Older, respected artists would tell me I wasn't really painting. I was just determining a shape and filling it with color. Because in those Abstract Expressionist days, it was not thought valid to plan a painting. You had to face the canvas as a battlefield." Kelly distanced himself in terms of not just what his finished work looked like but his approach to making it. Riding home on the subway from a party with one of the expressionists, Adolph Gottlieb, in his earliest days in New York, conversation turned to their work. "Describe what you do," Gottlieb said to Kelly. And when Kelly did, Gottlieb said flatly, "That's not painting." And still, Kelly had an unflinching confidence in his method. "My work is different because I get an idea, then plan the shape of the stretcher for the form. But I have to figure it all out beforehand. It's not finding the painting by doing it, the way, say, de Kooning or Pollock worked."

In New York, Betty Parsons visited Kelly's studio on a late winter evening in 1955 with her colleague David Herbert, and on May 21, 1956, Kelly's first solo show opened in New York at her gallery, including thirty abstract paintings and reliefs, eleven from his time in France. For Parsons, Kelly's abstractions had a simplicity that was joyful. "He was a very smart guy. And in a serious way he was a very

happy artist. Even when he worked in black and white—just black and white—he made the sun shine on you."

Kelly's first show crammed Parsons's modest space with his work—he had so much to prove. Paintings were hung over the front reception desk and on wires around the wall; his 1951 Paris compositions *Colors for a Large Wall* and *Cité* dominated the space. But work made since he'd arrived in New York was there too—some created so recently the paint, Bois has mused, must still have been wet.

Kelly's titles in his first show in New York often obscured that the paintings had any connection to place. Over the course of his career, his work titles would oscillate between pure abstraction and implied figuration, between the straightforward, formal description of color or shape (e.g., *Red Curves*) and a title that felt almost wildly suggestive like a bird's name, a desert, a tugboat. *Black and White I*, from 1956, as it was listed in the Parsons show, he later retitled *Wall Study*, referring to another painting, *Wall*, an unyielding black square, which in turn referred to Wall Street, at the end of the street where he lived, which in turn had been named because the Dutch had built a wall in the seventeenth century running the length of its route to keep out any invaders. The painting Kelly chose for the show's poster was titled *South Ferry*, which was just around the corner from the Slip, and where many of the artists living downtown would ride the ferry to clear their heads. *Wall Study* is one of two paintings in the show that sold. His total earnings, after the commission back to Parsons and paying for the newspaper advertisements and poster invitation printing (standard fees then covered by an artist, not the dealer), was $67.25.

Kelly was hesitant to think of this show as any kind of arrival in New York. He yearned to be understood and accepted by the established New York School and Abstract Expressionists, even as he defiantly moved out from under their shadow. Franz Kline, a friend of Mitchell's, came to visit Kelly's Parsons debut, and Kelly saw him staring intently at his paintings. It wasn't until two years later, at

the Pittsburgh International Exhibition of Contemporary Painting and Sculpture, that Kelly met him, through Youngerman. The older artist, famous for his black-and-white calligraphic abstractions, remarked, "You're the one who makes those beautiful color paintings." Kelly apparently thought that Kline was making fun of him, but Youngerman exclaimed, "He means it, he means it!" and Kelly wept.

In spring 1956, John Patrick Douglas Balfour, the third Baron Kinross, set sail across the Atlantic on the *Queen Mary* to see and write about America. His account, published as *The Innocents at Home*, included several long stays in New York City. Kinross hailed a cab driven by the painter Harry Martin, a friend of Kelly's who worked as a livery driver on weekends to make a living, and they struck up a lively conversation about art and culture in the city that led to a lasting friendship. Martin had a wide circle of friends, almost all artists, and Kinross hung out with them as an ornithologist might try to infiltrate a flock of birds.

Kinross describes Martin's crowd as poor and unconcerned about money, living in cold-water flats, "perplexed by personal problems ... they were people with a respect for civilized values, in the arts and in personal relations; with an approach to life which was zestful and essentially human, but with an honesty of mind which made them uneasily critical of much of the life going on around them." Kinross was at a loss to characterize the members of the group exactly, as they were neither "hipsters" nor "beat boys": they had "a mixture of sophistication and innocence. In a sense, they had learned everything; in a sense, they had everything still to learn."

To Kinross, Kelly was the most established of the group; he had already found himself as a painter. (Again, that persistent confidence.) But he was also one of the most morose: "sallow and withdrawn and misanthropic." Kelly had just achieved some success with his Parsons show but "was forever in a mood of perverse, perhaps romantic protest against it." (Again, his cautious remove.) Kinross watched

him deliberately discourage patrons. As if narrating a scene from an Edward Albee play, Kinross describes afternoons lunching with Martin at the Central Park Zoo, where they were sometimes joined by an agitated Kelly, "dejected by the sale of a picture to some unsympathetic client, and we would cheer him up by taking him to visit the leopards, slinky as hostesses, in their cages." When Kelly and Harry Martin were seeing Kinross off from New York on his return to England in 1956, they all boarded Kinross's "slow Cunarder" after a languorous lunch with carafes of red wine at a little Breton restaurant on the docks. Already tipsy, they drank another pitcher of Burgundy and a half bottle of scotch in Kinross's cramped stateroom, where Kelly "drew extravagant nudes with a piece of soap, all over the mirrors." He was never not thinking about art.

Just a few months after his Parsons show, Kelly was talking to Mitchell, who mentioned that he had seen a cheap warehouse loft for Kelly to rent one block away from his current place on Broad Street, at 3–5 Coenties Slip, where the Irish pub Jim Screen's occupied the first floor. Kelly moved in July to the top floor, an expansive if dirty space that, after cleaning and scraping walls and rafters for a week, he painted and immediately filled with his art and plants. He lived there for the next seven years. Youngerman described Kelly's space as "poetic": "very practical and very aesthetic at the same time, and very minimal." The building's gas meter had been left on, and Kelly hooked up to the illicit source.

Kelly was "drawn to the water's edge, the light and the silence that descended at day's end and on weekends," as Mildred Glimcher wrote of her conversations with the artist. "The area reminded him of childhood visits from New Jersey to his father's office on John Street." One hundred years earlier, the same buildings of Coenties Slip had been filled with commission merchants, sailmakers, and ship chandlers. Across from Kelly's loft was an abandoned lot, a common sight in this neighborhood where buildings were coming down at an alarming

Ellsworth Kelly with *Brooklyn Bridge II* (1958) in his Coenties Slip
studio, New York, 1958.

*(Courtesy Ellsworth Kelly Studio.)*

rate. It was full of feral cats that an old lady came and fed through
the fence every day. Just down the way was the water, and Kelly had
access to the roof of his building, where he planted sunflowers, corn,
and other plants in salvaged wooden barrels—the future subjects of
his delicate line drawings.

Kelly kept visiting the "Doghouse" for hot showers and twenty-five-
cent meals in its warm basement cafeteria, where sailors could order
baked beans and ham hocks and lemon meringue pie.

He was finally settled. Now Kelly needed to follow his own mantra
to look around him and paint what was already waiting to be seen.

# 4

## ROBERT INDIANA

ROBERT INDIANA ARRIVED BY BOAT in the fall of 1954.

He was still Robert Clark then, a self-described "scraggly" and "angry" twenty-six-year-old. He'd been abroad for thirteen months, studying at the University of Edinburgh on the GI Bill and traveling widely throughout Europe, following three years he would "rather forget" in the U.S. Army Air Corps. He was far less impressed with Paris than his future Slipmates Kelly and Youngerman: "They were still of that generation to whom Paris meant something. To me, Paris meant absolutely nothing. When I was there I couldn't find an interesting exhibit." His trip back to the States from England was dreadful. He'd needed to borrow money from the U.S. Embassy for his ticket, and sailed third class, surrounded by "middle-aged Germans," including a man who had, or so he claimed, "killed something like twenty-five American soldiers outside Pisa" during the war and been personally decorated by Hitler. Due to this history, the ex-soldier hadn't been able to get work in Germany after the war but had somehow found a job in America.

Indiana was so broke that he couldn't make it all the way back to Chicago, where he had originally embarked on his travels after graduating from the School of the Art Institute, and where all his paintings, possessions, and art materials were stowed. But he was used to adapting to temporary digs. His family had suffered during

the Depression: he had moved more than twenty times before he was seventeen.

"Marooned" in New York with "absolutely no contacts or friends," Indiana found an extremely cheap flophouse on Fifty-sixth Street on the west side that housed a lot of artists and poets. He secured a part-time job at the E. H. & A. C. Friedrichs Company art supply store on West Fifty-seventh Street, just down from the Art Students League and a few blocks from Betty Parsons Gallery, for $20 a week (less than a dollar an hour).

He wrote poetry and made some art, but was unsure what to do—even if he had announced to his parents when he was five that he was going to be an artist. He still didn't know what that meant. Indiana began hanging out with the poet José Garcia Villa, a colorful protégé of Edith Sitwell, "who sometimes wore a third eye painted on his forehead" and published work under his "true persona," Doveglion (short for dove, eagle, and lion). Garcia Villa introduced him to the poet E. E. Cummings, then at the height of his popularity, but even after the honor of having tea with him in his apartment on Patchin Place, Indiana turned away from poetry.

One mid-June day in 1956, "the most significant thing" happened to Indiana while he was working at Friedrichs. Indiana was arranging the windows of the art store with postcards and reproductions, and "a young man came in and asked for this particular postcard by Matisse, and that gentleman was Ellsworth Kelly." At the time, Indiana was "desperately in need of a new loft, a new studio," and Kelly was also looking for a larger loft than his Broad Street accommodations. "It was he who introduced me to the Slip," said Indiana.

Taking Kelly up on his recommendation for cheap lofts, on June 30, Indiana moved into the top-floor space of 31 Coenties Slip, paying $30 a month for Mitchell's former art workshop. (And before that, a Marine Works chandlery.) A week later, Kelly moved into a slightly larger studio at 3–5 Coenties Slip for $45. "That fifteen dollars made

quite a bit of difference in those days," Indiana once said, "so I took the cheaper one and let Ellsworth have the more expensive one." (In 1960, the average New York apartment rented for $78 a month, and was much smaller than the Slip's loft floors.)

The loft was in a bad state when Indiana moved in. Mitchell left behind a mess of drawings and supplies. And since his departure, the loft "had been used by derelicts in the neighborhood and it was piled high with refuse just from these waterfront characters." Indiana would not have been up for dealing with the situation on his own, but "having Ellsworth as a neighbor made it much, much simpler. We did these things together. He helped me with mine, and I helped him with his loft."

Indiana's space was covered with tin, "which of course white-washed very easily" and "it made for a very beautiful, light studio." To avoid the terrible draft, Indiana replaced its six windows. From his apartment, he had a view of the East River, the Brooklyn Bridge, Piers 5, 6, 7, and 8 along the river, the sycamore and ginkgo trees of Jeannette Park, and the lighthouse of the *Titanic* memorial on top of the Seamen's Church Institute. As he explained later in an interview, "There is a lighthouse that shines through my skylights called *Titanic*."

That fall, Twombly asked Indiana if he could borrow his studio to work on paintings for his upcoming show at Stable Gallery. He would paint during the day while Indiana was at his job at Friedrichs; Indiana welcomed the prospect of shared rent. Twombly's "miserably small" apartment was just a little north at 263 William Street, where he had lived intermittently since 1954. He depended on other artists' spaces to realize his ambitious work: he had already made a series of paintings in 1954 at Rauschenberg's Fulton Street loft.

Twombly's new canvases included thick surfaces covered over in layers of newspaper and wet white house paint mixed with overlaying graphite pencil in scribbled drawings that included words graffitied

into the skein of lines like half-emerging messages. Johns and Rauschenberg came by 31 Coenties Slip together to see how Twombly's paintings were going, and gave "a mind-blowing critique." As Indiana remembered it, "one squiggle had to go this way, and another squiggle had to go that way. It was very illuminating, and very informing." When Twombly left behind several of these canvases in Indiana's studio, Indiana used them for his own monochromatic explorations, tearing off some of the newspaper and painting over other sections to produce a collage effect. Canvas was an expensive and coveted commodity at the time. But when Youngerman arrived from Paris, Indiana realized his Twombly canvases were too close to what Youngerman had been doing for some time, "and with great accomplishment." Indiana was discouraged from pursuing this direction any further.

Just months later, Indiana's building was threatened by demolition; the owner had lost his liquor license for the bar on the first floor, and the building was worth more as a parking lot than a rental property. The first building to come down after the artists came to the Slip was 31. Indiana moved to 25 Coenties Slip in 1957, paying $45 a month.

Shortly after his move, Indiana was walking down by the Battery and bumped into the twenty-five-year-old artist Ann Wilson. He invited her back to his studio to see his work. Wilson had arrived in the city a few years before on a bus from Pittsburgh; her friend, the artist Ray Johnson, met her at the depot and immediately marched her to Sidney Janis to show her portfolio, where she was politely encouraged to look downtown at some of the younger galleries. At the time, Wilson was living in two rooms across the hall from E. E. Cummings and Marion Morehouse at Patchin Place in Greenwich Village (where Indiana had had tea) but longed for a proper loft to work in. Indiana pointed to 3–5 Coenties Slip and said that a space was available there for $40 a month. She moved in above Jim Screen's bar soon after.

Wilson painted the floor white but could never sand out all the splinters (you had to wear shoes), and she would bathe standing in a little plastic dishpan, awkwardly pouring hot water over her body. Later she hooked up a lawn shower, which leaked through the floor to the bar bathroom below. The owners of Jim Screen's were always banging on the ceiling with a broom handle to make her stop the rain. She worked on watercolors and collages using found quilts that she would paint and write over, including *Moby Dick* (dated 1955, before she came to the Slip, though so related to the place) and a later work from 1959–63 she titled *3–5 Coenties Slip, No. 1,* after her residence. Its grid pattern shows her interest in Martin's compositions at the time, but cleverly uses the preexisting segmented ground of the quilted surface. Wilson's new maritime trade environment connected back to a "practical" material history that she saw as inspiration for the imagination and poetry of American art: Native American blankets and rural folk quilt patterns and "the delicate handwriting and diagrams in old grocery ledgers, carpenter books, tool makers diagrams, ship sale makers."

Indiana's original wooden planked floor had been replaced by concrete when the building turned from a warehouse into a ship chandlery; the brick walls were painted white and large crossbeams ran across the ceiling. Indiana had only a potbelly stove as heat, and an old tub in place of a shower. The apartment was over a noisy restaurant, Rincón de España, that served the seamen of the Spanish lines that still docked nearby, and a helicopter pad would soon open on Pier 6 along the East River. Outside, in between the three rows of windows, words ran down the full length of the building to the awning of the Rincón in white paint: APPLIANCES, TV RADIOS, JEWELRY, CAMERAS.

"Before Coenties Slip," Indiana said, "I was aesthetically at sea." The Slip offered a productive port. He absorbed everything greedily. "The front of number 25 was covered with words that influenced me

in my work every day. Not just that; every boat, barge, ferry, train, or truck that passed nearby or on the river next to Coenties Slip, etched its markings into my work." He got two cats who never went outside; he would rinse out their cans of food and use them to mix his colors. He bought his art supplies at New York Central Art Supplies on Third Avenue.

A few years later, just after his thirty-fifth birthday in 1963, Indiana sat in his Coenties Slip studio, chatting with the collector Richard Brown Baker during a thunderstorm. The roof leaked onto them as they spoke, and one of Indiana's cats, Parcheesi, meowed loudly. Indiana gave the history of his loft as a ship chandlery. "It was on the busiest and the largest of all of Manhattan's slips. And—"

"What does the word 'slip' mean?" Brown Baker interrupted. "Does it mean a pier?"

"A 'slip' is that construction that a ship berths in, you see," Indiana said. "It slips into place and docks . . . The Slip has been an influence and a very formative force in my painting." For Indiana, the Slip became a generative locus for his own myth of "America": the source of his most compelling works, the site of their making, and where he found his place in art after being adrift so long.

# 5

## DELPHINE SEYRIG AND JACK YOUNGERMAN

DELPHINE SEYRIG AND JACK YOUNGERMAN arrived by boat on December 28, 1956, carrying two suitcases, thirteen paintings, and their six-month-old son, Duncan.

They were twenty-four and thirty. Youngerman had left for Paris a young apprentice of art, and he had yet to experience any kind of adult life in America. "So I didn't know what it would mean to live independently, especially in New York. Because even as a child, New York represented sophistication and important things." After nine years in which Youngerman hadn't been back once to the States because he couldn't afford the trip, "I became homesick and curious about New York." Then Parsons, on a tip from Kelly in New York, visited Youngerman's Paris studio in the summer of 1956 with her fellow gallerist David Herbert.

"She was tired and rushed, as gallery people always seem to be," Youngerman wrote to Kelly. "She seemed to like my new ptgs quite a lot (I only showed her seven, of the last year & a half, on D. Herbert's advice), said they were 'absolutely new images,' & that she would like to 'have me with her.'" Parsons, in her inimitable way, proclaimed, "'I'll give you a show . . . but you have to move to New York.' And I accepted immediately."

This meant a great deal to Youngerman, who was struggling with

money and deeply frustrated with the French gallery system. But this decision wasn't easy for Seyrig, an actress who was just building a career onstage in Paris, and whose family was in Europe and the Middle East. She couldn't know the future—that she'd end up starring in two of the most influential avant-garde films of the postwar period: the cult Beat film *Pull My Daisy* in New York, and, four years later, Alain Resnais's *Last Year at Marienbad*, a film that truly launched her career and brought her back to Paris permanently.

Youngerman, Seyrig, and Duncan traveled to America on the same boat as the artist and fashion photographer William Klein and his stylish wife, Janine. Klein had described Kelly's New York studio to Youngerman on a visit back to Paris: "You know, Kelly is living down by the East River near the Staten Island Ferry." Having never spent time in New York, Youngerman didn't know what these landmarks meant, but "it all sounded very, very intriguing."

Two days out in the Atlantic, standing on the deck in the brisk December day, the first thing Youngerman noticed was "this absolutely dazzling white light" hitting the ship's bulkhead and almost canceling out its own color. "I had gotten so conditioned to the kind of Paris light which is the hazy poetic sort of golden light when it is a good day, this Ile de France light. I had forgotten completely what American light was." And just like that, "all of a sudden . . . I'm back." Later, when asked to explain the bold use of colors—black, blue, yellow, red, green, orange, and white—in his paintings, Youngerman described white as "really involved with space, a sense of breadth." A deep breadth and a new beginning.

For Seyrig, it had been eleven years since she was in New York. When her father was deployed there during the war, she was just a schoolgirl. Kelly met the young family on the Hudson piers when they disembarked with their limited luggage; Youngerman had left most of his work behind in a small studio in Paris, and with Seyrig's family, but he brought some canvases and collages over on the boat.

Kelly helped them navigate to the Upper West Side, where they would live in the apartment of a friend, Fance Stevenson, an American poet and writer, for a few months on Riverside Drive. But Youngerman couldn't paint there. Kelly soon tipped Youngerman off that a building at the Slip where he lived was empty.

And so the Youngermans moved into the fourth and fifth floors of 27 Coenties Slip. Youngerman rented the building with an actor named Gerry Matthews, who lived on the third floor with his wife, Dolores. At first, Matthews resided at 3–5 Coenties Slip, under Kelly, and was a little hesitant to leave behind the free gas connection. Matthews was part of Julius Monk's well-known cabaret revue on Fifty-sixth Street; he did two shows a night for six nights a week.

In many ways, the Youngermans' existence was even more primitive than life in Paris on rations and the GI Bill's three dollars a day. "It was a time after the war when everything was kind of drained and

Gerry Matthews and Jack Youngerman at 27 Coenties Slip, New York, 1957. *(Courtesy Gerry Matthews.)*

dirty and old . . . and that's why we were able to rent lofts like that, because everything was down. It was kind of a Beckett landscape everywhere." The Slip was "rough living. We had to bring everything in, there was nothing."

The loft consisted of dusty, empty spaces. There was no heating (Youngerman found small gas heaters), no plumbing, no kitchen appliances or furniture. The ceilings were fields of peeling paint that couldn't just be left alone or immediately painted over—they needed to be carefully scraped down first and then repainted. Youngerman would cover his mouth with a bandana but it was slow going. The ceilings required days and days of scraping by hand and, as he remembers, "ingesting a lot of what you scrape off." He would work late at night. The project unveiled beautiful raw wood beams. Luckily, fellow artists had a penchant for being handy, and often worked in construction to make ends meet. A number of them helped him rig up a small kitchen and a living space.

The fifth floor, with its pitched attic roof, became Youngerman's studio. It was tar black up there; Youngerman cut an illegal hole in the roof, with the assistance of Matthews, and installed a skylight, which helped immensely. He didn't have time to do much else; he accepted the space on its own terms. A huge wooden hoist wheel dominated the studio, an old pulley from the building's sail-making days. Youngerman connected two-by-fours to the wide beams that ran across the ceiling and then put his paintings on them to work. He had a low table—a piece of plywood over crates—where he worked on his collages and the cut-up drawings that he had first made in Paris. He sanded down and painted the floor with scarlet deck paint; Matthews painted his school-bus yellow. Sometimes he put Duncan in a swing tied to the beams by his worktable. (Duncan's main recollection from his time as a child on the Slip was the sound of the foghorns on the water and the distinct smell of oil paint.) Without the luxury of good light or babysitters, Youngerman was mainly working at night and on weekends.

Whenever he had a chance. There's something comforting about being the only one awake creating as your family sleeps below.

Youngerman installed wire mesh in the hole between the living area and studio so that the family could talk to one another between the floors. Sound traveled easily in the old building anyway, particularly since the floors had so many cracks. When Matthews would wash the floors, eternally greasy from the building's previous commercial life, water would spill down the ceilings and walls into Lenore Tawney's neat space. "When one is young there's a kind of acceptance of a dramatic side to things," Youngerman remembered. "The loft went with that. I just lived with it and in some ways felt comfortable with it." The docks were visible from Youngerman's windows. In August 1957, he wrote a note to Parsons, who was vacationing in the desert, describing the view: "The long boats & the river bring rest—horizontals—to the daily grapple." The place provided "a kind of romantic feeling about art on one hand and New York on the other."

There was hardly anything downtown in the way of places to get daily supplies, and no art stores of any sort. There was one small grocery on South Street that served the fishing and tugboats, where you could buy cases of potatoes. The Youngermans later discovered an old bulk supermarket, Callahan's, where Seyrig would go every ten days and spend $25 getting steaks, 12 quarts of milk, vegetables, and eggs. Matthews and his wife shopped at the open-air market on the west side, where there was also a pet store; there, they bought a number of parrots that lived, along with two cats, in their apartment in antique birdcages that Matthews scavenged. Youngerman bought his art supplies at Rosenthal's on Broadway and Thirteenth Street. He and Seyrig found wooden chairs left out on the street. He bought tatami mats—the cheapest option—to put down on the wide floor planks. They hung binoculars by the window to watch the boats. Youngerman traveled to the end of the subway line in Brooklyn to Sears & Roebuck, and bought the least expensive table: a picnic table

that came with two benches. (At the end of his life, he still had one of the benches on his porch in Bridgehampton, New York, holding pots of herbs.) As he began to paint larger work at the Slip, he hung his human-size canvases throughout their living space. Seyrig sewed curtains and dresses for herself. Shortly after their arrival at the Slip, some friends were leaving New York, and gave them a bonanza of items: a vacuum, an elegant sofa and armchair, silk curtains, carpets, dressers, a mattress, cookware, lamps, and a pressure cooker. Seyrig was overwhelmed with what was otherwise going to be thrown away. "This country is nuts!"

Youngerman's brother even came to visit from Louisville, Kentucky. He had borne the brunt of abuse and poverty in their child-

Gerry Matthews on the roof at Coenties Slip, New York, ca. 1957.
(Courtesy Gerry Matthews.)

hood. Jack called him his "lightning rod." He was not impressed with how his little brother had landed, on a street with drunk homeless men sprawled on the sidewalk. "Can't you find a better neighborhood than this?" he asked. Just a few years later, he would die at the age of thirty-five of alcoholism.

...

THE SUMMER BEFORE the Youngermans arrived in New York, in August 1956, Jackson Pollock drove his Oldsmobile into a tree in Springs, on the East End of Long Island, killing himself and one of the two women in the car with him. This tragedy launched Abstract Expressionism from art world prominence to market dominance. The Museum of Modern Art, which had been raising funds to buy his landmark painting *Autumn Rhythm* for $8,000 just before Pollock died, suddenly found that his widow, the artist Lee Krasner, had raised the price to $30,000. The Metropolitan Museum of Art swooped in and bought it instead. It was the end of a certain optimistic innocence for the nascent postwar art boom in the States.

When Youngerman settled at the Slip, he didn't go to Tenth Street meetings of the Abstract Expressionist crowd at the Club. The group at the Slip didn't socialize in the same raucous, bellicose way. As Youngerman explained, "There was no Cedar Bar for us. Happily, because the Cedar Bar was the last of the whiskey and cigarettes, all of whom died young except for de Kooning. That was the end of that particular era of living." Or, put yet another way, "We were all a bunch of Protestants from the hinterlands, as opposed to warm New York Jewish people, like Rothko and Newman."

Despite his disconnect from the Abstract Expressionists, Youngerman was challenged by them, invigorated to respond to them in some way. These artists had made it possible to "be an American and an artist. Which before, to bear was very hard. To carry this idea, to

really believe it without being defensive, was hard." And because he showed at Betty Parsons, where many of those artists had (and a very few still did), he felt even more aware of their shadow. But by the mid-1950s, "the stakes already had been put out for a counter surge . . . by people like Ad Reinhardt and Kelly."

Youngerman, like Kelly, met artists around the neighborhood. Also like Kelly, Youngerman never connected with Johns or Raus-chenberg, though he visited Rauschenberg in his studio and was impressed by his self-confidence and outgoing, friendly personality. On a visit to the artist's Pearl Street loft, Youngerman saw Rauschen-berg's stuffed-goat-and-tire combine sculpture, *Monogram*, 1955–59, in process. Rauschenberg was sitting with Johns and Twombly, cut-ting pieces of aluminum for one of their Bonwit Teller window dis-plays. Rauschenberg had a platform in the middle of the loft. The goat work was on top of it, and there was a discreet handle on the side which pulled out a bed.

Artists became very adept at hiding that they actually lived in their loft studios, since it was illegal. "It was fairly easy to camouflage living" in these spaces, "which is what everybody had to do," Youn-german remembered. For the first months living in the Slip, Younger-man and Seyrig slept on the floor, but Youngerman finally made a bed in September. He found some louver doors with slats on the streets, and he put these up in his apartment in such a way that if necessary he could hide the bed behind them.

During his visit to Rauschenberg's loft, it didn't occur to Youn-german to share his own work. He was shy and self-conscious, but also gripped by an ambition that he later connected to his traumatic childhood and the "sense of constantly needing to reaffirm, I would almost say, [my] *right* to live." Youngerman "felt a little like an oddball coming from those many years in Paris and having my little French family." And yet the Slip offered a chance for him to give his young son a childhood far from his own, one brimming with art and artists.

# 6

## AGNES MARTIN

AGNES MARTIN CAME IN 1957 by bus from New Mexico.

On her lap she carried a whole ham from a neighbor for the trip. She was forty-five. It was a return, of sorts, and she was used to long road trips. In 1941, she had driven to New York from Washington State in an old Ford, taking a month to get there, to attend Columbia's Teachers College, an experience greatly shaped by the university's ongoing war effort. After time back in Taos teaching watercolor and portrait painting, Martin came again to New York and Teachers College for a year in 1951 to receive a master's degree in modern art, before returning to the desert. Now she was back for an undetermined amount of time, perhaps for good, and without the framework of a school degree or teaching position. Going back and forth between the city and the desert underscored a broader theme throughout her life, between separateness and community, that mimicked the great, stark contradictions of America itself: a landscape defined by ocean and desert, urban drive and pastoral stillness, capitalist appetite and Calvinist restraint.

Martin needed to find a place that might help her push past the soft landscapes and biomorphic abstractions she was painting in New Mexico. They were beautiful, synesthetic works that felt seeped in the weather and the light, but she was frustrated by their limitations. They did not satisfy a larger, impatient dream she had about

what purity could look like. She knew there was something missing—some way of working, a system of putting together a painting—that would also get past the anxious voices in her head. She hoped she might find it in New York City.

Martin's latest, arduous trip of thousands of miles was funded via the purchase of five of her small, colorful Expressionist paintings by Betty Parsons in Taos. Echoing promises the dealer made to Kelly and Youngerman, "[Parsons] said she'd show [the paintings] as long as I stayed in New York."

When she first arrived, Martin briefly lived with Parsons in her studio at 143 East Fortieth Street, and Parsons introduced her to other artists from the gallery. Martin soon moved to Coenties Slip after Kelly mentioned there was an available loft. She lived on the ground floor at 27 Coenties as a tenant of Youngerman, paying $45 a month, and then, in 1959, moved to 3–5 Coenties, above the artist Ann Wilson and in the same building as Kelly.

She occupied a vast loft, which she quickly furnished sparely and practically with things she found on the street, or made, including a long table fashioned from four boards, with little stools. She installed a bathtub in the bedroom. She had a cast-iron Acorn kitchen stove, and a rocking chair. Wherever she went, she had a rocking chair, because sitting in one place while still moving just a little, sometimes to wait for the voices in her head to pass, was part of her painting practice too.

Her space was unheated, but she found and installed a big gas salamander heater from a garage that was "quite economical." She had thick, snowsuit overalls that she'd pull on to paint in. She imagined the view from her apartment in terms of geometry and proximity: "The best thing about the slip was that it was a triangle, so it slanted so all the lofts looked across the triangle to the river."

Martin lived at a slight remove from reality. She tuned in to the

parts of her environment that fed her, and blocked out the rest. "There were a lot of drunken sailors around at night—many of them weren't working," Kelly said. "It wasn't that safe. I remember thinking, 'Boy, she's very brave, never to lock her door.'"

One day she knocked on Youngerman's door on the fourth floor, somewhat flustered.

"Jack, could you come down, there's a bum in my bed!"

Youngerman went downstairs with some trepidation to investigate and sure enough, a homeless drifter was snoring, fully dressed in the clothes he'd been sleeping in on the streets for weeks, under her sheets in her army bed.

Youngerman roused him. Finally, after some persuading, the man got up and left. "Well, he could have at least taken off his shoes," was all Martin had to say about it.

One of Martin's earliest mentors was Newman, to whom Parsons introduced her, thinking the two would be kindred spirits in their discipline and drive for a pure abstraction. Parsons was motivated to have her gallery's artists get along and support one another, but she also saw that Martin understood aesthetics "better than anybody, which is a sense of beauty which you could make out of your spit if you wanted." Newman's studio was right around the corner on Front Street, as Kelly had already discovered. Newman warmed to Martin, "loved her," as Wilson remembers, taking her to meet his own art world colleagues, stopping by her studio often to chat, and attending the parties that Parsons specifically threw to introduce Martin. He also helped hang her shows.

Martin became the mercurial den mother of the Slip. Kelly called her the "earth mother, a kind of sage." She and Kelly had breakfast together every day for a year and a half. She was known for her blueberry muffins. Martin proudly owned the fact that she had never been to Europe and thought of herself as "an American painter." She would

tell stories about her life in New Mexico, how she "lived with the Indians" and how to hunt for rattlesnakes, which left Kelly speechless. "When you're in your creative period, between twenty and thirty-five, you go through a lot of crises," Kelly said. "She was very much a healer. You'd go to talk to her and she'd soothe things. Sometimes she would correct us because of our follies, like a parent would in a way." Wilson described the conversations between Kelly and Martin as a "big exchange, a very important exchange."

And Martin began to paint. As she put it, "I never painted a painting I liked until I got to New York." Even this exaggeration shows Martin's need to define what would come next in her life as revelatory.

# 7

## LENORE TAWNEY

LENORE TAWNEY ARRIVED FROM CHICAGO in her black-and-tan convertible Daimler with her cat, Pansy, a refrigerator, a small bed, an espresso machine, and her loom and threads.

It was November 1957. She was fifty, though she understood "I'd be considered too old to establish myself as an artist in New York," and so claimed to be decades younger, and got away with it. She had smooth skin and thick eyebrows that could make her look like she had a furrowed brow. She often wore her hair pulled back in a no-nonsense bun. While she was the oldest of the artists at the Slip, hers was a young spirit—she had come to the Slip to start over, shedding the skin of her earlier life like a molting insect looking for new light. She imagined herself as hiding under a leaf, "quiet until I find my true self." She came to work with yarn and thread in a former sail-making loft.

The loft at 27 Coenties Slip was the first of eight loft residences that Tawney would occupy in New York, and she made each a kind of work of art in itself: filling the space with shallow bowls of perfectly smooth stones or spackle buckets full of two dozen drooping tulips. Critics noted how the place where she lived was akin to the work that she made there. Youngerman was her landlord and Martin her downstairs neighbor. As one acquaintance said, "Lenore was a sprite, very sophisticated and beautiful, and her loft was perfect,

orderly and elegant. Utterly different from Agnes's." Art historian Eleanor Munro described her as "a tiny, dark-eyed presence who enters a room like an Indian dancer, shy yet possessed of the flame."

Tawney was born Leonara Agnes, but shortened her name in the first grade because she felt it had too many letters. She had been married for only a year and a half in Chicago before her husband, George, a psychologist, died of a sudden illness in 1943 at the age of thirty-one. George came from a wealthy family and Lenore inherited farmland that would help her live independent of standard jobs for the rest of her life. A widow at thirty-six, she moved first to Urbana to be near his family, and then Mexico, before returning to Chicago. In 1946, she studied under the sculptors László Moholy-Nagy and Alexander Archipenko at the renowned Institute of Design. Recognizing her tal-

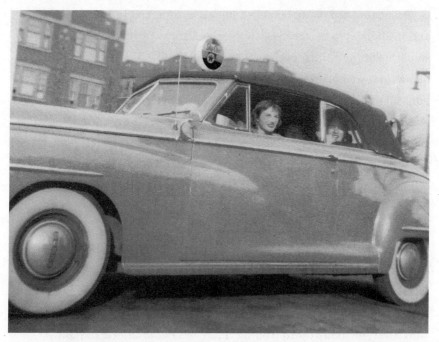

Lenore Tawney in the backseat of her Daimler, near Coenties Slip, New York, 1958.

(Courtesy Lenore G. Tawney Foundation.)

ent in sculpture, Archipenko invited her to his studio in Woodstock, New York, for the summer; there, working all day on a sculpture, Tawney had "my first ecstatic experience." The extremity of this seems to have scared her a little; she was not ready to give up her life for art. Returning to Chicago in 1948, she wasn't sure what she wanted to do. She would go running by the lake before breakfast in the winter, "and sometimes when I was over there and the snow was falling it was like I was in a world of my own. You couldn't hear a sound."

She was renovating a house she had just bought in the city, and "while the house was all torn up, I had a couple of wonderful parties with a famous jazz pianist. Everyone came and drank a lot. And I destroyed all my sculpture." Denouncing the work she had made up until that point, she bought a secondhand loom and "began to weave in a haphazard way." Her lack of formal training gave her the freedom to innovate from the beginning: "I'd never learned what you cannot do." But she soon put this aside too, moving to Paris in 1949. She did not know Kelly or Youngerman at the time, but like Youngerman, she bought a little car to take trips throughout Europe. There she met up with Merry Renk, an artist and jewelry designer from San Francisco, who joined her on an Easter Week jaunt through Europe and North Africa, where they smoked, drank sherry, and danced flamenco. In Córdoba, exhausted from driving, they planned to go right to bed, but the hotel encouraged them to go out to see the procession. They walked around to all the churches, marveling at the howling saeta flamencos, before heading back to their hotel. But it turned out that their room was adjacent to a little alleyway that led to the main cathedral, and soon they heard the pounding of feet on the cobblestones as crowds swarmed beneath their window. After taking the car by boat to Tangiers and then Morocco, they headed back to Paris, but Tawney ran into a tree.

In 1954, she decided to give weaving another try, and apprenticed with the great Finnish weaver Martta Taipale in North Carolina for

six weeks, before returning to Chicago to do her own work. She would continue weaving the rest of her life.

But she again grew restless in Chicago. "I had a friend who had a sailboat and we were always out in the boat on weekends and sailed across the lake. He was a great cook and he'd make sandwiches, all different kinds, and we'd have aquavit, champagne, everything. Oh, it was quite a thing there. And I left all that, I left him, I left Chicago, my house. I just thought I can't let this house burden me."

Her move to New York was supported by her filmmaker friend, Maryette Charlton, whom she had met when Charlton was a docent at the Art Institute of Chicago in the 1930s; Charlton had gone on to teach art in Beirut, where she met the Seyrigs and Youngerman, and where Tawney visited her in 1956, and then moved to New York, where she also lived downtown and was pursuing an MFA in film-making from Columbia. Tawney arrived in New York that damp November a wealthy widow, and she went from her champagne-tinged days in her big house in Chicago to an unheated, unadorned loft. She described her Coenties Slip loft as "terrible," and "on a street of the bums, the down and outers." But she was delighted to be among fellow artists, and with space to make her large-scale woven forms. And she was delighted to live near the water. "Water is fertilizing and water is dissolving and water is cleansing and water is life giving."

As she wrote in her journal, her loft "needed everything—painting, heating, but first, cleaning out." It was as if she had predicted the Slip all along. Just a few months before her move, on May 19, 1957, at 5 a.m., she wrote in her notebook of "the over-flowing heart / sky landscape stream / sky streaks / iced waves / depths of the sea."

She left Chicago "to seek a barer life, closer to reality, without all the *things* that clutter and fill our lives." She wasn't sure if she would stay, but once there, "I immediately felt free."

# 8

## JAMES ROSENQUIST

JAMES ROSENQUIST ARRIVED FROM MINNESOTA by bus in the autumn of 1955.

He was tall and thin and twenty-two. He had $300 in his pocket. Rosenquist found the city intimidating but threw himself into the center of it. "I walked everywhere and never took the subway." He sought out George Grosz, the great Weimar Republic artist émigré, at the Art Students League because he wanted to work with "real artists." Grosz was a laconic teacher (he spoke little English) but he was "sensitive"; rather than explain something, he'd draw pictures with thick Conte crayons to illustrate a point. He was also a famous womanizer; he took the young Rosenquist to parties at "beautiful penthouse apartments" to which Rosenquist only had his standard uniform of dirty khakis and a sweatshirt to wear. Later, in 1961 while working at Coenties Slip, Rosenquist made a painting called *Balcony*, which he described as "about the sensation of being at a cocktail party on the terrace of a penthouse in Manhattan—space described in terms of the sky, a lump of lady's hair, a man's cuff in the mirror reflecting the sky."

As a kid, Rosenquist wanted to be an aviator. Both of his parents worked in the field, but they discouraged him. So at the age of fifteen, over the course of a year, he built a wooden speedboat to sail down

the Mississippi. Air and sea would form the undercurrents of the places he lived and worked for the rest of his life, whether a drafty loft on the seaport of Lower Manhattan, a barnlike studio on the East End of Long Island, or a compound on Florida's Gulf of Mexico. And the urge to see something from a different perspective and distance would be a central component of Rosenquist's most famous art: huge canvases—sometimes room-scale installations—that fused the mural tradition of the first known artworks of humankind with modern culture's ubiquitous billboard advertisements typically encountered on the road.

Rosenquist was always dreaming of ways to expand the horizon of his peripatetic small-town childhood in North Dakota (which he described as "totally flat, like a screen on which you can project whatever you want"), Minnesota, and Ohio. And he was always making things: first model planes out of balsa, then the working boat, and throughout it all, drawings. When he was a teenager, his family finally settled in Minneapolis and his mother suggested, "Since you draw all the time, why don't you get a job doing it?"

So he found work with W. G. Fischer, doing lettering for gas-tank signs. It paid $1.60 an hour. Eventually he went to the University of Minnesota, where the painter Cameron Booth encouraged him to go to art school in New York. He applied to the Art Students League and got in. The summer before going, he took a job with General Outdoor Advertising, painting billboards in Minnesota: Coca-Cola, Davy Crockett fur hats, Corby's whiskey, Northwest Airlines. It was a way to make pocket change for school. He was the youngest painter on the crew by decades.

During his early days in New York, Rosenquist painted in Central Park to feel space, but what he really yearned to do was make murals, and no one at the Art Students League was doing that. (After the mural division of the Works Progress Administration in the 1930s and

'40s, it was considered passé.) But Rosenquist saw something new: "I looked at billboard painting again, and I thought, That's where the tradition lies, right there." At night, in the YMCA where he stayed, Rosenquist would make small abstract drawings with ink and watercolor on paper—the only supplies that he could afford. He spent his time trying to find spaces to work and trying to get enough to eat. "Life was precarious but interesting," Rosenquist wrote of those early days.

He left art school after a year, getting work as a chauffeur, bartender, and babysitter for the heirs to the Stern department store, who lived in a castle up the Hudson in Irvington, New York. He used to pick bushels of apples from their overgrown orchard and bring them down to New York for artist friends. He continued making his abstract drawings, but wanted to return to the action. Moving back to the city after a year, he took a job again as a billboard painter at the Artkraft Strauss Sign Corporation and joined Local 250 of the Sign, Pictorial, & Display Union. Rosenquist was drawn to the simplicity and lack of pretension in sign painting—you were too busy worrying about the weather and not falling to get caught up in the art of the job. "All the tools you need to paint a billboard are paint, brushes, a two-foot ruler, and a blue-chalk string to snap the line." And unlike his own indecision about what to paint, the job gave him a clear image to copy, and clear techniques to do so. His fellow sign painters called him "Rosie."

The silhouette of the city was subtly changing. East River Drive (now the FDR) had just been built on tons of landfill along the edge of the island. And more skyscraper projects were slated for construction around Wall Street. But the city's relative emptiness meant that rent and food were very cheap. "Down in what is now SoHo you had Hell's Hundred Acres, which had been the heart of the war economy: they manufactured gun parts down there. But by 1955 that was all

gone." Rosenquist describes artists procuring bags of food in China-town for $15: "Artists I knew would buy gunnysacks of pasta and rice and live on that for a month ... You could go to the Met for free and see Egyptian and Greek sculpture and Italian and French masterpieces." New York was the kind of place where you might meet anyone, and Rosenquist was open to it. One day in 1956, he was painting a sign on the waterfront, when "next thing I knew I was having a beer and some English sailors asked me to come on board their ship ... I had a few drinks and said, 'Well, cheerio, chaps!' and left" for an art open-ing. There, he met Man Ray. That was New York.

Rosenquist didn't have any money but he knew he wanted to quit sign painting and become an artist full-time. (In 1959, two of his fellow workers fell to their death. Rosenquist often painted twenty stories up without any safety wires. "We were like circus perform-ers," he once said.) By the late 1950s, billboard painting was already an industry in distress, as outside advertising was beginning to see the encroachment of television. Rosenquist would take leftover or discarded paint home from his day job to create compositions that he called "excavations": small canvases emphasizing brush-work and patterns. Their abstraction belied their source. Not un-like Kelly's experiments in France, the shapes and letters buried in these works derived from stairs, structures, and signs Rosenquist saw from his billboard scaffolds, and exposed pentimenti from demolition sites.

Rosenquist met the artist Ray Johnson, who invited him to a party in July for Jack Youngerman, thrown at a collector's apart-ment with huge windows over the Macy's fireworks display. He saw Jasper Johns and Robert Rauschenberg standing against the wall at the party, but never made an introduction. Then, one day, Rosen-quist was walking around Fulton Street, looking for a space to use as a studio. He knew the cheapest place to work was downtown near the

James Rosenquist outside his studio at 3–5 Coenties Slip,
New York, 1960.

*(Courtesy Estate of James Rosenquist.)*

water, where many abandoned warehouses offered ample if illegal
space. He entered a restaurant and asked the owner about available
lofts in the area.

"There's two artists living upstairs. Why don't you ask them?"

So he went upstairs and knocked on the door. Jasper Johns answered. Behind him was a bed on the floor, a big flower planter, and a painting of an American flag, entirely white. Robert Rauschenberg ambled by wearing granny glasses, and directed Rosenquist to a store across the way where the owner kept track of available studios in the neighborhood. Unfortunately none were big enough for Rosenquist, and it wouldn't be until a year later that he would find a place, when Ray Johnson introduced him at a party out in East Hampton to Ellsworth Kelly, who offered him Agnes Martin's old studio at Coenties Slip (she had by then moved down the Slip, closer to the river). The rent was still holding steady at $45 a month.

And so Rosenquist came to inhabit a corner loft on the third floor of 3–5 Coenties Slip. At first, he just used the space as a studio, and shared it briefly with the painter Charles Hinman, a friend from the Art Students League. Rosenquist lived with his new wife, the textile designer Mary Lou Adams, on the Upper East Side on Ninety-sixth Street for $31.10 a month, before they moved into the loft directly below his studio at 3–5 Coenties Slip to live. It wasn't a huge space—about twenty by one hundred feet, with broken plaster walls, exposed lightbulbs, a potbelly stove (but no central heat), a cracked ceiling, and "debris falling through the lath." But it would do, and it would change everything.

# GETTING TO WORK

# 9

## THE NATURE OF IT

1957

A YEAR ON THE SLIP, and Kelly sat in a new light. Shirtless on a hot day in short shorts and leather sandals on the roof of his building, a slight smile playing on his lips, he was dwarfed by wooden barrels of sunflowers that he'd planted, as if channeling Van Gogh. His arrival in New York three summers before was already a distant, anemic memory; he was no longer pining for Paris and writing dejected notes to his friend Coburn. He had even sold a painting to a major museum in New York: the Whitney Museum of American Art had bought *Atlantic* in February for $1,500, and with this windfall he'd immediately procured more canvases and a VW bug. He had moments of unexpected whimsy, rigging a high swing up to the ceiling of his Coenties loft, which resembled the trapeze swings he had photographed in Meschers in the summer of 1950 and whose negative space had informed the curves and rectangles of his compositions. On one occasion, Betty Parsons stopped by with her companion Annie Laurie, who hoisted herself up on the swing and, hanging by her knees like a circus acrobat, swung back and forth. Dining at Kelly's on a visit from his teaching stint at the Cranbrook Academy of Art in

Ellsworth Kelly on his Coenties Slip studio roof, New York, 1957.
*(Courtesy Ellsworth Kelly Studio.)*

Michigan, Mitchell had a mishap on the "marvelous and imperious trapeze." He later wrote to Kelly, "It is still so mysterious to me just how I and the stew collided."

The Slip brought Kelly unexpected access to nature within the city: out to his right, down the row of buildings and past Jeannette Park, was the East River with its lazy tugboats. And he also brought nature to the city. One of the first things he'd done in his new space was cultivate a small flower-and-vegetable garden on the roof, complete with corn. He filled his studio with rubber plants and smooth beach rocks.

Kelly would carry his smaller paintings up to the roof to look at in the raking light, or to photograph them, and he went there to escape the worst of the summer heat. As he put it to David Herbert, "Sunny

hot days, cool air caressing in the night-roof." Indiana (still Clark at this point), too, loved the roof, filling his daily notebooks with anecdotes about getting "a glorious dose of sun" there before going back to painting. And it's where, on a chilly late-winter day in March 1958, Kelly would suggest that the photographer Hans Namuth take some photos of the Slip group for his Expo '58 assignment to document Kelly in his natural habitat, skyscrapers rising around them like redwoods. The nineteenth-century scale of the Slip was never more obvious, more vulnerable than on its rooftops.

Kelly was always planting pits or seeds—he grew avocado, orange, grapefruit, and lemon trees this way. Everyone at the Slip had avocado plants, as they were easy to grow from pits. (A 1951 article in *The New York Times* explained exactly how to cultivate these exotic fruits with toothpicks, a glass, and water.) Indiana filled the old elevator shaft in his loft with pots of them, ferns, and fir tree saplings, reflecting his own interest in plants. (His favorite course in Edinburgh had been botany, held in the queen's botanical gardens.) He also hung found wheels, metal chains, winches, and stencils from the building's previous occupants, Marine Works ship suppliers. He drew from the avocado plants that "flourish under the skylights of the Marine Works," as he wrote in his autochronology for the year 1957. Even Seyrig wrote to her parents in Beirut with instructions on exactly how to grow avocados, and though she hated their taste, she gave a recipe for a trendy new dish that was very easy to prepare and a little like hummus. It was called guacamole.

For Kelly, the plants were more than cheap decor. He made sure he had plenty because he wanted to draw them. They were an "already-made" subject matter of endless variety. Later he would say that he chose them because "I knew I could draw plants forever." His studio would soon be filled with sketches of plants. They breathed oxygen into his paintings too.

His *very* first plant drawing was a daffodil on the cover of his junior

high school journal, *Chirp*, in April 1938. In damp February 1949 in Paris, Kelly had bought a little hyacinth plant at the flower market and brought it back to his small, cold room at the Hôtel de Bourgogne to "cheer myself up"; its bright perfume soon filled the air. He began to draw the flower, which was the start of a series of delicate contour line drawings of plants that he would make wherever he was living: fig leaf, seaweed, artichoke, wild grape, burdock.

Ellsworth Kelly, *Jack Youngerman (3)*, 1949, pencil on paper, 14¼ x 10¼".

*(Private collection. © Ellsworth Kelly Foundation.)*

Kelly's plant drawings evoked the confident, spare lines of two artists important to him: Matisse and Calder. But they had their own, independent essence; Kelly called them "portraits." When he first began making them in Paris, he was also drawing his friends— fast sketches in pencil at cafés, on park benches. Friends were ready-made models, but Kelly's incessant sketching was also a declaration that these composers, writers, dancers from Merce Cunningham's company, would make it someday and these portraits would be part of that story. He felt the need to be drawing endlessly, as if there were a direct line between his eyes and his hands.

In 1957, the plant drawings became a kind of daily practice at the Slip: when he first got up, or when he needed a break from painting. They were quick, instinctual, mostly made in ink or pencil; he never erased a line as he was working on them, and he discarded a lot.

Kelly had, in Youngerman's words, a "quiet focus that was always there." This ever-present attention was how Kelly understood na-

ture, too, which he once defined as "everything seen." What could nature offer up as spontaneous subject matter? In Paris, this might be the vault of a cathedral "or even the splatter of tar on the road," which seemed to him "more valid and instructive and a more voluptuous experience than either geometric or action painting." He was interested in things that "have always been there. The idea of the shadow of a natural object has always existed . . . a rock and its shadow and the separation of the rock and the shadow." On a return visit to Paris in 1966, he snapped a branch off an ailanthus tree he passed on the street and filled up his hotel bathtub with water to keep the cutting alive while he drew it, "delay[ing] my showers for a few days."

It's not just that nature provided subjects for Kelly that were "already-made," or that his drawings allowed him to think through forms in a way that instructed all of his paintings. He saw nature itself as the ultimate artist. "I want to work like nature works," Kelly said, as if channeling the poet John Keats. "I want to paint in a way that trees grow, leaves come out—how things happen." That he internalized the process of nature's spontaneous creation in producing a thing of beauty in itself helps us see how a continuous project that might otherwise be dismissed as a hobby could be at the center of his art. He called his plant drawings "the point of departure for all of my later work." This was about figuring out form—the curve or overlapping shapes of leaves. And about a direct transfer of what is seen. "I don't solve the painting by doing it; I solve it before with the drawings." Nature, for Kelly, was not just the world apart from human intervention—it was everything around him that was unaltered, giving his vision a kind of ecology that encompassed the whole environment. The city, then, could be as much a source of nature as a field or an ocean; it, too, is an ecological site. Nature is entwined with place in Kelly's view. And the persistence of place undergirds every abstraction he ever made. When asked, as an atheist, if there was anything he believed in, he answered without pause, "nature."

Kelly had spent his childhood as a shy, sickly boy bird-watching at the local reservoir in New Jersey with his grandmother. He liked to say that he developed his eye for color and form watching a little blackbird with red wings in his backyard; Kelly followed the bird as it flew into the pine trees behind his house "like he was leading me on."

Nature was his introduction to what it could mean to be fully committed to art. He had discovered John James Audubon's massive undertaking *Birds of America* at his local library when he was seven or eight, along with the ornithological illustrations of Louis Agassiz Fuertes. (Kelly later gave a copy of Audubon's book to Youngerman as a present, as both Youngerman and Audubon had roots in Louisville, Kentucky.) Audubon's huge drawings, partially made in the field from specimens he shot and pinned to a board as he traipsed across the United States in the 1820s and '30s, were crucial for Kelly. As a kid, turning page after page of the heavy volume, he took in the obsessive looking and understanding of color that each entry reveals, the sharp outline of the animals against the background, the way their figures filled a page so that a wing sometimes just seems to scrape against its edge.

His first year back in New York, he eagerly visited the New-York Historical Society, which has the largest collection of works by Audubon in the world. Just a few years after his death, Audubon's widow had sold the society the artist's original watercolor and pastel drawings for the engraved plates of *Birds of America*. Looking at these, Kelly had the exciting revelation that Audubon had occasionally employed collage to create his elaborate compositions—a technique Kelly also had been using to get the compositional patterns he wanted.

Kelly never showed his plant drawings with his paintings at Betty Parsons. He didn't exhibit them publicly for twenty years, until 1969, when the precocious thirty-four-year-old curator Henry Geldzahler included thirty in a designated gallery at the Metropolitan Museum of Art, part of a major group exhibition, *New York Painting and Sculp-*

*ture: 1940–1970.* Geldzahler took over thirty-five galleries at the Met usually reserved for European painting, underscoring the show's symbolic announcement that contemporary art had arrived, had rooted, and was flourishing in the United States. He filled them with more than four hundred works by New York artists; Kelly had the most of any artist, with forty-two.

Everyone at the Slip knew of Kelly's plant drawings in the '50s. Along with flowers and leaves and windows and shadows and stones, Kelly continued to draw the people closest to him. "Drawings have memory; each one has an episode," he said. Drawing proved to be an elegant and convenient way for the discreet artist to get into a relationship. He started dropping by Indiana's studio to sketch him or the scene out his window. A colorful Knickerbocker Beer sign on a wall of the parking lot outside of Indiana's studio at 25 Coenties Slip created a number of different patterns that intrigued Kelly's eye for found compositions. And Indiana in turn captured Kelly in dozens of line drawings. They became lovers. Kelly made a series of drawings of Indiana sleeping.

Kelly once again could use his environment as a source for experimenting with different representational elements becoming abstractions. The beer sign became the foundation for paintings such as *Paname*, 1957, and *Yellow with Red*, 1958. Kelly would later make a drawing for James Rosenquist's wife, Mary Lou, whose shape was derived from "the view of a Knickerbocker Beer sign out the window and Bob Indiana putting his pants on."

•••

ONE SPRING DAY in 1957, Indiana and Kelly sat by the water on the rickety wood of Pier 7, sharing an orange. The pier was at the end of Whitehall and South Street, just upriver from the Slip's Pier 6, where Harry Houdini embarked in 1912 to perform his famous escape stunt,

handcuffed and nailed shut inside a wooden box thrown overboard from a barge into the harbor. Indiana could see the piers from his studio window. He had not yet changed his name; he was still Bob Clark. But: "With Ellsworth, my whole life perspective changed." Indiana "could feel that something was going to be happening shortly . . . and it was just like going through a revolving door from night into day."

Kelly saved part of the unfurled peel. It made a beautiful shape in his palm, almost echoing its curve.

Returning to his studio, Kelly did some quick drawings, actually tracing the peel of the orange in pencil on paper, careful to include every rough contour. He began to paint, his easel leaning up against a stepping stool.

The small composition *Orange Blue* seems straightforward enough. A bright orange form on a bright blue background, just over a foot tall, its central shape looks like a torn petal or a squat Matisse cut-out figure, connected at the center of the picture and radiating out to almost kiss each of the painting's four edges. This shape's uneven edge makes it an outlier in his oeuvre. The shape is not symmetrical or smooth and yet it feels as if, when brought together on itself like an origami design, it might create a sphere or at least three dimensions. Kelly wrote on the back of the canvas: "FOR ROBERT AN ORANGE PEEL FROM PIER 7."

There are layers to all of Kelly's early abstractions. There's what you are looking at: a matter-of-fact statement of color and form. And there's where the shape and color came from, a complex narrative of extraction from the natural world. These are situations in time—a thing at a specific place that carries a specific sensation in that moment: the wind slapping beach cabanas and the hot metal of stairs and their shadow at Meschers, the acidic sweetness of an orange peel held over a murky blue river. The second layer constitutes a quiet, often unknown story about what Kelly happened upon and noticed. There's no one-to-one equivalence; he always shut that reading

down: "The form of my painting is the content." *Orange Blue*'s title
plays with these layers: the unique fact that *orange* is both a color and
an organic object that inspired the painting's form. (The work's orig-
inal title was *Peel II*.) You don't need to know what he once saw to see
the painting for what it now is.

Kelly's discovered mode of composing opened up not just a new
world to him but also a new way forward for abstraction in American
art: "I could take from everything: it all belonged to me." Younger-
man found this sense of ownership maddening, how, even in Paris,
having sold nothing and showing so little, Kelly still retained an un-
derlying confidence in the bounty of his vision. Youngerman, on the
other hand, never shook off doubt about what he was doing—it's what
spurred his work on.

Later that fall, 1957, Kelly and Indiana walked to the end of Co-
enties Slip, to Jeannette Park, a favorite spot for the artists to take
a break. Its namesake was tied to the sea. In 1881, The steamer USS
*Jeannette*, sponsored by the eccentric *New York Herald* owner and ty-
coon James Gordon Bennett, Jr., and named after his sister, was "lost
in the ice" while attempting to seek clear passage to the North Pole.
Stuck for two years, the vessel eventually sank, though the crew of
thirty-three escaped across ice sheets and then in a smaller cutter
that was better able to maneuver the frozen waters. Ultimately, ten
crew members survived the ordeal. At the time of this tragedy, the
Slip still had a functioning waterway cutting in as far as Front Street,
though it had become "something of a nuisance." People had to walk
around it on their errands along South Street—called "going round
the horn"—and drunken sailors too often fell into it. A park would
fix this problem; the waterway was filled in with "ordinary dumping
material," and the spot was christened in honor of the ship lost at the
North Pole.

In 1886, an article in the *Times* mentioned the great views avail-
able from Jeannette Park (which was then just a slough of dirt, where

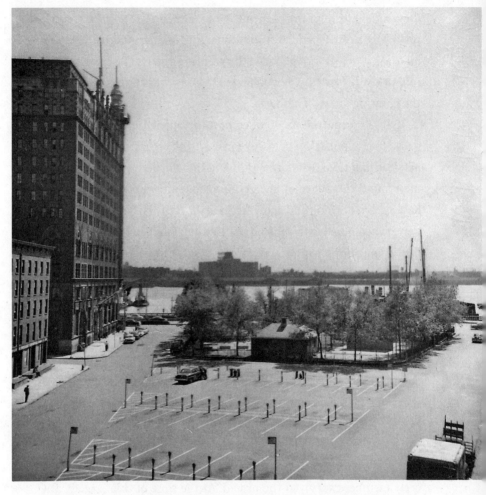

View toward East River on Coenties Slip, with Seamen's Church Institute and Jeannette Park, New York, 1957. Photograph by Gerry Matthews.

*(Courtesy Gerry Matthews.)*

urchins would make mud pies): "to the eastward may be seen the broad East River, with busy craft hurrying over its surface, while beyond rise the heights and spire of Brooklyn. To the westward there looms up, high above the surrounding buildings, the huge tower of the Produce Exchange." Six years later, the park was finally done.

"The proper place to see Jeannette Park at its best is on the nearest part of the Elevated Railway, where the cars round the sharp curve," a reporter from *Scribner's* wrote in 1892. "Here the jewel-like, richly decorative effect of the park is spread out in bird's-eye-view, and beyond, a few yards away, rolls the East River, with its varied shipping and incessantly dancing waves."

In 1957, Jeannette Park had lost some of its luster. Homeless people slept there. It was a meeting ground for artists and for sailors from the Seamen's Church Institute, which loomed twelve stories over it. But the park's main, proud feature was its mini arboretum: fifteen ginkgo trees. Indiana picked up some of the distinct fan-shaped leaves that shed every fall within the space of two weeks, carpeting the "black-blue asphalt" of the park in golden light and in the smell of vomit from their small, sticky fruit. There was nothing quite like the ginkgo's yellow. "My color, particularly in its darkened aspects," Indiana wrote in his journal. For Kelly, there were a thousand yellows in the world. Indiana never thought much about color "until I knew Ellsworth and heard his long discourses on the subject and watched his paintings being painted."

Indiana brought the specimens in his pocket back to his studio at 25 Coenties Slip across the street and started to paint them; what he called his "first hard-edged paintings," a term coined in 1959, and associated with Kelly's painting. He claimed that he took up the subject out of chance, influenced by *I Ching* sessions he, Kelly, and Youngerman would hold as entertainment, but also to release some mysterious next step of the creative process.

The ginkgo was Indiana's orange peel. There's even a connection to fruit; the ginkgo's name purportedly comes from a misspelling of the Japanese for "silver apricot." Indiana couldn't afford canvas at the time so he did the best he could. He worked on these paintings for more than a year, first on paper—"A medium claiming no permanency"—then on found planks, weathered plywood, and cheap

Homasote wall board he pulled down from the partitions in his studio. Indiana made a series of hard-edged paintings of ginkgo leaves, doubling the shape so that it reads like an abstract form, each precise and separate from the other. They are symmetrical where Kelly's *Orange Blue* is not. He mirrored the curved kidney leaf in the middle of the canvas—an almost sphere, a reflection, a pairing.

Botanists call the ginkgo the "survivor" because of its perpetual adaptation to new environments since prehistoric times. But already there's loss, sexual repression: Indiana noted that the ginkgo's horrible smell was its "anguished protest" at being in a habitat unsuitable for its reproduction. And he imagined himself "as a tree, casting off leaves at autumn."

A few years later in his studio, Indiana took up Kelly's familiar primary color palette and painted the doubled ginkgo leaf (now further doubled, side by side) on a black field, bordered by red and black stripes like caution signs. (In his journal, he calls these "danger stripes.") After four years, this would be the final use of the ginkgo motif in his painting. And, notably, it became his first use of words. Stenciled below the leaves, and above the caution stripes, he traced the words *The Sweet Mystery*, taken from the lyrics of an early-twentieth-century love song.

# 10

## MONEY

### 1957–58

THE AIR SMELLED of roasting coffee. That was the main impression of Ann Wilson, newly arrived in New York from the Midwest by way of Philadelphia, as she entered the neighborhood of the old slips to check out an art workshop that Betty Parsons had mentioned to her in passing. On this particular day, it wasn't a drawing class but a slide-show on art from Brazil, where Wilson saw Indiana, a fellow Hoosier. Soon she herself had moved to the Slip.

In the late fall of 1957, Indiana and Jack Youngerman decided to run an art class to make a few extra bucks. It was mostly Youngerman's idea, though the hustle for cash was familiar to most artists in the area.

His first months in New York, Youngerman got a day job through William Klein at a trade publication called *Interiors*. Youngerman became assistant art director, though he didn't have any commercial art training at all. He also became the magazine photographer, although he had no training in photography either. Youngerman didn't last long at *Interiors* before quitting. Seyrig, never a typical wife, was ecstatic at his decision to leave. She herself was going to endless auditions and

modeling on the side to make a little money. She saw how putting on a suit and tie and going to an office every day was killing her husband's spirit. "And now," Seyrig wrote to her mother in July 1957, "he goes to work, he's in overalls, working over my head . . . He's full of paintings inside, and they come out like a stream of water."

She was certain that the time was very soon when Jack would be able to live on painting exclusively. A couple of years later, he was still hustling, teaching art to kids in the basement of homes in the wealthy Scarsdale suburb and making theater sets. He taught art once a week at the Buckley School uptown, but was fired when they found him eating his lunch with the janitors in the boiler room instead of with the students.

Most of the artists living in the area had odd jobs that wouldn't last for long. Larry Poons, who had a studio on Maiden Lane and then lived and painted in a fourth-floor walk-up at 120 Pearl Street, worked multiple jobs, from Wall Street messenger to hardware store clerk, to short-order cook in the luncheonette below his apartment. Rauschenberg worked as a janitor at the Stable Gallery. Rolf Nelson, a neighbor of Indiana and Youngerman's at the Slip, was a painter, but worked as a director at Martha Jackson Gallery uptown, a connection that would prove beneficial to Indiana. Indiana would leave his job at the art supply store to go work as a secretary at the Cathedral of St. John the Divine in January, proofing the book *The History of the Cross*, and later took over Youngerman's Scarsdale teaching gig. Martin didn't get a job, but she was very poor (people say she filched change from pay phones). Tawney was able to sustain herself on her inheritance. And now Kelly, with a few of his commissions and sales, could paint full-time, though his friend Harry Martin still drove taxis.

Indiana and Youngerman's workshop would not be the first of its kind on the block. Fred Mitchell had run an informal drawing school—the Coenties Slip Studio—out of 31 Coenties Slip, beginning in April 1954 until he left to teach at Cranbrook in February 1955.

And when he returned to New York, he commenced teaching through the '60s at the Seamen's Church Institute's Downtown Art Center at the end of the block, with a balcony practically over the water. But Mitchell's was hardly a model for assured success. He charged a dollar an hour; the $600 he gained over ten months of teaching was purely from student fees, and no paintings ever sold. Mitchell's class was also far more ambitious than the one Indiana and Youngerman ever committed to. Teaching was the main reason he rented the loft at 31, and spent considerable cost painting it; buying used easels, tables, and chairs at secondhand stores along Third Avenue (and renting a station wagon to collect them); constructing a painting rack; setting up a telephone, kerosene, and electricity utilities; spending $20 a month for models; and making fifteen hundred copies of an announcement, even a small ad in *The Wall Street Journal*. Mitchell also set aside $45 to throw two parties "to stimulate growth in number of students," as he noted in his journal. Picking up where Mitchell had left off was not possible, as 31 Coenties Slip was demolished in the spring of 1957 to make room for a parking lot. Indiana had to relocate his own studio to number 25, a little farther from the river but still right on Jeannette Park.

As Youngerman reasoned, they were going out to Jeannette Park and the piers to sketch anyway—why not bring along a few Upper East Siders willing to pay for the adventure of this strange country within the city, the "down downtown" as it was known?

Indiana and Youngerman called their class the "Coenties Slip Workshop," and put together a brochure featuring a photograph Youngerman took of Indiana sitting on a pier and drawing in the center of a painted abstract shape by Youngerman, with text at top and bottom: "Paint on the Waterfront: Coenties Slip Workshop." Inside, somewhat ambitiously, Indiana added a quote from *Moby-Dick*: "Go from Corlears Hook to Coenties Slip, and from thence, by Whitehall, northward. What do you see?"

Coenties Slip Workshop brochure cover, with art by Jack Youngerman and photograph of Robert Indiana, 1957.

*(Courtesy Lenore G. Tawney Foundation.)*

Coenties Slip has a less famous cameo in Melville's earlier novel *Redburn* (1849), whose young protagonist describes it as a place of "grim-looking warehouses, with rusty iron doors and shutters, and tiled roofs; and old anchors and chain-cables piled on the walk. Old-fashioned coffee-houses, also, much abound in that neighborhood, with sun-burnt sea-captains going in and out, smoking cigars, and talking about Havana, London, and Calcutta." Redburn remembers standing on the Slip's wharf with his father, watching a ship head out to sea, and marveling that the sailors yelling "yo heave ho!" "so near to me then, would after a time be actually in Europe."

In the eighteenth and nineteenth centuries, the Slip was one of the loudest, busiest spots in the city, so the later commercial aims of the workshop artists fell into a long line of diverse trade. In 1852, a reporter walking up South Street described "barrels, bales and boxes of merchandise, coils of chains and cables, and huge anchors" obstructing the sidewalk, "while overall the bowsprits of magnificent ships peer in at third-story windows, as if to get a glimpse, in advance, of the rich stores destined for their supply." There were constant complaints about how crowded the sidewalks became as merchants weighed tea, coffee, iron, and hides, piling the goods in heaps taller than a man. Just above Front Street, the Slip was crowded with idling trucks waiting for orders to be unloaded.

Coenties Slip was not just a row of sail-making lofts, as has been so often reported. Every building had multiple trades stacked by floor, a snapshot of burgeoning American capitalism and speculation. On the ground level were grocers, dry goods merchants, earthenware dealers, saloons, weighers, measurers, hiring halls, ship stores and chandlery, then on the upper floors iron dealers, the Troy & Erie tow boat proprietors, accounting and clerks, cigar shops, dealers in salt fish, commission houses, pilots, steamship packet lines, the Marine Works manufacturer of hotel and ship supplies (they also had their own printing press), warehouses for flour and other merchandise.

Sailmakers occupied the top floors, which did not require support columns and therefore allowed for open spaces to spread out the canvas for cutting and sewing. For a short time just below the Slip, the shipyards were filled with racing clippers under construction, headed for California's gold rush.

The screech of the elevated train joined the neighborhood's bustle in 1875. From 5:35 a.m. until midnight, seven days a week, four-car trains began running thirty feet up through Coenties Slip on the Second and Third Avenue Elevated train lines, their clattering green steam engines dropping "soot, cinders, and burning coals" to the streets below, as the writer Edward Robb Ellis described. The most extreme double-S curve of the entire El line, a 119-foot radius, cut sharply east down the Slip at Pearl Street and then south again at Front Street—a giant, shrieking eel at the height of third-story windows. And in another account: "Trains slowed down very little, whipping around the bends with a lurch and scream of flanges intense enough to 'alarm the timid.'" Traveling south, there was a moment

An elevated railway at Coenties Slip, New York, 1884. Photograph by Otto Herschan.

when it looked like you might run into the sea, before the train veered right again and clattered away. Crashes at the site were common.

The El changed how light worked along its route, slicing it up into thin bars that dappled the street below, blocking out the sky for the tenement houses it passed, and cutting deep shadows into the miles of streets it ran over. Bars sprouted up under its path.

By the late nineteenth century, drinking places filled the ground floors of buildings on the water, crowded with seamen just off their vessels, their rickety outer stairways leading up to the offices of the shipping lines. Several sordid murders happened on the Slip near these saloons, involving the death of a canal boatman at the hands of a bartender in 1865, and a drunken longshoreman in 1880. The Slip was also where runaways gathered: an estimate of the city's homeless children in this period was over 28,000. The docks and ferryboats were a common place where they slept, if they couldn't find beds at the Newsboys' Lodging House on Park Place. All this, and yet the Slip was described as "a queer, old-fashioned, idle sort of a thoroughfare."

By the late 1950s, a different sort of desolation had fallen on the Slip both day and night. The El stopped running in 1942, though its steel armature wasn't fully dismantled until the following decade. Many warehouses were empty behind their shuttered windows.

The main activity downtown was in the very early mornings at Fulton Fish Market, and during the day a few blocks over at the Stock Exchange. The Fish Market had opened in a few sheds along South Street in 1822; by the twentieth century it was thriving. A 1952 Joseph Mitchell article in *The New Yorker* had the writer walking around the market at 5:30 a.m., before heading to the "cheerful market restaurant named Sloppy Louie's" at 92 South Street near Peck Slip and next door to an old fisherman supply store—a cheap favorite of artists on the Slip with some colorful seafood offerings—for an elaborate breakfast. His description of the market offers an olfactory tour of a particular time and place: "I could distinguish the reek of

the ancient fish and oyster houses, and the exhalations of the harbor. And I could distinguish the smell of tar, a smell that came from an attic on South Street, the net-loft of a fishing-boat supply house, where trawler nets that have been dipped in tar vats are hung beside open windows to drain and dry." Some of the artists would go there after a very late drink to watch the action as morning broke.

The other market came to life during the day. Working as a messenger, Poons used to walk into the Stock Exchange and watch the jam-packed floor action from the visitor gallery up above, wondering how anyone got anything done amid the chaos, but also wondering at the beauty of the noise and energy and movement, like one giant steam engine compressing energy in front of you. The seat of capital was so close to the seat of creativity.

This all subsided abruptly at 5:00 p.m. The neighborhood was surprisingly quiet during the evening. From his living room window, Youngerman snapped a photograph of a sailboat lazily passing by on the East River. Hinman called it "a country village" on the weekends. The writer Mary Cantwell went a step further, recounting that "the financial district on a weekend was as bleak and barren as a desert." When writing to her mother about adopting a stray dog, Seyrig assured her not to worry about them taking on an animal in Manhattan despite their lack of money, because, she explained, they practically lived in the countryside. Mitchell reminded Kelly to "preserve all the best traditions, all the hermetic ones especially, of dear Coenties." No one went below Thirty-fourth Street after nightfall; the streets were dark and silent, particularly as the Slip's cul-de-sac was not a through street and so there was little traffic. The main population were solitary sailors who spilled out of the Seamen's Church Institute at the end of the Slip and sometimes passed out on the sidewalk or in Jeannette Park.

"There's a kind of end-of-the-world feeling about Coenties Slip," Youngerman told a reporter for the Seamen's Church Institute's monthly periodical in 1957. "We couldn't imagine living anywhere

else in New York, and we have little desire to go back into the city, except maybe to see an exhibit. If this area goes—and they're talking about parking lots and housing projects—well, this is the end of the island, where to from here?"

The idea of "going back to the city" from Coenties Slip, despite its being very much in Manhattan, suggests just how separate a realm the neighborhood represented for the artists. And this was also true of their art. Coenties Slip was "completely apart from the New York art scene." Wilson remembers her fellow artists on the Slip working hard, "thinking a lot, concentrating on their work with no political distraction."

And even the newly emerging art stars, Johns and Rauschenberg, though just around the corner, were "too successful" to be a part of the Coenties Slip group, though almost everyone living on the Slip visited their studios. Rosenquist recalls Johns giving him a lift to the subway one winter in his white Jaguar, wearing a white fur coat.

...

SINCE IT WAS dug and shaped, Coenties Slip was always a place apart. Even when the new city was huddled downtown and the Slip was a central neighborhood, and even when its motley markets and warehouses drove Manhattan's commerce over three centuries, the Slip's specific geography made it stand alone.

At the threshold of land and sea, the Slip harbored a unique microcosm of labor. It was perpetually home to hybrid communities that were, in terms of place and industry, both deeply anchored to it and transient, including the sailor on leave, paying twenty-five cents a night for a room at the Seamen's Church Institute. One of the most distinct of these communities was the New York City canal boaters, about which a *New York Times* article opined: "Theirs is a dual life rolled into one—a life at all times equally at sea and of shore."

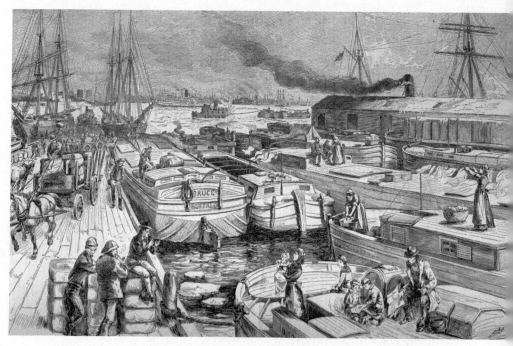

Illustration depicting a canal boat colony in Coenties Slip, East River, New York (*Harper's Weekly*, February 16, 1884).

(*Courtesy New York State Library.*)

From the early nineteenth century through the early 1940s, canal boats were the main movers of grain around the state. They traveled more than five hundred miles downriver from Buffalo to New York City with their cargo of thousands of bushels of wheat, skinny donkeys on board to help move through locks, occasionally carrying passengers, too, at a rate of two and a half cents a mile. New York and Pennsylvania were the country's biggest producers and exporters of wheat. The boats cluttered the end of Coenties Slip in the greatest concentration of any slip in the city, unloading their supplies via floating grain elevators to warehouse windows on the water. Fewer than twenty years after the Erie Canal opened in 1825, its commercial promises were borne out: New York was the busiest port in America. The Slip became the center of flour trade in New York.

The canalers and their families lived on their boats most months of the year, going up and down the river; when it became impassable with ice, or during the Depression when work was light, they moored more permanently at the Slip. The largest of the cabins in these squat fleets was no bigger than ten by twelve feet, and seven feet tall. (All had rocking chairs; some were outfitted with upright pianos and window box gardens.) The boats were nestled together so snugly that boaters often had to walk across several neighbors' decks to get to their own, or to come ashore. The hundreds of squat vessels visible from the El's S-curve were known as "Canalboat Village."

A series of articles in the late 1890s in *The New York Times* betrayed a romanticizing fascination with this professional class not unlike the vision of artists some seventy years later. And like the artists of the Slip, the canal boaters were constantly facing threats of eviction from where they lived through the closing of the waterway, and the shutting down of mooring rights.

The boaters' lives were portrayed in the press as simple but free. Toddlers were tethered to the deck to play, the hard work of freighting tons of goods up and down the river was not mentioned, and "no millionaire could be happier in his palace than they are in their cramped, stuffy little cabins." Even thirty years later, in 1924, the *Times* was still reporting on the unusual life of the canaler and his memories of a Slip skyline without skyscrapers: "He is different: no city man nor country man nor yet a follower of wind and current, but a being unto himself. He is as special as a merman." And in 1939, a journalist who'd hopped aboard a barge at Coenties Slip to report on the dying profession took pains to map these people's separation from the city—both by class and culture. He met a skipper and his family, canary, and dog, noting unbidden how tired the boater's wife looked. "'If you seen her with rooge and jool'ry and lip stuff,' the skipper assured us, 'you'd swear by heck she was a city woman.'"

*The New Yorker* chronicled the anomaly of the Slip within the city,

and its nomad class, in Burke Boyce's "Downtown Lyrics: Coenties Slip" in 1926: "Who knows the way to Coenties Slip / Where barges recuperate after a trip, / And seamen kill time between jobs on ship, / and tugs slide by with the tidal rip / Surprisingly near to Broad Street? / Who knows the row of houses with gables, / The trinkets for sale with nautical labels, / The smell of old pitch and the creaking of cables, / Or listens to phantasmagorical fables / Spun near the bottom of Broad Street? / And it's also a fact that at Coenties Slip / The grass still grows in a hummocky strip, / And drays still echo the crack of the whip, / And nobody mentions a stock market tip—/ Though it's brazenly near to Broad Street."

To live at the Slip was to live within a palimpsest of history where the present was never quite fixed. Cantwell again, arriving one dark, windswept afternoon to a saloon in the financial district in 1954, remembers a scene as if she had hallucinated it: "a room in which it was always 1905," with "a shirtsleeved man pounding on an upright piano, and a line of red-faced topers drinking boilermakers and cracking hard-boiled eggs at a long mahogany bar."

...

THE SCHEDULE FOR the Coenties Slip Workshop was ambitious: three-hour sessions, at $3 each (with weekly and monthly rates available), on Tuesdays and Thursdays, 10 a.m–1 p.m. and 7–10 p.m., Wednesdays, 2–5 p.m., and Saturdays, 10 a.m.–1 p.m. and then 2–5 p.m., meeting in the ground floor of 27 Coenties Slip. Indiana removed one of the wooden posts in the room to allow better sightlines for participants of the class; Youngerman was later fined by a building inspector for this violation of code and "barely forgave" Indiana. But Indiana put this removal to good use: the beam became his sculpture *School of the Slip*, 1957, in which found metal chains hang on nails around each edge of the squared wood like so many eager students. The evening sessions involved sketching from a nude model. "How you see," pro-

claimed the flyer: "You will explore the adventure of today's vision via the riverscape, the figure or studio composition in either a realistic or abstract approach, working under the individual guidance of artists sympathetic to a personal realization." Participants were encouraged to bring sketchbooks and drawing boards.

A series of related pencil drawings Indiana made capture some wonderful scenes, including *Jack Youngerman Cleaning*, 1957, Youngerman in shorts and a button-down shirt, standing on a step ladder with a bucket in one hand, attending to the front of the building at 27 Coenties Slip, and *The Tugboat William J. Tracy 18 July 1957 (Moored at Coenties Slip)*.

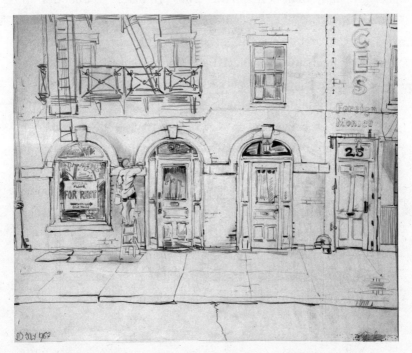

Robert Indiana, *Jack Youngerman Cleaning the Front of His Loft on Coenties Slip, 20 July 1957*, 1957, pencil on paper, 20½ x 24½".

*(Courtesy RI Catalogue Raisonné LLC and Star of Hope Foundation, Vinalhaven, Maine. © 2023 Morgan Art Foundation Ltd./Artists Rights Society [ARS], New York.)*

Indiana and Youngerman's main clientele were artist friends, including Mitchell and Kelly, who was already, in Youngerman's estimation, a "superb draftsman," and whom they felt guilty charging. The artist Ad Reinhardt came once to a workshop, and the dealer David Herbert. Slideshows happened on the occasional Saturday, as at the Club. James Rosenquist remembered attending a drawing class there, three years before moving to the Slip, on a tip from Ray Johnson, with Claes Oldenburg and Henry Pearson, and Delphine Seyrig sitting as the model. More often, Indiana and Youngerman enlisted an inexpensive, unknown model for figure-drawing sessions.

A December 1957 article in *The Lookout* described the workshop more robustly than perhaps was true: "To date, the Coenties Slip Workshop has about 20 students from all over town, a polyglot group including an architect, a barge captain, a sign painter, a local hardware merchant, an archaeologist and a bookkeeper for a union. Two merchant seamen who stay at the Seamen's Church Institute are students, during their time on the beach."

A few people came from uptown on Saturdays. Indiana and Youngerman would field questions from the handful of attendees, and then the two might suggest a way of drawing a particular subject. Activities varied, but the artists would often take workshop participants out to draw on the unused docks at the end of the Slip, where the East River Drive met South Street. It wasn't so much that the teaching methods were original as the setting—"New Yorkers didn't know that area," Youngerman mused. "They never came down there, and so that was the main reason why they [came]."

...

THE SLIP ARTISTS were unusual for actually living in the neighborhood they proposed to paint. But there was a long tradition of artists leading the public to these and similar "picturesque" New York City

urban views. In 1879, John Henry Twachtman painted thin sloops in repose with their white sails bundled at the jib next to double-decker oyster house barges in wet smears of brown, orange, and gray from a nearby pier that half made it seem like he was floating on water himself. The barges were an architectural anomaly—part house façade, part boat, not unlike the floating grain elevators that also dotted the slips—where men worked in the galleys below shucking fresh oysters that were then sold deck-side. From September through April, they jockeyed for berths at the slips along with the canal boats. Twachtman's depiction helped open up this part of the city for "polite society," as Michael Chiarappa writes, "to visit these venues under ethnographic, voyeuristically charged cover of 'slumming' in the hope that they, in the words of one artist, would discover 'the most delightfully picturesque bits of New York.'"

William Loring Andrews made things more official in the late 1890s when he founded the Society of Iconophiles in Manhattan, a sort of gentleman's club that sponsored a "visual biography" of the city via a series of engraved views and portraits made available in extremely limited-edition volumes. From its inception, the project was framed in preservationist and aesthetic terms that cloaked the endeavor's class voyeurism and frank commerce. Andrews commissioned Edwin David French, an accomplished book plate engraver, to produce "a series of views of buildings of interest in the city of New York, before the rapid march of improvement should sweep away these few remaining relics of the olden time."

The second series issued by the society in 1898 was called Picturesque New York, with twelve lithographs by Charles F. W. Mielatz, a German émigré who would make more than ninety images of the city. Of the whole city, *South Street from Coenties Slip* was among the dozen views chosen for this portfolio. In the scene, a policeman walks down South Street where it intersects with Coenties Slip, past the rickety pier sheds holding flour and other just-unloaded goods, and

the tall masts of ships appearing above them, past streetlamps and a street vendor selling oysters for one cent each. A telephone pole mirrors the ship's masts across the way. Pearl Street was the first to get electricity in the city, in 1882, supplied by Thomas Edison's factory at number 257, commemorated by a plaque that Indiana remembered in the neighborhood. A sign clearly visible on the top story of the building to the far left reads SAILMAKER. Looking back in 1913 on this project, Andrews said, "The rebuilding of this city as it is going on with breathless rapidity before our eyes, is a titanic work, and I am glad that I have lived to witness it. I only hope that a few of the narrow, crooked lanes in the lower part of the city, with their antiquated buildings . . . will outlast my time."

In the early twentieth century, a local American art scene arrived in New York, commemorated by the critic Paul Rosenfeld, embracing elements that felt homegrown: the sea, the skyscraper, the structural lines of the Brooklyn Bridge. Alfred Stieglitz, with his wife, Georgia O'Keeffe, brought together writers and artists in his galleries, the Intimate Gallery, An American Place, and 291. As early as 1893, Stieglitz had photographed Coenties Slip on a slushy winter day, also looking north across the busy intersection at South Street. The broad prows of the great ships cut over the street like a canopy of branches to the streetlamp, which itself resembles a mast. The sidewalk, below signs for sail lofts and sailmakers and paint shops, is crowded with overcoated men, and South Street is clogged with horses and carriages and a lone man shoveling dirty snow. In the far distance, the Brooklyn Bridge stretches against the murky gray sky.

After spending his twenties in 1920s Paris, soaking up the art crossroads there, Stuart Davis tapped into the hectic energy of a city that did not discriminate by subject matter. Besides art, he took his inspiration from "the thing Whitman felt—and I too will express it in pictures—America—the wonderful place we live in." For Davis, the

United States was wood and iron, "Civil War and skyscraper archi-
tecture; the brilliant colors on gasoline stations; chain-store fronts,
and taxi-cabs . . . fast travel by train, auto, and aeroplane which
brought new and multiple perspectives; electric signs . . ." He depicted
Coenties Slip in 1931 in his *House and Street*, a strange and colorful
painting that is bifurcated like two movie stills. Front Street is com-
posed of abstracted fire-escape ladders and windows, the Slip as a
series of lower brick warehouses, and bright blue triangles against a
green column suggest the elevated train tracks. Taller buildings even
then rising behind the nineteenth-century buildings are made from
patterned lines, stripes, and grids, not unlike samples of the work to
come at the Slip by Kelly, Martin, and Tawney.

Berenice Abbott, another artist returning from Paris to New York
to document an evolving metropolis, embarked on her decade-long
series Changing New York in 1932. She had photographed the down-
town waterfront area several times in her New York perambulations:
Coenties Slip as early as 1929, and the El at Hanover and Pearl Streets
in the spring of 1936 and '38. Abbott's *Shelter on the Water Front, Co-
enties Slip, Pier 5, East River, Manhattan*, captures a view of the Slip
at its seediest, with a group of down-and-out men squatting in front
of a ramshackle building and a row of low warehouses, set against
the taller skyline. On this early May day, she took pictures with her
new medium-format Linhof camera on a tripod while her assistant,
in the words of her biographer, Julia Van Haaften, "pacified some
drunks outside the East River pier caretaker's shack." As Abbott later
recalled, "They dragged these alcoholics out of the river every day."
Ship masts can be seen rising behind the structure. The only man
who is standing appears to have just hit one of the seated men; an-
other man is prone on the ground asleep or passed out from drinking.
Abbott became fascinated by the canal boat culture, and even looked
into buying a barge.

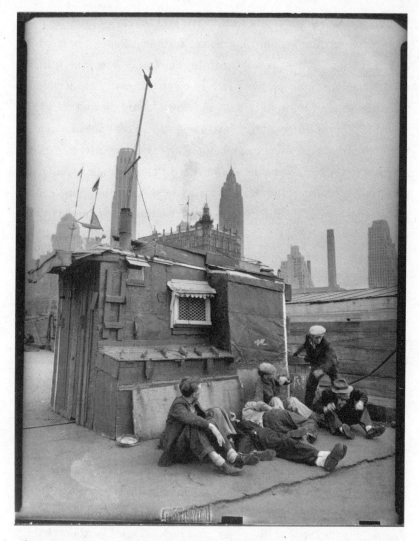

Berenice Abbott, *Shelter on the Water Front, Coenties Slip, Pier 5, East River, Manhattan*, 1938, gelatin silver print, 9¾ x 7¼".

*(Courtesy New York Public Library Digital Collections, the Miriam and Ira D. Wallach Division of Art, Prints and Photographs: Photography Collection.)*

Increasingly in the twentieth century, artists' attention to the "forgotten" pockets of a city was also framed in terms of national-

ism. One didn't need to go to Europe to find rich historical inspiration. None other than Newman was one of the earliest proponents of this stance in locating a "picturesque" scene right at home. In an essay from 1943–44 unpublished in his lifetime, he celebrated Lower Manhattan in phrasing that, like Davis, channels the poet Whitman. If "New York is an exercise in modern construction" to the world, one can really see its history and charm downtown in "the old city that has been neglected by that segment of our intellectual sentimentalists—the artists, the writers, even the movies—which concerns itself with the American scene."

As a lifelong New Yorker, Newman was a little defensive of his city. (In fact, he didn't even visit Europe until 1964.) Speaking of American artists who went to Europe and then "come back yelling 'America,'" Newman queries, "Do they not know that the picturesque past they sought in Europe could just as easily have been found on Cliff Street, on Gold Street, under the Brooklyn Bridge in New York? There are rows of houses here that still have the smell of whale oil in them, the silence of dead sea captain's voices, the dust of ship chandlers' offices, which would look as charming on canvas as any rue by Utrillo."

Indiana and Youngerman had of course both gone to Europe to study art. And both appreciated the American scene that much more because of it. For Youngerman, it was a sense of possibility opening outward. His time in Paris helped him see—and appreciate—his own country that much more. "When I came back I understood almost immediately what I think of as the unique American quality—a kind of openness, a non-stratified openness." Poons, too, talked about that sense of endless possibility in New York in the late 1950s and early '60s: "It was the prairie out west before they put up fences, before divisions and territories."

...

THE COENTIES SLIP WORKSHOP, one of the first joint efforts of artists on the Slip, was a failure, and limped to a close just a few months after its launch. As Indiana said in 1963, "We didn't make any money." The very draw of its location and bohemian conditions was part of its downfall—despite the romantic pull of an unknown pocket of the city, people found it inaccessible, or difficult to get to more than once—and Indiana and Youngerman couldn't afford to keep the space warm enough. While the artists dealt as best they could with their own drafty lofts in the winter, often by collecting old wooden pallets and crates from the Fish Market to burn in their stoves—"somewhat aromatic" as Wilson recalled—it was too much for the nude model and the students.

In many ways, the workshop was set up to fail. The artists' hearts were never fully in it. The Slip was their private place, a refuge from the very city the workshop invited in. And now that they were settled into their spaces, their ambitions of what they could make began to grow with their impatience to get to work. The *Cue* article holds this tension—while advertising the class, it also includes multiple quotes from the artists discussing their necessary detachment from Manhattan in order to concentrate on their art.

No one was more vocal about this need for a place apart than Agnes Martin. "Painters must live together because other social contacts are barred to them," she told the *Cue* reporter. "When you paint, you don't have time to get involved with people, everything must fall before work." To this Calvinist ethic she continued, "That's what's so wonderful about the Slip—we all respect each other's need to work. The rest of New York? Everybody groans about going into the city and sings when he comes back home."

# 11

## STRUCTURE

1957–60

AS SOON AS SHE SET up her space at the Slip, Agnes Martin donned the quilted overalls that made her look like a cross between an astronaut and a car mechanic, and began feverishly painting. "When I got to New York, I really flew at it."

Painting was her exorcism. In her first months back in the city, it was a way of expelling the mountain landscapes she'd made in the Southwest, which now looked to her like anthills, the soft, naïve flowers, the figure paintings from her time in Taos. She taught portrait painting at the University of New Mexico, as her own work experimented with Surrealist dreamscapes and heavy atmospheres; her landscapes began to undo themselves into floating colors and shapes that suggested the paintings of Newman, Rothko, and other New York–based painters she admired from afar. These biomorphic compositions were the canvases that convinced Parsons that Martin needed to move back to New York and join her roster of artists whose work was already inflected in them. (Kelly encouraged Parsons to show other artists working at the Slip, and she became the de facto gallerist of the group. Youngerman had his first solo show in New

Agnes Martin in her Coenties Slip studio, New York, 1960. Photograph by Alexander Liberman.

(© J. Paul Getty Trust, Getty Research Institute, Los Angeles.)

York at Betty Parsons in March 1958, then Martin in December. She never showed Rosenquist, though Kelly suggested she do so.)

But it wasn't until Martin got to the Slip that she arrived at the full abstraction she wanted. It was a twenty-year process, and even then, she wasn't satisfied. In New York, her steady approach reached a manic pace. "I just painted and threw them away and painted and threw them away." One of the first works she made and liked at the Slip, *Harbor No. 1*, 1957, was significant to her because it symbolized "a safe place."

In the early half of the twentieth century, women enjoyed a brief stint of liberation—encouraged by gaining the right to vote, the rise of industrial jobs that required their skills, and the exodus of so many

younger men from the workforce during World War II—that coincided
with the development of hotels and lodgings designed specifically for
them in the city. But by the 1950s, it was considered highly unusual
for a woman to live alone, and inappropriate outside of the designated
"women only" rooms that were part of separate hotels and buildings;
the implication across both sexes, in a decade that saw a huge spike
in marriage and citywide legislature against homosexuality, was that
such an exceptional arrangement might indicate that you were gay.
Chauncey outlines a parallel pattern of relative freedom for gay men
in New York through the twentieth century: gay men were "highly
visible figures" in the 1920s and '30s, "integrated into the everyday
life of the city," but by mid-century, the straight, "nuclear" family
was the prevailing model, and the 1950s and '60s were among the
most repressive for queer people in New York. While hundreds of gay
men were arrested every year in the city in the 1920s and '30s, this
number rose to thousands in the postwar decade. Even then, gay men
had greater freedom than lesbians, since so many public meeting
locations, whether bars or streets, were "culturally defined as male
spaces." The Slip offered a safer community, outside of the public eye,
for Martin and Tawney to each live and work alone.

Martin wrote sweet aphorisms about love and nature and discipline
in the spiral notebooks she kept handy, where she also filled the pages
with drawings, jotted texts and poems, and sketches of measurements
and math for her paintings, as their system of lines grew more and
more exacting. She also regaled Indiana with recitations of Gertrude
Stein's erotic poetry—he called her "a walking Stein seminar."

Stein was not an accidental reference; while the writer was in
fashion in New York after the war—it was as common to hear her
name at art gatherings, Wilson remembers, as it was to throw the *I
Ching*—she also epitomized queer love. Indiana and Martin champi-
oned queer writers and incorporated their texts into the titles of their
work. For Indiana, the locals Whitman and Hart Crane—in addition

to Stein—were North Stars; he followed in a long line of gay men who found Whitman to be their "prophetic spokesman," particularly in the poet's celebration of "the manly love of comrades."

The critic Jill Johnston first met Martin at a party on the Slip where Martin was reading Stein to a group of people who sat rapt during her tutorial. She contradicted herself often, seeming to enjoy how this continually unraveled any narrative thread about her life: she talked about innocence and purity as the goals of life and art in conversations that sometimes felt like lectures, but she also told a friend in 1950, "I'm going to make it. I am going to make it. And I don't care who I have to fuck or how I have to do it." She was not easily summed up.

The stakes were always high for Martin. The artist Chryssa Vardea-Mavromichali, who went by her first name, remembered seeing paintings in Martin's studio that she admired, but Martin had already rejected them because of a barely perceived texture on their surface. "When art becomes that austere, everything matters." If a painting wasn't going well, Martin would quickly take a knife to her canvas. She could not stand to have things around her that didn't work. A term that comes up repeatedly in her own writing, and for many that knew her, is *perfection*. Johnston wrote that the value Martin placed "on the known rather than the seen suggests innate ideas which she sometimes calls a memory of perfection." Youngerman remembered, "Agnes was a perfectionist about her work." This need for control was a strange way of negating a necessary step of any creative process—trials, failure—and, ironically for such a private person, a way of self-mythologizing, of "not admitting that you've ever done anything ordinary." And Martin herself once said, "I paint about the perfection that transcends what you see—the perfection that only exists in awareness."

Despite her frenetic approach, Martin's canvases in this period grew larger, more modulated, serene even. She had, in her own description, eliminated everything from her landscapes until she was

left with only the horizontal lines she liked, the horizons. In a review of her first solo show in New York in 1958 at Betty Parsons's Section Eleven gallery, a critic spoke of her "large quiet abstractions." And Dore Ashton, reviewing that same premiere, got to the essence of what had been considered but wasn't there—"The result of many years of refinement. She has eliminated all but essentials for her poetic expression."

Martin required specific conditions to work. "In the studio an artist must have no interruptions from himself or anyone else. Interruptions are disasters," she explained in a lecture a decade after her time in New York. Her second Coenties Slip studio, at 3–5, where she moved in 1959, was "very quiet," as Wilson remembered, with "an absence of agitation." Entering it was like entering "large quiet," with its white walls, gray floors, and homemade picnic table and benches. Everything needed to be calibrated. "You must be clean and arrange your studio in a way that will forward a quiet state of mind," Martin insisted. And she wrote in her journal once that "the sentimental furniture threatens the peace." The artist needed to get past "a lot of rubbishy thoughts" to the inner mind, where inspiration lay. "Composition is an absolute mystery. It is dictated by the mind." And her most famous text, transcribed and edited by Wilson in New Mexico in 1973, is called, fittingly, "The Untroubled Mind," which she saw as the ideal state for making art.

Control, quiet, the elimination of any distractions—these were also conditions necessary to Martin for excising the voices in her head. Early on, fellow artists on the Slip became aware that Martin sometimes suffered from fallow periods when she couldn't paint, and she could be private and withdrawn to the level of almost rudeness, sitting in her chair. She would go into trances; some inspired by sublime experiences, as when she stumbled on a choir singing Handel's *Messiah* in a small church on Second Avenue and "zonked out," as she put it, after three notes, others requiring hospitalization at Bellevue,

what she called being "put . . . away." But they did not have the vo-
cabulary or social context in the 1950s to fully define her situation.
And they would not know the severity of her schizophrenia diagnosis
until several years later.

When Martin couldn't paint and she couldn't sit, she left Coen-
ties Slip and walked northeast to the Brooklyn Bridge, and over it
to Brooklyn and then back again, standing between two places and
over the water. Martin explained, "The best thing to do when you
stop painting . . . is cross the Brooklyn Bridge." She walked from the
Slip to the Metropolitan Museum of Art, a morning's journey. "Agnes,
what's wrong with the subway?" Wilson once quipped when trying to
keep up with Martin's brisk clip.

The anonymity and silence of walking was a boon for Martin's
health. But the writer Mary Cantwell described the feeling of being
an invisible woman in a crowd on the streets of New York during this
period, where there were few safe places to pause and rest alone: "Un-
less you were in a park . . . you could not sit down. You had to keep
on walking until you got home, and if your home was like mine—two
rooms in which I could not seem to find a place for myself—you had to
go out and start walking all over again." Martin liked to walk as she
worked, alone. "We all did the same thing, like we went to Prospect
Park, and rode on the ferry, and things like that," Martin said, "but
we went alone, we didn't go together."

All of the artists at Coenties Slip rode the ferries. The terminal
was just around the corner from their lofts, and it was a quick way
to get out on the water and clear the mind. In her journals, Tawney
made several drawings of the view from the ferry looking back to
the Manhattan skyline; one, labeled "back of ferry," includes birds
swooping through churn that seems to tumble down from the city-
scape; another, labeled "wake," depicts an even clearer path cutting
in dark, tangled lines down the page—both not unlike the cascading
currents of her woven forms.

The Slip artists were also following in the river-crossing footsteps of the artists who came before them, including the most famous celebrator, Whitman. The poet "had a passion for ferries" and regularly rode the Brooklyn Ferry: "To me they afford inimitable, streaming, never-failing, living poems." Several stanzas of his "Crossing Brooklyn Ferry," which was published in the second edition of *Leaves of Grass* under the title "Sun Down," celebrate the cyclical tides of change around Manhattan, imagining those who would come after him, and still be dazzled by a similar, if ever-changing view.

Lenore Tawney's journal sketch from the back of the Staten Island ferry looking toward the Manhattan skyline, 1957.

*(Courtesy Lenore G. Tawney Foundation.)*

If her ideal state was alone, and her relationship to other artists erratic, Martin appreciated having them around. She let her quiet paintings do the public socializing: "I paint to make friends and hope I will have as many as Mozart," she wrote in a statement for a show in 1960. It does not seem untrue of her art, even as it does not seem true to herself.

The collective solitude offered by the living arrangement at the Slip was ideal—or at least the best setup considering Martin's precarious mental health during this period. She even threw a rare party in her apartment, though it wasn't exactly a success since Martin's need for control overrode the casual gathering. Youngerman and Seyrig, Kelly,

Rosenquist, and Indiana were all there. The glamorous sculptor Marisol came very late. Everybody was standing around drinking wine.

"Marisol, you're a snob," Martin said loudly. And Marisol didn't answer, she just stood there.

If Kelly and Newman had not hit it off, Newman was an important champion and constant presence in Martin's studio. He, too, tightly controlled the trajectory of his art. He destroyed all the work that he made before 1944, so that he was already thirty-nine when his "first" paintings appeared. His own frustrations around work—following a disastrous show at Betty Parsons in 1951, and a serious heart attack, he did not show again in New York until 1959—must have given Martin some hope to believe in her own convictions and slow start.

In the late 1950s, Newman had just started to paint again, and the powerful art critic and tastemaker Clement Greenberg was putting together a small survey of Newman's paintings for a new gallery opening uptown. Newman had a stubborn conviction that people would grow to understand the ambition of his paintings—and indeed a younger generation of artists eagerly absorbed how Newman's hard colors and flashes of line centered a particularly human scale of perception. He would come around the corner from his Front Street studio and talk: "He was fascinating but he would go on and on and on and on," Wilson remembered. Kelly was a constant visitor too, pulling up a chair to Martin's big Acorn stove, and even borrowing her studio to make *Broadway*, as he couldn't get the canvas up the stairs. He kept an eye on her; Wilson remembers him standing at the window saying, "There goes Agnes on her walk."

Sometimes Martin would ride with Kelly in his VW bug to the beach, kick off her shoes, and wade into the water with childish glee. Where, for Kelly, nature was a source of found compositions and process, for Martin, nature was a source of structure and the ultimate creative perfection. For Martin, there was "something ecological" about painting. "She was a nature lover, and I was, too. So we went

around together." They visited Jacob Riis Park or the Jersey Shore, where they sometimes slept on the beach. Many years later, she would say, "It is better to go to the beach and think about painting than it is to be painting and thinking about going to the beach."

...

AS THE STRUCTURE of their work was falling into place for the artists, the structures of their environment were falling. Demolition, new construction, and its accompanying threat of eviction, loomed over the Slip; it also provided fresh materials on the street for artists with no money. Everyone downtown, it seems, was suddenly experimenting with sculpture.

At the Slip, the development of sculpture seemed to happen all at once and everywhere. None of the artists came to the Slip as sculptors (though Tawney had already studied and rejected it), but almost all of them dabbled with it there, eager to be making something even in the stretches when they couldn't afford canvas, and urged on by one another's scavenging instincts and need to work out new creative paths.

Even as her abstract painting was finally coming into focus, Martin started to think about assemblage. Her oscillation between stasis and movement, calmness and contingency in her working methods is the paradox of New York City too. Bored deep into its bedrock is a story of constant formation. Musing that someone writing "the early history of what is done in America . . . will surely have much cause to mention what may be called 'the pull-down-and-build-over-again spirit,'" a young journalist, Walter Whitman, penned in "Tear Down and Build Over," published in *The Whig Review* in 1845. In his florid essay, the man who would become one of America's most famous poets worries over new construction's rush to build on top of old New York. Beams and rafters fall, "filling Manhattan island" with "showers" of mortar, dust, decay, and old lime "almost as pestiferous as the

sand-clouds of Sahara." He goes on, "Good-bye, old houses! There was that about ye which I hold it no shame to say I loved passing well." Whitman is quick to say that he is not against progress—"No friend are we to the rotten structures of the past, either of architecture or government"—but fears the speed with which history is razed. Or as one author put it in 1934, "New York not only adds to itself, but incessantly rends itself in pieces."

While the city's perpetual reach for the new was always a part of its identity, the period in which the artists lived at the Slip was bracketed by a particular acceleration of development projects, often under the sweeping urban planning of Robert Moses, and a particular blindness to what was being destroyed in the name of postwar optimism and social progress. The year 1957 was a record one for construction in New York City, and then 1958 surpassed it. In the ten years between 1947 and 1957, 108 office buildings were completed or under construction. And of the 44 buildings finished in 1957 or slated to be by 1960, 12 were downtown.

Gerry Matthews, the cabaret actor who lived below Youngerman, was one of the Slip's most successful hunters. He collected antiquities—nineteenth-century doorknobs, hinges, brass filaments, the bins that had been used to hold beans at Coffee House Slip. (He would eventually end up an antiques dealer in Seattle.) He was delighted to live in an 1840s warehouse on Coenties Slip, even if it meant sometimes dealing with the idiosyncrasies of artists.

One night, he invited Youngerman on one of his "recovery" missions, made possible by the massive development Manhattan was currently undergoing. They took a nighttime foray uptown to Sixth Avenue, to a lot surrounded by a huge fence. Inside, what used to be a grand town house was scheduled for demolition, to make way for another glass skyscraper.

Matthews found a hole in the fence, and the two slipped through, walked up the front steps of the town house and right inside the front

door. For the next hour, they went through the house, unscrewing doorknobs and light switch plates and fixtures in the dark. They had brought large plastic garbage bags, which were soon bulging with loot.

When they could carry no more, they slipped out of the site and took the subway back downtown. A policeman walked into their car, "and here we were, with these bags." The policeman looked at the two quizzically, but ultimately didn't say anything.

Other discoveries were more intimate. Martin and Kelly were eating breakfast by her stove when he folded the lid of a round coffee can, cut it, and set it back on the table, where it gently moved, evoking a rocking horse. Martin suggested that he should "make that." This became his first freestanding sculptural work, *Pony*, 1959, bright yellow-and-red-painted aluminum, like a circle bent into a pocket, which he exhibited in a show at Betty Parsons that fall. Another early sculpture, *Gate*, also from 1959, grew out of a sketch Kelly made at Martin's table, on an envelope addressed to Martin, which he then folded and cut and stood up too. Kelly remembered those moments with Martin in their morning ritual as unconscious breakthroughs—"I did it almost without thinking, almost as if I didn't decide; as if they just happened." He took his models to Edison Price, the manufacturer of lighting equipment that had helped him realize his *Sculpture for a Large Wall* in 1956, and they welded it for him under his watchful eye.

Kelly had started making reliefs in the late '40s in Paris, and one of his first, breakthrough commissions in the States was seven brass screens for the Greyhound Post Restaurant, and a wall sculpture. Kelly's friend the lighting designer Richard King was working on the new transportation building in Philadelphia, where the Greyhound bus terminal was housed, with Edison Price. Kelly had never made sculpture, but King somehow understood that the bent and shaped canvases Kelly was working on could lead to another kind of work; the multipaneled sculpture that Kelly envisioned for the lobby wall,

undulating just so to catch King's lighting, was a culmination of the artist's experiments in France.

Kelly worked in Price's studio under the 59th Street Bridge, drawing angles onto more than one hundred aluminum panels, which the men then cut; these were attached to metal rods to form the more than sixty-foot sculpture. He was paid a few thousand dollars for *Sculpture for a Large Wall*, and promptly opened his first bank account with the check. The work would later be bought by the Museum of Modern Art. ("I never could have imagined, when I came back from France in the 1950s, that my first commissioned sculpture would end up [at MoMA].") He and Indiana traveled to Philadelphia by bus on August 6, 1957, for a day trip to see the work. As Kelly wrote in his diary, "By Greyhound to Phila with Bob Clark to sign sculpture EK-in paint + scratched name, date on rear lower-right panel." They ate lunch in the Greyhound restaurant in front of Kelly's other work, and then visited the Philadelphia Art Museum, where they saw "3 loan exhibits with magnificent van Gogh sunflowers & rain & Cezannes—Matisse, Bonnard, & Gallatin & Arensberg collections."

And a few years later, Indiana was walking along Front Street and found an old wooden column on a loading dock "within sight of my front dormer," which he hauled back to his studio. This would become his own contemporary version of an ancient Greek herm—the first freestanding young male figures in art history. Martin and Indiana both reveled in the thick, long planks of wood they found from buildings and docks; Martin made a lot of furniture for her loft out of it. Indiana claimed that the support columns he found in demolition sites were themselves recycled ship masts, still bearing the scars where metal rings had held them together. He also gathered smaller treasures; a journal entry from January 15, 1960, notes that he's nailed pieces of junk from Water Street to his old drawing board for the work *Wall of China*, 1960–61.

Even Tawney returned to sculpture for a short period, making wooden constructions in the late 1950s and early '60s culled from street finds, like one from 1958 that included "a vintage hat mold with a lid" and "a tapering wooden spike used to separate rope strands." In 1960, she also acquired a sculpture by Edgar Negret, who reconnected with Kelly and Youngerman in New York after his time in Paris. Though the relationship among these artists traces a global network of abstraction, the work's inspiration was often very local: like Kelly, Negret experimented with painted aluminum, which grew out of visits to the harbor near Coenties Slip, watching sailors paint the metal hulls of ships in layers of red, white, and black to prevent oxidation.

Compared with the austerity of her painting, Martin's few surviving assemblages are startling. They involve nails, bottle caps, and jagged hunks of wood. Her first construction was *Garden* (now lost), which was made from thousands of nails fixed onto boards, and bolts from the old steel shacks on the docks that Berenice Abbott once photographed, and which had recently been taken down. In *The Garden*, 1958, Martin attached little drawer knobs to a plank of wood painted a dark gray-blue. She attached boat spikes in a five-by-ten grid to a figure-sized plank painted light gray-blue for *The Laws*, 1958. (Indiana would make a standing construction called *Law* in 1960, which included an iron-and-wood wheel on an old beam with thin gessoed white stripes, incised into a beam base taken from Youngerman's loft. He continued to tinker with it until February 1962, when he wrote in his journal that it was "unfinished until today.") Martin's *Water*, from 1958, incorporates painted wire and metal bottle caps mounted on wood, giving the impression of a worn pier. And then there's her 1959 assemblage of collaged canvas and nails, *Homage to Greece*.

Around this time, Chryssa became a frequent presence at Martin's studio, and a romantic partner. Born in Athens, and raised in Nazi-occupied Greece, she recalled a childhood of constantly stumbling on excavations of ruins in the streets, and picnicking on ancient stones.

She started looking at art in earnest when she moved to Paris. The first American work she saw there was a sculpture by Calder, which she loved for its strange simplicity. She married the artist Jean Varda (cousin to the filmmaker Agnes Varda, pupil of Picasso, and sometime teacher at Black Mountain College) in Paris in 1955 at the age of twenty-two and moved near the Slip. The two traveled back and forth to Sausalito, where they lived on a ferryboat (the Zen philosopher Alan Watts later joined Varda there for a decade) and hosted salons in Big Sur with the writers Anaïs Nin and Henry Miller. After less than three years, their marriage fizzled. (According to Nin, Varda threw a party in his all-white Manhattan loft the day the divorce papers were signed. Chryssa wrote to Parsons in January 1959, "since the 24th of December I am again a free woman from the slavery of matrimony. A winged woman?")

By almost everyone's description, Chryssa was volatile, a jagged bolt of lightning of creativity and—in the words of the museum director Sam Hunter—"cold fury." Like Martin, she suffered from mental illness throughout her life; her later gallerist Arne Glimcher described her as "much more violently psychotic than Agnes." She was messy, "mercurial," an incessant smoker. She cast off Europe, drawn to her new home, which she saw as "barbaric" and "full of freedoms," yet she still liked to listen to her "boozooki records" and cook Greek food. She bred drama; her confidence could crumble into uncertainty and rage. But her outbursts were often well-founded: the work that she wanted to make took time and a lot of money, and she could not keep up with her ambitions. "When I do work on a large scale, I must invest everything I have materially, and my entire existence, my health, in my work," she explained. "I live by the most inhuman schedule . . . I sleep in my clothes." She once apologized to a reporter about her appearance: "I've tried combing my hair for hours. It doesn't do any good."

In 1955, she began a series of clay relief tablets, called the Cycladic

Books. These small sculptures managed to refer back to her own Greek heritage and the smooth marble simplicity of ancient Cycladic objects—some of the earliest sculpture found in the world—while also to contemporary painters in New York, like Rothko, Newman, and Reinhardt, with their color field and diagrammatic monochromes. A year later, she started working on a series of shallow boxes with plaster letters inside, including *BACH*, a homage to a favorite composer. She was tearing through objects and words—the kind of everyday symbols that Jasper Johns was discovering at the same time, just around the corner. These were then followed by a series of single-letter reliefs that Chryssa began around the time she met Martin; they bear a striking resemblance to Martin's own assemblages. And then she began making prints and drawings from metal newspaper plates she found—almost claustrophobic grids whose structure began to fall in line with Martin's own ordered compositions.

Chryssa described herself in her first years in New York in the late 1950s as "utterly alone, broke, and very happy." She was drawn to Times Square and the blazing vulgarity of all its lights. Her *Gate to Times Square—Analysis of the Letter A* was her most ambitious project of the 1960s, a structure big enough to walk through, which gave one critic a headache for its flashing neon tubing that was "hard on the eyes." She was inventing something through her work in neon. Hunter proclaimed that she was "actually the first artist to use direct emitted electric light and neon."

By January 1961, she had a solo exhibition of "sculpture-constructions" with numbers and letters at Betty Parsons (her only show there, thanks to the encouragement and connection of Martin), with a positive mention in the *Times*, and a major survey show scheduled that same year, in November, at the Guggenheim; the museum would buy two works from the show for its permanent collection. In the September 14, 1962, issue of *Life* magazine, Chryssa was called one of the "red-hot hundred" leaders of a new generation of breakthroughs

Chryssa, untitled, 1962, offset photolithograph, 34⅜ x 25″. From the series Newspaper Book, 1962.

(Courtesy the Museum of Modern Art/Licensed by SCALA/Art Resource, NY. © Chryssa.)

in American culture; other artists on the list included Jim Dine, Richard Hunt, and Marisol. In the article, she stands meekly in flats and a sensible skirt and blouse, dressed for a part seemingly in contradiction to her work and spirit. She was, during this period, much better known than Martin on the art scene.

For all her mercurial energy and outbursts, Chryssa kept insisting on control. Like Martin, she talked often about the need for a quiet mind—what she called a "cool mind"—in order to create. She liked to spend time alone and she despised small talk, which was a distraction from thinking about work, or making it. She was, in her own description, "the cat who likes to walk by herself." She kept visits with friends brief. She would go days without seeing anyone except for the man who delivered her laundry and the man from the deli who delivered cigarettes at midnight. In a lecture, Chryssa talked about "the need to control our various roots of inspiration." She returned often to Greece, leaving her affairs in bad states back in New York. In a letter sent to Parsons in March 1961 from Athens, she wonders where her art had ended up from her gallery show that winter that was promised to the Chase Manhattan art fund, and writes, "There is apparently a chaos between us. I do not understand why and how this happened. I hope you will help me to bridge it." And a year later, in March 1962, after Chryssa had left Parsons and begun showing with a different gallery, Parsons wrote a distraught letter to a collector, returning a check for a work by Chryssa because the artist "did not wish to live up to her commitment to the gallery to sell you this sculpture." Parsons went on, "This is the first time I have ever had this experience in over twenty years as a gallery dealer."

Like Martin, Chryssa also had the contradictions of stasis and agitation. "She resembles her work," Hunter wrote, "in that she can never quite decide to come to rest, or to accept any simple or obvious solution, like staying rooted in one locale for an unbroken period of time."

...

MARTIN WAS NOT just scavenging wood and nails and other scraps from the street. She was observing the colors where the river met the sky, the geometry of the skyscrapers stacked on top of one another and emerging upward around the Slip's low profile. Working something through took on a physical dimension; she was building something too. She experimented with compositional strategies in her assemblages that she might then pursue in two dimensions: how nature could edge into abstraction, how things in a field could form a grid, how subtle color gradients could make someone look longer as the composition threatened to disappear. It wasn't a notebook or a canvas but found wooden slabs that Martin drove rows of nails into that "constitute her first true series of grids" as Frances Morris, director of Tate Modern, argues. And like the wellspring of the sonnet as a form that breeds innovation through its very constraints, the grid's strict structure opened up more possibilities for her painting that she continued to pursue for the next forty years.

The control afforded to Martin by the grid's bordered framework in a painting couldn't be contained in the constructions. They depended on chance material finds from Martin's many walks, and as finished pieces, they always felt like a fragment of some other preexisting whole—a compilation of parts, a section of a nineteenth-century relic prized from the docks. The fragment undermined Martin's idea of perfection. But this was the very characteristic that Chryssa embraced in her own work of the same period. "When things are spelled out they mean less, and when fragmented they mean more," is how she put it in 1966.

Like so many narratives about women—and particularly queer women—there is scant archival evidence, and even outright silence, on Chryssa and Martin's relationship. In many ways, it barely exists

to history, even as a fragment. What do we know? We know it was intermittent. We know they both didn't attempt to fill in the record even when they had a chance. References to each other were fleeting, and like any other offhand remark about another artist. Chryssa mentions once that Martin was one of the first artists in New York she "knew and respected." Parsons called their relationship "a mess." Martin does not ever acknowledge Chryssa as an influence or friend or lover. There is no visible proof of their time together, no (as of yet discovered) letters. There are small, passing references to broader stories—Indiana noted seeing Martin and Chryssa walking down the Slip in a journal entry from May 16, 1961, Chryssa just back from Greece and still carrying her luggage. There is this friend's testimony versus this friend's denial. This statement on record versus this un- documented, ordinary day together in New York.

And we have the work, whose existence feels as precarious as Chryssa and Martin's relationship. After her experiments in the late 1950s and early '60s, Martin never made sculpture again. Echoing Tawney's rejection of her own early sculptures in Chicago, Martin attempted to track down all her assemblages and destroy them. She found them "too aggressive." It's in great thanks to Tawney, who bought several of them from Martin right away in the late '50s and early '60s—including *Kali, The Laws,* and *Homage to Greece*—that we know these sculptural works at all. (Tawney also collected Chryssa's work, buying her aluminum *Tablet I and Tablet III,* among other pieces.)

Tawney's support would soon far exceed that of patron during the most difficult episode of Martin's life. It was the structure that al- lowed Martin to work at all.

# 12

## AUDITIONS

### 1957–59

DELPHINE SEYRIG WAS WAITING. At twenty-five, she felt the world wasn't coming to her fast enough. She'd been a precocious teenager in Paris: she was mentored by the actor and director Roger Blin, who was Antonin Artaud's and Samuel Beckett's confidant; she appeared in two Sherlock Holmes films while still a student; she helped realize Beckett's surprise success of a play, *Waiting for Godot*, in 1953, recognizing its genius at such a young age.

In New York, everything was an endless audition. For three years, she attended Actor's Studio classes, where she ran into Marilyn Monroe, though she never passed the admittance exam. She did Off-Broadway theater and productions in Westport, Connecticut, and Washington, D.C. Either she was constantly called back, then the role went to someone else, or promising productions she was cast in, that were supposed to get picked up in larger markets, lasted only a few weeks in the suburbs. And yet she acknowledged that there was more possibility in the States than back in France; that age and rank didn't matter as much if you could just be seen by the right person.

She would take Duncan for walks around Manhattan in his baby

**Delphine Seyrig on the roof at Coenties Slip, ca. 1957. Photograph by
Jack Youngerman.**

*(Courtesy Duncan Youngerman/Jack Youngerman Archive.)*

carriage, and wonder if this was really her life now. On one such walk
around Battery Square Park, Seyrig was spotted by a dog, a medium-
size, brown scruffy mutt, part basenji, who seemed to have been wait-
ing for her to come along. The animal kept jumping up and licking
Duncan. Seyrig phoned animal rescue—the dog seemed well fed and
clean, though she didn't have a collar—but no one claimed her.

Youngerman immediately objected to this added complication in
their life. "You have to choose between the dog and me."

Seyrig chose the dog. "The dog stayed and I stayed," Youngerman
confessed, "and I learned to love her."

They couldn't decide what to name her. Two nights after her arrival,

**Delphine Seyrig with Duncan Youngerman and Orange, Jeannette Park at Coenties Slip, New York, 1958.**

*(Courtesy Duncan Youngerman/Jack Youngerman Archive.)*

Youngerman was working late in his studio, and dropped some vermilion paint, which fell through the metal grating between his studio and their living quarters below. The paint landed on the dog, who was sleeping under the grate on the couch on the fourth floor. And so she was christened Orange. (Delphine playfully called her "L'Orange.")

Orange became a central figure for the Slip artists and the broader neighborhood. In the morning, Youngerman would go down and let her outside, and she would disappear. And then at four o'clock she would be waiting to be let in at the front door. The bums and the policemen in the neighborhood all knew and petted her; they called her Brownie, which was closer to her natural color. She even went up to the roof of the Slip, posing in Namuth's iconic group portrait.

Those first years on the Slip were a time of extremes—the oppressive heat of New York in the summer; an unexpected deep snowfall in February and early March that sent all of the Slip inhabitants out on makeshift sleds to Jeannette Park. (In the middle of one night, with the snow four feet high and no one else in the park, Tawney made snow angels.) Seyrig borrowed a thousand dollars from her parents to keep things afloat. She borrowed a thousand more, hoping that one day she could return the support when they needed it. And yet, "Even if we were very rich, we could not find a house more to our taste," Seyrig wrote to her mother. She loved Coenties Slip.

While she waited, she sewed herself dresses and modeled on the side for $40 an hour. She marveled at her neighbor Dolores Matthews's new washing machine, which sat like a big pot on the table,

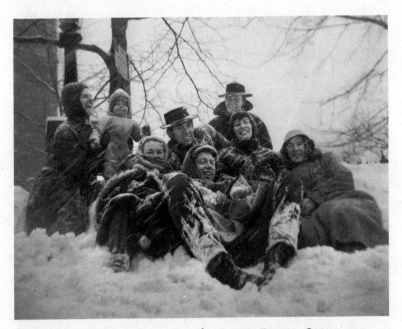

Delphine Seyrig, Duncan Youngerman, Lenore Tawney, Gerry Matthews, Ellsworth Kelly, Robert Indiana, Dolores Matthews, and Agnes Martin in Jeannette Park at Coenties Slip, New York, 1958. Photograph by Jack Youngerman.

*(Courtesy Duncan Youngerman/Jack Youngerman Archive.)*

and imagined how convenient it would make cleaning linens, pajamas, and towels in Meschers. With her neighbor the filmmaker Maryette Charlton and her son, Kirk, she walked Duncan in his stroller by the beleaguered piers, past the sailors on shore leave and homeless men hanging around the door of the mission at the end of the Slip, and around the Seamen's Church Institute. She rode a little green Vespa that Jack had bought her; it made her feel like she was back in Paris sometimes. She went to auditions. So many auditions, and often at inconvenient times.

She met Gordon Parks, who opened up a whole other side of New York City to her. The photographer, composer, and filmmaker was the first African American staff writer and photographer at *Life* magazine; by the 1950s he'd established an international reputation as one of the leading imagists of American life. She wrote to her mother that this was her first Black friend. Parks took her to Harlem, where she had never been before, and she reveled in seeing "all the nooks and crannies," meeting musicians and artists she might not have otherwise.

But mostly, she waited. She was a match, poised to be struck. The days bled into weeks without much happening, and yet she was busy and exhausted. She enjoyed being around artists. But she realized more and more how different the process of work was for them than for her as an actor. Even their attempts at work, their works in process, yielded something palpable to look at and ponder and discuss. Her work was more transient and contingent. She watched Jack in his studio, impressed by the way he was building larger and larger canvases to fill with jagged blooms of paint. She liked to talk to Kelly about books, and to Indiana about films—he kept a running list of everything he went to see. In letters home, she argued with her father about Herman Melville, even as she felt like she had no time to read anything but theater reviews.

She and Youngerman and Duncan and Kelly would pile into Charlton's old station wagon to go visit Alexander Calder and his wife, Louise,

in Roxbury, Connecticut, on weekends. Calder's eighteenth-century farmhouse had a studio that was made from an old icehouse, with huge windows looking out over the countryside. Kelly wrote in his journal: "A walk with Jack in the woods—after an early morning snow—Sandy made pins for Delphine and Charlton a belt buckle for me—in brass—Louisa cooks magnificently—a daub w. risotto—much wine—Saturday night—dancing to drums." On another occasion, they all played touch football in the backyard. Calder devised a tin pull toy for Duncan; its clatter was audible in the Matthewses' apartment below.

...

THEIR FIRST CHRISTMAS at the Slip, the Youngermans got a Christmas tree. Jack strung bright crepe-paper garlands, and they made an extravagant purchase of balls and lights. Duncan kept wanting to pull down the shiny decorations. "I try to teach him to have the same respect for the tree as he does for Jack's paintings," Delphine wrote to her mother. "Jack was afraid the tree would be depressing, and is very pleased with his decorations."

The Youngermans decided to host a New Year's party, but Calder, one of their guests of honor, didn't want to drive down from Roxbury because of drunk motorists on the road. Seyrig and Youngerman had thrown a party for the Calders when they were heading to Paris in June 1957; as with most gatherings involving Calder, Kelly had a terrible hangover the next day. And then, a few weeks later on their return to the States, the Slip again hosted the Calders, where Seyrig was unsuccessful in getting them to dance to rock 'n' roll. Not wanting to miss the guests of honor at their holiday party, Seyrig planned a Twelfth Night fete instead. Henri and Miette donated a case of whiskey from Beirut. They were expecting about sixty guests for the party. (Youngerman kept drunkenly inviting more people at the various Christmas parties that preceded it.) Seyrig was planning

to serve hot dogs and whiskey to keep things inexpensive. But as she was setting out to the supermarket, Callahan's, to get supplies a few days before, Jack said, "Why not ask Murry, the grocer, if he has any ideas for that crowd?"

Murry was delighted for the challenge and said not to worry, he would handle everything.

The next morning, an elegant Cadillac with a driver in a black cap arrived and delivered various food packages: potato chips, soda, sausages that Seyrig left out on the fire escape because there wasn't room in the fridge.

Plainclothes police officers, including the chief of the neighborhood station, showed up that evening and rang the bell. They had heard that a black Cadillac had delivered food and whiskey to the building, and were convinced that the artists were harboring gamblers. "In the absence of a confession," Seyrig wrote to her mother, "the distinguished character left us a phone number to call if we saw the slightest appearance of something fishy in the neighborhood."

The police suspicions were not irrational. The building next door sometimes still hosted illegal card games and gambling, a vestige of another century. On April 30, 1870, there was a crackdown on gambling houses, with arrests made at 23 and 21 Coenties Slip, and the seizure of "implements of faro, roulette, and other amusements of like character." And in 1886, another faro game was broken up on the third floor of 31 Coenties Slip. These police blotter mentions only confirmed the neighborhood, to contemporary readers of the *New York Times,* as seedy and full of people passing through.

The Youngermans and the Matthewses had a good laugh over tea about this unexpected visit. And then, on Sunday morning, Murry arrived in the early afternoon and made sandwiches until ten o'clock at night: egg salad and olive. Every table was covered in sandwiches.

Youngerman cleaned up his studio on Monday, and hung lights. The party would be there, on the fifth floor, with guests leaving their

coats and bags in their apartment on the fourth floor. Murry arrived again to help set up the sandwiches, which Seyrig anointed "a masterpiece. Never in my life or those of our guests had we seen such a table."

Everyone arrived at 9 p.m.: the Calders (Sandy wearing his signature red shirt), the cartoonist Saul Steinberg, Betty Parsons, who was excited about Youngerman's recent paintings and who loved to dance. Youngerman wore a white shirt and black corduroy waistcoat. Everyone was "euphoric," the party's setting was "magical," and the festivities lasted until five in the morning, with lots of dancing to rock 'n' roll records. Kelly was so drunk at the end that he could barely speak, and Youngerman got sick.

The next day, Seyrig observed that because so many guests had also brought whiskey, their supply would "last until the end of our days," and they still had "mountains of sausages."

...

THEN, SUDDENLY, the dam seemed to break in an explosion of work—several theater gigs came through, and Youngerman sold two paintings and there were inquiries about several more, and everything felt fine. Seyrig considered buying a guitar, giddy at the idea of such an indulgence. Youngerman and Kelly, also swept up in their success, ordered new canvases, paint, and brushes. Seyrig met the director Eli Kazan, who selected her from hundreds of applicants to audition for the Tennessee Williams play *Sweet Bird of Youth*, in which he asked her to have a southern accent. (She did not get the part, but wrote to her mother that she felt it was a matter of appearances more than talent, as the chosen actress was small and blond.) Another play she was cast in, *Henry VI*, with set designs by the Youngermans' friend the artist and experimental architect Frederick Kiesler, opened in Philadelphia in 1958 with great promise, but closed after only eight days without making it to New York. Youngerman also became involved in

Off Broadway theater as the production designer for a 1958 staging of Jean Genet's grim play *Deathwatch*, though he had a falling-out with its director, Leo Garen, over the spare sets. And the next year, in another rare project outside of painting, he made ballet costumes based on magazine advertisements and comic book pages for the Robert Joffrey Ballet Theater.

The Matthewses decided to move upstate. No sooner had they left their third-floor apartment at 27 Coenties Slip than Youngerman's old ROTC friend from Paris, Dick Seaver, wrote, inquiring if Jack knew of any cheap places to live now that he was headed back to New York. Encouraged by Youngerman, Seaver and his French wife, Jeannette, an accomplished violinist, moved into the Matthewses' vacant apartment with their two children, Nathalie and Alexander. Seaver remembered this time with romantic fondness in his memoir: "The comforting cacophony of the tugboats plying the waters at the nearby confluence of the Hudson and East rivers, incessantly sounding their horns, and the privacy of the area, which after five was virtually empty as the denizens of the nearby financial district scurried to their suburban homes, combined to make the place irresistible, especially when we learned that our share of the monthly rent would be $75."

But Youngerman also recalled that the reality of the Slip's conditions was tough for them; they didn't stay long. Still, it was welcome company for Seyrig. She and Jeannette would ride on the Vespa up to Canal Street to go grocery shopping, "hair flying in the wind." And Duncan would ride on the front of the Vespa with his father on the way to his day care by the Brooklyn Bridge, which he called "the Broken Bridge."

On the boat over from Paris, carrying back all of the ambitions of his time there, Youngerman had an epiphany about light and shape. He was ready to do something with his experience—this new stint in New York was his first burst of true independence as an adult. Seyrig's understanding of this creative moment came a little later, during

her out-of-town theater runs. She had been married so young, going straight from "my parents' arms to my husband's," as she put it. She was impatient to understand her own needs.

She and Youngerman fought often, and loudly. The Matthewses could hear them arguing through the ceiling, and when the Seavers moved in, Delphine used to run downstairs and confide in Jeannette. She was tired of their endless rows. It felt liberating to be alone in a hotel room prepping to become someone else onstage. But still, "I know myself well enough to know that in the long run, this kind of loneliness will weigh me down." She was grateful for the acting life, in which such a separation from her regular routine, the suspension before returning to the world, had a time limit. She realized that it was part of her talent that she could easily slip into another life and then out of it again. She learned not to miss either too much.

Through the photographer and filmmaker Robert Frank, she ended up with a part in a short film he was making with the painter Alfred Leslie and a ragtag team of musicians, writers, and poets. Her role was "the wife." It paid $18 a day. The working title was *Beat Generation*, after Jack Kerouac's unpublished play, though for copyright reasons it was eventually changed to *Pull My Daisy*, the title of a bawdy poem by Kerouac and Allen Ginsberg.

The novel *On the Road* had come out two years before, and Kerouac had also written the introduction for Frank's photobook *The Americans*, published in the States in 1959. This next project was a much narrower vision of American life, an attempt to capture the giddy, goofy energy and cultural influences of a band of artists and writers, what the critic Jeremy Tallmer called "beatthink" in a 1961 introduction to the film. The plot, such as it was, related to an episode that had really happened at the home of Neal and Carolyn Cassady in San Francisco: a couple, and their wisecracking poet friends (Ginsberg and Gregory Corso, playing themselves), are visited by a bishop. Bohemian life crashes against tradition.

Shooting began the day after New Year's, 1959, and lasted six weeks. The set was Alfred Leslie's cluttered apartment and studio on the Bowery, with some of his artwork visible throughout. As the composer David Amram, who played the bishop, recalled, Leslie had "rigged up all kinds of lights all over the ceiling of his studio and had put quarters and nickels in the electric fuse box so that we could rent extra-high-powered lights and not blow out the fuses." (Amram had also composed the music for *Deathwatch*.) One scene was shot on a set in a freezing warehouse under the Manhattan Bridge.

Seyrig is the first person you see in the film as she throws open the curtains of the dark apartment to let in the morning light. But you never hear her voice, for it was shot on 35mm without sound. The thirty-minute film is overlaid with an original jazz score by Amram and narration by Kerouac, in a kind of combination of dubbed dialogue and scat description of what's going on in each scene, allegedly recorded late one night in a single take with a very stoned and drunk Kerouac, though other accounts suggest that the voiceover is an edit of three takes. The improvisational, spontaneous prose ethos of the Beat writing style belied the fact that the film was heavily scripted, blocked, and staged. (Most of the extra footage from the shoot was lost in a terrible fire in Leslie's studio in 1966.) Leslie described the film in formal terms, as "quiet in tone and movement, with a strong subtext of subversiveness, a Samuel Beckett, Chekhovian kind of quality in which nothing happens."

Seyrig was well versed in Beckett, and Leslie's description stretched the reference. She was the only professional actor in *Pull My Daisy*, and she burns through the screen. The group of writers and painters, other than Frank, were not in her circle of acquaintances: besides Frank, Leslie, and Amram, there was the artist Larry Rivers (playing her husband); the poets Ginsberg, Corso, and Peter Orlovsky; the painter Alice Neel; the dancer and choreographer Sally Gross; and Kerouac (although he was apparently banned

from the set by Leslie several times because he kept showing up drunk with homeless people).

The shoot was difficult; some mistakenly recollect that Seyrig couldn't speak English, but perhaps she chose to play down her perfect English so as to avoid the conversational mayhem. (As Leslie reportedly told Amram, "Since none of you except Delphine Seyrig are actors, you'll all be your delightful, crazy, anarchistic selves." And Orlovsky wrote to Carolyn Cassady that they acted as a bunch of "dry hams.") There were very few women on set, and throughout the course of the filming, the men acted like boys, clowning around, smoking pot, and shouting out toasts to literary heroes including Hart Crane. The spirit of the film was, in Tallmer's description, a kind of ugly beauty. He points out that the poem "Pull My Daisy" is "ugly for its put-downs, its woman hatred, its sexual squareness (all beat sex is square), its holier-than-thou infantile anarchies." For Tallmer, this was also part of its beautiful honesty. Ginsberg walked around naked at one point; Rivers started playing the saxophone; entrance cues were ignored. "Most of us were drinking wine and trying to think up outrageous jokes that we could pull on Robert Frank," Amram remembers, "so that he would laugh so hard that he wouldn't be able to film us in action." The "plot," such as it, is has misogynistic undertones: the woman of the house is constantly cleaning, feeding, and waiting on the clowning men, and at the end of the night, when she just wants to go to bed and is fretting that they weren't good hosts to the bishop, her husband goes out on the town with the poets, leaving her crying.

Seyrig took the role seriously. She wanted to understand her part better, but any attempt to read through the script and discuss character motivations was "met with ridicule and laughter." Her character, who is supposed to be a painter, is never seen as an artist. She takes care of the child, feeds everyone, hosts everyone, gets upset by their rude, stoned antics. "Poor Delphine would pace up and down on the side, having practiced something that she was going to do,"

Amram recalled, "and when she would begin acting, Gregory would say, 'Come on, come on. Stop that shit . . . Later with all that acting. This is rea-al-ity . . .'"

In May, Seyrig wrote to her father. She could not put a cheery spin on her last play, which had closed after just three weeks. She was exhausted with the deceit of living in such an intense, hand-to-mouth way, and then going to modeling calls and auditions having to look elegant and without a care in the world. She had to be ready at any moment to appear before a producer or director—her hair just so, her face perfectly powdered, fake eyelashes and nails.

This was in opposition to how she would prefer to dress and go out. Seyrig called herself a hippie *avant la lettre*. As her son explained, comparing her to "straight" (i.e., conservative or mainstream) women and actresses of the time, "who were all made up . . . she was pretty wild." Youngerman, who took many of her early headshots on

Delphine Seyrig in a still from Robert Frank and Alfred Leslie's *Pull My Daisy*, 1959.
*(Courtesy Anthology Film Archives, New York. © The June Leaf and Robert Frank Foundation/© Alfred Leslie.)*

the roof and fire escapes of Coenties Slip, remembered her as some-one without any personal vanity. For her, "to be beautiful was like a role." She had no qualms about nudity. She visited the Matthewses downstairs for coffee in the morning in a sheer nightgown, deliber-ately standing against the window in the light, which embarrassed Youngerman. On occasion, she wouldn't bother putting shoes on when she went out, and walked down Coenties Slip barefoot. When not on an audition, she wore her hair natural, a dark frizzy cloud that accentuated her eyes and chiseled cheeks.

Her fellow Slip artists worried about their careers in other terms, of influence and abstraction; she hated that she was so mired in an artificial obsession with how she looked. She thought of the superfi-cial aspect of acting as "a kind of prostitution." She was worn down by keeping the Slip apartment in order and clean (a near impossibility in such an old building), taking care of Duncan, and the intense compe-tition of the theater scene. It was as if there wasn't much left of her; when she sat down to write a note to her parents, "I realize that I have forgotten to live."

A few days after writing this to her father, *Pull My Daisy* was screened at the Museum of Modern Art for friends and family. In her letters, Seyrig made no mention of the difficult shoot or first screen-ings of the film (after MoMA, it premiered in November at Cinema 16 in New York). In its screenplay, her role is attributed to "Beltiane," her middle name. It was not until a year later, in April 1960, with its stan-dard release at the New York Theater, that she wrote to her parents that her "film about the Beat Generation" was coming out in New York.

By then, it was a cult classic. "I don't see how I can review any film after *Pull My Daisy* without using it as a signpost," the critic and film-maker Jonas Mekas wrote in *The Village Voice*. And by then, Seyrig had connected with the French director Alain Resnais in New York, and was about to embark on a film project with him that would lead her away from the obscure Slip and into the public eye.

# 13

## FIRST WORDS

1958–61

IN THE MESS of his new loft at 25 Coenties Slip, Indiana scrounged up leftover paper and printer's ink from the Marine Works print shop, and began painting a mural. He quickly filled forty-four heavy sheets with abstract, crisp forms, executed in the "hard edge" style that expunged expressive brushstrokes, emotion, or drips. It was a style that circled back to the beginning of the century and the first experiments in abstraction, willfully ignoring the patchy color fields, theatrical fervor, and textural thickets of the Abstract Expressionists. In its complete state, the sheets of *Stavrosis* (Greek for "crucifixion") stretched more than half the width of Indiana's loft, its grand—even pretentious—title influenced by his secretarial job at St. John the Divine, but also the work's ambitions to symbolize an inflection point.

If its style was hard edge, its referents were decidedly not. The composition's three compartmentalized sections took a page from the crucifixion scene in Matthias Grunewald's *Isenheim Altarpiece* (1512–16). Made to hang in a hospital that specialized in skin diseases then ravaging Europe, Grunewald painted commiseration—in all its comingled misery. His multiple folding wings host scenes of

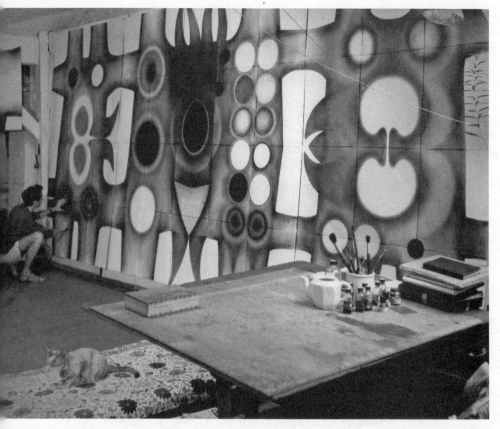

Robert Indiana working on *Stavrosis* (1958) in his Coenties Slip studio, New York, ca. 1958.

*(Courtesy RI Catalogue Raisonné LLC and Star of Hope Foundation, Vinalhaven, Maine. © 2023 Morgan Art Foundation Ltd./Artists Rights Society [ARS], New York.)*

tormented suffering and surreal rapture in an architecture of revelations and concealments tied to the liturgical calendar. Instead of Christ's tortured death—one of the altarpiece's best-known details is Christ's hand, covered by sores and impaled by a nail, twisting in agony—Indiana brought in familiar forms that held a more personal symbolic reference and reverence: the ginkgo and the avocado pit, which he sometimes described as a womb.

Indiana had never seen Grunewald's strange and elaborate Renaissance altarpiece in person, but he had heard about the work from Kelly, his art ambassador. When Kelly made the five-hour trip from Paris to Colmar, France, in 1948 specifically to see it, he had been overwhelmed. He'd even produced a multipaneled work, *Tiger*, a few years after his visit, that reflected the brilliant colors and unusual structure of Grunewald's piece. Kelly often talked about his own interest in the scale and display of murals, which were among his first commissions when he arrived in New York.

*Stavrosis* was a hinge piece—revealing Kelly's influence on Indiana, but also purging that influence, as if Indiana were painting his way through it. As soon as he finished, he changed his last name. "Indiana" linked his childhood to his identity (he was born in that state), and more broadly to America, as it contained within its letters New York's own first inhabitants. He saw this as a gesture toward the Renaissance tradition of an artist taking his last name from his geographic location. Shedding *Clark* was also stating his arrival in New York's art world. "I could feel that something was going to happen shortly," he said, in his typical way of weaving a myth around his biography, "and I didn't want to have something nice happen with the burden of a name I didn't like." There were a few other artists around with the plain name Robert Clark, and "I should like to be the only person with my own name and I think at this point I am," he later explained in an interview. "It was just like going through a revolving door from night into day." Kelly quipped, "Should I call myself Ellsworth New Jersey?"

For his inaugural solo show in New York, four years later at Stable Gallery, Indiana wrote a biographical note: "Robert Indiana was born in the state of the same name in 1928. He studied in Chicago and Edinburgh and returned from a traveling fellowship to ~~live~~ paint on the New York waterfront. Here in his first one-man show he recapitulates salient events in one American life." Indiana carefully struck through "live" to protect against the fact that it was illegal for him

to be residing at Coenties Slip. And "paint on the waterfront" refers back to his failed Coenties Slip Workshop with Youngerman; their brochure contained the same phrase. But he also lays bare that "salient events in one American life" was the focus of his work—a bold claim at a time when most of his compatriots were making work that deliberately left behind any personal biography.

As he was immersed in *Stavrosis*, Indiana started a daily journal in a hardbound ledger he bought from Findler & Wibel Stationers on Nassau Street, a few blocks from the Slip, and two other nineteenth-century ledgers he'd found unused in an abandoned loft. He had kept journals of some kind since high school, but his new commitment indicates a self-conscious awareness of his own autobiography in formation. "Is an artist talking to himself or is he trying to communicate to other people?" Indiana mused. "I suppose he's doing both, but sometimes one doesn't know for sure which is more important."

Each day, with few exceptions, got its own page, where he recorded the day of the week, the weather, plays and movies he saw, scenes from the river out the studio window. He inserted newspaper clippings, and sketches and notes of what he was working on. He wrote about who called, who stopped by, or if no one did, what he ate for lunch and dinner (lots of meals at Sloppy Louie's or the Grand Central Oyster Bar or the "Doghouse"), and what songs came on the radio as he was working. He made sketches about reworking paintings, adding wheels and objects to sculptures, and noted buying apricots, Belgian endive, and fresh pineapple (ten cents a slice) at the Staten Island Ferry Terminal. He wrote about the bums who slept against the side of Kelly's Volkswagen, a drag race on Water Street just in front of Rauschenberg's loft, visiting the dentist and getting a filling (he draws a tooth), lacing up his desert boots with electrical wire, and his cats pissing on art catalogues. He wrote about walking down to the Battery in the evening to read under the light of a lamp, watching a coast guard hook a boat, and picking up lilacs that he put on his

desk. He noted showering at Tawney's loft after watering her plants, and getting money from her to pay overdue light bills. He wrote about dodging building inspectors and the incessant noise and filth of construction—and demolition—around the Slip. He mentioned getting blisters from tightening canvases. Mirroring a growing interest in language, he wrote about countless Scrabble games played with his Slip neighbors, including his winning words. He recorded a terrible fire across the river on the Brooklyn waterfront, an unexpected fireworks display on a walk home, and going up to the roof to listen to President Kennedy's July 4 speech. His official documentation as Robert Indiana, artist in and of his time, had begun.

Under his new name, Indiana began making a series of ten abstract black-and-gold paintings. He tore down his studio partition walls and painted white or gold-leaf circles in symmetrical rows on the cheap Homasote board. With these works, he oscillated between great excitement and intense anxiety about the influence of other Slip artists. That January, everything was "cold and exhilarating," he wrote in his journal, describing ice "flowing seaward in a thin stream down the middle of the east river straight, and I feel as directed and centralized: single purposeness [sic] at work." But discussing his painting Source 1, 1959, in which the black avocado pit/womb of his mural returns, surrounded by white and green, with a cobalt form encroaching from the right, he fretted about his originality—his shapes taking on those of Jack Youngerman's, his circles being too close to Agnes Martin's, the color of his painting being "too 'Kelly' for comfort."

It's as if Kelly dominates all of Indiana's thinking around color, and for good reason: for Kelly, color was the central life force of any painting. An unexpected anecdote from that previous summer underscores how even Kelly's reserve was undone by color: One very hot day, Kelly was "profoundly moved," in his own telling, by the red of a painting he had just finished. So he made a ring of stepladders under a skylight in his Slip studio, and propped up a red painting on each lad-

der. He was already shirtless because the loft was stifling, but he took off the rest of his clothes and proceeded to do an uninhibited dance in the middle of his red paintings, under the streaming light of the noonday sun.

If Kelly had a grip on certain colors, Martin claimed certain shapes. As early as 1957, when she first arrived at the Slip, Martin had begun a series of paintings with symmetrical circles. At first, they were loose floating suns in diaphanous blue abstract landscapes, as in *Drift of Summer*, 1957, or the domino-like six dark circles on a rectangle in the now-lost *Water Sign*, also from that year. (Three years later, Martin would make this metaphor concrete with *Dominoes*, 1960, in which a complete set of dominos is drawn in a continuous square grid in between two large ocher circles.) After a number of hovering rectangular compositions, and even several with Newman-like zips down their center, Martin settled back on the circle, but this time mapped to careful grids on the canvas and precise paint application. She exhibited twenty-two works in her second show at Betty Parsons's offshoot Section Eleven gallery, which opened just a week after Kelly and Youngerman's participation in *Sixteen Americans* at MoMA in December 1959, and although it's a slight exaggeration, Martin described the hanging as "a whole show of circles." Indiana had already embarked on his series when he saw Martin's work. Their shared motif "begins to make it rather hard," he wrote in his diary. "Unfortunately for me, not for her."

Like Martin, Indiana also started to make constructions from pieces of wood he found in the neighborhood, including nine-foot beams from sail masts that he sawed in half to fit in the door. He began a series of simple upright columnar constructions in the winter of 1959, calling them his herms, after the ancient Greek statues that often served as place markers on the road and talismans against evil. (Four years of Latin in high school had left Indiana with an enduring interest in classicism.) The ancient hermae were minimal and geometric, hewing to

the natural vertical contours of their marble slab. Their one extravagant flourish, which delighted Indiana, was an often-exaggerated erect phallus (apparently part of the formula for warding off evil).

Excitement mounted for him in the studio too. Indiana attached found iron and wood bicycle and carriage wheels to the sides of his hermae, allusions to the wings of the Greek god Hermes, and to mobility. He felt like he was doing something new with one of art history's most fundamental forms, and, as he crudely put it, "if you wanted to be original or contribute something fresh, you really had to scrape pretty hard."

The artist Steve Durkee, who lived in a Fulton Street studio near Rauschenberg and Johns, tipped Indiana off to a good spot to find abandoned wheels of all kinds. Indiana good-naturedly competed with Durkee and another neighborhood sculptor, Mark di Suvero, for wood and materials at downtown demolition sites. ("With so many prospectors working the field," Indiana explained, "a piece spotted and 'claimed' in the morning may disappear by nightfall, the propitious time for beam salvaging.") Indiana was overwhelmed by the number of construction ideas that occurred to him. As long as he didn't have money for canvas or stretchers, he reasoned, it was "just as well." And two months later, he had made almost twenty works.

Kelly still loomed large, though both had long moved on from any romance. Indiana began spending more time with one of the newest arrivals at Coenties Slip, the fashion designer John Kloss, who moved into "Ellsworth's building," 3–5, and then into Indiana's loft. Like Indiana, the handsome twenty-one-year-old had recently changed his name, from Klossowski, when he migrated from Detroit to Paris and then to New York. He was already making a new name for himself dressing off-duty models—the ultimate sign of insider status in the clothing business. A profile in The New York Times in 1962 mentions the "downtown studio" of Kloss on the Slip, filled with paintings, plants, and a potbelly stove, much like the other artists' studios there.

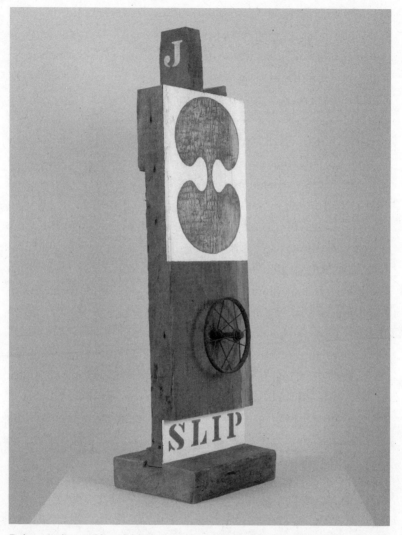

Robert Indiana, *Slip*, 1961, gesso, oil, and iron wheel on wood, 45 x 13 x 11".
*(Private Collection. © 2023 Morgan Art Foundation Ltd./Artists Rights Society
[ARS], New York.)*

But in making clothes, "his use of the space harks back to an older
New York loft tradition"—that of the seamstress (and sailmaker).

On New Year's Eve, 1959, Indiana didn't take any break from obsess-
ing over his own position in the New York art scene (even as he proudly

stood apart from it) and from avidly taking in the city's cultural gifts. He wrote in his diary about working on a small cobalt-blue work he called *October Painting*, whose dendritic forms across the canvas recall Youngerman's. Acknowledging "great debt" to what he called his neighbor's "tortured forms," Indiana also wrote of Youngerman's grace and largesse when he witnessed Indiana's similar style, as compared with "Ellsworth who trembles lest anyone hard edge."

That evening, Indiana and Kloss turned down several New Year's party invitations (including one from Tawney down the street), and instead had dinner in Greenwich Village at the diner Pam-Pam's with plans to catch a film after. Nothing appealed, so they made their way up to the Apollo Theater at Forty-second Street, where the lauded, intense new British film *Room at the Top* was playing. They then visited the Concord Book Shop around the corner, and found B. H. Friedman's just published *School of New York: Some Younger Artists*, which Indiana (always checking up on the competition) bought for $1.95 before returning home through a surprisingly empty Times Square.

It was a freezing, raw night, and so they "decided to come back to the Slip + see the New Year in quietly in the loft—over hot cider." As they sat warming up, they heard a blast from one of the tugboats at the pier. Indiana opened the blind and dormer window just in time to see "Ellsworth running with his arms + legs out like pinwheels . . . spinning down the Slip with Orange at his heels.—Such was Hogmanay on the Slip. 1959."

...

THE HERMS STOOD silent for a few months under the skylight in Indiana's loft, keeping him company. And then Indiana realized that, as road signs, they needed words. He had found die-cut brass stencils in Tawney's and his own loft, and he used these to add what would become the trademark of his entire oeuvre: letters, words, and cryp-

tic autobiographical references. *ZIG, EAT, HUG, ERR, PAIR, HOLE, CHIEF, AHAB, TUG*—the sides of his wood sentinels suddenly made commands and allusions to a maritime past, including the letters seen on the hulls of seacraft moving by the windows and around the neighborhood, and to the expressions of early American poetry and former lovers. Indiana found a printer's calendar in his loft on which he modeled his number paintings. These additions were shocking in another way: Indiana did not attempt to hide his use of stencils and tracing, directly channeling how advertising might appear on signs or walls or products. As he made all these works in his loft, just outside, between the windows of 25 Coenties Slip, words trumpeting commercial wares were emblazoned vertically down the façade. "I lived in an Indiana," he later described the building.

The aspiring artist Rolf Nelson, Indiana's Slip neighbor who worked as a director at the elegant Martha Jackson Gallery, brought Jackson down to the Slip to see Indiana's new constructions in his studio; she invited him to participate in a group show about assemblage, *New Forms—New Media*. (Like Parsons, Jackson was a formidable gallerist; she would walk around her shows with her pet macaw, Chucky, on her shoulder.) Indiana's debut in New York opened in June 1960, and included *French Atomic Bomb*, one of his smaller herms, which stood just three feet tall, with a wheel found on Fire Island and a white gessoed top like a jagged headstone. It took its title from France's shocking test of a nuclear weapon in the Sahara Desert on February 13, 1960, which Indiana noted in his journal that day. He later called this work "a small protest against a pretentious small atomic bomb."

That same month, in June 1960, 27 Coenties Slip—where the Youngermans, Martin, Tawney, the Mathewses, and the Seavers had all lived within the last four years—was demolished. (Tawney, Martin, and Youngerman moved closer to the river on South Street, and the Seavers uptown.) Indiana salvaged a wooden column from the

building for a sculpture he named *Duncan's Column*, after Younger-
man and Seyrig's son. *Duncan's Column* incorporated lots of stenciled
references: S*hip Slip, Barge Tug, Jeannette, Love Pier, 15 Ginkgoes*
[sic], *Orange,* and *Doghouse.*

Another assemblage that he began working on during this pe-
riod was *Mate,* a common phrase at the Seamen's Church Institute,
and a term whose allusions to sex were not lost on Indiana. Indiana
found a "choice piece" of old maritime beam with haunched tenons,
the hand-cut locking devices grooved into the wood to fit stairs and
shaft openings, and carried it back to the Slip and up five flights with
the assistance of Kloss. Since these beams were too heavy to handle
alone, "mate" also referred to the help and "accomplishment" of get-
ting the piece even into his studio.

That fall, Indiana began adding words to his paintings, too. He
found there was suddenly "a reason and space" to add them. Words
fill a consistent strain of modern art, harking back to the Russian
constructivists' posters and books, and Braque's and Picasso's incor-
poration of newspapers and references to their everyday café world
in their Cubist collages. In the United States, Charles Demuth, a
member of the circle of artists around Alfred Stieglitz who Rosenfeld
commemorated in his "Ports of New York" essay, made eight poster
portraits of his artist friends in the 1920s that incorporated letters,
numbers, names, and symbols as coded clues to their professions,
loves, and relationship to him. And much closer to home, in the mid-
1950s, Indiana's neighbor over on Pearl Street, Jasper Johns, had
started using Stenso company prepackaged alphabet and number
stencils to trace words and numbers onto his paintings, until 1959,
when he carefully closed the spaces between the loops of the letters
that gave away their precut status, often almost burying the forms in
thick encaustic paint.

Both Johns and Indiana had seen Demuth's 1928 painting *I Saw
the Figure Five in Gold* at the Metropolitan Museum of Art. It was an

enigmatic "portrait" of his friend the poet William Carlos Williams, inspired by his poem "I Saw the Great Figure," where Williams describes encountering a fire engine on the rainy evening streets of New York on his way to the artist Marsden Hartley's studio. It was Indiana's "favorite American painting" in the museum's collection, and he would go on to incorporate its floating "No. 5" and star iconography in several paintings of the early 1960s. (Johns also based his earlier 1955 painting *The Figure*, a single number five against a gray encaustic field, on Demuth's painting.) Indiana even inscribed his own autobiographical connection to the work, pointing out that it was made the year he was born.

Indiana's found words also allowed him to commune with the literary greats whose ghosts stalked Coenties Slip and downtown New York, most prominently Melville and Whitman. Indiana and Youngerman had called on Melville's famous opening lines in the brochure for their failed art school, and Indiana's herms embody the author's "silent sentinels," fixed on the ocean. Indiana extended this citation directly into his paintings. As art historian Jonathan Katz has written, it's also not accidental that Indiana cites queer literary heroes (Melville, Whitman, Crane, Stein) in a moment when homosexuality was still a public taboo.

The outpouring of words onto previously abstract fields marked the final shift from Robert Clark to Robert Indiana. Just as with his assemblages, some of Indiana's earliest paintings with words refer directly to the Slip and his neighbors. The first was *The Sweet Mystery*, with its doubled ginkgos surrounded by warning strips, like hazard cones around a heart. Next, he repurposed one of the abstract, eight-foot-tall orb paintings that had become too similar to Agnes Martin's own gridded circles. He stenciled the names of eight Manhattan slips within the circles—which now appeared more like an ocean liner's life buoys—with a blue line running down the center, and called it *The Slips* (1959–60).

That dividing line had a very specific neighborhood reference too. Back in March 1959, Indiana had visited Newman's exhibition, assembled by the critic Clement Greenberg, at French & Co on Fifty-seventh Street, and wrote in his diary about the experience. Newman, always grouped with the first generation of Abstract Expressionists, hadn't really shown his work in the city in almost a decade. That, coupled with the fact that the most influential critical voice in New York was presenting it (and calling it "an historic occasion"), made his re-entry onto the art scene an event. Seeing twenty-nine of Newman's early canvases on view, dating from 1946 to 1952—their refusal of atmosphere but not subject matter, their matter-of-fact presence—was a formative experience for Larry Poons in his own abstract painting. It's one of the few exhibitions he remembers going to at the time, and talking about with other artists.

Newman happened to be present the day that Indiana visited, and the big artist, dressed in a bow tie and suspenders, guided Indiana through the show with his signature slow lecture style, "carefully picking up the chronological thread and putting me on the right track." Newman always insisted that his paintings were not windows in which you traveled from an exterior to an interior world, or representative of a piece of the world, but a kind of totality in which the beginning and the end were present at the same time. He spoke about approaching his paintings in an almost metaphysical way, so that seeing them was like the impact of seeing a person, all at once. He also often discussed how the size of a painting didn't really matter; what counted was human scale. He was after an absolute truth in art, which he claimed was "as real as your belly and brain." Newman's strong vertical zips inspired Indiana to experiment with using "the natural line down the length of the board" to "set up a tension, not yet seen in my work." Indiana continued to search for other models besides Kelly for effective abstract painting; a later visit to see Mor-

ris Louis's expansive color-washed canvases at the same gallery was "even more meaningful."

But it was Indiana's stenciled words that ultimately delivered the most tension. They interrupted the otherwise abstract grounds. They announced language as the trait that makes us human, that sets us apart from other living things. And they turned the very materials (canvas, wood, paper) on which Indiana was stenciling back to their original commercial uses: whether a sail or crate or barge or sign.

...

IN THIS MOMENT, Indiana didn't just find his signature approach; he imprinted it onto his work. And he did so in direct defiance of Kelly. Words became a way for Indiana to go his own way, and he made it clear that this was at the center of the rupture between them. "That's where my relationship with Kelly deteriorated—he didn't think paintings should have words." Kelly had also been upset that Twombly was using Indiana's studio to paint in 1956; it's unclear exactly why, perhaps jealousy or anxiety over Twombly's own influence on Indiana's work and closeness with Rauschenberg and Johns, but also perhaps because of Twombly's use of graffiti. Twombly's canvases went a step further in the way that they incorporated text as a kind of defacement. Among the scribbled words on his painting *Academy,* made in Indiana's loft, is *FUCK.* And much later, Indiana explained that Kelly "abhorred the idea of words in paintings." Not wanting to give Kelly credit for this turn in his work, Indiana nevertheless insisted that Kelly "had absolutely nothing to do with the fact that my work became exclusively devoted to words."

And yet, Kelly had *himself* experimented with words a few years earlier, when he and Indiana were still seeing each other—a chapter in his art that is far less known.

Along with drawing plants, another ancillary project for Kelly that built up momentum after his first year at the Slip was a series of post-card collages. While he created these throughout his life, the most concentrated batch date to his time on the Slip, from 1956 to 1963. The curator Diane Waldman sees Kelly's collages as the first acknowledgment of his New York–based life, and of the history of downtown New York where he lived: a more "direct expression" of his return to the United States than his abstract paintings of the same time. Waldman points out that Kelly's postcard collages illustrate his engagement with early Dutch New York and the history of its ports for immigration and artist refugees. This is also a period in which mail art was gaining ascendance in art's underworld, particularly in gay circles.

Ray Johnson was at the center of this trend, and a figure who popped up at the Slip on occasion, most often at Tawney's loft, un-invited at 3 a.m., so that she had to eventually ask him to stop coming by. (Tawney also began making mail art in 1964.) Johnson had attended Black Mountain College in North Carolina in the late 1940s, where his classmates included Rauschenberg and Ruth Asawa. When he moved to New York in 1948, Johnson lived with a sculptor friend downtown on Monroe Street, across the hall from Cunningham and Cage, who had taught at Black Mountain. A few years later, he moved to Dover Street, next to the Brooklyn Bridge, in an apartment that was just above the level of the cars on the bridge and had "stacks of collages going up to the ceiling." Kelly mentions Johnson in a letter in 1954, but may not have met him until 1955. By then Johnson had already established a kind of anti-fine-art practice of "mail art," in which he sent witty, campy collages through the mail to friends and famous artists and celebrities he didn't know; he would go on to dub this activity the New York Correspondance (*sic*) School.

Kelly's postcards were often of places: a beach, a city skyline, a garden. These collages always maintained the shape and support of the original card. He would then make witty adjustments to the de-

picted scene through collaged elements, or a piece of paper blocking the whole image. Sometimes they were studies for sculpture or other paintings glued over a hackneyed tourist shot. And, following Johnson's practice, Kelly sent many of them through the mail to friends, lovers, dealers, curators. He sent postcards to Ralph Coburn, Leo Castelli, Betty Parsons, Henry Geldzahler. "But then the postman started to steal them."

In one of his first postcard collages, Kelly referenced an orange in direct relationship to the Slip. He glued a torn magazine image of fruit—some citrus, some grapes—over an aerial view of the Slip and Lower Manhattan harbor. The postcard was from the Seamen's Church Institute; Kelly's additions completely obscure the building and Pier 7, but the gingkos of Jeannette Park are just visible. (Perhaps this also makes subtle reference to Kelly and Indiana's first meeting over a postcard.) Kelly's mash-up of scale and subject matter reappears a few years later in Claes Oldenburg's imagined monuments series of blown-up objects placed into cityscapes from 1965 to 1969, or James Rosenquist's magazine-image paintings made on the Slip. (Rosenquist always insisted that Kelly was in fact the first Pop artist, taking even this original distinction away from Indiana.)

The postcards also became a ground for one of the most anomalous and short-lived sources of found imagery for Kelly: letters. At exactly the same time that Kelly was painting *Orange Blue* for Indiana, he made a series of postcards with words. In one, he painted *GO* in yellow oil paint across a colored postcard of Times Square; in another, the white letters *COOL* are collaged over a river view of the United Nations building, completed just six years prior; in yet another, the left side of a fallen-over letter *A* forms the shoreline of an aerial view of the city with the United Nations prominently featured, its central bar standing like a tall tower next to that building. The words whimsically intervene with the pictures, suggesting some kind of directive, description, or formal buttress.

Kelly also worked on a painting from April through August 1957—again, the same period that he was painting Indiana's peel—called *New York, N.Y.* It was so large (80 x 50½ inches) that it couldn't be removed from his Slip space without being disassembled. The painting, as Bois has noted, gave Kelly a lot of trouble, and it is one of his most worked-over canvases. It is also one of his most unusual, in that it incorporates two monumental, stylized letters, *N* and *Y* in white, with a band connecting the top left corner of the *N* to the right corner of the *Y*, against a black background. The letters themselves form a kind of abstracted skyline, which Rosenquist once pointed out to the curator Michael Auping. Speaking of the Expressionist painter he greatly admired, Kelly called this work "somewhat the reverse of a Kline." (Franz Kline made black calligraphic gestures on white canvases.) It is the only painting in Kelly's considerable oeuvre that uses a word, and that embodies a place so literally. *N.Y.* was shown in *Seventeen Contemporary American Painters* at the '58 World's Fair (the reason for the Namuth rooftop photoshoot on the Slip), which traveled to London after Belgium.

Kelly never used words or letters directly in his paintings again, and he soon abandoned their presence even in his postcards. "Making art has first of all to do with honesty. My first lesson was to see objectively, to erase all 'meaning,' of the thing seen. Then only, could the real meaning of it be understood and felt." He found words to be a dead end, too obvious: they took that subliminal, source layer of a painting and hoisted it to the surface, pinning it there.

More and more, Indiana took an almost diametrically opposed approach to Kelly in both art and life; where Kelly favored discretion, Indiana added apparent symbolism. Maybe, as Indiana defensively put it, he had "a more literal mind" than Kelly but he "could never be happy" with the paintings he made that were influenced by him. "It wasn't enough for me." As if revising the record, he went back

and added words to most of the abstract work he had created under Kelly's spell; many others he simply painted over completely.

Indiana was still thinking about the ginkgo, though. On April 12, 1960, he wrote in his journal, "I noticed that this morning the ginkgo trees are almost budded and their slender branches are rough with this turgid greenness." And that September: "Jeannette [Park] is now littered with the fallen yellow leaves of the ginkgo, and now fall weather alternates with stubborn summer's holdout." On April 8, 1962, he painted a solid green shape of a ginkgo leaf into his journal, like a mini-Kelly work, noting, "The ginkgos are noticeably in bud now, their new greenery making a definite tracery in Jeannette."

He was not the only one who returned again to the ginkgo. In 1972–73, ten years after leaving the Slip, Kelly made an ink-on-paper drawing, *Ginkgo*. It is unusual among his plant drawings. Rather than a lone specimen, it depicts two leaves side by side on a single page, not unlike Indiana's own doubling of the motif. The critic Douglas Crimp has pointed out that when, very occasionally, Kelly did include more than one plant in a single composition, it was usually a complicated flower, like a sweat pea, seen from various angles, or multiple leaves on a single branch. The ginkgo side-by-side pair is an exception in Kelly's plant drawings, each leaf alike but different in its contoured edges. Crimp's description of the leaves could almost describe two people: "The ginkgo leaves stand on the page not as they might grow on a tree but simply one next to the other, two similar but distinct individuals."

# 14

## SIXTEEN AMERICANS AND TWO FRENCHMEN

### 1959–60

YOUNGERMAN SAT IN HIS ATTIC SPACE at night over a table filled with tubes of Windsor & Newton oil paint. He was working on a small study for what would become an almost-eight-foot canvas, *Ram*, which he completed in 1959. He called these studies for larger paintings "seeds"—about to break open into the "potentialities of shape."

Departing from the blacks and reds that dominate his work of the time, he took up the identical complementary color combination of Kelly's little painting *Orange Blue* that Kelly had made for Indiana. A four-sided orange form is at the center, though listing toward the left and out of the composition, overlaid on a bright blue form that takes up the same petal structure of Kelly's orange shape, and also leads to each edge of the picture. The shapes around the blue form are filled in by chalky white paint that leaves its smudgy powder along the boundaries of blue, refusing to be read simply as negative space. Unlike the smooth edges and surfaces of Kelly's shapes that sometimes seem to erase brushwork entirely, all of the forms in *Ram* employ Younger-

man's signature jagged edges—impatient bursts of color stretching out in thick impasto.

When Youngerman visited the caves of Lascaux in the 1940s, he'd marveled at how some of the animals and abstract symbols had been painted—seemingly not with a brush but, as the theory has it, with pigment applied to the wall through a blowpipe technique. To Youngerman, the caves looked like they were covered in modern spray paint, though most of the paintings had been made seventeen thousand years before. Crouched in that claustrophobic space, Youngerman couldn't believe the "disappearing edges" of the cattle and horses. Seeing those paintings changed his life. And the idea that a painting could change your life changed his life.

...

COMPELLED BY EVIDENCE of the enduring need for humans to make art from their surrounds, Youngerman was also anxiously aware of his own historical moment. Speaking in 1958 at the Club, Alfred H. Barr, Jr., pondered the continued dominance of Abstract Expressionism. "I look forward to a rebellion," the former director of the Museum of Modern Art—and still, as director of its collection, its influential curatorial voice—said, by way of throwing out a challenge to the artists in attendance, "but I don't see it."

But change was already under way, what Youngerman deemed a "counter surge" to the art then monopolizing headlines and galleries in New York. In late December 1954, Barr's colleague and right-hand woman, the Museum of Modern Art curator Dorothy Miller, visited Kelly's Broad Street studio. A tireless crusader for living artists, Miller was an essential figure in postwar art. She had the chance to meet artists across a broad swath of the United States when her husband, Holger Cahill, was Federal Art Project director during the New Deal from 1935 to 1943. He even stepped in as interim director

of MoMA when Barr took a year off for "exhaustion," and Miller went to help him, working part-time for a dollar an hour. Miller and Cahill had met at the Newark Museum of Art, where Miller was taking a museum-training class, fresh out of college; Miller joined MoMA officially in 1934. By the 1950s, Cahill was writing novels and accompanying his wife on her marathon Saturday studio visits.

Excited by what she saw at Kelly's studio, Miller asked the artist to send six paintings to the museum for the acquisition committee to consider. None were accepted. But Miller still figured out a way to get him into MoMA. She exhibited *Study for Black Ripe*, a 1954 pencil-and-ink drawing in which a black form not quite a square or circle squishes up to the edge of the paper, in the 1956 show *Recent Drawings USA*, the first time his work was on view at MoMA. Miller included him again in 1959–60 in the influential *Sixteen Americans* exhibition, the penultimate in Miller's important series of six surveys of contemporary American artists that she curated between 1942 and 1963. These shows included the majority of artists from the Slip: Kelly and Youngerman in 1959, and Indiana and Rosenquist in 1963.

"The 'Americans' shows set the tone for my time," Frank Stella, the youngest participant in *Sixteen Americans*, explained. "You were either in or you were not. They were exhibitions of what was going on, pointing to the future." (In addition to Kelly, Youngerman, and Stella, the 1959 roster included Johns and Rauschenberg, along with Jay DeFeo, Louise Nevelson, Wally Hedrick, James Jarvaise, Alfred Leslie, Landès Lewitin, Richard Lytle, Robert Mallary, Julius Schmidt, Richard Stankiewicz, and Albert Urban.) Of course, this often meant that the shows were met with critical disdain. The *New York Times* critic John Canaday wrote in a letter, "For my money, these are the sixteen artists most slated for oblivion."

Miller's *Americans* series also demonstrated the vision of a singular woman curator in American art history. Barr felt that "every show should be one person's choice and no one else's," Miller once

explained, against the idea of curating by committee. "So I never had any interference with those American shows. I just put whoever I wanted in it. I could ask as much advice as I wanted, but I wasn't troubled with, 'No, you can't put that person in,' or 'Put this one in.'"

After seeing Youngerman's show at Betty Parsons in 1958, Miller and Cahill came down to Youngerman's Coenties Slip studio, too, in early September 1959. For the artist, it was a "momentous studio visit." His living in an "out-of-the-way place" in a "very out-of-the-way part of the building" meant that "just to visit was an act of generosity on her part." For so many artists, Miller's openness to meet them on their turf and terms was refreshing. "There was no big ego out there to block her vision." She was also particularly sensitive to the conditions in which artists lived and worked. In one correspondence with Indiana from the winter of 1962 where she asks if she can come soon for a studio visit to see more of his work, she gently writes, "I hope your stove is working."

To get to Youngerman's studio on the fifth floor of 27 Coenties, one climbed the open staircase from the street to the fourth floor, and then up a rickety ladder to the attic space. Youngerman was worried about how unprofessional it was to have a curator from MoMA hoisted up a ladder in heels to see his work. "But maybe Dorothy thought it was funny." Miller herself felt that it was necessary to visit artists: "If I hadn't known any artists I wouldn't know a damn thing about art. You simply have to know the people and see them working and let them tell you about their pictures."

Miller took two large paintings, including *Ram*, and three small ones back to MoMA to show to the acquisition committee. And eight days later she phoned to say that the museum had bought one of the large paintings, and that Youngerman was invited to exhibit six paintings in her upcoming exhibition *Sixteen Americans*. Youngerman only half joked, "I think I was the last person chosen for this—I was the sixteenth American."

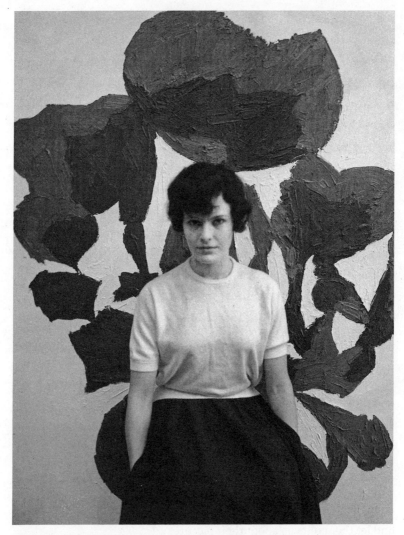

Delphine Seyrig in front of a ca. 1958 Jack Youngerman painting,
Coenties Slip, New York, 1958. Photograph by Jack Youngerman.
*(Courtesy Duncan Youngerman/Jack Youngerman Archive.)*

At the same time that Youngerman was pulling together his work
for *Sixteen Americans,* Seyrig finally heard good news from her end-
less auditions. In October 1959, she was offered a part in the Henrik
Ibsen play *An Enemy of the People* in Boston. It was difficult leaving

her young family but at the same time she got a taste of a particular kind of freedom and independence that was thrilling. She realized that she loved the touring life. "I feel comfortable in an anonymous hotel room, where nothing belongs to me," she wrote to her mother during her Boston stay. She was also cast in a sitcom, *Pete and Gladys*, shooting in Hollywood, a spinoff of the popular *December Bride* on CBS. Her role was the French neighbor; she was asked to fake a French accent when speaking English (since she herself did not have one) and she hated it.

And then the Youngermans received a call from a passing French acquaintance. The celebrated young director Alain Resnais was in town. He didn't speak English; he remembered that visit to New York as a long, lonely wander, taking photographs of everything, until he looked up the only two contacts he had there, the Youngermans and the Seavers, whom he had met briefly through William Klein in Paris.

Resnais's films couldn't be more different from *Pete and Gladys*. He had directed a short, textural documentary about Vincent van Gogh, then *Night and Fog*, about the Nazi concentration camps; he had just completed the acclaimed *Hiroshima Mon Amour*, his first feature-length film, written by Marguerite Duras. His next film would also be dealing with love and memory, with an enigmatic screenplay by the experimental writer Alain Robbe-Grillet.

The Youngermans invited him to Coenties Slip; the Seavers stopped by from the floor below. Resnais arrived in his slim suit and glasses, with his camera. Conversation flowed in French. In Paris, Youngerman and Seyrig had their education in film by going to the Paris Cinémathèque, with its folding chairs and a little screen that unrolled. And here, suddenly, an acclaimed and rising director was sitting in their loft. He climbed up to Youngerman's attic studio above and snapped photographs of his paintings in process, which he greatly admired. But it was Seyrig he most admired. She swept him away. He took pictures of her from every angle as she sat at their

picnic table. He even traveled to Boston to see her in *An Enemy of the People*, and was struck by her sensitivity and musicality. He insisted that she work with him on his next film project back in Paris.

Seyrig felt something opening in her chest; she could already imagine that they would collaborate well and had always dreamed of this possibility. She didn't know how that might work with her Hollywood contract and her family on the Slip and wondered if the idea of working with a Frenchman suddenly seemed so appealing because she was just homesick. Even as she was pondering the decision to her mother in a letter—"I have always needed to have someone on the horizon who enlightens me . . . because otherwise I feel alone and helpless to make that light myself"—she had already made up her mind. As she confided to Jeannette Seaver, she, too, had fallen in love, and she could not ignore its pull.

Seyrig wrote to her mother on December 15, 1959, "Tomorrow, screen test for me, opening at the Museum of Modern Art for [Jack]." Finally the big break they had each believed possible for the other had arrived, and just as they were breaking apart.

...

YOUNGERMAN WAS THE ONLY ARTIST with no statement in the slim *Sixteen Americans* catalogue. At the time, there was no critical text published either; he would have had to ask someone to write something, but was perhaps too "unsure or self-conscious." And he didn't know any art writing that he truly appreciated. Kelly included excerpts from E. C. Goossen, who wrote that the artist's color on the surface was "a kind of spaceless skin." He went on: "the hard, crisp edges command the eye to feel them as the hand would feel soft flesh. The emotion is like that we sustain before sculpture." Other powerful statements in the catalogue include the personal ones by Johns and

Rauschenberg, who chose bold pronouncements of their artistic mission. Johns channeled Cézanne, Duchamp, and Leonardo to define his work: "At every point in nature there is something to see. My work contains similar possibilities for the changing focus of the eye." And Rauschenberg's famous text reads, "Painting relates to both art and life. Neither can be made. (I try to act in that gap between the two.)"

Youngerman's silence in the catalogue points to a larger reason than just his modesty; a writer hadn't emerged yet to champion his work, as Harold Rosenberg, Clement Greenberg, and Frank O'Hara had been so influential in doing for the Abstract Expressionists. (In a review of Morris Louis and Kenneth Noland in 1960, Greenberg would write, "I myself admire, or at least enjoy, the works of Raymond Parker, Ellsworth Kelly, Jack Youngerman, and Jasper Johns, but find them a little too easy to enjoy. They don't challenge or expand taste. This may not condemn their art, but it has made it, so far, less than major in its promise. And I do not see any reason why we, in America, should go back to celebrating what is less than major.") Greenberg's bombastic judgment mimics the great early-twentieth-century art historian Edwin Panofsky, whose cutting descriptions of early modern and Renaissance painters ranked them into "major" and "minor" (and sometimes "major minor") camps. Greenberg's influential system for assessing modernism and the ascendancy of American painters after World War II was proscriptive; to uphold its pronounced tenets meant refusing Pop, Minimalism, performance, Happenings, and more.

Youngerman ended up showing seven paintings, all dating from 1959, though they reflected the previous two years of his time at the Slip: *Aquitaine, Aztec III, Big Black, Coenties Slip, Palmyra, Ram,* and *Talmont.* Kelly showed eight canvases, also all dating from that year: *Charter, Falcon, Rebound, Running White, Slip, Summac, Wave Motif,* and *York.* That both artists chose a painting titled after the Slip,

unbeknownst to the other, indicates the pull of the place where they worked.

Youngerman met the twenty-three-year-old Stella at the exhibition's opening, and was dumbfounded by his matter-of-fact black stripe paintings made with house paint. Stella's four black paintings in *Sixteen Americans* were a direct rebuke to the Abstract Expressionist gesture (he greatly admired de Kooning, but he kept a reproduction of one of the artist's paintings nailed up in his studio as "a reminder . . . of what I must not do"), and a bridge to Minimalism's reduced means in which materials, structure, and form were deployed in systematic austerity. As Stella famously explained, "All I want anyone to get out of my paintings . . . is the fact that you can see the whole idea without any confusion . . . What you see is what you see." Youngerman connected to the scale of them, particularly as his move to Coenties had allowed him to start painting much larger canvases. Stella would eventually buy Youngerman's huge *Aztec III* from the show, a spiraling pattern of jagged red and white, like a cave painting or crude jewelry.

The composer Philip Glass was blown away by the exhibition when he visited as a young music student; seeing it was "a liberating moment" in his own career, as he realized how quickly modern painting was continually innovating and reformulating itself—he had just gotten a handle on the Abstract Expressionists—as opposed to a music world that was still calling "new" what was more than fifty years old. The show gave Glass the impetus to seek as strong a break in modern music as he was witnessing in modern art.

At the opening of *Sixteen Americans*, Youngerman stood in line for dinner, which was served cafeteria-style in MoMA's dining room. A fellow *Sixteen Americans* artist, Louise Nevelson, was just ahead of him in line, wearing white orchids. Unimpressed by the dinner, she turned to Youngerman and said, "Well, aren't we big shots." And then, "You know what I say, I say fuck 'em."

...

AT THE SAME TIME that Miller was selecting the artists for *Sixteen Americans*, she was negotiating for a major series of Claude Monet's *Water Lilies* to enter MoMA's collection from France. The museum had purchased one of the Impressionist's late paintings in 1955, but it was destroyed in a fire that broke out at MoMA in 1958. In 1959, the museum, with the help of Mrs. Simon Guggenheim, purchased a major Monet triptych, each panel over twenty feet wide. These were among the paintings that Kelly had marveled at a decade earlier in Monet's studio. That his work should be shown at the same time that this major acquisition was joining the collection was not lost on him.

Monet's paintings were damaged by artillery shells and bullets fired randomly by the Germans in their retreat from Paris at the end of World War II, as well as years of neglect and exposure, the results of which Kelly had seen firsthand in Giverny. They needed major renovation before their March 1960 debut. MoMA's conservators removed the canvases from their original stretchers, now too warped to be useful. Miller offered these original stretchers to Kelly, Youngerman, and Mitchell; Mitchell's fourteen-foot-long 1960 painting *Jeannette Park (Towards Coenties)* recycled Monet's armature. And thus their time in Europe visiting their heroes came full circle, incorporated not just via influence but also actual material into the paintings they made at the Slip.

# 15

## DARK RIVER

1958–62

EVERY MONTH, JUST WEST of Coenties Slip's abrupt dead end before the East River, Lenore Tawney hosted concerts and readings at her open, sun-flooded loft at 27 South Street. Where large canvas sheets once spread across the floor to be stitched into something to propel a ship at seventeen knots per hour, and a sailmaker sign still graced the door, wealthy women collectors mixed with avant-garde artists and writers. Tawney's three-floor studio was big enough to feel sparse even with a crowd and filled with several looms, works hanging from the beams, hundreds of balls of yarn, bones, feathers, eggshells, stones, some old furniture left by the sailmakers, and a deck chair with cushions. She had painted the space all white, which made the light coming through the skylights even more brilliant. Tawney herself called it "a noble space" that had a hold over the work she made there. The writer Anaïs Nin, who frequented Tawney's gatherings, likened it to a church.

Tawney was "brilliant" and "sophisticated," Ann Wilson remembers. "I saw some extraordinary things at Lenore's loft." One of her

featured guests was the composer and musician Harry Partch, who came on the winter solstice of 1958 from Illinois with a selection of his handmade, hand-designed wooden instruments. During the Depression, Partch had been homeless for almost a decade, wandering around California with hobos, working in federal camps, and composing the whole time in his head—making music, as he once wrote, from "a quarrel in a potato patch." He also became friends with Jean Varda.

Nin, herself a daughter of a composer, was present that night. As she wrote in her published diary, "In New York I heard Harry Partch's music again. I saw Tawney's poetic weavings, filigree in wool. I saw her amazing studio on South Street near the Battery." And later the following fall, Nin saw Partch again at Tawney's, in an evening during which he showed a film about his music and instruments, and when she introduced the ever-struggling composer to someone who might help him realize some of his work. She felt the need to again write about "that fabulous place I love, the sailmaker's loft down by the Battery."

Tawney's own recollection of Nin's presence at her parties has a slightly different cast. Nin was always paying her "too many compliments"—here, Tawney sounds a little wary of the famously bisexual Nin—and asking for Tawney's work in exchange for her own hand-printed books. "It seemed very important to her so I finally agreed. Once I gave her the weaving, she stopped coming to the loft."

When her cultured guests emptied out, Tawney was left alone for long periods, as she preferred. Despite the scale and complexity of her work, she didn't have an assistant until the final decades of her life. (Indiana acted more as an apartment caretaker, watering her plants when she was away, and helping himself to some of the leftover stencils and materials from the sailmakers.) Nin could not understand how Tawney didn't get lonely in her situation, but Tawney felt free, completely engaged in translating the intense external environment into

"interior landscapes." She called her loft "an island." At night, she'd watch the boats going by at different speeds and in different directions, all lit up "like Venetian glass." In the winter, she noted that the change of weather was more extreme on the Slip than anywhere else in New York. She felt the wind coming off the river and saw ice forming on the water and over her skylights. If it was too windy, Tawney struggled to get her stove started. But even in the cold, she found it beautiful.

The maritime history of New York was still suspended in hanks of rope outside her window and worn into the grooves of her studio floor. Like Martin, she felt the East River running through her work. "I looked out my window at these tugs and they had these enormous knots hanging over their sides . . . beautiful knots made of huge pieces of rope to keep them from hitting the ships that they took out to sea." Tawney often finished the warp thread ends of her elegant, hanging woven forms with sailors' knots, sitting in a chair by her window looking out over the water.

The stretch of road running up the east side of Lower Manhattan was so steeped in its trade that a major publication of the city's sailing history was called simply *South Street*. In the second half of the nineteenth century, sail-making was still a small workshop industry, with high wages and no industrialized machinery. A typical loft was located in the upper stories of a water-adjacent building that didn't require column or pillar support. This allowed for an unobstructed, wide area for the sailmaker to plan the pattern of each sail—called "lofting"—and then cut it. (In Nantucket, unable to find such a space, one tradesman took his sails out to cut in an open field.) For the later artists that discovered these spaces, the lack of walls and columns allowed for bigger canvases, looms, sculptural materials to be brought in, and most important, unobstructed light.

Sail workshops typically had five male employees, and grossed about $10,000 in new sails and sail repairs every year. A master sail-

Copy negative of Jeannette Park, Coenties Slip, New York, 1871.
*(H.N. Tiemann & Co. Photograph Collection, 1880–1916. © New-York Historical Society.)*

maker was a distinguished craftsman who managed journeymen and apprentices and averaged yearly wages of $400, which the scholar Mark R. Wilson notes were "among the highest in any US manufacturing industry of the time." There are stories of master sailmakers arriving at dusty, rat-infested lofts with high hats and canes. They took off their refined gloves before they began work, exchanging them for pairs of iron and leather, with open fingers, along with sturdy thimbles. Outfitted in homemade clothes of a canvas shirt and pants to protect the sailcloth, the men employed long needles, awls, and knives to work the sails.

The common stairwells of the buildings were thin and narrow—a major issue also for the Slip artists in getting their work in and out a century later—so sails were hoisted in through third- and fourth-story windows, where a beam projecting from the window was used

to raise the rolled sail with thick manila rope, and where the knotty pine boards were sanded smooth from dozens of sails pulled across the floor. One account of sails going into a loft included four-inch brown West India cockroaches dropping out of the sail and onto the sidewalk—"And how they would run!"

The height of business for sail-making lofts was at the beginning of the Civil War, in 1861, when sailmakers were commissioned by the Union government to make canvas tents for soldiers. Mercantile firms tried to find canvas duck, scarce during the war, and hired the sailmakers to cut the material and oversee the sewing, which was done primarily by women working in factories and smaller workshops. By the end of the war, there was a surplus of tents, and the market was never the same. Sailmakers in New York were not only aiding the North, and abolition: in December 1861, a ship chandler working out of Tawney's future building at 27 South Street was arrested for outfitting a slave ship en route to Cuba.

...

TAWNEY'S OCCASIONAL PARTIES brought many personalities through her loft, but Martin remained one of the constants. The two were intimately entwined, even if their connection is difficult to quantify, not unlike Martin's relationship to Chryssa. Wilson has said they were romantically involved, but no one else confirms this. Like so many women, and like so many women artists, their story is invisible, but not unpresent, in the historical record.

Some 250 years earlier at the Slip, women acting outside the mores of society were put in their place and shamed via the public spectacle of the ducking stool. Now the street hosted two artists whose independence impelled their creativity. Tawney and Martin shared an aversion to traditional roles for women, particularly in the 1950s, the twilight years for distinct gender roles and homogenous consumer

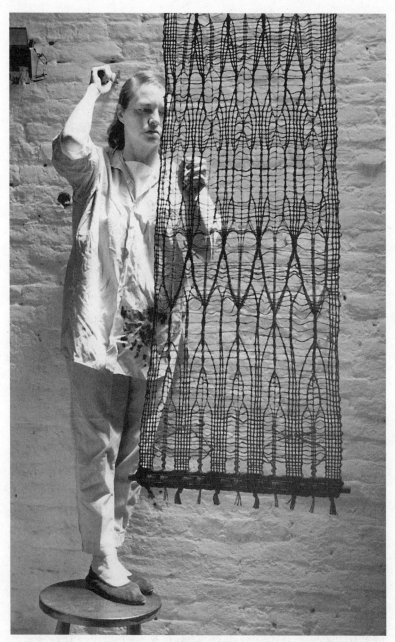

Lenore Tawney with *Vespers* (1961) at her South Street studio, New York, 1961. Photograph by Ferdinand Boesch.

*(Courtesy Lenore G. Tawney Foundation.)*

goods. Wilson remembers them both urging her not to get married and have children, for she would lose the freedom to make art (she ignored them). This stance was bolder than it may appear in a period that saw a seismic upswing in marriage and children, spurred on by a burgeoning middle class in America and a societal emphasis on returning to typical gender roles after the war. The birthrate in the mid-'50s in the United States peaked after more than a century of steady decline. This renewed focus on the importance of children actually grew out of political fears around communism's inroads into American culture, with, as the scholar Elaine Tyler May states, stable families acting as the "best bulwark against the dangers of the Cold War." And this extended to the perceived security risks of anyone not participating in this heteronormative trend; homophobia had one of its worst spikes during this period, with homosexuality seen as "a mark of potential subversive activity." In May's now famous treatise, the U.S. government's efforts to contain the Soviet Union's spheres of influence around the world, and contain the threat of the atomic bomb, had a parallel containment effort in the domestic space, particularly for women. They were relegated to the home, "housewife" was elevated as a job, and the family was seen as a model of normative strength and growth for the country.

Both Tawney and Martin lived alone, in spaces that were not designed for domesticity; they did not even have proper kitchens. In film footage shot by Charlton for a never realized documentary on Tawney, the artist moves assertively around her loft, sitting in front of a loom to work, standing on the broad beams across the ceiling to hang a work, cranking one of her tall woven forms up on the sailmaker's winch that still traversed multiple floors, then sitting at the window, watching tugboats pass and helicopters land and take off next to the river as she braids the ends of ropes together. Like Seyrig, Tawney made her own clothes. Martin eschewed traditional dress, or

at least, expectations of gendered propriety. Rosenquist remembers her walking across the street to buy coffee from the Seamen's Church Institute in her pajamas, without any self-consciousness.

The Slip offered a release from societal expectations but also community; its siting as a sociopolitical refuge is a part of how we can think about collective solitude. Its isolation allowed for that community to be self-selecting—whoever was invited down for one of Tawney's parties, or the fellow artists who had also chosen to live at the "end" of the city. Martin enjoyed holding court, lecturing a group at a party on Gertrude Stein or on truth and beauty, but then she needed to be away from everyone. Tawney and Martin were captivated by the story and writings of St. Teresa of Avila, who wrote in sixteenth-century Spain about the power of prayer and one's "interior castle"—the soul's space of devotion and care. In her clear, descriptive writing, Teresa, who suffered from what she called divine "raptures," writes of the "great noise" in her head during her visions, "so that I consider it almost impossible to finish what I am commanded to write." Tawney and Martin both meditated, and read widely across cultures about spirituality and beauty. D. T. Suzuki's free lectures on Zen philosophy at Columbia University in the 1950s had influenced many New York artists, including Reinhardt and Cage; Martin also read the ancient Taoist philosophers Chuang Tzu and Lao Tzu on a daily basis. With Youngerman, Kelly, and Indiana, they read and practiced the *I Ching*. Back in Urbana, as a young widow living with her in-laws, Tawney had discovered her father-in-law's huge library (he was a philosophy professor). In those stacks she uncovered two books of Swami Vivekananda's talks, which fundamentally changed her perception of religion. Struggling with the death of her husband and the prescriptive moral binaries of the Catholic faith she'd been raised with, Tawney was drawn to an Eastern philosophy that, as she put

it, "didn't say we're right and everybody's wrong. They said all re-
ligions are going to the same place, they're simply on a different
path." She ended up stealing these volumes from her father-in-law.
Just before moving to New York, she would read Vivekananda's lec-
tures every night before bed and when she woke up. "It was a way of
going into myself."

Both Tawney and Martin embraced a stillness broken by feverish,
almost manic windows of production—Martin ever more so because
her schizophrenia made those productive stretches so precious. Hers
was a life suspended between extremes. You might describe her ab-
stractions that way too: the open field of her canvas's grounds in-
terrupted by the controlling line, the wide bands of paint without a
whisper of brushstroke, and the intimate threads of graphite.

Tawney's breakthroughs in her own work coincided with some of
Martin's worst breakdowns—never an easy dynamic. Things could
tilt so quickly for Martin. Good days turned bad without warning.
She would go walking for hours over the Brooklyn Bridge, and, look-
ing into the dark river running beneath her, forget where she was
and who she was. Tawney was always buying Martin's work to save it
from destruction (by Martin's own hand), and to give her friend some
money.

They kept each other posted on what they were making, and how
they were making it (Martin, with a ruler and pencil attached to a
string; Tawney, with a shuttle she wielded like a paintbrush). Crit-
ics compared Tawney's weavings to paintings and sculptures, and
Martin's delicate grid paintings to weavings. Martin did not welcome
the association, which felt like a gendered relegation to craft; her dis-
avowal must have disappointed Tawney. A woman working in textiles
was immediately assigned to the domestic space, outside of art and
culture—the space that Tawney and Martin eschewed. In response
to this condescension, an artist once remarked, "Painters forget they
paint on fabric."

...

TAWNEY'S DEALER, MARNA JOHNSON, helped secure a variety of commissions, some more commercial than others. Occasionally, Tawney had to ask Johnson to stop placing her work in wealthy homes in Chicago. As she wrote in the fall of 1959, "I want no pressure, no selling, nothing . . . At present I am in a slow pace and not in a hurry." She was lucky enough to be in a position where there was less urgency to sell her work to support herself. "I need a year or two to work quietly through."

But Tawney was excited to make a tapestry for the new cross-denominational Interchurch Center being built uptown on Riverside Drive. She wove three panels of linen, silk, and wool together to form an eleven-by-twelve-foot *Nativity in Nature*, in which the outline of Mary holding her baby is represented only as shimmering streams of light, amid herons, egrets, owls, and reeds. The building committee rejected it, and returned it to her studio in 1960, ostensibly on the grounds that its ties to the spiritual were too abstract. Martin intervened, writing a letter of support for her friend's representation of "nature illustrated by the holy spirit," and concluded, "That which is new, with the support of those who can appreciate it, slowly gathers force." The building's architect also cast his support, and a second review of the tapestry approved it; it still hangs in the narthex today.

Around this time, the curator James Coggin visited Tawney's loft and immediately knew that he wanted to show her work. Tawney's first major public display in New York happened at the city's periphery, at the Staten Island Museum. Tawney took this in stride; she was delighted that most people would have to take a ferry—her "favorite diversion"—to see it. It was also the first solo museum show in New York for any of the artists working at the Slip. Tawney's exhibition included forty works made over six years. This was her coming out as an artist, rather than as a craft artisan, the first in a series of key

exhibitions in the 1960s for her—which also included *Woven Forms* at the Museum of Contemporary Crafts in 1963, and *Wall Hangings* in 1969 at MoMA—that attempted to undo the sexist and racist pigeonholing of textiles into "craft" work rather than fine art.

The young artist Alice Adams—sister to Mary Lou Adams, who married Rosenquist—had a regular beat writing reviews for *Craft Horizons*. At $12 an article, it was a good gig, as Adams worked on her own textile art, on a loom she had hauled into the industrial loft space of her father's printing press business at 911 Murray Street. Her studio there, in the midst of other businesses, had a view past City Hall to the harbor. Adams had studied painting at Columbia and was among the first students to graduate with a bachelor of fine arts. She was introduced to weaving on a trip to France on a grant in 1953–54, where she learned tapestry weaving and mural painting in the small town of Aubusson.

Adams remembers trekking out to Staten Island and being astonished by what she saw, overwhelmed by its seriousness and beauty. She felt that more people should be made aware of it. Her review in *Craft Horizons* was one of the first appraisals of Tawney's work and cited her "delightfully disreputable" forms and "the consistently free and courageous approach to the materials used." She deemed Tawney a "sensitive experimentalist and a leader in the increasingly vigorous field of creative American weaving." Two years later, Adams would be showing with Tawney at the Museum of Contemporary Crafts.

Martin contributed a statement for the Staten Island Museum's slim catalogue; it would be the only writing she ever did for another artist. Like Coggin, she seized on how Tawney had taken a very old tradition and reimagined it—"Not just one new form but a complete new form in each piece of work," as she wrote. Her short text is moving in its emotive description, which is hard not to connect to her general feelings toward Tawney: "The expression in one square foot of any piece cannot be hinted at. But it can be said that trembling and

sensitive images are as though brought before our eyes even as we look at them; and also that deep, and sometimes dark and unrealized feelings are stirred in us."

Martin's catalogue introduction for Tawney was one of the final things she was able to complete before suffering a major breakdown. In December 1961, she left the Betty Parsons Gallery after three years. It was a difficult decision, considering her closeness to Parsons, and respect for artists like Reinhardt that Parsons still represented, but also a practical one. Parsons would send statements itemizing that "after expenses for moving, storage, publicity, et cetera, I owed *her* money." Every morning for two and a half years, as Martin put it, she asked her mind if she should change galleries, and for two and a half years it said, No, no, no. "Finally, it said 'Yes.' I leaped out of bed, went uptown, and told Betty Parsons I was leaving." She first approached Leo Castelli. He suggested she try Robert Elkon, who had just opened a gallery on Madison Avenue showing Picasso and Pollock.

She spent a considerable part of 1962 committed at Bellevue, unable to work. Tawney helped pay her medical bills and arranged her first exhibition at the Robert Elkon Gallery that November, a year after Martin had left Parsons. Martin also lived with Tawney for a brief moment then, before moving into her own new apartment on 28 South Street, next door to Tawney's. She called it "a perfect loft"; with windows onto the river, two skylights, and fourteen-foot ceilings. "I could see the expressions on the faces of the sailors, it was so close to the river."

...

JUST BEFORE LEAVING Chicago in the 1950s, Tawney had had the first of two major breakthroughs. She invented an open-warp weaving, in which the standard tight interlacing is broken apart into a looser form that renders sections of weaving fully transparent. Her thread could be more dynamic, like drawn lines. She was working on

a tapestry she would call *Family Tree*, in which she left space, with threads hanging loose, around the forms of two intertwined trees, and worried that it wouldn't be any good, but she pushed on. "I don't have to show anybody; it's just for myself. And I felt so free!" When she took it off the loom and "threw" it on the floor, "I felt that tiny click near the heart that meant: it was not bad."

This innovation came at a price: it was extremely impractical, as it made the work fragile. Its open delicacy was a danger as the weave was not fixed: wefts could, as Glenn Adamson described, "slide up and down within the composition, or even slither out of the tapestry altogether. The unwoven warps could easily snap and fray." With her open-weave innovation, she was violating the decorative art tradition of weaving, at the same time that her eight-foot forms, which she hung from the ceiling like drying fishing skeins, were also not accepted as fine art. But her invention was spurred in part by wanting to find a way to push her work firmly out of utility and into art. She saw that it "caused quite a controversy. No one had done this kind of weaving... It's against the rules, and those people who go by the rules were against it." Yet she was delighted that she had found a way to approximate a spider's web, with a "picture hanging in ctr as in space," as she wrote at 5 a.m. in her journal in May 1957, when she was visiting New York: "add fine silver thread here & there/glint of rain/spark of early morning/explosion of crystals inner + outer/sharp cries of birds/cooing soft of doves."

In 1962, by then in New York for five years, Tawney experienced her second breakthrough moment, though one invisible to all but the most entrenched artists and critics of textile art. As Youngerman later noted, her artist neighbors didn't even realize what she was up to or how innovative she was, "doing art in what until then was considered a craft," but she was "maybe the most 'outlier' of all of us on Coenties Slip." Tawney invented a new kind of reed—an object that could help her more readily create the kind of open-weave forms she

had first discovered just before leaving Chicago, work at a grander scale, and leave behind a rectangular shape.

The year before, Tawney had taken the artist Lili Blumenau's Peruvian textile gauze-weaving workshop, held in her New York City apartment. (Blumenau had taught weaving at Black Mountain College, New York University, Columbia University's Teachers College, and the Fashion Institute of Technology, and she was the textiles editor of *Craft Horizons*—weaving was a small world.) Tawney took the class very seriously and tried to be a "perfect student" at the age of fifty-four; more than any other artist on the Slip, she sought out the most inclusive and therefore expansive geographical traditions of "American" art. She didn't let on what she was working on in her studio, but one day she invited Blumenau to the Slip. Her teacher was amazed.

As was Jack Lenor Larsen, the textile designer, collector, and curator, who came down to her studio to see her work for a *House Beautiful* article on "creators who will influence your life." (Elizabeth Gordon, editor of the magazine, owned several works by Tawney, including *Hanging Reflections, Spring,* and *Vitae,* and this was not Tawney's first feature in the magazine. Her studio appeared in a January 1960 spread too. Her work had better traction in craft and domestic periodicals than exclusive "art" titles like *ArtNews, Art in America*, and the just established *Artforum*, in which her Slipmates were gaining mentions.)

Peering very closely at the forms, he asked, "How do you do them?"

Tawney explained her invention, an object that disrupted the uniform spacing between the warp threads. The steel parts of her reed were open at the top with a removable wooden piece that went over it. To use it, Tawney explained, she had to "take the thing apart, open the reed and then put each thread over the top of the reed to space it out. Then I'd put the top on the reed and weave again until I wanted to change the spacing again." Her invention was not a time-saving one—in fact, "it was a lot of work, but nothing compared to what you got. It enabled me to make the kind of woven form I wanted." The

new shapes she was able to make, departing from a square base, she called "woven forms," and she described them as if they were always necessarily in motion, like lungs: "Expanding, contracting, aspiring forms—sometimes expanding at the edges while contracting in the center." Her patience was a kind of routine reverie, a way of meditating. "It's not patience," she insisted. "It's done with devotion. It's just working. My work is my pleasure, it's my life, it's what I live for."

Larsen and Tawney spoke about fame (she had no interest in it), competition in the arts (she had no interest in it), and her own flexibility of working (she was forthright about her wealth allowing her to work without the constraints of another job, or—unspoken—a partner). They talked about the nineteenth-century French poet Arthur Rimbaud's idea that life is about transforming the self into a maker of poetry or beauty, and that "this transformation is more important than anything done along the way." After their conversation, Larsen would write, "She looks forward to getting better, living better, doing better work. To her, life is an accumulation leading to feeling more, expressing more. The idea, she says, is to be awake. Most of us are asleep."

...

THE EAST RIVER ran outside Tawney's and Martin's studio windows, and other rivers ran through their art. So many of their works from this period are connected to water—oceans, waves, rain, rivers. Tawney ordered "a great deal of black and white linen thread. I only knew I wanted to weave forms that would go *up*." She described her best work as flowing out of her. *The Fountain of Word and Water* from 1963 could also be a title from Martin's oeuvre, and certainly from her writings. Martin would later write of "the current of the river of life." As if acknowledging her own debilitating lapses into stillness, she spoke about the need to be aware of life, beauty, and happiness— this was the current. "With great awareness we move rapidly. With

no awareness we do not move." Here, too, we see the influence on Martin and Tawney of St. Teresa of Avila's writing. Teresa found water to be the most apt way to explain "spiritual subjects," and she wrote, in sensual terms, of the marriage between God and the devoted, as "like rain falling from heaven into a river or a stream, becoming one and the same liquid, so that the river and the rain water cannot be divided; or it resembles a streamlet flowing into the ocean, which cannot afterwards be disunited from it." The "great noise" that sometimes interrupted her visions she felt contained "within it many vast rivers."

By 1962, encouraged by her reed contraption, Tawney had come full circle to her first art experiments in sculpture back in Chicago, and was thinking about weaving in volume, and her pieces as "sculptures" more than paintings in space.

Tawney was extremely focused during this time and didn't see many people. Larsen invited her to visit Africa with him, and though she was tempted to go—it was just the sort of spur-of-the-moment major trip she was known for—she turned the opportunity down. She had "all this work ready inside. If I left and went to Africa I didn't know whether I'd have it when I came back." It was a "thrilling" time, when she felt "the weaving just grows and keeps coming." She would sing and dance "with joy" by herself at night in the studio. She woke up early and worked all day. Her work "poured out like a fountain or a river. . . . The river was right out my window, and I looked at it every day."

She spoke to Martin on the phone, even though she could have just popped next door. But the two respected each other's workflow.

One day when she called, Martin told her, "I'm doing a river." Martin's painting, *The Dark River*, 1961, was one of the earliest of her elegant gridded paintings on a six-foot-square canvas, which she considered her arrival at true painting, once she had excised any additional geometric shapes like circles, triangles, or squares. The

natural muslin color of the canvas is interrupted by five descending columns of tan dashes; in between them, delicate darker brown lines run horizontally. Altogether, the blocks and lines form a hovering square. From a distance, though Martin would disavow such imagery, the pattern looks like a weaving or a tatami mat. Up close, one notices that the dashes are not quite regular, and the lines waver up and down in barely visible trembles, rendering them almost alive.

"Oh, I'm doing a river too!"

Tawney's *Dark River*, 1962, was made of black linen and wool in her new open-weave approach, and stretched almost fourteen feet high, with a wooden collar at the top that gathered the braided and tied ends of each line. She could see the work only a foot at a time, before it would roll under the loom. As she was making it, Tawney felt the work "kept going higher and higher. I thought, no one will ever show these, they're too tall for a gallery so I'll keep going." Even in the tall ceilings of her South Street studio, when she hung it up, *Dark River* dragged on the floor. Tawney described the piece taking form: "The changing ways, the current, the surface. I knew what it was going to be, and I think I knew it was the river. I had it inside, and I think that when it is there on the inside it seeps through to your mind. It is an inner landscape that I am doing." The work was exhibited in April in the Fine Arts Exhibition at the 1962 Seattle World's Fair, along with seven other pieces. In October, she had a one-person exhibition of fifteen works back in Chicago at the Art Institute, called *Woven Forms by Lenore Tawney*, and she worked relentlessly from January to June for the curator Paul Smith's 1963 show *Woven Forms* at the Museum of Contemporary Crafts in New York, an institution founded just seven years before. (It would later become the Museum of Arts and Design.)

Mildred Constantine, curator of textiles at MoMA, acquired *Dark River* from Tawney in 1963 following her first studio visit to the artist. (MoMA has never shown it because of its huge scale.) A few

years later, Constantine acquired a related work, *Little River*, 1968, that could fit in MoMA's twelve-foot-tall galleries. She and Larsen included it in *Wall Hangings* the following year, one of the major art institutional shows to exhibit textile work as art. In retrospect, Constantine and Larsen called her 1961 Staten Island show "the point at which Art Fabric was healthfully and joyously launched in America."

For Tawney, the preparation for these institutional shows was overwhelming. At one point she imagined placing her works in the water, "one by one and watching them float away." She felt that the river would "take them where they need to go."

...

JUST A FEW MONTHS before the opening of *Woven Forms* in New York, Tawney confessed that Martin was worrying her friends "enormously," and "I shall be glad to be away from her and her problems for awhile."

The truth was that Tawney herself suffered from serious depression during the very period, 1959–61, that she was developing her work in exciting new directions, and supporting Martin through her own breakdowns. Like Martin, Tawney wandered the city, stopping only in churches for a moment to sit and "try to feel some comfort." She went as far north as the Cloisters in Upper Manhattan. Sometimes her excursions took on a form of meditation, as when she sat "under the portico of a courtyard, watching the water as it met the ground, an unending, hypnotizing experience." Or she rode the Staten Island Ferry back and forth, "standing at the bough, watching the water be ploughed aside, watching drops rising and falling away." Gone is the ecstatic description of the work flowing through her: water here is a different kind of dark river, relentless and without end. One also wonders if Tawney was conjuring Martin's own ruminations on nature to

Installation of weavings by Lenore Tawney in the group exhibition
*Woven Forms*, Museum of Contemporary Crafts (now Museum of Arts
and Design), New York, 1963. Photograph by Ferdinand Boesch.
*(Courtesy Lenore G. Tawney Foundation.)*

different ends; Martin once said, "There's nobody living who couldn't
stand all afternoon in front of a waterfall."

And then it was March 1963, and Tawney was getting ready to at-
tend the opening of *Woven Forms*, the most public display of her work
thus far—and this time, in Midtown. Tawney wore a Dupioni silk dress,
"a square black Arab coat, and a big knot of black linen yarn in my hair."

Though the exhibition was not monographic, she was its undeni-
able star. Smith took the title of the show from her term, twenty-two
of the forty-three works in the show were by her, her pieces were the
first a visitor encountered, and in the catalogue's introduction, Smith

dwelled on Tawney's inventive contributions to the textile arts, what he somewhat drily called her "reevaluation of the weaving process," which led to form being determined not by the exacting logic of patterned movement but "by distortion of the set pattern of the warp and weft while the piece is still on the loom." Tawney's friend and former Slipmate, Ann Wilson, wrote the short text in the catalogue on her process, stating, "Many of these weavings suggest the flow of water: river, fountain, cataract."

Underscoring the hierarchical role of the arts and pigeonholing of weaving into "craft" versus arts, an April 1963 profile on Tawney in *The New York Times* proclaims that she is "more than just a weaver— she is also an artist," signaling that the amateur status that weaving connotes hardly covered the expertise of her work. "All of Miss Tawney's hangings on view at the museum now are for sale," the critic closed his short profile, with prices ranging from $150 to $2,000. While artists' works shown in museums often were available, it's rare that a review would mention the price; here, again, Tawney's work is relegated to a more commercial, craft status. In retrospect, *Woven Forms* has been called by the scholar and curator Glenn Adamson "arguably the most influential fiber art show of the twentieth century."

After the opening, Martin hosted a celebration for Tawney at Robert Indiana's loft, where everyone danced and drank scotch. "Next day," Tawney wrote, "nothing hurt but my head."

...

FOR ALL of her mystical language about inspiration and the source of art, Martin was pragmatic, and not above hustling. On April 24, 1961, she walked three small drawings made that year (*The Robe*, *Arrow*, and *Words*) up to MoMA, to the curator William Lieberman, to be considered for *Fifty Drawings: Recent Acquisitions*. Dorothy Miller had

championed the purchase of Chryssa's work, and Martin felt confident that she, too, should be a part of the collection. But Lieberman did not acquire or exhibit the drawings, which were priced at $300 each.

In 1963, Tawney anonymously donated Martin's large *White Flower* to the Guggenheim Museum, another institution that had celebrated Chryssa and in which Martin felt she should be represented. It was one of the few works from Martin's December 1959/January 1960 show at Parsons that she did not destroy, saved in part because Tawney bought it. That same year, Martin painted a shimmering incised gold leaf and red oil painting, perhaps inspired by Tawney's own incorporation of gold thread, carefully cut through into a grid, which she titled *Friendship*.

And that fall, Martin wrote Tawney a letter. What exactly it references is unclear—the Guggenheim donation? The support when she was institutionalized? Money for therapy? Buying more artwork? In any case, she chose to profess her gratitude in metaphors of water and measure it in forever:

> *Dear Lenore*
>
> *I am not going to be able to tell you anything really. You have made this day the turning point in my life. It means an enormous opportunity for me. Now I can take my time and really get to work. The whole scene is changed. There is no way to grasp the size of it. There is no way for me to get hold of it at all.*
>
> *I do not think you will be able to imagine even a small part of the enormous changes in my position.*
>
> *Any expression of gratitude is like the soundless sound. It is going to be like the waves over and over again.—Forever is not to* [sic] *long.*
>
> *I think it is the "real thing."*
>
> *Agnes*

# 16

## SIMPLE THINGS

1960–61

IN THE MIDDLE of his Coenties Slip studio, twenty-six-year-old James Rosenquist stands dressed for a brisk walk to the office in a suit and tie and overcoat, dark hat on his head covering his already thinning blond hair. His stiff posture, eyes closed at the instant the photo was taken, and a thin water pipe (or perhaps wire) running the length of the image and past his outstretched arm, make it appear as if he is carrying a walking cane. He looks uncannily like a figure plucked from a 1940s Magritte painting and inserted awkwardly into a diorama of a warehouse. A couple of canvases are propped against the back wall—fuzzy abstractions he'd been reworking for months without progress.

Rosenquist was heading to a job interview—never mind that it was most likely work painting billboards forty feet up in Times Square, for which he would not be wearing a suit, or that in a matter of months he will quit commercial sign painting altogether, get married, and begin to collect unemployment while trying to make it as an artist full-time.

Every day, Rosenquist traveled down from his cold-water tenement

on the Upper East Side to this narrow, windy tip of Manhattan Island. He wandered around the neighborhood, a strange mix of Revolutionary America and nascent modernist high-rise, working piers and Wall Street, tight cobbled streets and broad commercial plazas, dropping in on artists who lived and had studios nearby, or sitting listlessly in his studio with the windows open, waiting for something to float in with the river breeze and inspire him. He thought of his life as "nomadic" and filled with "simple things and simple pleasures," for instance "a marijuana joint, a peanut-butter sandwich." As he later explained, "I wanted to be an artist but I didn't have any idea what I wanted to do as an artist. At first, all I had was a strong feeling of what I *didn't* want to do." He stretched four canvases of six by eight feet and sat wondering what to put on them. Sometimes he sat the whole day watching people out the window. Some people might be stressed by this state of limbo, but Rosenquist just took it all in.

Nowhere in the city is its history more readily visible than downtown near the East River, its oldest corner. Rosenquist was waiting for inspiration to strike at exactly the place where so much of American history had first been centered. Fulton Fish Market proved an especially compelling diversion for 4 a.m. bouts of insomnia; one million pounds of fish were delivered to the booths of two thousand workers every morning at dawn. ("It's a lot like Wall Street," one fishmonger told a reporter, with a lot of "buying and selling.") As the *New Yorker* writer Joseph Mitchell described, it produced a "heady, blood-quickening, sensual smell."

In the late 1950s and early '60s, the neighborhood was a jumble of destruction and construction. "Buildings to the left, buildings to the right are razed to make way for future skyscrapers," Indiana observed. As a sign painter with a unique vantage point to study old buildings up close, Rosenquist had always been interested in them. Perhaps out of habit, he was often looking up as he walked around his

new neighborhood, and he saw buildings as a collection of shapes and lines that offered compositional inspiration too. A later work made at the Slip, *Above the Square*, from 1963, which combines two canvases, came from a building he saw set against the blue sky with a parking lot in front of it. He imagined a plumb line dropping from the sky down the side of the building.

He kept returning to images from the billboards he'd painted, and how magazine pictures from ads and articles appeared one after another as you flipped through the pages—what he called "media flak." Painting and seeing and hearing advertisements incessantly "felt like being beaten over the head with a hammer"; Rosenquist equated the noise with a kind of numbness. He wanted to use that power to make a new kind of painting with "a visual punch." "On Coenties Slip I stopped thinking of doing abstract paintings and began to think about how to paint things." He collected old *Life* magazines, cut out pictures, and started making collages that might be prototypes for larger paintings.

Rosenquist's time on the streets helped coalesce what he'd experienced working in the sky. "The brain itself is a collage machine. All day long you unknowingly take pictures in your mind of the things you see; in your sleep you try to sort these juxtapositions through dreams. And that's what I'm trying to do in my paintings." At the same time, he wanted the fragments in his paintings to be "corrosive." Despite the celebration of material stuff in postwar America, Rosenquist was interested in the splintering of these glossy images and products, the "bizarre" way in which advertising was selling an idea about America itself. "With collage there is a glint, a reflection of modern life. If, for example, you take a walk through midtown Manhattan, you might in quick succession see a street vendor, the back of a girl's legs, and then out of the corner of your eye catch a glimpse of a taxi."

...

"SOMETHING HAPPENED in painting around 1950," the art historian and critic Leo Steinberg contended in 1968, in one of the most famous modern art essays. That something, a new horizontal orientation to the picture plane itself, was associated most closely with Robert Rauschenberg and honed just around the corner from the Slip. Steinberg called Rauschenberg's approach the "flatbed picture plane," in which found objects, cardboard, and other materials were added to the composition along with pencil and paint. The new pictures "no more depend on a head-to-toe correspondence with human posture than a newspaper does." A newspaper is not an accidental reference: information from daily life and culture was part of the material hybridity of this new art, both literally and through references. Steinberg saw these works reflecting a modern ethos rather than a staid classical conception of painting, and also an aesthetic that now we can see pointing to a digital future of Photoshop and the Internet—spaces that piece and gather together very different things. Steinberg equates these new paintings' surfaces to studio floors, bulletin boards, and data entry points.

That a painting might reflect such receptive surfaces mirrors Rosenquist's own sense of the brain as a "collage machine." (His phrasing recalls practices of early American modernism: Stuart Davis called the split in some of his compositions a "mental collage.") Rosenquist began to devise other ways to think through a painting's new surface besides Rauschenberg's horizontal tilt and informational surfaces: "It occurred to me that another way of disrupting the picture plane might be to create images so large they would *overwhelm* the viewer. I was thinking, of course, of my billboard experience."

An overwhelming, visual punch: Rosenquist was getting to a new way of seeing, one inflected by his neighbor Newman's own huge ab-

stract fields, but on a less metaphysical plane. How could he use his perspective as a billboard painter, too near to an image to ever fully comprehend its whole? And what could this vision say about America? "I was always close up to a huge image and it had to be exact. I felt as though I was painting this whale, like a Moby Dick—that feeling." The Slip's maritime past was never far from the creative discoveries it actively fostered.

Rosenquist visited Kelly's studio upstairs, and admired his precision. Kelly taught him how to prime and stretch his own canvases, and Rosenquist began working on an eight-by-eight-foot grisaille composition. A laughing (or perhaps screaming) young woman, hand to her face, is overlaid by an almost abstract rendering of what appear to be water droplets and plant leaves, with enigmatic shadows and pools of light. (The object is actually a close-up of a tomato; Rosenquist loved to scale up the most ordinary image to the degree that it was nearly impossible to make out.) In fact, the work is a palimpsest of dozens of other buried images that have been painted over. "It was a process—something I was going through to get to my art," Rosenquist explained, calling *Zone* "the first painting."

*Zone* flirts with the various possibilities implied in its title: the erogenous, seductive element of skin and surface, the violent division and overpowering of space and portion, and, as the art historian Judith Goldman has pointed out, the ambiguous area between fine art and advertising in which Rosenquist was working. It is also an embodiment of Rosenquist's arrival as a painter with his own unique style—he had gotten into the zone.

*Zone*'s flat banality can be attributed to one of Rosenquist's most oft-repeated ideas: that of numbness. "I thought maybe I could make an aesthetic numbness out of these images, a numb painting where you don't really care about the images—they're only there to develop space." He connected this back to the aggressive approach of billboard painting, whose "sole purpose was to sell stuff, to sell product.

James Rosenquist working on *The Light That Won't Fail I* (1961) at his Coenties Slip studio, New York, 1961. Photograph by Paul Berg.

I didn't like that aggressive approach, but it was an ideal vehicle with which to produce an emptiness, a numbness on canvas." What, he wondered, inspired that numbness, after the brutality of an enlarged image? In another early work, *The Light That Won't Fail*, 1961, Rosenquist added a comb across the top of the picture. "You get up, comb your hair, put on your socks, have your first cigarette, catch the sun." But he saw these daily routines as keeping you in a kind of cell, with the comb's teeth turning into prison bars.

The detachment and excessive, discordant images that Rosenquist experienced in his walks around downtown and translated into paintings that melded different registers and overlapping colors anticipated a future digital world. We update our metaphors in

sync with our technology—Rosenquist's paintings *look* like manipu-
lated screens and Photoshopped images, when in fact they arose out
of physical collages cut and pasted together from old magazine and
newspaper photographs and layered in paint on conjoined canvases
over the course of many months.

...

ONE DAY, ROSENQUIST was sitting in Sloppy Louie's. He realized
that the dealer Ivan Karp was eating a sandwich nearby at the long,
communal table. Karp had just been appointed the first director of
the Leo Castelli Gallery. In the early 1950s, he had also started the
Anonymous Arts Recovery Society to rescue old cornices and stone
pieces from buildings that were being torn down around the city.

Rosenquist had not met Karp, but he sensed an opening. He went
up to Karp and abruptly asked, "Aren't you the man who saves the old
stones?" (The collector Robert C. Scull, who a year later would be the
first person to buy a painting from Rosenquist, described the artist
as someone who spoke in a "painfully abstract manner.") Rosenquist
proudly explained, "I have a couple of old stones, too."

"I'd love to see what you have," Karp said, and Rosenquist invited
him back to his Slip studio, where he showed Karp two "melancholy"
stone heads salvaged from a building. They lay among other foraged
treasures from the neighborhood. "The room was knee-deep with
things I found on the street," and he thought of "the whole studio . . .
[as] a blackboard, a bulletin board"—the eclectic mess producing
serendipitous relationships between different images and objects.
Paul Cummings described Rosenquist's studio as a blizzard in which
moving across the floor was like trudging through snow. Rosenquist
elided this mess in his painting *Coenties Slip Studio*, 1961, in which
one can see a reflection of his space—spare, almost empty—in the
large spoon in the foreground.

The paintings that he was working on were turned with their stretcher backs to the viewer, but Karp managed to get Rosenquist to flip them around so he could see them too. (It's hard to imagine that he had to do much convincing.) Staring back at Karp was "a giant depiction of Franco-American Spaghetti, and the front of a Ford car." (This would be *I Love You with My Ford*, finished in 1961, which melds the fender of a car painted in gray tones, the supine profile of a beautiful woman, also in black and white, and the colorful squiggles of canned spaghetti in three stacked registers.) What Karp saw astonished him. Though none knew about the other, Rosenquist's paintings seemed to have some exciting relation to work by two young artists the gallerist had visited just a few weeks before: Andy Warhol and Roy Lichtenstein.

...

GENE SWENSON, THE CRITIC who would be Rosenquist's most important champion in just a few years, once described the artist as preferring "stories to answers, especially in response to questions demanding a hard and fast moral. It is a matter of honesty." And it was not just in his paintings; Rosenquist was a great storyteller, and he framed his life that way.

Even building calamities, of which there were many at the Slip, didn't seem to faze Rosenquist, or disturb his mellow demeanor. During a huge blizzard in 1961 the water heater broke in the fourth-floor apartment of Jesse Wilkinson, who wasn't home, and water poured through the ceiling into Rosenquist's studio, and then through the second floor to the old Irish bar on the ground floor. "I remember sitting there with Ellsworth and having coffee in the middle of the night during the blizzard while this rainstorm was going through the building. It didn't damage much."

There were other surreal and magical moments on the Slip. Just after Christmas that year, Rolf Nelson invited Rosenquist to his apartment (he lived in Ann Wilson's former loft, just below Rosenquist's studio). Nelson opened the door for Rosenquist into a loft filled with the vision and scent of scores of Christmas trees that he'd collected from the curb when people had thrown them away after the holidays. "'Come along,' he said," Rosenquist later wrote of the experience, "and I went down the path between the trees and there was a little settee at the end with two gay guys sitting there having tea . . . it was like walking through a wood."

"Part of the reason the art scene of the 1960s was so cohesive is very simple: nobody had any money," Rosenquist explained. "There were parties all the time. Parties for openings, antiwar parties, parties for eclipses, parties for the hell of it." Living near him at Coenties Slip was a songwriter, Jay Taylor, who once threw a party Rosenquist attended with his fellow artist Frank Stella, an entire Bulgarian soccer team, and a beautiful blond, with Taylor playing Chopin and Gershwin on the piano.

Rosenquist started to throw a lot of parties himself at the Slip, including a memorable one at which girls danced between road flares set on the floor until soot stained their nostrils, and a bum climbed up the fire escape and helped himself to a drink at the bar. "Even when things didn't work out, I would always have a big party, saying, 'Hey man, it's really great to be able to live and paint and have a big party afterward.'"

# 17

## THE AMERICAN DREAM

### 1961–63

IN THE LATE FALL of 1960, Rosenquist began painting on the back of several thin Masonite panels that he'd recycled from his old job. They barely fit into his studio, almost scraping the tin ceiling, and in the end, the full composition stretched the length of a Chevy sedan. He was done with the abstract works that he realized he had made only in order to distance himself from his day job, but it was tricky to work in the larger-than-life realism of a billboard painter and be making something for art rather than advertising.

Onto the left panel, Rosenquist painted the smiling head of the politician John F. Kennedy, just elected, about to be sworn in as the first president born in the twentieth century and the youngest in history, offering the United States a "new frontier" stretching all the way to the moon. Kennedy's face, bigger than a door and with teeth the size of toasters, seems to be taped with paint strokes, like the glue brushed over a tissue paper collage, to an image of manicured hands breaking apart a layered slice of moist cake, and this attached to the side of a gleaming auto in the far-right panel. Rosenquist at first portrayed a flipped car on fire, but

then painted over this and added a standard, "flat, ugly Chevrolet." Its banal, reflective surface distilled an image of America coming out of a postwar period of unprecedented commercial growth, entering a new decade already showing the strain of so much optimism amid so much discordant reality. As he was working, Rosenquist placed the panel with Kennedy's face in the window of his Slip loft, near where his studio mate Charles Hinman usually worked at his easel, so that anyone looking up might see the incoming president smiling blankly out in the middle of a row of warehouse lofts, a vision no doubt disorienting for the quiet street's main travelers: vagrants and tipsy sailors returning late to Jeannette Park or the Seamen's Church Institute.

...

LIKE THE OTHER paintings Rosenquist was starting at the time, *President Elect* used the materials of the artist's old job, stitching together incongruous advertising images that all promised something. Kennedy's portrait was lifted from a black-and-white campaign poster photo (Rosenquist was struck by how the politician "already looked like an ad"); the devil's food cake mix and the car were both dredged from ads in the piles of *Life* magazines lying around his studio. Rosenquist painted the oversaturated, bruised-peach colors of Kennedy's skin based on his memory of seeing Kennedy down at the seaport on Broad Street "in a convertible whizzing by with a bright orange face." It wasn't a subtle picture—Rosenquist wasn't interested in that—but like the work of his Slipmate Indiana, it contained an enigmatic sum of contemporary culture in its forthright referents. What ties an incoming president to moist dessert to a car? The painting's passive voice—images pilfered, not imagined, and their incongruity allowing potential metaphors to pile up into everything and nothing—was disconcerting. Wrapped up in its attention to surface was a cool

**Robert Indiana, *Electi*, 1960–61, oil on canvas, 71½ x 44¾".**

*(Courtesy the Portland Museum of Art, Maine, Gift of the artist.
© 2023 Morgan Art Foundation Ltd./Artists Rights Society [ARS],
New York.)*

control, like the wax on an apple that makes it appear shinier, but also has to be rubbed off in order to taste the fruit.

He put the painting aside and began to work on another.

Around the corner, Rauschenberg made a transfer drawing with a news clipping of Jackie Kennedy's face, *Election*, that he would later send to the White House as a gift, and a few doors down on the Slip, Indiana began a work he also called *Election*. He was still working on it two months later in January, weeks before Kennedy's famous inaugural address, of "ask not what your country can do for you—ask what you can do for your country," calling his work "a commemoration of Kennedy's victory" in his journal. He stenciled *ELECTION* across the bottom, with vertical stripes of khaki and black running up to the top edge like wallpaper; between the stripes and stencils are colorful red and blue boxes with circles painted in black-and-white geometries, like sailing signs or spinning hourglasses. Aside from the word, the whole painting looks like an abstract shuffleboard. But those disks have a direct reference to the work's title. A central star of Election Night on ABC, NBC, and CBS in the newly minted age of television coverage was each network's unique supercomputer, which would crunch numbers in real time to predict a winner. (At the beginning of the night, CBS famously predicted Richard Nixon would win in a landslide; only NBC held out for Kennedy, and the winner wasn't actually announced until seven in the morning.) And while Election Night had been covered on TV since 1948, the neck-and-neck race in 1960 was by far the most watched ever, what one TV critic called "the most suspenseful evening anyone ever spent in front of a TV set." The turning "memory tape" disks of NBC's massive RCA 501 computer formed the backdrop of the newsroom set of Chet Huntley and David Brinkley's coverage throughout the long night. Their spinning rows bear a striking resemblance to the abstract circles of Indiana's painting; churning computations made visible, though what that visualization actually signified was ever more abstract.

Like Rosenquist, Indiana was always working on multiple paintings at once. At the same time that he was making *Election*, he began painting over a canvas of the same size, an abstract composition he had just finished. *Agadir* was named after an international crisis earlier that year, when, in February, an earthquake cracked open the Moroccan city of Agadir and fifteen thousand people died—an event that so shook Indiana that he'd cut out a newspaper article about it and glued it into his journal. Indiana didn't have the money to buy more canvases and was already editing his young output, returning to works that wore the influences of other artists on the Slip too openly, and painting over them or adding text to them—as if those terse words canceled out any other affinities.

*Agadir*'s circles and subtle palette were too close to Agnes Martin's, its shaped background too akin to Ellsworth Kelly's. The work had another level of reference for Indiana, another fault line, that he scrawled in his March 2–3, 1960, journal entry describing the original painting: "Possibly a commemoration of last year's event of [this] day: [the] madness of [the] two of us sharing a loft: a south street fiasco for sure, if it had gone through." Indiana may be referencing his breakup with Kelly. So here, again, is another clue to why he might choose another layer of distance via the addition of words. Indiana kept the dark "fault line" running like a jagged gash through the middle of the canvas, but reworked the rest of the field, transforming his hard-edge shapes into signs. Throughout January 1961, in the weeks leading up to Kennedy's inaugural address, Indiana wrote in his journal about how he was reworking *Agadir* through color, symbols, and references. It was part of his calculated, ambitious shift away from any international reference or abstract aspiration, to become "an American painter of signs."

In the end, what was left and what was added became a mysterious message: four circles now had stars at their center, on a mud-brown and black background. The circles were black, with crisp stenciled

numbers and letters in bright, flat colors: yellow, orange, blue, and green. The top left star is empty, the top right star says, *TAKE ALL*; *TILT*, reads the bottom left star, while the bottom right star is also blank but its circle perimeter spells out the work's title: *The American Dream*. These shapes could be gas signs or poker chips. The profusion of symbols, from shapes to letters to numbers, gives the work a loud if enigmatic quality: a shockingly simple code of references and commands.

Concurrently on the Slip, Rosenquist and Indiana had painted their own pronouncements of the state of national affairs, one like a billboard and one like a road sign, both imagining a winner taking it all, and also announcing their own ambitious arrival on the New York art scene.

...

THE AMERICAN DREAM I had its debut just weeks after it finished drying, in the spring of 1961, in a small show at the David Anderson Gallery (a space connected to Martha Jackson's gallery, and run by her son), along with work by the abstract artist Peter Forakis. Indiana was again indebted to his Slip neighbor Rolf Nelson, who organized the show and continued to give the young, unsigned artist public visibility.

The show had a brief, two-week run, and nothing sold. But Barr had heard about Indiana's painting, and called for *The American Dream* to be sent to MoMA for a viewing. He found it "spellbinding," immediately purchasing it through the Larry Aldrich fund for emerging artists. He couldn't put a finger on what he liked about it, but he couldn't shake its effect. *The American Dream I* went on view at MoMA that December, in a recent acquisitions exhibition, along with work by other Slip artists, including two paintings that had appeared in *Sixteen Americans*: Youngerman's *Big Black*, 1959, and Kelly's *Running White*, 1959.

Indiana's eager excitement spills out into the questionnaire that the museum asked all the artists of newly collected works to complete. He did not try to play it cool or be humble or discreet that he, a galleryless thirty-two-year-old artist who had yet to have a solo show in New York, was finally—already!—entering the collection of the Museum of Modern Art. His answers went on more than most, and with a literary verve bordering on cheekiness—how you might imagine Walt Whitman, one of the artist's heroes, would fill out a rote survey. Explaining the subject of *The American Dream I*, Indiana wrote that his model was the quintessentially American actress Mae West, whom he saw in a late television showing of her 1932 film debut, *Night After Night*, as he was painting this work. The numbers in the top left star (40, 37, 29, 66) refer to "all those dear and much traveled US Routes" and *TILT* to "all those millions of Pin Ball Machines and Juke Boxes in all those hundreds of thousands of grubby bars and roadside cafes, alternate spiritual homes of the American." Indiana didn't let any possible cultural referent go unmentioned, and the more ordinary and ubiquitous and working-class, the better. He's not foregrounding art history but the image culture lifted from everyday life—the television on late at night in a lonely studio, the road sign that appears out of nowhere in the beam of headlights on a deserted stretch of highway.

Perhaps most revealing is how Indiana chose to answer the question "What in your ancestry, nationality, or background do you consider relevant to an understanding of your art?" He wrote, "Only that I am American. Only that I am of my generation, too young for regional nationalism, surrealism, magic realism, and abstract expressionism and too old to return to the figure." Having thrown off some of modernism's, and MoMA's, most central movements, he turns to the centrality of place for his identity, and therefore for his work. "Only that for the last five years I have lived and worked on the Slip and the waterfront, where signs are much more profuse than trees

(farewell, Nature), and much more colorful than the people of the city (farewell, Humanity), and the scene much too busy for calm plastic relationships (farewell, Pure Intellect.)" It's as if the Slip itself represented a certain version of the American Dream, holding within its radius a hectic history of industry, landscape, and art that pivoted the narrative away from Europe and elitism. Indiana proposes "to be an American painter, not an internationalist speaking some glib visual Esperanto; possibly I intend to be Yankee. (Cuba, or no Cuba.)"

Indiana's survey response, like his adopted name, was another performance. But his fake-it-till-you-make-it posturing suddenly dissolved into the bright lights of opening night of the exhibition at MoMA. There he was, in the mix. He saw Kelly across the room chatting with two men, and approached him. Kelly introduced one of them, a French collector, to Indiana, but not the other figure, who was Barr himself. Indiana was annoyed that his more established Slipmate wouldn't make the introduction, but he reached out his hand himself, and Barr warmly shook it, mentioning how much he enjoyed Indiana's questionnaire comments ("thought them as much a 'masterpiece' as my painting.")

Indiana would later say that *The American Dream I* was a pivotal canvas that "changed the entire course of my life." At the time, he also couldn't know that its theme would stay with him in a series of paintings that stretched into his final decade—as he added his own autobiographical flourishes to the references and wreckage of where he lived.

...

JUST AS INDIANA had formed a close kinship with his herm sculptures, Rosenquist held his first paintings close. "I thought of them as my companions—this was my environment and I wanted to keep it that way to see what would evolve out of it." When Jasper Johns

dropped by to visit Rosenquist's studio, he asked, "Where did you learn to paint like that?"

A few other friends stopped by in the summer of 1961, including his Fulton Street neighbors Steve Durkee and his wife, Dakota. Viewing *Zone* and *President Elect*, among others, Dakota burst into laughter. "People are really going to be amused when you show them these paintings," she said, and promptly sent the gallerists Allan Stone and Ileana Sonnabend down to Coenties Slip. When the stocky Stone arrived, he just sat in a chair and read the newspaper for forty minutes, then, on his way out the door, said, "Maybe you could have a show with Bob Indiana in two years," implying that neither artist's work had quite ripened yet. (Indiana's frequent journal mentions of Rosenquist's gallery show status indicate that he was keeping tabs on his neighbor's success.) Sonnabend came alone and stayed four hours, poking around the studio and, in Rosenquist's memory, "giggling." She was advising her ex-husband, Leo Castelli, at the time, and soon Castelli came with Count Giuseppe Panza di Biumo to pay a visit; the count bought a handful of paintings on the spot—a gamble and a shot of confidence for Rosenquist. Castelli remained skeptical of the work, even after his assistant Ivan Karp's enthusiastic promotion of it, seeing its imagery as passé surrealism. Rosenquist didn't wholly disagree with this connection; he recalled that in these early paintings, he was experimenting with "all sorts of surrealistic things, yet the scale was too large for what I thought surrealism was."

Another influential early visitor was the critic Gene Swenson, who was already making a name for himself as an important interlocutor for what would come to be known as American Pop Art. Swenson was, in the critic Lucy Lippard's description from 1959, when they were both graduate students at the Institute of Fine Arts, "a nice-looking, tweed-jacketed, bespectacled boy from Kansas, very earnest." He had a bad stutter, a voracious, wandering mind that seemed

unencumbered by anyone else's opinions, and "exploding blue eyes," as Jill Johnston described them. On his first visit to the Slip, Swenson spent several hours, despite the cold. He remembers Rosenquist in a "paint spattered and more than comfortably tattered outfit," jumping up and down as he talked, perhaps less out of animation than to keep himself warm; Swenson was worried that the tall artist might hit the low ceiling, a worry exacerbated by the scale of the paintings he was looking at, so that "at any minute I expected either the roof slowly to begin rising or the walls to move in, storybook fashion." As Rosenquist remembered, "We talked about Kansas, flat land, airplanes, farming, the Midwest, and billboard painting." The artist offered the critic "a swig of rot gut rum." Swenson demurred, trying to keep warm instead by taking copious notes.

Swenson went back to his fifth-floor apartment on East Fourth Street "bewildered and quite upset." As he would later write, in admiration, of Rosenquist's paintings, "They temporarily defeated me, my training, and my esthetic philosophy." (Here, Swenson also seems to be deliberately channeling Clement Greenberg's response to Pollock.) Swenson called up Rosenquist to ask if he could come by the Slip again. He went a second and a third time to see the paintings, "collecting notes on their 'disturbing strength.'" He saw a "ruthless clarity" in Rosenquist's work around the "jarring, discordant images of everyday life." Swenson's response to art was "a gut reaction," as Lippard put it. "He was just hipper than most people, knew what he was seeing and feeling faster." For his part, Barr, when visiting Rosenquist's studio around the same time, didn't know where to stand to view the huge paintings—up close or farther back. He, too, had to return again the same week to take it all in, though he was less enamored in his bewilderment, seizing instead on a reference that he could easily understand. An avid birder, Barr identified the animal in Rosenquist's painting as, in the painter's memory, "Narragansett

Duck, wood duck or some damn thing," before leaving. Rosenquist's work wouldn't enter the collection of MoMA until 1967, and then as a gift.

One Sunday in early fall of 1961, Karp, of the shared stone relics obsession, returned to Rosenquist's studio with two influential visitors: quirky Dick Bellamy (who ran the newly opened Green Gallery on the top floor of 15 West Fifty-seventh Street, reached by a tiny elevator), and the Metropolitan Museum of Art curator Henry Geldzahler. They stood smoking cigars outside and shouting up to Rosenquist's windows, since none of the entrances had doorbells.

Karp was chattering away. Bellamy, in his typical fashion, was much quieter. As he once described his process of visiting artists: "When you go to an artist's studio, I think it is best to keep your mouth shut. One always wants to look good in the artist's eyes and to say something brief and astute, if one can. Generally, I would say nothing." Bellamy thought of himself less as a dealer (like Parsons, he had a terrible business sense, much to the chagrin of his silent partner, the collector Robert Scull) and more as "an observer who just happens to be in a position to give exhibitions to people." Or, as Rosenquist described him, Bellamy was a dealer who was also a poet and prophet: "Dick came from a different era, one when art was a kind of bohemian religion."

On this particular occasion, Bellamy was overcome with excitement. "Ah, I've finally found something I can show!" he exclaimed after entering Rosenquist's studio and looking at the work. These paintings seemed to tap into a specific frequency that Bellamy heard in several other young artists trying to bring real-world images directly into their compositions. Bellamy told Rosenquist that he needed to show soon. "You think you're the only artist in America doing nondrip paintings? . . . There's a guy in New Jersey—he's doing comic strips!," referring to Lichtenstein.

Rosenquist agreed to work with Bellamy; his first solo show of

twelve paintings opened at the Green Gallery on January 30, 1962. Rosenquist and his friend Ray Danarski put out some whiskey and sat down on the floor, waiting to see if anyone would show up. In fact, eleven works were sold before the show opened. And then the floodgates opened and everyone began showing up at his studio on the Slip. Bellamy brought Scull (who incidentally was color blind), who, with his wife, Ethel, would become the biggest collector of Pop Art; soon the collectors Burt and Emily Tremaine came by and bought work too. Tremaine showed up wearing heart-shaped glasses with blue-tinted lenses; Bellamy wondered how she could actually see any art through them. Funny connections between a collector's source of wealth and the images in Rosenquist's paintings sometimes arose: Bellamy also brought by the Mayers from Chicago, of the Sara Lee cake fortune, to see Rosenquist's painting *Blue Spark*. Rosenquist was sick at the time with pneumonia but didn't want to disappoint Bellamy (or lose out on a potential sale), so he left the door open and the painting hanging on the wall while he lay on the couch. Bellamy and the Mayers knocked on the door and opened it to see the painting, at the same moment that a giant wharf rat made his appearance in the studio. As Rosenquist remembered, "The Mayers see me on the couch, they see the rat, see the painting, and say, 'We'll take it!' Then they slam the door and leave."

That summer, Bellamy hosted a group show at his gallery that included Rosenquist, Andy Warhol (whom he reluctantly showed after the encouragement of Scull; this would be Warhol's first gallery show in the United States), Yayoi Kusama (he showed her *Accumulation No. 2*, a couch sprouting fabric phalluses), Robert Whitman, and Robert Morris.

In the pages of the very magazine that Rosenquist used as material for his work, *Life* proclaimed that June that "Something New Is Cooking" in the works of Wayne Thiebaud, George Segal,

Roy Lichtenstein, and "the gigantic fragments of billboard images" of Rosenquist. Swenson's important article, "The New American 'Sign Painters,'" came out in *ArtNews* in September 1962, investigating a group of men (Rosenquist, Indiana, "Andrew" Warhol, Roy Lichtenstein, Stephen Durkee, Richard Smith, James Dine) "who use the materials and approaches of popular and commercial art to make new 'cool' images." His 1963 follow-up article in two parts, "What Is Pop Art?" would use the more lasting moniker for this crew, but his very early summation of their shared affinities established two aspects so important to Rosenquist and Indiana in terms of what they saw out their window on the Slip: their interest in "the painters of commercial signs and designers of advertising copy"; and the fact that the strange, straightforward mash-ups of ordinary objects was less about how things were in the world, and more about what things meant to one another. For Swenson, the meaning behind the "commercial familiarity" of Rosenquist's everyday references when they are suddenly combined—a smiling politician, a piece of cake, a car, say—"Point[s] up the death of our senses which has made these three things equally indifferent and anonymous."

Swenson was the perfect critic for Rosenquist and Indiana; he was tired of everything being defined within formalist terms that didn't allow for the messy world to leak in, and regularly railed against the reductive authoritarian approach of Greenberg, who was famously grumpy about Pop. Over a series of reviews, articles, exhibitions, and diatribes, growing ever more impassioned as his own paranoia (about everything from the state of the country to his own position in the art world) caught up to his opinions and he had to be admitted to Bellevue Hospital more than once, Swenson also sought to understand why these artists used specific contemporary references in their imagery. It was not a celebration of culture; it was not merely a reflection of it either. Like Rosenquist, he attached the incessant repetition of

these items to the numbing of the senses, but he also argued that people had become so removed from their own experience of the world that they had to find their way back to understanding by literally objectifying that experience. Warhol's and Rosenquist's work mirrors that passive discovery, offering up objects and turning "feelings into things so we can deal with them."

In October 1962, *The New Realists* opened at the Sidney Janis Gallery on Fifty-seventh Street across from Parsons's gallery, providing yet another name tag for this group. Rosenquist, Indiana, Lichtenstein, Dine, Claes Oldenburg, Warhol, and others, were included, and Janis billed the show as a kind of turning point in art. If Abstract Expressionism defined the 1950s, this crew, he claimed, "may already have proved to be the pacemaker of the 60s." The postwar masters had been supplanted; Adolph Gottlieb, Philip Guston, Robert Motherwell, and Mark Rothko all withdrew from Janis Gallery in protest of these interlopers. The opening was "insane," in the description of the curator Walter Hopps, approaching a kind of manic hysteria. Entering the show meant acquiescing to work that literally called out for attention: Jean Tinguely had rigged a refrigerator that Duchamp had given him so that a loud siren and red lights went off whenever anyone opened the door. Willem de Kooning, who at the time was represented by Janis, went to the opening, but he could not bring himself to go inside: "Instead, he stared in from outside," as Mark Stevens and Annalyn Swan write in their biography of the artist, "then walked away unnoticed. He was ready to leave New York."

The same month as *The New Realists*, Indiana had his first solo show, at Eleanor Ward's Stable Gallery, which had started out in a converted horse stable before moving to the ground floor of Ward's Upper East Side town house. (Rauschenberg and Twombly had cleaned out the original basement stable in 1953 to have their first show there.) Ward had seen Indiana's work in the penthouse

exhibit at MoMA, and learning that the artist didn't have a gallery, quickly signed him. She exhibited Indiana's *American Dream* canvases, followed by Andy Warhol's first solo show there in November. That December, MoMA hosted a symposium interrogating a new style of art, evoking both Indiana's and Warhol's names to introduce the term *Pop*, which many on the panel and in the audience that evening saw as being in bad taste.

Critics could not agree on whether Pop was a celebration of commodity culture or a strong critique, a lazy reflection of society or a clever infiltration of its quotidian images, but they did acknowledge the work's efforts to present a new *idea* of America. As they came up together in the New York art scene, Indiana and Rosenquist held tight to the concept of an American art that meant something to where they had come from in the Midwest, and the country's history they saw around them at the Slip. The critic Thomas B. Hess found Rosenquist's "ambivalent parody of the billboard" caught "by the sentimental Whitmanesque Americanisms that haunt these artists," obliquely referring to Indiana as well, who would have seen a compliment in such a reference to his writing hero. Rosenquist would take offense at any accusation of sentimentality in his attention to American images, but like Indiana, when asked if he thought of himself as a Pop artist, he replied instead in terms of place: "I think of myself as an American artist, growing up in America, thinking about America."

When Swenson interviewed Indiana for his article "What Is Pop Art?" (which incidentally shared layout pages with a profile on Kelly), the artist insisted that even if Pop Art had technically started in Britain, its core theme was America. Even if Pop sweeps every continent, Indiana explained, "The pattern will not be far from the Coke, the car, the hamburger, the Jukebox. It is the American myth. For this is the best of all possible worlds."

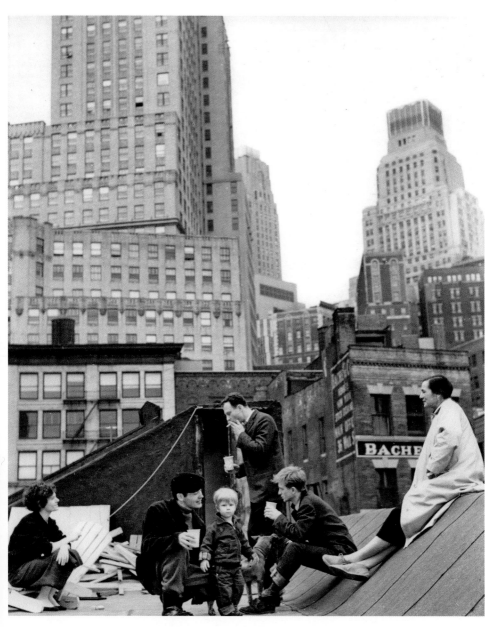

Delphine Seyrig, Robert Indiana, Duncan Youngerman, Ellsworth Kelly, Orange, Jack Youngerman, and Agnes Martin on the roof of 3-5 Coenties Slip, New York, 1958. Photograph by Hans Namuth.

*(Courtesy Center for Creative Photography, University of Arizona. © 1991 Hans Namuth Estate.)*

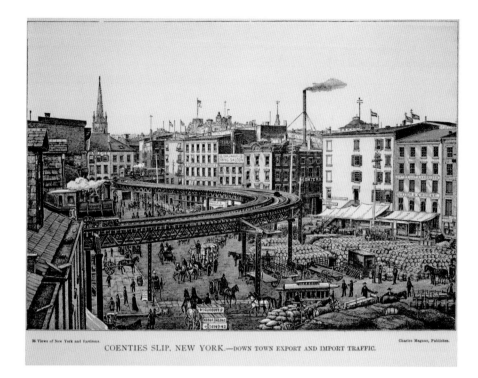

Hand-colored engraving of export and import traffic at Coenties Slip, New York (Charles Magnus & Company, 1850–1900).
*(Courtesy the Metropolitan Museum of Art, New York, The Edward W. C. Arnold Collection of New York Prints, Maps and Pictures, Bequest of Edward W. C. Arnold, 1954.)*

Borough of Manhattan, New York, map detail showing Coenties Slip and the elevated train S-turn, 1900.
*(Courtesy the New York Public Library Digital Collections, Lionel Pincus and Princess Firyal Map Division.)*

Stuart Davis, *House and Street*, 1931, oil on canvas, overall 26⅛ x 42⅛".
*(Courtesy Whitney Museum of American Art, New York/Licensed by SCALA/Art Resource, New York. © 2023 Estate of Stuart Davis/Licensed by VAGA at Artists Rights Society [ARS], New York.)*

Robert Indiana in the plant room at his Coenties Slip studio, New York, 1963. Photograph by William John Kennedy.
*(Courtesy KIWI Arts Group LLC. © William John Kennedy.)*

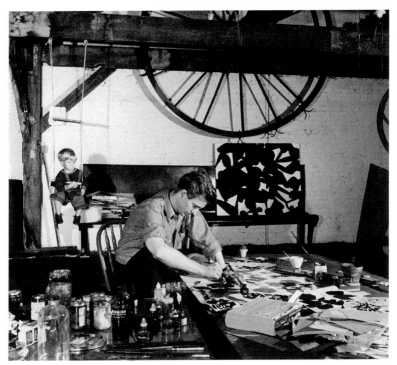

Jack Youngerman at work in his Coenties Slip studio with Duncan Youngerman, New York, 1957. Photograph by Tom Baab.
*(Courtesy Duncan Youngerman/Jack Youngerman Archive.)*

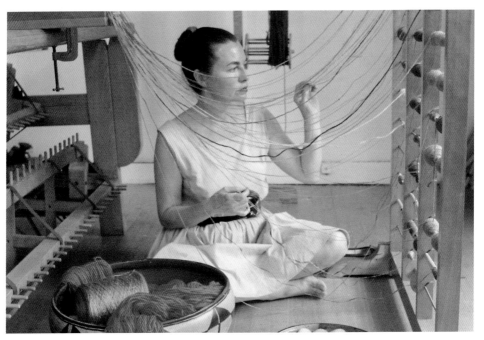

Lenore Tawney in her Coenties Slip studio, New York, 1958. Photograph by David Attie.
*(© David Attie.)*

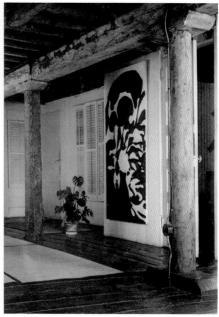

Exterior of 27 and 25 Coenties Slip, New York,
ca. 1958. Photograph by Jack Youngerman.
*(Courtesy Duncan Youngerman/Jack Youngerman
Archive.)*

Jack Youngerman and Delphine Seyrig's
loft at 27 Coenties Slip, New York,
ca. 1958.
*(Courtesy Duncan Youngerman/Jack
Youngerman Archive.)*

Jack Youngerman and Delphine Seyrig's loft at 27 Coenties Slip, New York, ca. 1958.
*(Courtesy Duncan Youngerman/Jack Youngerman Archive.)*

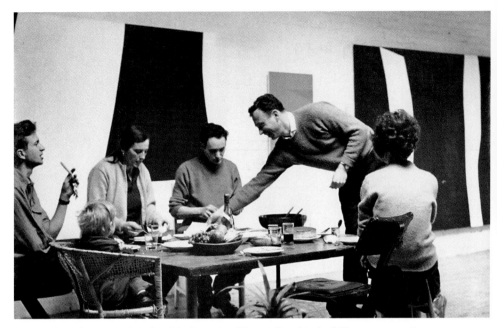

Ellsworth Kelly serving lunch in his Coenties Slip studio with Jack Youngerman, Agnes Martin, Robert Indiana, Delphine Seyrig, and Duncan Youngerman, New York, 1958. Photograph by Hans Namuth.

*(Courtesy Ellsworth Kelly Studio. © 1991 Hans Namuth Estate.)*

Agnes Martin, Robert Indiana, and Ellsworth Kelly, New York, 1958. Photograph by Hans Namuth.

*(Courtesy Center for Creative Photography, University of Arizona. © 1991 Hans Namuth Estate.)*

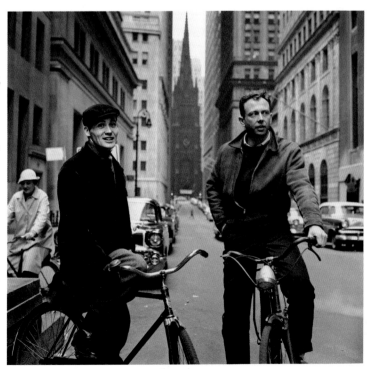

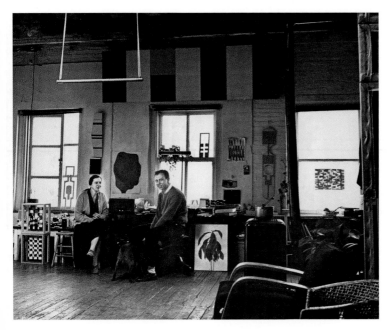

Agnes Martin and Ellsworth Kelly in his Coenties Slip studio, New York, 1958. Photograph by Hans Namuth.
*(Courtesy Center for Creative Photography, University of Arizona. © 1991 Hans Namuth Estate.)*

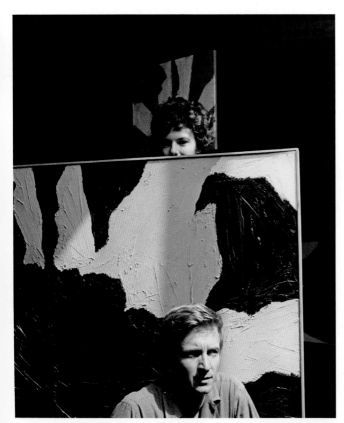

Delphine Seyrig and Jack Youngerman at 27 Coenties Slip, New York, 1958. Photograph by Hans Namuth.
*(Courtesy Center for Creative Photography, University of Arizona. © 1991 Hans Namuth Estate.)*

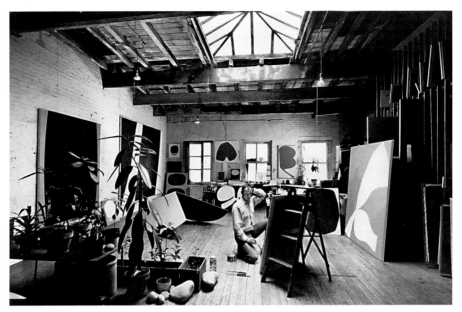

Ellsworth Kelly at his Coenties Slip Studio, New York, 1961. Photograph by Fritz Goro.
*(Courtesy Ellsworth Kelly Studio.)*

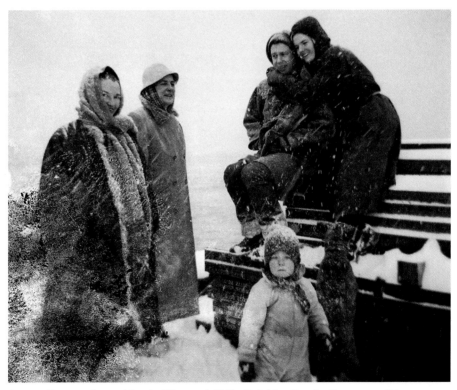

Lenore Tawney, Agnes Martin, Ellsworth Kelly, Delphine Seyrig, Orange, and Duncan Youngerman on the pier at Coenties Slip, New York, February 1958. Photograph by Jack Youngerman.
*(Courtesy Duncan Youngerman/Jack Youngerman Archive.)*

Agnes Martin, *Harbor Number 1*, 1957, oil on canvas, 49¾ x 40".

*(Courtesy the Museum of Modern Art/Licensed by SCALA/Art Resource, NY. © Agnes Martin Foundation, New York/Artists Rights Society [ARS], New York.)*

Lenore Tawney, *Vitae*, 1959–60, linen, wool, silk, 89¾ x 32".

*(Courtesy Lenore G. Tawney Foundation, New York/Cooper Hewitt, Smithsonian Design Museum/Art Resource, New York.)*

Ellsworth Kelly, *Coenties Slip*, 1957, postcard collage, 3½ x 5½".
*(Private collection. © Ellsworth Kelly Foundation.)*

Ellsworth Kelly, *Orange Blue*, 1957, oil on linen, 16 x 12".
*(Private Collection. © Ellsworth Kelly Foundation.)*

Jack Youngerman, *Coenties Slip*, 1959, oil on linen, overall 81⅛ x 68".
*(Courtesy Whitney Museum of American Art, New York/Licensed by SCALA/Art Resource, NY. © 2023 Estate of Jack Youngerman/Licensed by VAGA at Artists Rights Society [ARS], New York.)*

Ellsworth Kelly, *Avocado*, 1959, ink on paper, 14 x 17".
*(© Ellsworth Kelly Foundation.)*

Jack Youngerman, *Ram*, 1959, oil on canvas, 90¾ x 64⅛".
*(Courtesy the Museum of Modern Art/Licensed by SCALA/Art Resource, NY. © 2023 Estate of Jack Youngerman/Licensed by VAGA at Artists Rights Society [ARS], New York.)*

Ellsworth Kelly, *East River*, 1959, oil on linen, 47 x 100".
*(Courtesy the Art Institute of Chicago, Gift of Mr. and Mrs. Albert L. Arenberg/Art Resource, New York. © Ellsworth Kelly Foundation.)*

Ann Wilson, *3-5 Coenties Slip, No. 1*, 1959–63, found quilt, acrylic, and pigment on canvas, 65½ x 61¼".
*(Courtesy Museum of Arts and Design, New York, Gift of Tamar Turin Opler, 1993.)*

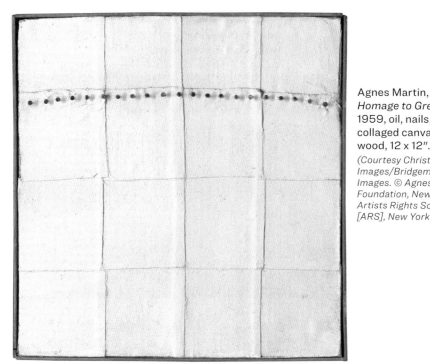

Agnes Martin, *Homage to Greece*, 1959, oil, nails, and collaged canvas on wood, 12 x 12".
*(Courtesy Christie's Images/Bridgeman Images. © Agnes Martin Foundation, New York/ Artists Rights Society [ARS], New York.)*

Fred Mitchell, *Jeannette (Towards Coenties)*, 1960, oil on canvas, 78 x 168".
*(Courtesy Philip Douglas Fine Art.)*

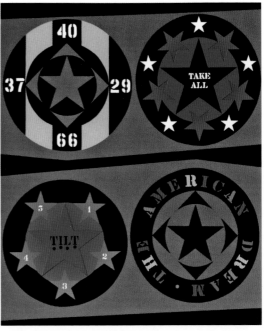

Robert Indiana's journal page dated Wednesday/Thursday, March 2–3, 1960. (Drawing refers to the first state of the painting *The American Dream I*, 1961.)
*(Courtesy RI Catalogue Raisonné LLC. © 2023 Star of Hope Foundation, Vinalhaven, Maine/Artists Rights Society [ARS], New York.)*

Robert Indiana, *The American Dream, I*, 1961, oil on canvas, 72 x 60⅛".

*(Courtesy the Museum of Modern Art/Licensed by SCALA/Art Resource, New York. © 2023 Morgan Art Foundation Ltd./Artists Rights Society [ARS], New York.)*

James Rosenquist, *Coenties Slip Studio*, 1961, oil on canvas and shaped hardboard, 34 x 43".

Jack Youngerman, *Delfina*, 1961, oil on canvas, 106 x 80".

James Rosenquist, *President Elect*, 1960–61/64, oil on Masonite, 89¾ x 144".

Lenore Tawney with *Dark River* (1962) and *The Torch of Night and Day* (1962) in her South Street studio, New York, 1962. Photograph by Ferdinand Boesch.
*(Courtesy Lenore G. Tawney Foundation.)*

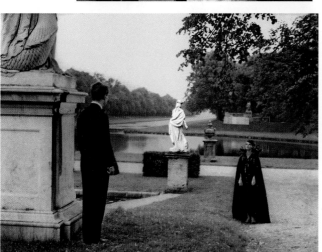

Giorgio Albertazzi and Delphine Seyrig in a production still from Alain Resnais's *L'Année dernière à Marienbad* (Last Year at Marienbad), 1961. Photograph by Georges Pierre.
*(Courtesy Collection L Pierre de Geyer. © Georges Pierre.)*

Ellsworth Kelly, *Tablet #65 [Five Sketches]*, 1960s, newspaper on paper, 15½ x 21″.
*(Courtesy The Menil Collection, Anonymous gift in honor of James A. Elkins, Jr. © Ellsworth Kelly Foundation.)*

Agnes Martin, *Friendship*, 1963, gold leaf and oil on canvas, 75 x 75″.
*(Courtesy the Museum of Modern Art/Licensed by SCALA/Art Resource, NY. © Agnes Martin Foundation, New York/Artists Rights Society [ARS], New York.)*

Robert Indiana, *Leaves*, 1965, oil on canvas, 60 x 50″.
*(Courtesy the McNay Art Museum, San Antonio, Texas. © 2023 Morgan Art Foundation Ltd./ Artists Rights Society [ARS], New York.)*

...

INDIANA COULDN'T REMEMBER exactly where he first heard the phrase "the American dream," probably from his parents or from films he saw. But it was "brought into focus" for him on seeing Edward Albee's one-act play of the same name on Broadway when it was first produced in January 1961 at the York Theatre. The dark plot, of a couple who have murdered their first child and are encouraged to adopt another from the Midwest, named American Dream, does not paint a rosy picture of the country. Albee's satire, as the playwright explained, was "a picture of our time," and "a stand against the fiction that everything in this slipping land of ours is peachy-keen."

Indiana, like Albee, shared an obsession with the nuclear family's role in America. Both were adopted, and both infused their art with autobiographical references to their difficult childhoods and complicated families; Indiana claimed that two life-size portraits of his parents were a part of his American Dream series. The American dream directly connected to the extreme emphasis on the successful nuclear family in the period of the 1950s and early '60s as part of a political tactic to promote domestic stability and stifle communism. Later he described *The American Dream I* as "cynical" and "caustic," coming out of his childhood in the Depression, in which the "dream" had been "perverted into a very cheap, tawdry experience . . . life was so mean." One of the more shattering transitions into adulthood is realizing the limitations of your own parents' hopes and dreams. Indiana could not shake the futility of his thrice-married father's ambitions. He worked for Phillips 66 gas stations and left his family to travel to California on Route 66, full of his dreams for "the big house on the hill," which never materialized. (Rosenquist had painted those same Phillips 66 signs back in the early '50s in his first round as a sign painter in Minnesota.) For his own take on the American

dream, Indiana included signs of transience, passing through, gambling and luck: highways, pinball machines in roadside bars, and one of the eternal through lines in his work, jilted love. In his journals, he called *The American Dream I* "my Mexacala Rose," referring to a pop song in which someone bids their love farewell.

The "American dream" marshaled by Indiana in his painting's title and the series that grew from it encompasses a history of the shifting and often conflicting interests of the country over the last century, or as the artist put it, "it seems to be a kind of obsessive thing in this country because everybody is always talking about it . . . it's a cliché which seems to affect everybody." To seek a definition of the American dream is to seek what the country stands for; to go back to the hopes of the Founding Fathers. But it really was a modern invention that saw its greatest purchase in the twentieth century. The phrase was used to argue for isolationism, in Woodrow Wilson's neutrality stance during World War I, but also for immigrant hope, as a description of the "archetypal" experience that gave everyone a chance in their new country. It was tied to both racist policies and racial justice, the idea of class equality associated with socialist values and the personal wealth associated with capitalism.

It wasn't until the 1950s that the phrase took on the economic bent we now strongly associate with it, as postwar prosperity fueled a shift in American policy toward "enterprise" and away from social democracy. This tilt of meaning can be traced through presidential policy: President Truman pointedly gave a speech in 1947 that revised President Franklin D. Roosevelt's famous four freedoms, delivered in his 1941 speech arguing for America's involvement in World War II. Roosevelt's freedom of speech, freedom of religion, freedom from want, and freedom from fear morphed into Truman's freedom of speech, freedom of religion, and freedom of enterprise. This is when the American dream began to symbolize tangible things rather than Puritan-rooted values that were in fact wary of materialism:

the nuclear, white family in their suburban tract home with a car and a blender; or the rags-to-riches upward mobility route to acquiring those things. It's also when Abstract Expressionism began to be deployed around the world in traveling exhibitions as a calling card for the individual freedom and prosperity of democratic capitalism as compared with communist socialism.

The idea of the American dream had particular traction in the first half of the 1960s, with so much riding on the aspirations of Kennedy's presidency. The ascendance of the middle class was accompanied by affordable technology. A prescient publication from 1962 by the historian Daniel Boorstin linked the artificial construction of American prosperity in its very title: *The Image, or What Happened to the American Dream*. Describing what he called "pseudo-events" in culture, Boorstin examined the proliferation of images in the country—the threat of "illusions" replacing the ideals that had earlier been the stuff of American dreams. Boorstin finds it ironic that a place so known for its ethical values has a "reputation for being materialist . . . our prosperity and our technological success have doomed us to present ourselves to the world in images."

All of this was not lost on a new generation of artists who sought to distance themselves from the mythic ethos of democratic capitalism that abstract art had become embroiled in. Art that directly referred to popular culture, to the automation and ease of technology in that space, and that even incorporated its exact images in the work, was one way to nakedly show the American dream not as a universal, political ideal but as a transactional reality or even dystopia, hovering in the very medium (images) that was art's domain.

Rosenquist knew he was a "product of the big, booming 1950s," when the media presented a bombardment of stuff. "The idea being promoted was that everybody should be peppy and happy and could have everything they wanted: two and a half cars, three and a half children, and instant everything." Rosenquist wrote that in the early

1960s, "people clung to the idea of their own personal utopia, which had been fused in the American imagination onto commercial products. Every ad in every magazine and TV commercial was telling you that you could buy happiness on the installment plan." His unusual sculpture *Doorstop* from 1963 taps into the darker aspects of this dream. A painted floor plan of a middle-class three-bedroom tract house appropriated from a magazine has seven lightbulbs suspended from it, and the whole thing is hung from the ceiling in a disorienting effect of being upside down. Rosenquist was by then living at 3–5 Coenties with Mary Lou, far from the model suburban home.

For Indiana, freedom was part of the context of his *American Dream* painting, however illusory or elusive. As a gay man living in an illegal loft, freedom was no small thing. Even in the privacy of one's domestic home, it was illegal to engage in homosexual activities— and Indiana didn't even have a sanctioned home. Raids were regular at gay bars across the city and Brooklyn. The "jukebox" America he painted in *The American Dream I* could be as much about the dream of openly going out and dancing in a bar in New York as it is about a kind of Midwestern status quo. He infused his paintings' references with campy cultural icons such as Mae West. But the broadest freedom illustrated in his work was that of the road, perhaps the ultimate American symbol of conflicted dreams: manifest destiny and forced Dust Bowl exodus, the open road of Beat restlessness and the familial need for the road to have a destination, rooted in a community, leading home.

Both Rosenquist and Indiana began to take up civil rights in some of their work of this period, but they rarely discussed the broader disconnect around race and freedom. And yet this was one of the more profound crises of the American dream. As Sarah Churchwell argues in her book *Behold America*, Martin Luther King, Jr., "powerfully revived" the initial understanding of what the American dream might be with his famous speech at the March on Washington for Jobs and

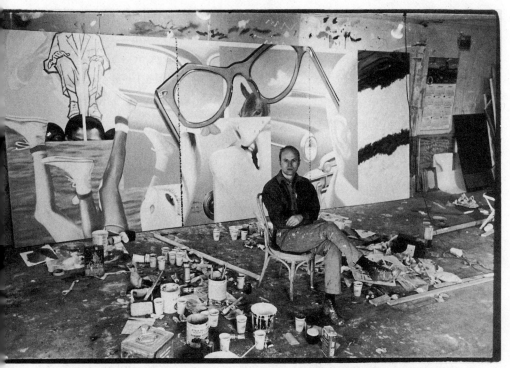

James Rosenquist in front of his in-progress *Painting for the American Negro* (1962–63), 3–5 Coenties Slip, New York, June 30, 1963.

Freedom in August 1963, returning it to a question of civil rights for the millions of Black Americans who were still dispossessed. "I still have a dream. It is a dream deeply rooted in the American dream. I have a dream that one day this nation will rise up and live out the true meaning of its creed: 'We hold these truths to be self-evident, that all men are created equal.'"

The summer before, Rosenquist had begun a huge painting, spurred by his own attempt to grapple with the feelings around race in America simmering just below the surface—tensions that had everything to do with a reductive view of seeing *only* surface, only skin tone. His *Painting for the American Negro* includes, among many

other disconnected images, the outline of a man in a suit sitting as if waiting to have his shoes shined while his feet rest or press down on the foreheads of several African American figures, next to upside-down Converse-sneakered athletic legs of basketball players. Absorbing cultural fragments of racial unrest and societal blindness then sweeping the country, Rosenquist saw *Painting for the American Negro* as "one of my more overt social commentaries." His work, he claimed, was about "the middle-class Black who is educated and successful but is still being discriminated against." The novelist and art collector James Michener stopped by the Slip and admiringly told Rosenquist, "That's what I've been trying to write about in my books, the plight of the middle-class American Negro." (Michener had also collected several Indiana works.)

Rosenquist's juxtaposition of consumer ads with images of Black figures getting stomped on seems a little easy—what good, to take up his title, does this work do *for* Black citizens? The painting signals its condition without signifying the deeper national issues—in a way, illustrating the experience of the civil rights movement for many well-meaning white people across the country. Despite campaigning on a civil rights platform, Kennedy dragged his feet on any major reform. As late as January 1962, the president was contemplating signing an executive order against racial discrimination in federal housing even as he was cautioning that he didn't want to get too far ahead of public opinion. The National Association for the Advancement of Colored People (NAACP) felt the need to launch a specific drive in the summer of 1962 to urge the president to speak out against racism. Sit-ins and marches and protests happened just a few blocks north of the Slip at City Hall, and the crisis built in Manhattan through the next years across topics as far ranging as garbage collection policies and school segregation, but civil rights was not something that directly affected artists at the Slip.

More than anything, *Painting for the American Negro* showed

Rosenquist's ambition to address national concerns, underscored by the fact that he visited Picasso's great political mural *Guernica*, then on view at the Museum of Modern Art, while he was painting it. Rosenquist's work made an impression on the young artist Ed Ruscha, who had his own American dream moment that summer on seeing Rosenquist working on this painting in his studio. Ruscha hitchhiked with his friend and fellow artist Joe Goode from Los Angeles to New York, and met up with Andy Warhol at his studio in an old firehouse uptown on East Eighty-seventh Street. Warhol suggested that they all go downtown to visit Rosenquist, whose work Warhol admired, and so the three artists set out for Coenties Slip. Ruscha remembered Rosenquist working on "a painting that had basketball players in it." Ruscha was also struck by the mess of the studio, which "was sort of perfect for what he was doing, with visuals all over the walls and floor." As a fellow Midwesterner, Ruscha felt a special affinity to Rosenquist during that short visit. "The fact that somebody came from North Dakota, or Minnesota, that somebody from those simple places went to a big city like that and started to interpret the fast, modern world—it took my breath away. I was inspired by him for that reason."

...

ON PALM SUNDAY, 1963, the experimental filmmaker and photographer Hollis Frampton stopped by the Slip. He'd made a series of photographs of artists, and was there to meet and shoot some portraits of Rosenquist for a fashion magazine layout that never ran. In contrast to Rosenquist's own account of the electric early '60s in New York, Frampton describes a serene, domestic scene, "cool, neat, and pleasant."

Upstairs in Rosenquist's studio, Frampton took ninety-six black-and-white shots in two hours. In the last photo of the session, the

painter sits in a folding chair in the foreground, looking idly off to the right, holding open a copy of a magazine with a map of the United States illustrating the distribution of songbirds. Behind him we see the studio he purposefully kept messy as a kind of mind map of his working process, with mismatched wooden chairs, buckets of paint, coffee mugs, naked stretchers, rolls of paper, and other clutter. Hanging on wooden poles and propped against the back wall are several works in progress, including *Above the Square*. Frampton and Rosenquist would become close friends; Frampton later wrote, "I cannot recall one moment spent in his company that I didn't completely enjoy."

...

INDIANA'S *AMERICAN DREAM I* was back on view at MoMA a few years later, in the summer show *Americans 1963*, which also counted Rosenquist and Chryssa among its fifteen artists. Curated by Dorothy Miller, the exhibition was the latest and last in the series of six that included *Sixteen Americans* in 1959. At this point, every Slip artist but Agnes Martin and Lenore Tawney had had a significant showing at MoMA.

Rosenquist had seven works in *Americans 1963*, all made at the Slip. Indiana was one of the first artists tapped, and his solo gallery included eight works: two assemblages and six paintings. Of those six, half were from his new American Dream series.

Just as he had done with *The American Dream I*'s first outing at MoMA in 1961, Indiana closely linked the Slip to his own identity as an artist and the work he was making. For the catalogue, he chose a portrait photo in which he's standing on the roof at Coenties Slip with the harbor stretching out behind and beneath him. He sees it all.

No critic noted Indiana's focus on place. In his expected pan in

*The New York Times,* John Canaday mentioned only that this show seemed to confirm the ascendancy of Pop and the retirement of Abstract Expressionism, as if categories were so neat and tidy, and movement only happened within movements.

The American dream had all kinds of detours. That summer the fashion designer John Kloss moved out of the Slip. Though he and Indiana had broken up, Indiana would remain a major influence on his clothes through the 1960s. A spread in *Time* in 1966 shows two models in Kloss lingerie and a dress posing in front of Indiana's *Number 5* painting; their outfits mirror the painting's bands of color and neat geometries. Kloss continued to find success throughout the 1970s, though never with the same press coverage as during his first days in New York living at the Slip. (In 1987, plagued by tax issues associated with his business, he died by suicide at the age of forty-nine.)

Just as Kloss was leaving the Slip, Indiana met the young British painter Gerald Laing, who was in town from London for two months to soak up the American art scene. During his brief stint in New York he managed to meet four artists with whom, according to a friend, his work had affinity: Lichtenstein, Rosenquist, Warhol, and Indiana. Indiana was the most open, and invited Laing to be his assistant during his stay. Laing was shocked by the incessant droning of helicopters taking off and landing from the heliport just outside Indiana's studio, and by the summer's heat and humidity; it was "so uncomfortable and strange that it seemed as if I was living in a dream." He would duck into the marbled lobbies of banks downtown to cool off in their air-conditioning. But he was also amazed by the bright, open studios of New York, the vivid colors that artists like Indiana employed straight to the canvas, and the bold assurance in what they were all doing. Laing's two main jobs were to help Indiana build canvases around deep wooden stretchers (Indiana did not use frames, and was fanatical about the precise folding and smooth surface of his canvas),

and to help chisel down the ends of old beams that Indiana used for his herm sculptures so that they would stand upright. He remembers sweat running into his eyes as he worked. At 5 p.m. each day, Laing turned to his own paintings in a little area at the back of the loft.

Here he developed his own style of Pop, mixing appropriated images of beautiful celebrities from magazines and pixelated dots with references to astronauts, racing cars, skydivers—a kind of techno-futurist, star-spangled American dream. The first work he made in Indiana's studio was *Ursula of Coenties Slip*, incorporating a painting of a publicity still from the Bond film *Dr. No*. At the end of the summer, Laing couldn't afford to send the paintings that he had made back to London, so he left them with Indiana. Later, the dealer Richard Feigen would see Laing's paintings at Indiana's loft and telegram the artist in London to say he would like to show them in New York at his newly formed gallery, helping launch the stateside career of one of the central artists in Britain's Pop movement. Directly following Laing's show at Feigen in 1964, Charles Hinman had a solo show; he had continued to refine his painting after leaving his shared studio with Rosenquist on Coenties Slip, and was building elaborate three-dimensional abstract paintings that were compared to sailboat design.

...

MARY LOU DIDN'T want to start a family in the bare-bones setup at 3–5 Coenties. In early November 1963, Rosenquist moved out of the Slip and into a larger studio on Broome Street with cast-iron columns; he could now afford to rent a full floor of an old Cuban hat factory for $250. He hauled the huge, bowing Masonite panels of *President Elect* with him.

A few weeks later, Kennedy was assassinated while driving in a

campaign motorcade in Dallas, Texas. Swenson remembered weeping "comfortless tears." At the time, he was working on the transcripts of his interview with Rosenquist for *ArtNews*, and he called the artist. "We talked of little but the tragedy of Dallas."

In his new studio, Rosenquist pulled out the 1960–61 painting that he had ostensibly finished at the Slip. We now know, thanks to the meticulous detective work of the art historian Michael Lobel, that Rosenquist significantly reworked *President Elect* after the assassination. The main area of his focus was Kennedy's face, which he repainted, perhaps remembering again the day down at the Slip in October 1960 when he saw the presidential candidate drive by in a convertible, a strange cinematic overlap with his later death scene.

Indiana's own artistic reference to Kennedy's election from that same season also underwent major changes after it was "finished." In a freak accident in his crowded studio, one of the artist's heavy wood beam sculptures, *Zig*, fell on *Election* in the spring of 1961, badly ripping the canvas. At the time, Indiana salvaged the work by cutting off the destroyed quarter of the canvas at the right so that the text now read *ELECTI* across the bottom, as if a Latin reference to the elected. This, too, took on new significance in late autumn 1963, its missing quadrant a kind of premonition of the fourth year in office that Kennedy would never have, including some of the whirring disks of the computer that could not have predicted such tragedy. The journal pages that Indiana had copiously filled in the years prior with movies he'd watched and friends he'd had dinner with dried up in the last quarter of 1963, perhaps because he had grown so busy with shows and no longer needed to plot the story of his life—it was in forward motion. But for a brief moment, Indiana turned back to his journal in stunned disbelief, the white ledger page filling up again in November with no fewer than four references to the president's death.

So much happened for Indiana and Rosenquist during those three

short years of Kennedy's presidency. In an interview a few weeks before the assassination, Indiana was asked what it felt like to be suddenly famous. (He demurred from answering; besides, his studio was leaking badly as he fielded questions during a thunderstorm.) If not fully reflective about all the aimless days he wandered around downtown a little stoned, trying to decide what and how to paint, Rosenquist chose to frame his whirlwind ascendance as a kind of rupture in a place where anything can happen. As he put it, "New York is full of sudden transformations."

Both artists were waking to a new dream.

# 18

## POP WILL EAT ITSELF

1964

IN THE LATE WINTER of 1964, Andy Warhol told Indiana he wanted him to star in his next film, *Eat*.

President Kennedy had been dead for almost three months. Warhol was bothered by how Kennedy's assassination had transformed into an inescapable newsreel—not just the Zapruder home movie that, despite efforts to contain the footage, seemed to loop in the national subconscious, but also a news cycle that kept "programming everybody to feel so sad." Warhol started working on hundreds of silk screens from news photographs of the first lady looking up with a smile as she arrived in Dallas, and then with bent head, veiled in grief as a mourning widow. He wouldn't make his own filmic response to the shooting, the improvisational *Since*, until 1966, unless you count the day of Kennedy's funeral, when Warhol filmed the critic Jill Johnston in the New Jersey woods with a rifle. Instead, in the years 1964–66, he threw himself into shooting and screening films that avoided any sentiment or affect at all.

Warhol scheduled Indiana to meet him for the *Eat* shoot at Serendipity, a campy café on East Fifty-eighth where Warhol loved to

drink cappuccinos and people-watch in the prismatic glow of the colorful Tiffany table lamps. He had just moved into a new studio—dubbed "The Factory"—ten blocks south, at the very unfashionable and unbohemian Midtown address of 231 East Forty-seventh Street, and his assistant and (briefly) lover Billy Name, whom he had met at Serendipity when Name cooked in the kitchen, was busy covering every corner of it in silver foil. Soon, the Factory would be the setting for the hundreds of short screen-test films Warhol made in 1964 alone.

But for whatever reason, perhaps Indiana's preference to "act" in his own space, Warhol ended up heading downtown to Coenties Slip that Sunday, February 2, 1964, to shoot the movie there instead. It was raw and cold; a little above freezing with the wind whipping off the water.

•••

INDIANA AND WARHOL had met a few years back, in 1959, at the bar in the Broadway Central Hotel. They shared the same glamorous dealer, Eleanor Ward of the Stable Gallery, where they'd had back-to-back debut shows in late 1962. And they both "performed" the role of the artist, though to different ends. Indiana's interview panache was overshadowed by Warhol's embrace of the part with an added dash of camp costuming: stage makeup, silver wig, and sunglasses indoors. Name once said, by way of a compliment, that Warhol was "purely synthetic" like "a can of spray paint." Indiana didn't want to hitch his star too closely to Warhol's and wasn't a Factory mainstay. Warhol would occasionally stop by the Slip with friends. In the spring of 1961, he paid Indiana a visit with the composer John Ardoin and Norman Fisher, best known as a drug dealer for artists, shilling some of the best cocaine; Indiana gave them an *I Ching* reading and served din-

ner on the worktable where he was making paintings that spelled out *EAT* across solid color field backgrounds.

Warhol had more in common with another Slip artist, Rosenquist. After eleven successful years as a commercial illustrator in New York, drawing advertisements and window displays for shoes and perfume, Warhol crashed the art world party. With his crossover ambitions to enter the "real" art world, and urged on by Indiana, Warhol had begun altering the prop paintings he was making for clients such as the Bonwit Teller department store, adding drips and visible brushstrokes over his hand-painted depictions of goods. When Ivan Karp made a visit to Warhol's studio that fall, he asked about those drips, which Warhol explained was his way of paying homage to Jackson Pollock "and all the great dripsters." To Warhol's relief, Karp encouraged him to stop dripping and just deal with the simple images themselves.

For all Warhol's self-consciousness about his past career, many artists were forced to do commercial work to make ends meet. Rauschenberg, Johns, and Rosenquist also worked for Bonwit Teller doing window design for the store. Nor did it seem lost on Warhol that his crossover to fine art came with his adoption of a commercial printing process: silk-screening. Or that the silk screen, in its use of photography, was endangering hand-drawn advertising work of the sort he had been doing. Like Rosenquist, with his insistence on billboard-scaled paintings, Warhol did not hide where he had come from, choosing for his subjects domestic brands and symbols of the commercial world: Coke bottles, dollar bills, Brillo boxes, and Campbell's soup cans. Warhol moved quickly through series, cultural images, painting styles. Just as he was gaining renown (and, as always with Warhol, notoriety) for his assembly-line-produced silk-screened paintings, he declared painting dead and turned his main attention to film.

When he approached Indiana about starring in a film, Warhol was

still figuring out the medium. The summer before, he'd been lent a 16mm 1929 handheld Bolex camera and began to experiment. Film was a natural extension of his interest in watching people with one layer of remove; he was, as he put it, "shooting movies just for the fun and beauty of getting down what was happening with the people we knew." Indiana is present in some of Warhol's earliest footage, the silent four-minute *Bob Indiana Etc.*, where Warhol captured the artist on the croquet lawn at Ward's Connecticut house, along with the painter Wynn Chamberlain, the poet John Giorno (Warhol's lover at the time), and the sculptor Marisol.

Very early on, Warhol imagined how film might pick up some of the aspects of his silk-screened paintings—mechanical processes creating never-quite-the-same repetition—but then push these characteristics to an extreme. And to this he could now add duration. In the next few years, Warhol shot hundreds of films (more than six hundred, in fact). Some of them last just a few minutes; some—including his first major work, *Sleep* (1963), in which a stationary camera appears to show Giorno sleeping for five hours in his uptown apartment, and *Empire* (1964), in which a stationary camera captures the Empire State Building for eight hours—are very long.

When Warhol arrived to film at the Slip in February '64, it had been less than a month since he publicly debuted *Sleep* at the Gramercy Arts Theater, in a screening attended by fewer than ten people, including Warhol, Rosenquist, and the young curator Henry Geldzahler. Two people walked out.

...

INDIANA HADN'T BEEN given much stage direction for the *Eat* film, but as a devotee of movies, he had some ideas of his own. The night before, he went uptown to catch the acclaimed *Tom Jones*, playing at Cin-

ema 1 on Third Avenue and Sixtieth Street. So that he might perform a version of the movie's famously improvised bacchanal dinner scene, in which the two main characters lustily and provocatively devour lobster, a roast chicken, oysters, and pears, ripping apart shells and meat with their hands, juice running down their faces, licking their fingers and lips in suggestive silence, he starved himself before the shoot.

But from the large selection of fruits and vegetables Indiana had bought for sixteen dollars and had on hand as props, Warhol chose a single mushroom for the artist to eat. (Had he seen Craig Claiborne's *New York Times Magazine* food column from that day, celebrating the common mushroom?) He set his camera up on a stationary tripod and shot nine rolls of black-and-white, silent film of Indiana slowly eating the mushroom as he sat in his carved wooden rocking chair by the window, wearing a hat and his signature wool cardigan and button-down shirt, his favorite cat, Parcheesi, sometimes climbing over his shoulder, and one of his flourishing rubber plants just visible behind him. Any movement in the scene comes from the cat, Indiana rocking toward and away from the camera in the chair, and the perception of a thick, bright light coming in the window and momentarily blotting out the defining edges of the room. For thirty-nine minutes, that is the sum of what happens on screen.

Warhol's camera kept falling apart during the shoot, and he kept having to pause to fix it with paper clips. "God, why are we wasting our time?" Indiana thought. He didn't find it "very professional." They also "cheated," according to Indiana, in that he ended up nibbling on more than one mushroom to complete the film, though the impression that it's a single mushroom is central to the premise. After the shoot, the two walked across the street to the Seamen's Church Institute, where, among the sailors, Warhol treated Indiana to a cafeteria feast.

Robert Indiana in a film strip from Andy Warhol's *Eat*, 1964, 16mm, black-and-white, silent, 39 minutes at 16 frames per second.

*(Courtesy The Andy Warhol Museum. © The Andy Warhol Museum, Pittsburgh, PA, a museum of Carnegie Institute. All rights reserved.)*

...

WHY, OF ALL the fruits and vegetables for the taking at Coenties Slip, did Warhol choose the lowly fungus? At this particular moment in the United States, the mushroom was a loaded object. It signaled the cloud of atomic threat still hovering over the world; it was a staple in middle-class cuisine with fancier aspirations; and it was a symbol for mind-altering drugs that were enjoying some unexpected cross-overs into mainstream culture. Humans had been using organic hallucinogens to create images since the first known cave paint-ings. But mid-century America was the zenith of magic mushrooms' popularity in the West, spurred on by a 1957 article in *Life* investi-gating their use in shaman rituals. (This was also the first time the phrase *magic mushrooms* appeared in print.) For awakening his own creative muses, Warhol preferred amphetamines. He was on speed at the time of his first films; Giorno thinks this adrenaline helped fuel his creative productivity. And while Warhol probably didn't know this, one of Indiana's earliest childhood memories, teased out in sessions the following year with his friend, the psychologist and art collector Arthur C. Carr at Columbia University, was finding a mushroom "like a Gothic church spire," and running to show his mother, who "was very pleased, and she picked the mushroom, took it and cooked it for my lunch."

Within the art world, the artist most readily linked to mush-rooms at the time was Cage, who deeply fascinated Warhol. He had a devout following from his music scores, lectures, and teaching that mixed a Zen minimalism with the spontaneous art performances of the day, but he also had a reputation as an expert mycologist, hav-ing won top prize on an Italian game show for identifying twenty-four species, and with a side hustle supplying restaurants in New York with mushrooms. Sometimes his two vocations would merge: he taught an art class with a lot of Fluxus artists at the New School

in the summer of 1959 in which they foraged for mushrooms and learned how to identify them.

Just a few weeks before the *Eat* shoot, a Cage student, Allan Kaprow, had staged his elaborate Happening, also called *Eat*, at the old Ebling Brewery caves in the Bronx. For an hour, visitors could wander among various installations involving people or structures offering food and drink (a boiled potato if you climbed a ladder, an apple hanging from a strip, sliced bananas fried in brown sugar). If the theme was in the air, it was all about how you interpreted consumption in America. For many of the Fluxus artists, like Kaprow, art meant embracing everyday activities, as in Alison Knowles's *Proposition (Make a Salad)* score in 1962, and the aesthetic democracy of repeating simple instructions and following simple demands.

The larger political theater presented broader implications for the connection of eating to the American dream. Standing in a model American kitchen at the American National Exhibition in Moscow in 1959, Vice President Richard Nixon launched into the now famous "Kitchen Debate" with First Secretary Nikita Sergeyevich Khrushchev of the Soviet Union. Khrushchev was unimpressed by the American suburban kitchen and all its gadgets, which he likened to the machine in Charlie Chaplin's 1936 film *Modern Times* that forces food into people's mouths. But if Khrushchev's vision of capitalism was excess, Nixon's vision of communism was scarcity. The impromptu Kitchen Debate also put a spotlight on the nuclear American family by recentering women into the kitchen after flashes of independence, when they took on jobs previously held by men who were away fighting during World War II. All of that, and the new abundance of food meant to make that life in the kitchen more efficient: cake mixes and canned spaghetti and instant soup, the stuff of advertisements and billboards and, increasingly, artists' compositions.

...

THE FILM *EAT* is a homage to Indiana, even as, in typical Warhol fashion, it pays its respect via appropriation, borrowing its title and subject from some of Indiana's best-known paintings. Indiana began painting his signature *EAT* canvases in 1962. For Indiana, *EAT* as a word had the same significance as the ten commandments, the "fundamental of human existence." Some were standalone works, some were pendants for his EAT/DIE series, and some formed part of his Eateria series. He stenciled the word onto his standing columns and other sculpture, too, enjoying its terse command, as with other early monosyllabic words he added to otherwise abstract fields: *DIE*, *HUG*, *ERR*, and later, *LOVE*. But in making *Eat*, Warhol was also publicizing himself. In 1962, he had gained considerable notoriety for his *Campbell's Soup Cans*, thirty-two canvases depicting all the available flavors of that brand's soup (among them, mushroom!), a work that he said was inspired by eating the same lunch for twenty years.

Rosenquist, similarly, was becoming associated with boxed cake and canned spaghetti, the motifs brought into his huge paintings from magazine advertisements. He claimed he liked the imagery of spaghetti because of the colors, "alizarin crimson and yellow," and the fact that it wasn't a subject with deep meaning like a crucifix, or something to get nostalgic over. But it was also a frequent meal at dinner parties with artists—everyone would pay fifty cents and someone would make a huge pot of spaghetti. Blown up to the scale of Rosenquist's canvases, the spaghetti slyly took on a kind of commercial redress to the thicket of lines in many Abstract Expressionist canvases too. "No drips or splashes for me," Rosenquist explained, "just clear, crisp areas."

For Indiana, *EAT* related to America in much more emotional ways. His reference plumbed deep memories going back to his own

childhood during the Depression, and the nostalgia of the iconic EAT road signs familiar to the itinerant traveler along Midwestern highways. The word symbolized the hunger of Indiana's own family hardships. He repeated his personal connections to *EAT* often in interviews. *EAT* signals "all the roadside diners (no DINE signs) that were originally old converted railway cars, taken off their wheels and mounted on blocks amid zinnias and petunias when the motor bus displaced the railroad in the '30s." To support the family after his father left them, his mother worked in a similar café "offering 'home-cooked' meals for 25 cents," and Indiana saw his *EAT* paintings as the "window signs of these establishments." The EAT signs were "a prominent part of my life . . . It's autobiographical, this is my whole childhood."

Indiana also linked the prevalence of *EAT* in his art of the early 1960s with his own misgivings around the American dream. "It is pretty hard to swallow the whole thing about the American Dream," Indiana commented the same year he was making the film *Eat*, and perhaps also explaining why he thought a feast rather than a single mushroom might have been more apt. "It started from the day the Pilgrims landed, the dream, the idea that Americans have more to eat than anyone else. But I remember going to bed without enough to eat."

...

EAT IS CONNECTED to excess, but also related to hunger. If you don't eat, you die, a simplistic equation that Indiana painted as one of his central paired canvas works. "Everybody eats, and everybody enjoys life, and everybody consumes, and very few people ever think about what all this is really leading to. And after all that is where we are all going, and I find it provocative perhaps to think about it once in a while, and that's why the *DIE* is on the other side." Indiana

claimed that his mother's deathbed wish in 1949 was for him to "eat"; later, his father dropped dead while eating breakfast. The roadside sign EAT itself was already a signal of obsolescence—of the diners, the railroad, and Indiana's intact family unit.

Warhol also tapped into the darker side of American consumption. In 1962, he began his "Death and Disaster" silk screens, taken from newspaper headlines, including his Car Crash series. One of Warhol's paintings took this pairing of eating and dying quite literally: his 1963 *Tunafish Disaster* silk-screens a newspaper clipping about two women who died from eating a contaminated can of tuna fish. And for his film *Eat*, Warhol doesn't choose any old food for Indiana to consume: his friend blithely nibbles away on an item that implies potent danger. As the mushroom expert Cage once said, "The more you know them, the less sure you feel about identifying them."

Always framing and editing his narrative at the very moment he was living it, Indiana was also thinking about the historical half-life of art. Part of the shift from Abstract Expressionist thinking to Pop was to divorce the project of painting from a mythic and timeless activity and instead marry it to one that eagerly and even urgently referenced the current cultural moment. "Art is really alive only for its own time," Indiana once argued. "That eternally vital proposition is the bookman's delusion." Or, as one critic in 1964 wrote, "If one revealing characteristic were to be applied to the subject matter of 'pop art,' it might well be—not necessarily banality as some writers have suggested—but transience."

In 1972, Indiana would embark on an ambitious series, Decade: Autoportrait Paintings, in which he looked back on the 1960s, a time he had already anointed as the most important decade for his art. Each year is represented by a single painting. The painting for 1964 includes the words *Coenties* and *Eat*. This underscores the importance of his collaboration with Warhol, and its connection back to his studio on the Slip. It also is one of the ways that Indiana knew

to measure true success: as an artist, he was finally able to support himself—to eat—during this crucial period living at the Slip.

At the same time that they were filming *Eat,* Warhol and Indiana were also completing their commissioned projects for the 1964–65 World's Fair in Flushing, Queens, which would open two months later in April. For Indiana, this would be the broadest stage yet for his art, and he chose, for his international debut, an artwork made up of letters spelling out *EAT.* Warhol knew about Indiana's World's Fair sign in production, and we can see his film as a subtle hat tip to Indiana's work, at the same time that it subtly cannibalizes it.

···

THE 1964 WORLD'S FAIR was the brainchild of Robert Moses, who had been working to plan the event as president of the World's Fair Corporation since May 1960. He tapped Philip Johnson, the architect and onetime MoMA curator, to design the New York State Pavilion; part of this complex included the round Theaterama building. Back in December 1962, the same month that President Kennedy came to New York to attend the official groundbreaking ceremony for the fair's construction, Johnson commissioned ten artists to make work for its curving exterior walls. Slip artists—including Indiana, Kelly, and Rosenquist—made up almost a third of the young, white, mostly gay male artists chosen to represent the current art scene in New York.

Each was given a few thousand dollars to develop art no bigger than twenty by twenty feet to be attached to the building's curved exterior like barnacles or—perhaps more aptly—like billboards. (One artist commented that the works would be like a "charm bracelet" around the building.) Abstract Expressionism was no longer anywhere in sight—less than a decade after it had played such a key role in Cold War cultural outreach. Everything at the fair was about spectacle

and automation, even the High Renaissance: Michaelangelo's famous *Pieta* was flown in and on view at the Vatican's pavilion, where a conveyor belt whisked viewers past the sculpture, which stood behind bulletproof plastic, flanked by velvet drapery and flickering electric lights.

Indiana, perhaps sensing the futility of plopping art up high on a building's exterior in the center of a hectic fairground, began working on a twenty-foot electric sign of five standalone letters, spelling E-A-T in two diagonals with the *A* in the shared middle spot. He had the piece fabricated by a commercial sign company on Broadway; each round letter was six feet across and weighed 300 pounds. (Later, it would cost the Stable Gallery $250 to have it removed and transported back to his studio.) He imagined the work lighting up and turning off and on, "flashing its imperative with real energy." This would be a way to visually activate the command found in his earlier paintings.

Indiana's sculpture hung between Ellsworth Kelly's abstract *Two Curves: Blue Red*, shapes cut from sheets of aluminum and painted, installed to mirror each other and the rounded exterior of the building itself, and another neighbor, Robert Rauschenberg's massive *Skyway* painting. The World's Fair commission offered Kelly the opportunity to realize something that he had been talking about since his days in France. He had written to Cage from Paris, "To hell with pictures—they should be the wall—even better—on the outside wall—of large buildings." Here was his wish come true—it was not so much about reaching a broader public but taking art away from its designation as "easel paintings for collectors, a luxury item." Rosenquist's twenty-by-twenty-foot oil-on-Masonite *World's Fair* mural incorporated some of his signature advertising images: cars, a reflective spoon, the legs of a woman, along with peanuts, the moon, a blossom coming out of an Uncle Sam hat.

Indiana anticipated that the artists chosen might get "those damned Abstract Expressionists" out of the news and the new

generation of artists into the spotlight. This was a shift not just in the art world's attention but also in perception around which artists might be found culturally acceptable. The Ab Ex crew was famously macho, loud, aggressive, emphatically heterosexual (even as Mary Gabriel's recent book *Ninth Street Women* has happily complicated that field). As a gay man, Indiana was hoping to change that paradigm—and he consistently championed prewar queer artists like Marsden Hartley and Charles Demuth to further emphasize an alternative American lineage. But he also realized that mainstream controversy—such as the initial reactions to many of those Ab Ex canvases—was not a bad thing. In a September 1963 interview about the upcoming fair, he imagined that "there'll probably be more reproductions of this, and more coverage in the press, than on anything that I might have done otherwise." And fairgoers will "practically riot against it." The opening dinner for the art pavilion was not without its own scandal; it launched with a screening of Robert Whitman's experimental film in which, in the description of Rosenquist, "in front of a roomful of fancy people, a huge behind appeared on the screen, and out came a giant turd."

...

THE RIOT THAT Indiana welcomed lasted but a day, and wasn't a reaction to the art so much as a confusion over whether it *was* art. The sign was lit for the fair's rainy opening on April 22, 1964, in which fewer than 50,000 people came through the turnstiles from an expected projection of a quarter million strong. On that first day, Indiana's evocation of diner signs from his childhood proved too successful: crowds mistook the artwork for a literal sign of where to get food. It was turned off for the rest of its two-summer run. As Indiana put it, "Too many people had reacted, that first day, to the imperative." Indiana interpreted his own sign's suppression in gendered

terms. If it was not activated, he felt that his work became "emasculated and tame."

Indiana's slight was overshadowed by the biggest scandal around the pavilion's art, which no doubt annoyed him. Warhol's *Thirteen Most Wanted Men*, in which he blew up and then silk-screened mug shots from a police bulletin of the most wanted criminals, was censored by Governor Nelson Rockefeller before the fair even opened, for fear of retaliation from the Italian-American community, the demographic background of the vast majority of the criminals in the mug shots. Warhol's backup plan of doing silk-screen portraits of Robert Moses was also rejected, and so rather than supply a new artwork so late in the game, Warhol simply asked for the silk screens to be painted over in silver aluminum paint, delivering thirteen monochromes with hints of what had appeared underneath. The art historian Richard Meyer has pointed out that Warhol's work was about erotic desire and looking—wanting "wanted" men, and the provocation of bad boys—and that this censorship also had undertones of the repression of homosexuality still dominant in the culture.

In the months leading up to the opening of the World's Fair, police launched major raids on gay activities and spots around New York City, ostensibly to "clean up" the city for the suburban tourists and families who would be coming from around the country. (This followed a major crackdown in the winter of 1959, when the police shut down all the city's known gay bars, urged on by the writing of a *New York Mirror* columnist, Lee Mortimer.) As the sites of both experimental and pornographic gay films and cruising, movie theaters were central targets. Prominent queer artists took note. The poet Frank O'Hara wrote to his onetime lover, the artist Larry Rivers, in March 1964: "In preparation for the World's Fair, New York has been undergoing a horrible cleanup (I wonder what they think people are *really* coming to NYC for, anyway?) All the queer bars except one are already closed, four movies have been closed (small ones) for showing

unlicensed films like Jack Smith's *Flaming Creatures*." He went on, "The fair itself, or its preparations, are too ridiculous and boring to go into, except for the amusing fact that Moses flies over it in a helicopter every day to inspect progress." This "cleanup" coincided with a lengthy front-page article in *The New York Times* in December 1963 that ran to another full page inside, warning: "Growth of Overt Homosexuality in City Provokes Wide Concern." The article estimated that New York had the largest population of gay men in the world, with lesbianism also on the rise, and that this was the city's "most sensitive open secret." Homosexual behavior was defined as a crime or misdemeanor, but it's still hard to imagine that as late as 1963, the newspaper of record characterizes homosexuality as a deviant illness that can be cured, quoting the institutions that shaped middle-class order and values: psychiatrists, priests, and policemen. The article's suspicions of crime-syndicate-run gay bars also connects to the suppression of Warhol's *Thirteen Most Wanted Men* at the fair a few months later. And it's another reminder of how Indiana's identity could be denied and publicly degraded as deviant in the very city where he was living, some five years before riots at the Stonewall Inn would begin to shift policy and public opinion away from classifying homosexuality as a crime. And that a neighborhood like the Slip, on the outskirts of that city and so off the radar as to not even be mentioned in this article as a center for artistic and therefore assumed homosexual activity, could offer him a certain freedom to live as he pleased.

Warhol's film work was where he most openly flaunted gay culture. *Eat* flirts with provocation even as it's a very straightforward and even silly film. Indiana had already participated in Warhol's film *Kiss* (1963), in which many of the artist's acquaintances kiss each other in succession. (Indiana has a snog with Marisol.) The sensuality of *Eat* is more subtle, as much in the way it's made as in what's going on. First we see one gay artist turning his camera and attention on an-

other, and in the intimate space of his own home. Warhol spliced the film's three-minute rolls together nonsequentially (the Bolex could accommodate 100-foot spools of film at a time) so that the mushroom keeps reconfiguring itself in Indiana's hands. And he shot the film at 24 frames per second, the regular sound speed, but projected it at the silent speed of 16 frames per second, so that Indiana appears to move in slight slow motion, accentuating the banal, casual erotics of nibbling the mushroom head. "It's amazing how many strange sensations one can have while eating one mushroom," Indiana later said. The dinner scene in *Tom Jones* ends in urgent consummation. Here, Indiana does not even get the satisfaction of finishing his mushroom. "Make it last" was Warhol's one direction.

For Warhol, the concept of a single "actor" on-screen "doing the same thing: eating or sleeping or smoking" was a way of reducing any movie to the main reason why people might watch it, "to see only the star, to eat him up, so here at last is a chance to look only at the star for as long as you like, no matter what he does and to eat him up all you want to." *Eat* takes on a double meaning—Indiana may be eating the mushroom, but we are eating him. Of course, the ultimate form of visual consumption is pornography. And in fact, Warhol's 1966 follow-up to *Blow Job*, *Blow Job II*, in which the critic Gregory Battcock talks on the phone and eats an apple while (or so the title suggests) receiving oral sex, was also known by the title *Eating Too Fast*.

*Eat* was Warhol's first head-on portrait film—a format that would become famously associated with his "screen tests" featuring personalities who stopped by the Factory and agreed to sit for the camera for three unblinking minutes. One of the earliest compilations of these portrait tests from that same year is his *Thirteen Most Beautiful Boys*, another riff on the silk screens Warhol made for his "most wanted" mural mug shots. Warhol's film *Eat* was thus also linked to his own planned World's Fair artwork as much as it was linked to Indiana's.

...

IN MARCH 1965, a year after making their film together, Indiana and Warhol were profiled in *Vogue* in an article titled "A Second Fame: Good Food." Though a flip piece of public relations, it subtly illustrates how their approach to food exposes not only the differences in Indiana's and Warhol's philosophies of art, but also their sexual identity.

The French food journalist Ninette Lyon finds Indiana's Coenties Slip studio after some trouble. (She gives the wrong coordinates in the piece, citing the Hudson River, not the East River, which may have delighted Indiana, who was just months away from eviction, and she only gets the artist's attention thanks to the help of a vagrant's whistle that brings him to the window.) Heading upstairs to where Indiana and Warhol are waiting, and noting the white tin ceilings, she asks, "Do you just open a tin can to eat?"

A little indignant at this comment, which seems to assume a lower-class bachelor pad, Indiana says that he does not, and offers up a recipe for fondue bourguignon that involves four different kinds of dipping sauce. Warhol meanwhile insists, "Food does not exist for me. I like candies." Later in the interview he extols the importance of a macrobiotic diet. Lyon had herself been profiled by the *Times* the year before, offering advice for how a young woman could capture a man in two hours (it involves preparing dinner in advance, including chicken flamed in whiskey, and letting the man do the talking). She asks Indiana why he paints so many *EAT* paintings, and he gives his oft-repeated reply around road signs and autobiography and even death. But he also adds that he finds the word reassuring. "When a mother feeds her children, the process makes her indulgent, a giver of life, of love, of kindness." Here, the only woman present in Indiana's domestic space is the ghost of his mother; and while Warhol didn't mention his own directly, she also played an outsized role in his art

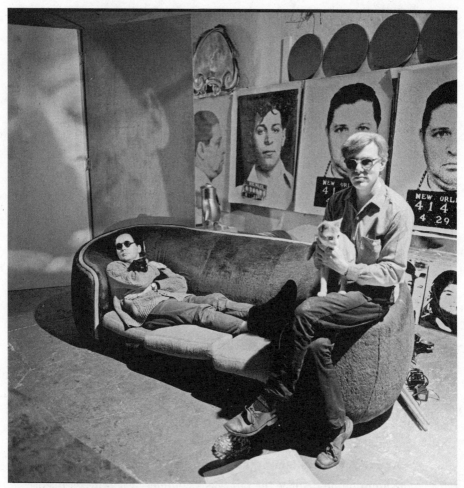

Robert Indiana and Andy Warhol at the Factory, New York, 1964.
Photograph by Bruce Davidson.

(© Bruce Davidson/Magnum Photos.)

and her influence is implied: Warhol tells Lyon, "I was given the same food for twenty years . . . soup and sandwiches, and I can tell you, my favorite is Campbell's Tomato Soup."

Shortly after, Indiana suggests that they travel uptown to Warhol's studio, where they can show Lyon just what she's looking for—their collaborative film *Eat*. In the Factory, sitting on the velour couch

made famous by Warhol's films, with several peeling silk-screen tests of *Most Wanted Men* from his failed World's Fair commission visible behind, they screen *Eat*. Then they go out to dinner.

...

EVEN IF THE ARTWORK clinging to the Theaterama's walls was only a small piece of the visual smorgasbord, and even if several of the projects there, including Kelly's and (in the end) Warhol's, were abstract, the preponderance of corporate rather than state-sponsored pavilions led to the fair being called at the time the "Pop Art Fair." "The World's Fair is a huckster's paradise; everything is for sale," went one review in the summer of 1964. And another critic lamented that the fair was "a giant spectacle that outpops all competition"—implying that any "scandal" or even commanding presence of the work of the young New York artists was lost in the kitschy mix. Rosenquist felt anxious about this. Seeing the huge photographic billboards on the eighty-foot Kodak pavilion "picture tower" nearby, he was concerned that his own work would be dwarfed. (The Kodak tower also emphasized the obsolescence of Rosenquist's earlier painting profession, as more and more billboards featured photographs.)

And yet: despite all the brands, and the spirit of progress through consumption on display, the fair was a commercial failure. Tens of millions of people came, but that was well under estimates, and there was inevitable corruption in the contracts, bids, liens, and loans for the development of its six-hundred-acre campus. One symbol of its commercial failure was the bankruptcy of the much-heralded Top of the Fair restaurant. And as the disappointments racked up, one man had put himself in such a position of commanding power that it only made sense that he would take most of the blame. A September 1964 article in *Fortune*, "New York: A City Destroying Itself," listed terrible race relations, the rise in violent crime (up 13 percent), and "the

indifference of the powerful" among the reasons that the city was on a "death march." The author attached many of the city's failings to Moses, who "rules as an absolute despot, beyond the reach of public opinion," and has "too much authority for one man." Moses lost his controlling grip on the city. In the words of his great biographer, Robert Caro: "The Fair had destroyed what was left of the legend of Robert Moses."

The figure most responsible for the development policies that ravaged Coenties Slip and caused so many of the artists to leave was also the mastermind behind the greatest public exhibition of their work. His fall from grace came just a little too late to save the Slip. The year that marked the final departure of the last artist—Indiana—from the Slip, 1965, was the year that Moses's forward-charging plans for the further redevelopment of downtown New York were finally stopped by a new mayor and the sustained campaign of Jane Jacobs and other cultural preservationists. Moses knew well from his own ground-shifting projects around the city that nothing, and no one, stays in place forever.

# PART IV

# DEPARTURES

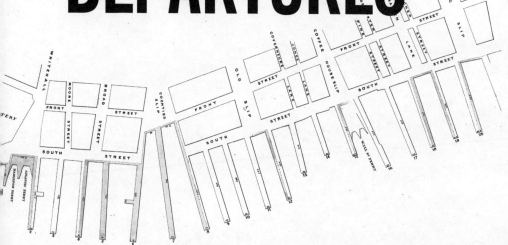

# 19

## A DELICATE CITY

YOU HAVE TO CROSS WATER to get to Manhattan.

Even if you don't come by boat, you travel under or over the East River or the Hudson River to reach the island. Where you arrive and set foot is not original coastline, but a pier, wharf, subway station, highway built on landfill, a coastline gradually extended by the first Dutch settlers and enslaved people. Under the control of the British monarchy, the continual improvement of the waterfront became the first site of real estate speculation in New York as well as maritime trade. Municipal charters guaranteed wealthy merchants water lots that they could fill in, at their own expense, and develop, with future wharfage fees more than compensating for their initial investment. Just four years before the American Revolution, seven private individuals were granted water lots stretching from Whitehall to Coenties Slip, which were filled in with the excavation materials and rubble from new construction farther inland. More than twenty-one acres was added to Manhattan through the development of the slips and water lots, making South Street the new shoreline, a boundary that was always precarious and rapidly beaten back by nature's erosion and storm surge. From the beginning, this place was a stolen gift, something that gave and gave and then suddenly took away.

And how you arrive in Manhattan is often how you depart. Here is F. Scott Fitzgerald's initial vision of the island in 1936: "The ferry boat

moving softly out from the Jersey shore at dawn—the moment crystallized into my first symbol of New York." He is echoing Whitman, who echoes others who came and are coming: What can we make of this place? What will this place make of us? Immigration through New York's waterfront led to its unstoppable population surge, from 33,131 counted in the first federal census of 1791 to almost 1.9 million in 1900. The neighborhoods around the East River slips were predominantly occupied by Irish immigrants by the mid-1800s, with thousands working the piers as longshoremen, "waiting for ships to arrive or weather to clear" in the bars, or working as teamsters, boatmen, or bricklayers, and living just a few blocks north and west of South Street in the city's worst tenement slums.

If Coenties Slip was once the center of New York Harbor's trade, and the harbor the center of New York, the newly coined term *skyline* became the city's emblem in the first decade of the twentieth century, and the architecture and scale of downtown New York shifted from sea to sky. This change reflected a larger one in capitalism—the economy of corporate America replacing industrial America. The artists who lived at Coenties Slip in the late 1950s and early '60s were already living in a nostalgic relic of the city and its economy. Following the Depression, from the 1930s to the later '50s, there was hardly any construction or upkeep downtown. "Industry was leaving, so people who owned the buildings weren't getting any rent," as Youngerman saw it, "and that's what allowed this generation of artists to in a way transform Manhattan."

By 1955, perhaps sensing this shift away from the sea as the defining characteristic of New York, sailors were growing restless with the Coenties Slip neighborhood. It didn't seem safe to them. Suddenly, the rooms at the Seamen's Church Institute felt too small, the neighborhood too eerily empty at night. The "bustling, seafaring community" had been replaced by hundreds of thousands of office workers who traveled uptown or to the suburbs in the evening, "leaving the

area lifeless except for a few policemen and the residents of the fringe of tenement houses." Sailors feared being mugged at night on their way to the Doghouse.

Ironically, this was also the concern of one of New York's richest men, David Rockefeller, whose Chase Bank had already outgrown its headquarters on Pine Street, just around the corner from Coenties Slip. Now Chase was merging with the historic Bank of Manhattan, begun by Aaron Burr in 1799 under the false pretenses of establishing a water company for New York, and would need even more space, but Rockefeller was reluctant to abandon downtown—"An area . . . rich in history," as he wrote—for the new banking capital of Midtown. In February 1955, Rockefeller heard a building was about to be sold next to the Chase headquarters; he managed to delay the sale, raise the necessary capital for a counteroffer, and close the deal the following day. His next order of business was to get permission from New York City to close part of Cedar Street to allow for the construction of a new headquarters on the two-block parcel, and he knew just who to go to. "The key to getting the plan approved was to have the support of Robert Moses," Rockefeller mused, partnering two of the most powerful men in New York City to reconfigure its path. Among Moses's many titles, he led the New York City Planning Commission. "Much to my relief, Bob proved to be an easy sale." Rockefeller's swift development was also aided by Title 1 of the Housing Act, passed in 1949, which pledged a billion dollars toward urban renewal, essentially allowing governments to seize private property and hand it over to private developers.

Change came swift as a wrecking ball. A photograph of the Mutual Benefit Life building, standing just before a crane, led Walker Evans's 1956 *Fortune* magazine black-and-white portfolio "'Downtown': A Last Look Backward." Evans had been a close friend of the poet Hart Crane, one of Indiana's heroes, and had photographed many corners of America, including sharecropping in Alabama in the 1930s, on

assignment with the writer James Agee. (*Fortune* killed that spread, and it became the book *Let Us Now Praise Famous Men.*) Evans was the first photographer to get a solo exhibition at MoMA. At *Fortune*, where he was staff photographer from 1945 to 1965, he was pretty much allowed to do whatever he wanted. He took the photos, wrote the texts, and edited the layouts of his portfolios. And he was most interested in how the United States was changing—the speed with which whole neighborhoods were transforming or disappearing, and the way that the Depression of the 1930s fueled the explosive ambitions of Manhattan real estate's precarious recovery. "The financial quarter and its fringes as they have looked for a generation are presented in the pictures on the following pages. In a sense this is a last look backward," Evans wrote. "A score of new construction projects have been planned downtown. The building boom now commencing will change the face, and a good deal of the atmosphere, of the whole district." By the time the Coenties Slip artists were first moving *into* their lofts, the area was already slated for demolition, and the little four-story Georgian-style brick buildings of their street destined for other plans under the watchful eyes of Moses and Rockefeller.

In the same issue of *Fortune*, another article, "Wall Street's Other Boom," took a slightly less nostalgic view of the change. "In the next five years, almost a score of sleek, air-conditioned office buildings are going to transform the dark, old look of the financial section of Manhattan. Gray stone will give way to shining metal and glass. Setbacks, open plazas, and widened streets will open the area to the sun."

Evans snapped narrow streets cast in deep shadow, ironwork on bank columns, a group of men in hats shot from above waiting to disembark from the Barclay Street ferry, the Mutual Benefit Life building, later razed to make way for the new Chase Manhattan headquarters. He captioned one of his photographs, a row of four-story warehouses with square and arched windows, "South Street just below Coenties Slip." The block has an almost stage-set qual-

ity in its eerie stillness and utter emptiness (the windows all appear boarded up or with dark-paned glass, the iron and wood doors shut).

At the start of construction for the new Chase headquarters in late 1956, the crew hit an underground stream, fifty feet below the surface. This was the same water source that had caused the earliest settlers to build the first homes and streets in this area. The cofferdam and foundation Chase had to then erect ended up doubling the estimated cost of the building. But in the end, "One Chase" was considered a success, and a symbol of the next era in New York. "The big, broad-shouldered Chase stated crisply the mood and abilities of a newer age," *Architectural Forum* proclaimed. "It was not so much a cathedral of money as a powerful and superbly equipped machine for handling it." Rockefeller set aside an additional $500,000 to furnish the building's offices with great art, under the advice of a museum committee, including Gordon Bunshaft, a partner at Skidmore, Owings & Merrill and the architect of the new Chase tower, and none other than the Museum of Modern Art's Barr and Miller.

Among the first works purchased with this fund was *Big Red*, 1959, "a great big, red, black, and white painting, very handsome," in Miller's description, by Youngerman, a sale that helped Youngerman and Seyrig immensely. The irony of this support was not lost on the artist when he later found out that his art was entering the collection of the very bank that was evicting him from the Slip. Bunshaft himself visited Youngerman's studio and picked out three paintings, one for his personal collection (*Naxos*) and two for the bank. A vice president of Chase, who had originally insisted that he didn't want any art in his office, became very taken with *Big Red*, and hung it over the sofa in his palatial office so that he could see it from his desk. Miller pointed out to him that "Jack Youngerman lives right down there . . . You could see Jack's windows." The banker invited Youngerman to lunch. As Youngerman would later put it, it was a moment to reflect on the many contradictions inherent in being an artist in a city like

New York, where your survival counted on an elite class of capital-
ists often at odds with your own political stance and sensibility. "I
was a walking contradiction between my French leftist, pro-Cuban,
downtown sensibility, and the new corporate architecture." Miller
had another view: "I don't really believe that corporate buying had
a significant impact on the artists themselves. I think that the best
artists go on doing what they are doing, no matter what the market
is or where art is being seen." What did have an undeniable impact
was the downtown development of these corporate interests. Indiana
described the beam that makes up his *Moon* assemblage, made in the
winter of 1960, as "from an early 19th century warehouse on the New
York waterfront demolished by Moses, Rockefeller, and Progress."

Rockefeller also led the new Downtown-Lower Manhattan As-
sociation, which issued its master plan in 1958 for the rezoning of
564 acres, from Canal Street to the Battery. The association recom-
mended the widening of streets, the demolition of waterfront piers,
and the relocation of Fulton Fish Market in order to expand the fi-
nancial and insurance districts east into newly filled land along the
river. As Rockefeller wrote in his *Memoirs*, the plan suggested

> removing rotting piers and bulkheads . . . building the Lower
> Manhattan Expressway, an elevated highway that would link the
> Manhattan Bridge with the West Side Highway . . . and clearing
> the long-abandoned warehouses and tenement district on the
> East Side, to create an expanded financial services industry; and
> promoting Wall Street as an "around-the-clock" community . . .
> by building affordable housing in Coenties Slip and in the run-
> down blocks south of the Brooklyn Bridge.

As part of the Downtown-Lower Manhattan Association's vi-
sion, the architecture firm Skidmore, Owings & Merrill drew plans

for a World Trade Center that stretched from Fulton Street to Old Slip, Water to South Street, across thirteen acres. Incorporated into this project were 21,000 units of housing, "in the expectation that the entire east side of Lower Manhattan, with its hundred-year-old houses and warehouses, having served recently as marginal office and storage space but now largely unoccupied and considered derelict by planners, would be replaced by a new twenty-four-hour community." Supporters of the plan continued to emphasize that this new development would revitalize the area, taking away exactly the attributes that the artists of Coenties Slip held dear. "The district," one real estate developer proclaimed, "will no longer become a ghost town after 5 every night." In the end, the World Trade Center plan was shifted to the west side, and construction began in the summer of 1966 on twin towers that would be the world's tallest and biggest buildings.

The rapid encroachment of banking did not completely displace the trade that had built up downtown. In 1960, 20 percent of all goods arriving in the United States via the ocean still came through New York's piers. Walker Evans returned to Coenties Slip that year to take more photographs. A second photo essay for *Fortune*, "On the Waterfront," documented warehouses along the port of New York and the Brooklyn Bridge in late-afternoon sunlight. Full-page black-and-white and color images in this seven-page portfolio highlighted intricate brickwork, metal star grommets, shutters, and doorways of eighteenth- and nineteenth-century structures on South Street, Market Slip, Broad Street, and farther uptown. The description of the teas, tobacco, and spices passing in and out of these spaces ends with a jarring paragraph: "Just now, with trade booming, these venerable barns are not so obsolete as they look, because space is in short supply near the docks. But there are signs that their day is over. For example, the Housing and Redevelopment Board of New York has just

published plans to replace twenty-nine acres of Manhattan riverside warehouses."

Preservationists, sociologists, and architectural historians were also documenting the changing city, and wondering about modernism's hurry to displace history. In fact, the artists' short decade on the Slip is bracketed by a history of battling for preservation legislation to be approved before too much new building was begun: the Bard Act, in 1955, just as artists were first settling at the Slip, and the Landmarks Law in 1965, when Indiana finally moved out. The Landmarks Law was approved just a few years too late to make a difference for the Slip. Before that law, there was no official process for protecting the city's cultural heritage.

Albert S. Bard was a lawyer and civic leader, and president of the Municipal Art Society. Linking with the New York chapter of the Society of Architectural Historians, the Municipal Art Society created an Index of Architecturally Notable Structures in New York City in 1952–53. A year later, spurred on by Moses's plans to tear down Castle Clinton in Battery Park to build a huge bridge, the society printed a forty-page mimeographed list of notable buildings in the city that might also be under threat. Lower Manhattan's profile was cited as "perhaps the most thrillingly beautiful and world-renowned feature of this great city." Bard by then was eighty-eight years old, partially blind and deaf, but laser-focused on the cause of finding legal recourse for saving buildings. He worked from an office downtown at 25 Broad Street. In 1955, a bill bearing his name passed the New York State Assembly and Senate, but was vetoed by the governor. (It passed in 1956.) One of the most intriguing aspects of the Bard Act was that it centered on the "special character" of place, not just structures, as a necessary trait to preserve.

Momentum continued to build, emboldened by Bard's perseverance. An influential show, *Monuments of Manhattan: An Exhibition*

*of Great Buildings in New York City 1800–1918,* opened in 1955 at the University Club, and in April 1956, forty people showed up in sleeting rain for the first walking tour, arranged by the Municipal Art Society and Society of Architectural Historians. The historic plaque program also began in 1957 in New York City—one more effort to save and tell the story of buildings in the middle of people's daily commutes. All of these efforts flew, of course, in the face of the massive construction taking place around the city. Already in 1958, 10 percent of the buildings on the Municipal Art Society's 1952 list had been destroyed.

In early 1960, Richard Seaver and Jack Youngerman hired a young lawyer, Seymour (Si) Litvinoff, to ward off eviction at 27 Coenties Slip. Before they could buy the building from the owner—who was frankly happy to get it off his hands, asking $20,000 and then dropping that number to $18,000—it had to be brought up to code. Seaver and Youngerman calculated that this would cost them $3,000, and they negotiated with the owner to bring his cost down to $16,000, for a grand total of $19,000 to stay at the Slip. Litvinoff began the necessary paperwork to secure a mortgage, but the banks balked, asking why anyone would want to live in a decrepit building near South Street. (They couldn't say that they were *already* living there.) As Seaver remembers, "A week later we received an envelope from Chase Bank, which I carried to the top floor, waving it in triumph." His elation was short-lived when he actually read the letter: "Dear Sirs," it began, "we regret to inform you that, after a careful assessment of your application for a building mortgage at Coenties Slip, your application has been denied." In April 1960, they were evicted from 27 Coenties Slip and the building was destroyed two months later.

They were just a year too early in their bid for legal residence; a little farther west and north, a group of artists living south of Houston Street petitioned Mayor Wagner to be allowed to live, not just work, in commercial zones and buildings that did not have certificates of

occupancy, and by August 1961, the idea of an Artist-in-Residence (A.I.R.) status was born; in 1964 visual artists were allowed to have live-work spaces zoned, which changed the landscape of neighborhoods like SoHo.

In 1961, another important breakthrough came in the awareness of older buildings. The urban activist and writer Jane Jacobs published *The Death and Life of Great American Cities*. She was an "unaccredited journalist-mother, with no college education," and her book was initially dismissed by many of the most celebrated critics and urban scholars of the day, though it is now seen as a central treatise on how cities work. Perhaps because of her outsider status, Jacobs looked at the smaller details of a city that had not received much attention: the sidewalks, the stoops, the hodgepodge variety of life and trade. Among her arguments for preserving the vitality of the city block was the necessity to save old buildings, which allows for a diversity of industry and aesthetic styles through the "ingenious adaptations of old quarters to new uses." As if describing the Slip artists' own repurposing of book depots, sail-making lofts, and ship chandleries into home studios, she goes on, "These eternal changes and permutations among old city buildings can be called makeshifts only in the most pedantic sense. It is rather that a form of raw material has been found in the right place. It has been put to a use that might otherwise be unborn." Jacobs acknowledged not only the inspired repurposing of the past by artists and others who adopted these difficult or derelict spaces but also the need for a city to have this creative class, who safeguarded stretches of history through their forced ingenuity and also enriched the diversity of a city's block.

The Landmarks Preservation Commission was finally formed in 1962. A *New York Times* editorial in March 1962 warned, "If we are slow enough—and we have set an ignoble precedent on this score— most of New York's architectural heritage and almost all of the city's remaining early nineteenth-century structures of historical interest

will be gone." The following month, on April 21, the first Landmarks Preservation Commission met; that October, Penn Station began to be torn down. An editorial in *The New York Times* in February 1964 lamented the destruction of a swath of historic buildings "along the East River from the Battery to the Brooklyn Bridge, where sailing ships, spice, and coffee merchants, importers and chandlers, once engaged in the trade that made the city rich and great." Ivan Karp's Anonymous Arts Recovery Society (the very same that Rosenquist had used to lure Karp back to his studio to see his own salvaged stoneworks) stepped in on Beekman Street downtown in October 1964 to rescue the column capitals of the architect Louis Sullivan's only building in New York, a salvage operation documented by *The New York Times*'s first full-time architecture critic, Ada Louise Huxtable.

And the next year, the same year that the Artist-in-Residence program was created to protect artists in industrially zoned buildings from eviction, Huxtable's slim paperback *Classic New York: Georgian Gentility to Greek Elegance* came out. Huxtable kicked off a series on Manhattan's "special flavor that derives from its architectural potpourri"—foregrounding older buildings and the necessity to preserve them in the mix. And not just city halls and mansions: Huxtable was interested in the regular houses of past periods, the "street architecture" that helped tell the story of trade, class, everyday life. "Before urban renewal was scheduled to 'improve' lower Manhattan, it seemed as if it might always be possible to re-enter the sailing and commercial community of the early nineteenth century, where vernacular Georgian and Greek Revival structures served ship chandlers and spice merchants, and also displayed the fine-scaled taste and craftsmanship of an earlier age." For Huxtable, street architecture was as central to preserve as historical monuments: "It is the ensemble of these modest groups of minor buildings that creates the essence of a period and the spirit of the city."

Huxtable walked the city streets, pointing out with obvious delight

the neat brick and symmetrical windows of the Georgian style in nineteenth-century New York, noting, as when she is walking down Coenties Slip, the "gaping wounds or pulled teeth" of parking lots that interrupt the rows of modest 1830s four-story buildings. (For some time, after the building was torn down, 27 Coenties Slip was a parking lot.) For brief interludes, as when ambling down Front Street "on a cold and sunny winter Sunday morning, with no automobiles," she mused that "it is still possible to step into the past." Huxtable wrote that "all of these buildings are doomed, or in danger," and "living on borrowed time."

Jacobs's book came out after more than half the buildings on Coenties Slip had already been razed, and Huxtable's when the final artist studio of the Slip group, Indiana's, was condemned. At the Slip, number 31 was torn down in 1957; number 27 in 1960; number 25 in 1965, just months after the April 19 passage of the Landmarks Law. The mayor signed the law despite serious opposition from Rockefeller and Moses's very powerful Downtown-Lower Manhattan Association. The only building left standing when the rest of the lofts were destroyed in the 1960s to make way for financial center high-rises was 3–5 Coenties Slip; it still stands today.

In 1966, the young photographer Danny Lyon moved back to New York City, to a loft on Beekman and William Streets, in the heart of the downtown financial district near the entrance to the Brooklyn Bridge, and just next to where Lenore Tawney briefly relocated after being evicted from South Street. Echoing many accounts, Lyon remembers it as a "ghost town" after 5 p.m. Half the buildings on his block were boarded up, waiting to be demolished. In the next year, sixty acres of nineteenth-century New York below Canal Street were slated for destruction and clearing. Over the course of six months, Lyon began photographing the buildings, which he called "fossils of a time past," including buildings from

the Civil War, "houses of the dead. In their last days and months they were kept company by bums and pigeons." Lyon captures the empty, desolate structures in the bright morning sun; he captures the "Slavs, Italians, Blacks from the South, American workers of 1967 drinking pop-top soda on their beams at lunch time, risking their lives for $5.50 an hour, pulling apart brick by brick and beam by beam, the work of other American workers who once stood on the same walls and held the same bricks, then new, so long ago." His photographs capture the sudden break in a row of buildings where an empty lot now stands like a gaping hole; a group of young boys sitting in the doorway of an abandoned building on a Sunday morning; an artist's loft on Ferry Street with charcoal drawings on the kitchen wall; the top floor of an old sail building, its huge wooden pulley gear and gabled windows still in place, much like Youngerman's attic loft at 27 Coenties Slip. Lyon documents the proud work of the housewreckers and demolition crews, who smash cast iron with sledge hammers and can "bring down a loft building at the rate of a floor a day." He is amazed by how much happens by hand—how buildings come down "brick by brick." And he is amazed that in the six months he photographs the destruction, he doesn't see a single other photographer documenting the loss, despite the hundreds of professional photographers living in Manhattan at the time. It was, in his description, a "non-event." In 1969, he published his photos as a book, *The Destruction of Lower Manhattan*. "The buildings and rooms pictured on the following pages have been demolished," Lyon wrote in the introduction.

Fall 1966 also marked the Seamen's Church Institute's formal announcement that it was leaving 25 South Street, whose occupancy rate had reached its lowest numbers that summer. "The metropolis is peculiar to rapid changes—everything must yield to the necessities of the living present, with little lingering respect for the old landmarks

or time-hallowed associations." It would occupy smaller quarters on State Street beginning in February 1968.

In 1967–68, Fred Mitchell, the artist who had accidentally launched the artist community at the Slip when he told Kelly about some vacant loft buildings, was still painting and teaching at the Seamen's Church Institute, though his days leading plein air classes along the high balcony underneath the SCI tower's gargoyles were numbered. He walked around the neighborhood snapping photographs of the destruction; these were personal records of the loss of a street that had been so important to his first years as an artist, unlike the more public project of Lyon. Where once ships' masts reached upward, a forest of metal cranes clogged the skyline. The most poignant photograph shows a five-story nineteenth-century brick building, mid-demolition, shot from across a parking lot of low-slung cars. Behind it, a large new glass skyscraper rises, its fluorescent ceiling lights on each floor a pattern of dots and dashes. The little building has a pile of rubble against its wall, and a gaping square hole smashed into the side one floor up. An exhaust pipe snakes out of the wall and up past windows with cheerful shutters to the roof. But the detail that perhaps caught Mitchell's eye as he stood photographing this forlorn wreck on one of its last days was the sight of a window swung open on the third floor, as if to let in the breeze.

In 1968, the place that had been, in Indiana's formulation, the "kitchen, bath, library, theatre and laundry to its ill-accommodated artist neighbors" was torn down and Cuyler's Alley gobbled up, to make way for a 165,000-square-foot office tower site, 55 Water Street, joining the fate of most of the buildings on its street. In August 1968, a feature in *New York* included a photograph of a hard-hatted demolition man astride a huge supine gargoyle, proclaiming, "Anybody in the market for a seven-foot stone gargoyle from the roof of the historic Seamen's Church Institute can make a trip to 25 South Street,

where the demolition people are offering cast stone bears and eagles for $500 each (reduced from $1000.)" The crew was later issued a summons for acting as a secondhand dealer without a permit. For more than fifty years, people in the neighborhood and port had set their watch daily to the SCI's canvas-covered ball on the roof, which lowered on a pole above the lighthouse at noon. And the SCI's bell had rung out every half hour over the water and over the Slip—time taking its toll.

# 20

## DELPHINE AND JACK

1960–61

CHRISTMAS 1959 was a warm affair at 27 Coenties Slip, with a big tree, too much wine with the neighbor and resident "den mother" Jesse Wilkinson, and a "mountain" of gifts for Duncan, including a black cowboy hat from Kelly, and a blackboard and train set from his parents. A few months later, Seyrig wrote to her mother with the difficult news that they were being evicted on April 1, as the building was getting torn down like so many others in the neighborhood.

The date marked exactly ten years since Youngerman and Seyrig had met on the streets of Paris with Richard Seaver, and less than two years since the Seavers had joined them at the Slip. Youngerman and Seyrig finally had some security, on the heels of Youngerman's appearance in *Sixteen Americans* at MoMA and Seyrig's in the TV show *Pete and Gladys* in Hollywood. They were terrified they'd have to leave their "beautiful home" to rent a "dark and no-views apartment" in a "depressing neighborhood" somewhere in Manhattan—one could imagine someone coming from uptown having the same fears about the Slip—but in February, Seyrig reassured her mother that they had already secured another apartment next door to the

Seamen's Church Institute, on the top floor of the grocer's that sup-
plied the fishing boats and tugboats with cases of potatoes, a spot
with plenty of skylights and views of the water.

When spring arrived, her move farther east on the Slip with Youn-
german was less certain. She was being pulled across the ocean.
Eager to reconnect with Alain Resnais and all the latent promise of
their brief New York rendezvous, Seyrig left for Paris with four-year-
old Duncan the day their building was condemned. Youngerman was
reluctant to abandon New York just months after his MoMA show,
and with so much to do to move apartments. He lived temporarily in
3–5 Coenties Slip, and then two months later, realizing he was losing
his wife, he asked Kelly to look after Orange, and followed his family
to Paris. Then 27 Coenties Slip was razed; Indiana salvaged some of
its beams for his herm sculptures.

In Paris, Seyrig felt giddy. She reunited with Resnais, who was im-
mersed in the development of his next film project, with the *nouveau
roman* novelist Alain Robbe-Grillet, who had emerged in the 1950s
in France, along with Albert Camus and Michel Butor, as a writer in-
terested in uncoupling language from its sentimental and traditional
conventions, including metaphors, chronology, and expression, pro-
ducing what the theorist Roland Barthes called "a style of absence
which is almost an ideal absence of style." The novelist and the di-
rector had just met the winter before, introduced by producers who
thought their creative interests and approaches would gel, and they
agreed to do a project together.

Their first conversations around film focused on structure. What
if it were possible to extend the flashback device used often in de-
tective films to a more internal purpose, to explore the thoughts or
imagination of two people, but presented as if reality? To disrupt
the all-too-predictable linear unfolding of events with a tempo
that reflected the emotions, and the crisis of chronology that usu-
ally accompanies emotional memory? A week after their meeting,

Robbe-Grillet submitted four scripts to Resnais; the director was enthusiastic about all of them but they decided to begin with *L'Année dernière à Marienbad* (*Last Year at Marienbad*). Resnais told Seyrig that she must play the lead.

Seyrig cut her hair short, a sleek dark bob styled by Alexandre de Paris that contrasted with the "hippie" frizz of curls she'd had in New York. (The haircut became a trend after *Marienbad* was released.) She visited the theater and the movies with Resnais; at breakfasts together, Resnais continued to take photographs of her and study her movements for the film. In June, Henri Seyrig was appointed head of all the museums of France by André Malraux, the powerful minister of culture. And that same month, Youngerman came over to France from New York, desperate to understand where he and Seyrig stood, as she wasn't answering any of his letters or phone calls. Seyrig told him she had changed, though it was superficially easy to see that. Seyrig had to return to the States for the rest of the summer to finish shooting her part in the sitcom *Pete and Gladys* in California. Youngerman wanted to accompany her but she insisted on returning alone, so he continued on to Meschers for the summer with Duncan.

Freed of her Hollywood duties and contract, Seyrig arrived back in Paris on August 19. She was ready to start preparing for her *Marienbad* role, around which the entire enigmatic plot revolves. Just as she had for *Pull My Daisy* (though there to the exasperation of its makers), and in her various theater roles, Seyrig wanted to be fully immersed in the motivations of her mysterious character. To do so, she needed to cut out all distractions, all of the real world around her. At the beginning of September, she took Duncan with her to Munich to begin shooting *Marienbad* at Nymphenburg Palace.

Realizing that he had lost her to the role, Youngerman returned to New York on the French liner *Le Havre*. On board in the ship's library, he found two paperback translations in French of Kafka: his depressive *Diaries*, and *Wedding Preparations in the Country*. Wed-

*ding Preparations* was published by Max Brod after Kafka's death, although the writer had asked him to burn it, and consists of unfinished stories in fragments sometimes as short as a single sentence. Youngerman was moved by these books; he found them to be a revelation even as his own marriage was unraveling. Back in New York, he realized that Kelly had become so attached to Orange that he wanted to keep her, and would not budge despite Youngerman's situation. And Martin had taken the apartment over the grocer's by the Seamen's Church Institute that Youngerman had been planning to live in. His marriage as he knew it was imploding, he was evicted from his building, and then he lost his dog. He found another loft on South Street with huge windows onto the river where he lived for a few years before moving around the corner to Fulton Street.

For Seyrig, her breakthrough role was only one in a long series of moments where she was confronted with the difficulties and constraints of being a young mother and pursuing her artistic career. As the critic and theorist bell hooks would write, "Women artists cannot wait for ideal circumstances to be in place before we find the time to do the work we are called to do; we have to create oppositionally, work against the grain." During a grueling play run, Seyrig would sometimes bring Duncan to the theater; he would fall asleep there in her dressing room, and then after the show she would bring him home and tuck him in. "Delphine was tormented by some of this. But she's a person that without her work, she would have died," Youngerman explained. "She couldn't live without it; she could hardly live without daily work. That's why theater was so important to her."

...

LAST YEAR AT MARIENBAD was shot from September 12 through November 27 in Munich and Paris. The setting is a baroque spa hotel (the Polish town of Marienbad has a famous one, though it's unclear

if this is supposed to stand in for it) with formal gardens, a series of reflective marble, mirrored hallways, and labyrinths. Its "opulent but icy" setting, as described by Robbe-Grillet, was all too true: the shoot was freezing. There are three main characters: A (Delphine), M, who may or may not be A's husband but is the man she is currently with, and X, who spends the film trying to convince her that they have met before—last year, in fact, in the same place—and were lovers. (Incidentally, the two novels that Robbe-Grillet wrote just before this screenplay were *Jealousy* and *In the Labyrinth*.)

A is adorned in Chanel costumes and careful styling that evokes Greto Garbo and older Hollywood. Seyrig later said that her own expressionistic mannerisms and poses in the film were propelled not just by the adoring lens of the director but by "an enormous awkwardness. If I had known how to make myself up, do my hair, and walk in heels, I wouldn't have had to invent every gesture, every step."

The film itself has a kind of anachronistic, timeless feel. Resnais wanted to refer to the history of silent film. "We even went so far as to ask Kodak to manufacture again for us, a film that was not 'anti-halo,' so that the whites would run. That did not prove possible, but by dint of evoking the silent cinema, we finished up impregnating the whole film with it." As with *Hiroshima Mon Amour*, Delphine's brother Francis Seyrig composed the soundtrack, complete with brooding organ interludes that matched the overwrought opulence of the sets.

The film is meant to evoke a mental image but also the impossibility of memory, particularly among lovers. (X continues to try to convince A that they have met before and it was her idea to rendezvous here again a year later.) Rosenquist framed his own experience of watching the film around the "odd overlapping of memory, movies, and art." He remembered seeing Seyrig "wearing a beautiful housedress and pushing her son, Duncan, down the street in a stroller. And then one year later she was in *Last Year at Marienbad* and had become an international movie star. I thought, That's strange! I just

saw her last year in Coenties Slip and now she's in a big movie. I found it strange that the movie had the same tone in my memory and the movie itself was about memory and coincidence."

As Resnais said, "It is the feelings which interest us, the exchange of feelings between the characters, not the characters themselves." Resnais never fully said what the movie was "about," but suggested that it was, in part, a reflection on "the uncertainties of love or on parallel universes, about imagination or the difficulties of communication." Seyrig was immersed in this mysterious world at exactly the moment when she herself was in a kind of love triangle with her husband and Resnais. Resnais's first assistant on the film, Volker Schlöndorff, described the film as a great declaration of love by the director to Seyrig.

···

IN JANUARY 1961, Delphine announced that her marriage with Jack was over. She was twenty-nine. (They would not get divorced officially for many years, and would remain, in Youngerman's description, "best friends.") In April 1961, Youngerman was again in Paris to be close to Duncan, working in a studio there, writing to his gallerist about the paintings pushing to get out and how Delphine was already a sensation even before the film's premiere, because of turns in two plays, including *The Seagull.* He wrote a month later imploring Parsons to let him show with a French gallery, as things had been slow in New York and his financial situation was "alarming." He explained that he was throwing himself into his painting, a necessary distraction from his home life, "working steadily here, & that is the main thing for me." He went to see a Matisse cutout show at the Musée des Arts Décoratifs with Henri Seyrig, where the work was hung quite spectacularly in the space, and was deeply moved by it. He started painting *Delfina,* an almost nine-foot canvas whose

composition seems to come from dropping jagged white pieces of ripped paper onto blue water, with a few green pieces like torn leaves at the bottom. A kind of inlet appears to form, bridged by two jagged rectangles of white. The shapes move in and out, like a centuries-long time lapse of tectonic plates and shifting land masses, or the first few minutes when paper hits moving water and eddies away. It's hard not to think of Youngerman's answers to MoMA's questionnaire around his 1958 painting *Naxos,* painted on the top floor of 27 Coenties Slip and bought by Gordon Bunshaft. "It mirrors my inside/outside life then. <u>Naxos</u> is the place name of the Greek island. Never visited, it resonated for me, like many place names, unvisited."

*Last Year at Marienbad* premiered at the Venice Film Festival on August 29, 1961, where it won the Golden Lion. It was banned from Cannes because Resnais, along with Alain Robbe-Grillet, had signed the "Manifesto of the 121" against the Algerian War. In 1962, Seaver's Grove Press published the screenplay and Robbe-Grillet's introduction in the United States. Youngerman returned to New York in October 1961, sailing on the *Flanders.* Seyrig wrote to Youngerman that same month of the violence on the streets of Paris over protests around the Algerian War.

Seyrig predicted the film's critical reception in a letter to her mother early in the shoot, when she imagined that people would either hate it or love it, but not be indifferent. In France, it was a surprise box office smash, and opened to rave reviews in the major papers, with critics hailing it as the most important French film in the last twenty years, and comparing its fragmented, experimental style to the artistic breakthroughs of Picasso. Six months after its premiere, it was called "the most controversial French film ever produced," and it remains one of the most polarizing titles, appearing on both "best" and "worst" lists of twentieth-century cinema.

For its New York premiere in 1962, *The New York Times* wrote, "It may grip you with a strange enchantment, it may twist your wits into

a snarl, it may leave your mind and senses toddling vaguely in the regions in between. But this we can reasonably promise: when you stagger away from it, you will feel you have delighted in (or suffered) a unique and intense experience." As Resnais's fellow French director François Truffaut said at the time, "With *Marienbad*, Resnais carried the cinema farther than it had ever gone before without worrying about whether or not audiences would follow. If he were a novelist or poet, this wouldn't matter—but in the cinema you're supposed to worry about your audience." And Seyrig joined her fellow Slip artists in appearing at the Museum of Modern Art: the institution hosted seven "evening previews" of the film at the Carnegie Hall Cinema to benefit its thirtieth-anniversary drive before the first public showing on March 7. Indiana noted in his journal on February 15, 1962, to pick up tickets via mail for "Delphine's premier and benefit." It was hard to attend a cocktail party in New York in the spring of 1962, or so claimed *The New York Times*, and not join a passionate conversation about the film.

...

YOUNGERMAN AND SEYRIG spent the summer of 1963 together in Meschers; they sent Parsons a postcard, each writing a little signed message as they had done decades earlier to Calder and Kelly. Youngerman wrote of his work taking form and coming into being, and of drinking white wine and eating little green oysters; Seyrig wondered if Parsons had received the hat that Seyrig had borrowed from her for a film.

But their lives would become increasingly separate. In 1964, Youngerman painted *Delfina II*, almost identical to *Delfina* but even bigger and in acrylic, not oil. Its little interior harbor is lost, now closed off entirely. It is an abstract map, impossible to know what is meant to be land or water or somewhere in between. The green

crests at the bottom look like waves; maybe the cobalt blue slips over a craggy iceberg, or maybe the white veil floats over the blue like the wispiest clouds. He called these works "a bridge" between his earliest New York paintings and his work from the late 1960s—a way, perhaps, to travel from his earlier life with Seyrig on the Slip to a new reality, still connected but not together. They were his "homage" to his marriage and to Seyrig. That same year, Youngerman was on the cover of *Art in America* with an unusual project, a stoneware tile mural that was part of the magazine's pilot program to invite twelve painters and sculptors to make ceramic work at Bennington Potters in Vermont. He participated in the artist Daniel Spoerri's 31 Variations on a Meal series, in which Spoerri "snared" the remains of meals with artist friends in New York into fixed sculptures (Youngerman appears to have had breakfast). The next year he had a solo show at the Worcester Art Museum in Massachusetts, and in 1968, he enjoyed a solo show at the Phillips Collection, Washington, D.C.

Seyrig was drawn to a certain state of volatility and action, part of what made her both adore and feel trapped by her time at the Slip. Now she wanted to be at the heart of political and social change. Marguerite Duras described Seyrig on the streets of Paris in the late 1960s "wearing a raincoat, no makeup, book in hand, in case movies should ever disappear from the face of the earth ... no one else seems so fragile. In fact, though, she is as rugged as a North Sea sailor." Seyrig wrote to Youngerman in early June 1968 of the Paris riots and revolution, the "greatest that ever happened," standing on Boulevard St. Michel ripping up paving blocks to throw across the barricades, with "jazz coming out of the windows of the 2nd floor of the Sorbonne and people sitting on the window ledges and lights on through the night and just this crazy, *unbelievable* feeling of FREEDOM."

She began to date the actor Sami Frey, who worked with many of the same directors as Seyrig and had risen to a certain celebrity sta-

tus in France after briefly dating Brigitte Bardot in the early 1960s. Youngerman started spending more time on the East End of Long Island, where he had first gone to visit Kelly at his summer rental in 1959. Youngerman bought a small shingled house and barn on the edge of a horse farm in Bridgehampton. By 1970, without "a next move in painting," he shifted "headlong" into making sculpture and shaped canvases.

Seyrig took her strong convictions about work and motherhood and channeled them toward feminist projects in France. After a series of films with leading male directors of the day, including Resnais, Truffaut, Jacques Demy, William Klein, and Luis Buñuel, she decided to accept only those roles in theater and film that offered a complex female character rather than one at the end of the adoring male gaze. In the 1970s, she met the filmmaker Carole Roussopoulos, and along with Ioana Wieder, the three founded a film collective called Les Insoumuses, or the Defiant Muses, a play on words in French that also references the painter Frida Kahlo's pronouncement "I am my own muse."

The three produced a series of videos, often shot with Sony's new Portapak, light recording equipment that became available in France in 1968, that took on such subjects as abortion (Seyrig also aided women in getting abortions when that was illegal, including at her own apartment, and pushed for legislation), sexual independence, and the rights of sex workers, and filmed demonstrations and marches across France. Echoing her own frustrations about auditions and modeling in her letters home from the Slip in the 1950s, Seyrig talked about how new advances in portable video cameras and being able to control the picture liberated her from those passive duties of just looking good for the camera. It was "a revelation, an enormous pleasure, an enormous revenge against the fact that I am called at 6 a.m. to have my hair done, makeup done."

During this period, she chose to work with female directors such as Chantal Akerman, Ulrike Ottinger, and Agnes Varda on films that offered more complex characters (if far narrower budgets, distribution, and audiences). These directors, Seyrig explained, changed everything: "Now I feel I don't have to hide behind a mask, I can be my own size. It changes acting into action, what it was meant to be." If *Marienbad* launched her career as a kind of untouchable enchantress, the film that embodied her new political engagement was Akerman's *Jeanne Dielman, 23 quai du Commerce, 1080 Bruxelles*, 1975, in which she plays a housewife forced to take on sex work to support her son. We watch Jeanne from some remove over the course of three days through a fixed camera without any close-ups, showing the scale of her constrictive apartment and the mundane daily tasks she undertakes, of which sleeping with a stranger is but one box checked, and how the careful control in these tasks comes undone slowly until the film's dramatic final ten minutes. Akerman had traveled to the States from Brussels as an aspiring filmmaker in the early 1970s; among the few films she watched was Warhol and Indiana's *Eat*. But in the end, she wanted to produce a film only with women: "It was a point to make at the time."

Duncan was living in New York with Youngerman. Seyrig wrote to her teenage son from Brussels in January 1975 at the start of shooting *Jeanne Dielman* with the twenty-four-year-old director. "Although I am excited about her film, the need to act is fading inside me, and the discovery of video has given me desire for other things."

Among those "other things" was her 1976 documentary *Sois belle et tais-toi (Be Pretty and Shut Up)*, which sounds like something made yesterday in the midst of the #MeToo movement. Seyrig interviewed twenty-four fellow actresses, including Jane Fonda and Maria Schneider, about life on set, interactions with directors and other actors, aging, and the lack of good roles for women. In 1982, along with

her fellow defiant muses, she founded the Centre Audiovisuel Simone de Beauvoir, which extended the mission, producing, documenting, and archiving women's perspectives. Seyrig explained that her feminism lay "in my communication with other women, this is the first thing. Listen to other women, talk with them . . . I could not live if I didn't have this."

Seyrig's work was cut short; she died of cancer on October 15, 1990, in Paris, at the age of fifty-eight. Youngerman recalled vividly her final visit to New York after her diagnosis. The two went bicycling up from the Village to Central Park and around its whole perimeter, like their days in Paris forty years earlier when they used to ride bikes everywhere. "One of the last, best memories I have is Delphine on her bicycle, smiling. I was a little behind her." For a moment, she became a teenager again, back when her family lived just off Central Park during World War II and she'd first discovered rock 'n' roll, pedaling fast down the hill through the park's curtain of trees and into the sun's spotlight.

# 21

## LENORE

1962

THE NUMBER 27 was unlucky for Tawney. After leaving 27 Coenties Slip for 27 South Street, she found out that she was being expelled from her illegal, three-story loft on the water, where she had hosted so many informal salons and where her work had grown to fill the sweeping height of the building like so many spiderweb sails hanging from hoists. "I fought in the courts to stay there but they still put me out," she later said. In protest, she wove a piece, *Untaught Equation*, that was twenty-seven feet high.

Despite her refusal to conform to contemporary domestic expectations, Tawney was always inextricably connected to her homes. For her, more than any of her colleagues at the Slip, her living spaces were extensions of her work itself. She was not a housewife but a house artist. As the novelist Deborah Levy writes, "Domestic space, if it is not societally inflicted on women, if it is not an affliction bestowed on us by patriarchy, can be a powerful space." Friends and critics always commented on how Tawney's lofts were works of art. "Often the place where an artist lives is remarkably like the work that is made there," the poet and art critic James Schuyler wrote in 1967. He was visit-

ing Tawney's new loft on Spring Street—two moves after the Slip—
still downtown but at its northern edge, and still a manufacturing
neighborhood with huge trucks clogging the narrow cobbled streets.
He found her space filled with "tough but fragile treasure." All these
moves were taxing as she continued to accumulate more and more
specimens, not to mention her heavy looms and her endless library of
books; the rare, expensive ones she cut up to make collages and post-
cards to friends, and the others that kept her company. "There is a
play between what changes and what stays," Schuyler wrote, "what is
worth keeping, and what is kept."

By the summer of 1962, Tawney had moved to Thomas Street and
then to her Beekman Street studio, still far downtown. She had her
*Woven Forms* debut exhibition in Manhattan. She was commissioned
to make another artwork in a religious setting, back in Illinois, the
veil covering the ark at Congregation Solel's temple. After doing ex-
tensive research at the Jewish Theological Seminary in New York,
she made a somber ten-foot natural linen piece, covered in gold wire,
which she described as a "veil of light and dark... It stands wrapped in
dignity and silence, protecting the sacred doctrine, commanding sol-
emn joylessness." She visited a label factory in New Jersey that had a
Jacquard loom that could make twenty labels at a time; she likened it
to music playing. She lived briefly with Martin on South Street while
she was moving between her Thomas and Beekman Street lofts.

This was a period when, despite growing recognition through a se-
ries of commissions and exhibitions in New York, she was in a deep
depression, perhaps instigated by the loss of her loft at the Slip, and
certainly not eased by the exhaustion of helping Martin through her
own breakdowns. "I went symbolically down, down into the earth. I
stayed there a long time, months, years. I died there, became a seed,
slowly, slowly. I became a new shoot, I rose slowly, slowly. New ten-
drils came out tender, new born, that was in 1964. I began the boxes,
collages, drawings. They were completely new. I became happy, for

a time." Indiana noted that Tawney suddenly was "looking younger than ever, and the great weight that bore her down on the Slip gone."

Tawney here refers to her shift from weaving (which she never fully abandoned throughout her life) to small sculptures, collages, assemblages, and postcard art, made with stones, eggs, feathers, turtle shells gathered on the beaches of Cape Cod and Long Island. She was friendly with Ray Johnson at the time, exchanging mail art with him, although she kept getting annoyed by how late he would show up at her loft, and a flip story he liked to tell of a friend carelessly destroying a wire sculpture given to him by a woman artist, probably Ruth Asawa, when the friend sat on it. No doubt this story was particularly painful for Tawney, as another woman artist working to have her craft be understood and seen as art.

In 1965, the fiber art pioneer and Bauhaus alum Anni Albers published *On Weaving*, which would become a central treatise on the history of textile art. In addition to its emphasis on the ancient weaving traditions of Peru and their importance for contemporary artists, Albers included Tawney's *Dark River* as one of the illustrations. Tawney had been written into the new canon of weaving.

In 1966, she moved again, to the loft on Spring Street that so captivated Schuyler. She had a solo show on the East End of Long Island at the Elaine Benson Gallery, where to her great delight the twenty-seven-foot *Untaught Equation* hung from a giant elm tree outside. Mildred Constantine, the curator of architecture and design at MoMA who had bought Tawney's *Dark River* in 1963, began planning *Wall Hangings*, a major show of textile art for the museum with the textile designer and collector Jack Lenor Larsen, who had interviewed Tawney for *House Beautiful*. It would open at MoMA in 1969 after traveling to eleven cities in 1968–69. The show sought to demonstrate how, over the last ten years, "developments in weaving have caused us to revise our concepts of this craft and to view the work within the context of twentieth-century art."

Against this framing, the artist Louise Bourgeois, one of the few reviewers of the show, found that its works "rarely liberated themselves from decoration," and were far less demanding on the viewer than painting or sculpture. Constantine was furious at this reception: "It represented exactly the attitude we were trying to work against." Within the craft/fine art divide is a racist and gendered one too. African American and Indigenous traditions passed down craft and textile as some of the earliest utilitarian art. In 1968, one of Tawney's great critical champions, Katharine Kuh, would couch the artist's work within a confession that immediately resigned it to a very particular domestic domain. "Until recently, I always considered weaving a ladylike pursuit for frustrated housewives," she wrote, "but I am drastically changing my mind. The best weavers are, to be sure, still women, but some of them are also first rate artists."

Tawney saw Martin briefly after Martin left New York, in 1967. She flew out to California and they traveled together through Big Sur, Death Valley, Las Vegas, and Flagstaff in Martin's camper van, during the five-year period when Martin was not speaking to anyone or making any art. During this trip, Martin had one of her schizophrenic episodes, and Tawney held her head in her lap in the van. But this reunion was brief. "I was with her for twelve days in her camper traveling around but now I don't see her, I don't write, I don't have any contact at all," she explained in an interview in the 1970s. In 1991, Tawney would visit Martin in her remote Cuba, New Mexico, home, one of the last times the two saw each other.

In 1973, Larsen and Mildred Constantine published *Beyond Craft: The Art Fabric*, a survey of the textiles movement in the 1960s and, like Albers's *On Weaving*, a touchpoint for the growing interest in the serious art of woven forms. In its pages, they called *Dark River* (titled simply *The River* and dated to 1961, not 1962) "the undisputed masterpiece of Tawney's major black-and-white period."

Tawney continued to think about the Slip, and the relationships

and materials it brought her. In one journal entry from 1978, walking downtown, she wrote,

> So much is recalled by the smell of the river. Coenties Slip, the
> Battery, tugs, the ferry, Battery Park in the rain, in the snow . . .
> I recall one Easter, Agnes and I took the boat to the Statue of
> Liberty. It rained and was cold. Whenever I was in Battery Park,
> I picked up pigeon feathers, even birds.

In a commencement address at the Maryland Institute College of Art in Baltimore in 1992, where she also received an honorary degree and put on an exhibition, Tawney framed place as the central motivation for her art, within an internal geography. She spoke of an artist's need for the work to come from a place in one's deepest self, at once "mysterious and thrilling. The attitude of openness toward this place in yourself can be like the thick bed of leaves on the forest floor. It is always there no matter what goes on above." She went on,

> One thing I must tell you: what we most try to avoid in life is, in
> fact, our greatest teacher—that is pain, anguish. This pain and
> this anguish take us off the surface of life and into the depths
> where the treasure lies. This is your life, dear friends; meet it with
> bravery and with great love.

# 22

## ELLSWORTH

1963

IN HIS LAST MONTHS at the Slip, Kelly bought yards of canvas from a marine hardware and sailmaker company on Chambers Street, bringing his supplies back to paint on in a loft where once such canvas was used to sew sails. One of the final works Kelly made there was *Blue Green Red*, 1963, which was immediately snapped up by Henry Geldzahler for the Metropolitan Museum of Art. Kelly had been working on a suite of figure/ground paintings employing these three colors since 1958, though he never considered them an independent series. But they were among the most important paintings that he made at the Slip, a reflection of his breakthrough. Parallel to Martin's own experience, he explained, "I was deciding what I didn't want in painting and just kept throwing things out."

An explosion of color after a period of mainly black-and-white, or black-and-a-single-color works painted at the Slip, and an expansion on his initial use of the primary colors, red, yellow, and blue, these works also signaled his "discovery" of the curve in New York. These are "voluptuous" works, to borrow a term that Kelly often applied to his painting, even if it seems antithetical to their straightforward

presence. Many were shown in his November 1963 Betty Parsons show, about which the critic and curator William Rubin noted that the works' "intense color" introduced "a starkly reserved and ascetic style" that produced "a peculiarly American combination of the hedonistic and the puritanical." The same could be said of Martin, who coupled a disciplined minimalism with an exuberant celebration of what art could be—an approach mirrored in their countless talks in Martin's loft about finding an egoless plane for working. Unlike his neighbor Youngerman, Kelly did not want to focus on the edges of his painting, even as his technique was often referred to as "hard edge," and preferred instead to think about "mass and color." For Kelly, the edges were incidental, things that "happen because the shapes get as quiet as they can be."

These colors, like so much of Kelly's work, emerge from a vivid childhood source. When he was twelve and out trick-or-treating on Halloween, he saw a bright spectrum in a ground-floor window of a house, but couldn't discern what exactly he was looking at. When he got close to the house and "chinned" himself up to the window, he looked in on a "normal furnished living room." But when he backed away, he again saw the strange trio of colors. "This was probably my first abstract vision." In the end, it was just a red drape, a fireplace, and a blue couch at different distances that created the effect, but Kelly was so dazzled he stopped trick-or-treating and stayed looking on the lawn of the house. Another more recent reading, by the art historian Sarah Rich, points out the ascendance of color television during the period that Kelly was making these works, with its green, red, and blue projected light waves. NBC, the first corporation to broadcast in color across the United States, adopted the trio of colors for its well-known logo in the 1960s.

The first time Kelly isolated these three colors together was in 1956 on a postcard collage, *Beauty Contest,* that grouped three circles of red, green, and blue cut from a magazine onto a black rectangle,

which was itself collaged onto images from a bathing suit contest and the profile of a man's head. And then, in 1958, he painted *Mask*, a small canvas just over two feet tall, in which a blue triangle and a red tilted rectangle cut left into a green field. The blue could be a cutout for eyes and the red for a mouth, but this assumption comes only with the title; and in fact, like so many of Kelly's bait-and-switch titles, the composition was derived from the pattern of shadows falling on a book he was reading while on the bus in Staten Island in one of his first excursions in New York.

In the midst of this exploration of color, Kelly moved uptown, to the ninth floor of the studio co-op Hotel des Artistes at 1 West Sixty-seventh Street. Kelly was forty years old when he left the Slip, a decade after arriving in New York. He went from a derelict, illegal sail-making loft, where a few struggling artists dared to tread in makeshift apartments and borrowed showers, to one of the most famous artist studio buildings in New York, one designed specifically for artists from its founding. The Hotel des Artistes had huge north-facing windows, as well as much smaller rooms that struggling artists could afford, and was completed in 1917 as a little piece of Paris in New York. It boasted the city's oldest indoor pool, a squash court, a theater, a ballroom where the dancer Isadora Duncan once performed, and a celebrated café. Among the famous artists who had lived there before Kelly were Edna Ferber, Noël Coward, Rudolph Valentino, Zora Neale Hurston, Esteban Vicente, and Berenice Abbott (in the very period that she was photographing downtown New York and the Slip). It was gilded bohemia.

Kelly's major transition was eased by his continued proximity to nature. "At Coenties Slip, I looked over the wide-open water with boats; the high buildings were behind me. Then, when I moved uptown it was necessary to be near Central Park." Kelly took Orange every day to the park, and the subjects of his continued plant drawings, such as *Oak*, 1964, suggest the specimens of his new neighborhood.

Following on his solo show at Parsons, Kelly won a painting prize at the triennial Carnegie International exhibition in Pittsburgh (he must have been delighted that one of the sculpture prizes went to a hero from Paris, Jean Arp), and his first solo museum exhibition opened on December 11 at the Washington Gallery of Modern Art in Washington, D.C., traveling to the Institute of Contemporary Art, Boston, in 1964.

But his relationship with Betty Parsons was not faring as well. In September 1964, Kelly wrote a blunt letter to Parsons: "You have done your job in the way you see it, but the way the gallery operates does not seem to work out for my painting." Parsons was extremely upset by the prospect of Kelly leaving; he had been with the gallery since 1956 and she was "selling him like mad." She told him, "Alright, so you wish to leave me, but please don't go to Sidney Janis." By May 1965, Kelly was showing with Janis, and in 1966, Geldzahler chose him as one of the artists featured at the American pavilion of the Venice Biennale, following Rauschenberg's splashy and controversial Golden Lion win there.

Kelly continued to look for inspiration in the environment around him, even as he had at this point established a diverse source of shapes and colors that he often recycled and revisited from earlier collages, drawings, and paintings. He was working in larger scale and often with reliefs that sat in front of the picture plane or bent the work entirely, like window shutters or religious paneled paintings; similarly, his sculptures always had the flat, two-dimensional quality of painting surfaces. While he was walking in Central Park, his eye was caught by a woman's silk scarf; he followed her until he could work out the proportions of green and white in its pattern, which then informed his *Green White*, 1968.

For a few years beginning in 1959, Kelly summered in Springs, East Hampton, the Long Island hamlet to which Pollock, Krasner, de Kooning, and other Abstract Expressionists had decamped in the

1950s. Kelly worked in a studio near de Kooning's, off Fireplace Road. For several days, Kelly drew the wild grapes that were growing along the side of the road. He was working on a six-leafed specimen (now at MoMA) when de Kooning rode by on his bicycle.

Ultimately, Springs felt too much like the terrain of the Abstract Expressionists, and Kelly looked for a country spot farther afield. He left Hotel des Artists seven years after arriving, in March 1970, when he could no longer rent his apartment, and as he needed more space. His paintings didn't fit in the famous old elevators in the building, and he had to place them, and himself, on top of the elevator to get them down, "holding onto the greasy cables." He moved upstate, to Spencertown, where he bought a farmhouse. He rented a large space in a theater in the neighboring town of Chatham to work on a scale he had never been able to before, and which brought him a new energy and productivity.

In 1973, just shy of twenty years in New York, Kelly enjoyed a major retrospective at the Museum of Modern Art. Hilton Kramer wrote in his glowing review of that show, "If there is something intensely private in the artist's vision, there is also something intensely social in its mode of address." That same year, Kelly looked through his archives of preparatory sketches, materials, advertisements, and newspaper clippings for his art from Paris and New York, and began pasting them into formal groups on large gray boards. These eventually numbered 188 frames, assembled as a portfolio (and later book) called *Tablet*, including a triangular snow-cone paper cup, a cigarette wrapper with an interesting crease, images of sailboats and bridges, some annotated by lines, and the impromptu sketch of his sculpture *Gate* made on an envelope addressed to Martin at the Slip. *Tablet* is a working scrapbook of his daily life in Paris and New York; references to the Slip abound. Clearly as early as 1973, Kelly wanted to assemble the sources from which he was working to document the importance of this period and this place.

Even if many see a strict formula in Kelly's work—from his first experiments in Paris to his larger-scale development at the Slip to his final paintings from 2015—he was constantly adjusting, refining, and expanding his vocabulary, always looking at his environment and what it might offer him as inspiration. "In a sense, what I've tried to capture is the reality of flux, to keep art an open, incomplete situation, to get at the rapture of seeing," he explained in 1996.

In 1999, Kelly bought Youngerman's *Ram* when it came up at auction. The 1958 painting had clear color and compositional affinities to Kelly's own much smaller composition *Orange Blue* for Indiana, and it had appeared in their joint group exhibition *Sixteen Americans* at MoMA in 1959. Now, forty years later, Kelly gave it to the museum. Youngerman saw this as a hugely generous gift, one even more moving for *Ram*'s affinity to Kelly's own pursuits, and a gesture to memorialize that crucial, early time and place in both their lives.

# 23

## JAMES

1963

JUST A WEEK BEFORE the assassination of President Kennedy, Rosenquist left Coenties Slip. He moved into a bigger studio on the third floor of a former Cuban hat factory on Broome Street to accommodate the expanding scale of his canvases. He couldn't shake the Slip or its most famous associated figure, and his nineteenth-century exploration of industry and art: Rosenquist's *Broome Street Trucks After Herman Melville* from that year offers a strange portrait of a red GMC truck, with its bottom half obscured by a yellow filter of paint and a small canvas attached, its image almost but not quite aligning with and mirroring the truck's windshield below it.

Rosenquist made his piece for the 1964 World's Fair at Broome Street, and it was there that he began working on a related project, his epic, multipaneled painting *F-111*. It was a return to his childhood love of flying, but via a terrifying scale: the U.S. Air Force's newest bomber plane, developed for the war in Vietnam.

The huge plane seems to fly through other familiar Rosenquist images from advertisements, or what the artist called "the flak of consumer society": spaghetti with a fork, a young girl under a hair

dryer that takes on the connotations of a rocket ship cone, a cake, lightbulbs, flowers. The painting stretches thirteen feet longer than the plane it depicts, for a total of eighty-six feet. Like his old neighbor Kelly, he was channeling Monet in the scale and immersive space of his painting, but he could not shake the foundation of his own art in commerce rather than nature. He did share with Monet the oblitera-tion of certain orienting horizons. He remembered those long after-noons painting billboards alongside Local 230 men in Times Square, as they talked about how, in the event of an atomic attack, the Rus-sian bombs were all trained on Canal Street, and here on their scaf-folds above the city they would watch it all go down.

The Slip was where Rosenquist developed his style and sensibility beyond, but not outside of, that commercial work, and *F-111* was the painting in which it was all distilled, what his frequent studio visitor, the Metropolitan Museum of Art curator Henry Geldzahler, called, "the grandest" work of Pop Art. Rosenquist painted it in sections in his Broome Street studio because even his new, larger space could not accommodate the size of the piece. Word traveled about the sheer au-dacity of his project, and fellow artists stopped by the studio to see what he was doing. *F-111* was all he worked on for almost a year. Its hangar-like dimensions were designed to fit into his new gallery, Leo Castelli, where it was shown in the spring of 1965 to great critical at-tention if not exactly praise. Castelli managed to sell off most of the panels to individual buyers, but the day the painting was being loaded into trucks to ship all over the country, Rosenquist's first collector, Robert Scull, stepped in and offered to buy the entire work to keep it together.

Despite its obvious gesture toward the military industrial com-plex, with its fostering of a booming war economy and huge con-tracts for war planes, Rosenquist saw his painting as having a more local focus, too. Upon its completion, in an interview with Swenson

in *The Partisan Review,* he dwelt on the New York architecture being demolished all around him, and he described his painting as a kind of architectural relic, made of dozens of fragments of a vision already passing. Rosenquist mused that if the piece had been split up and each of its panels sold separately, it was not unlike someone "collecting it like a fragment of architecture from a building on Sixth Avenue and Fifty-second Street." And he went one step further back in time, to an image of the city in the nineteenth century: "Years ago when a man watched traffic going up and down Sixth Avenue, the traffic would be horses and there would be a pulsing, muscular motion to the speed on the avenue. Now what he sees may be just a glimmer, a flash of static movement; and that idea of nature brings a strange, for me even now, a strange idea of what art may become, like a fragment of this painting which is just an aluminum panel."

Rosenquist's next decades were restless. Still needing more space, he would move to a studio he had built with high ceilings in a little shingled barn beside his house in East Hampton, then back to the same neighborhood as the Coenties Slip studio, to a two-story loft at Water and Wall Streets, to a huge studio in Ybor City, Florida, that had once been a store, then to a house and studio on Aripeka Island, Florida, in the Gulf of Mexico, and a five-story building on Chambers Street in New York. In all of these locations, he was never far from the water; throughout a long career, he was always channeling the attributes of his first studio at Coenties Slip. "Whenever you are near water, there is a luminosity that permeates everything."

In his work and in his daily life, Rosenquist remembered a Manhattan that had already passed before he moved to it. This framing of place was part of his obsession with obsolescence, with incorporating advertising images for items that were already out of style. He thought about "all the things that are lost and gone," and among them, "way down on the Lower East Side," the "big carved marble

dishes for watering the draft horses, put there by the Humane Society. They must have weighed hundreds of pounds, beautiful smooth stone roughs." This was, of course, from a time some hundred years earlier, when horses were the machines of the city, moving all the goods off the Slip's open-air markets and warehouses, hauling streetcars from stop to stop, when editorials were filled with concern over the pollution of so much manure and the animals' hooves chipping away the cobblestones of the streets into dusty powder.

# 24

## ROBERT

### 1964–65

IN 1959, INDIANA STARTED WORK on a nineteenth-century wooden loading ramp he found at the Slip stripped of its heavy metal flanges. For more than two years he tinkered with it, adding eight wheels of differing sizes, their spokes overlaid on the numbers 0–9 just as he did in the sculpture *Mate* from the same period, and painting numbers and arrows next to these roulettes that suggested a serpentine, dizzying journey down the length of the board. The center of the piece is a conspicuous, ragged hole, where "fifty years . . . of use and wear and tear" made their mark. Above and below this gap in the planking, Indiana painted the mirrored letters *M* and *W*, which give the piece its name, *Marine Works*, from the chandlery that formerly occupied his studio. Indiana painted the top and bottom edges black, with red stripes, the same hazard framing from the back of trucks and street signs that he gave to his disillusioned ginkgo love letter painting, *The Sweet Mystery*, also made at this time. In April 1962, he wrote in his journal that he had decided to finish *Marine Works* "once and for all," suggesting that it was a difficult piece for him to let go.

Like *Mate*, *Marine Works* refers to maritime life in its title, its

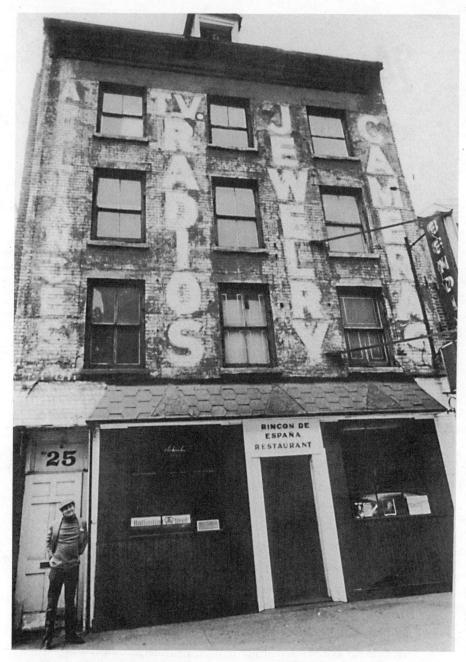

**Robert Indiana outside 25 Coenties Slip, New York, 1965.**

*(Courtesy RI Catalogue Raisonné LLC and Star of Hope Foundation, Vinalhaven, Maine. © 2023 Morgan Art Foundation Ltd.)*

materials, and the erotic edge that the itinerant sailor had long symbolized. Arrows point in all directions, wheels spin like a lottery, and pairs abound: whether a "mate" or in the mirrored *M* and *W* circling each other. Gerry Matthews remembers Indiana getting in trouble trying to pick up sailors at the Rincón de España, the Spanish bar and restaurant on the first floor of 25 Coenties Slip. One sailor got so angry that Indiana had to run up the staircase to escape, and ducked into an apartment that wasn't even his to hide out.

And yet *Marine Works* ended up in the collection of the Chase Manhattan Bank in 1965, selected by Barr, Miller, and Bunshaft. The irony of this didn't seem to upset Indiana, who noted the acquisition not in terms of its benefactor but in terms of place: he was happy that the piece was hung on the sixtieth floor of the new bank skyscraper "overlooking the very site of the Marine Works and whole harbor of New York."

Another important work from a few years later makes subtle reference to love and relationships by way of the sea. In 1964, Indiana made a four-panel painting, *The Brooklyn Bridge*, which was originally meant as a homage to the painter Joseph Stella, whose early-twentieth-century scenes, including the five-paneled *The Voice of the City of New York Interrupted*, 1920–22, celebrated the grand engineering and energy spanning the city's bridges, ports, and skyscrapers. But a visit to the Whitney Museum to see Stella's works in person left Indiana cold, and he decided instead to honor the poet Hart Crane.

Indiana was also aware of Kelly's own series of paintings called *Brooklyn Bridge* from 1962, with their strong white curves against a black background echoing the architectural structure of Indiana's. In the mid-'50s, Kelly had made many sketches of the bridge and its impressive pylons on walking trips over its span; the curator and critic Goossen wrote that he was "especially affected by the way the light broke through the gothic openings in the end pylons and the great sweep of the curves formed by the suspension cables." Though

*Brooklyn Bridge VII* appears to reflect that sweep, its source is actually the blown-up image of piping on a tennis sneaker.

Crane published his epic poem *The Bridge* in 1930. Walker Evans, a neighbor in Brooklyn Heights, contributed several oblique photographs of the Brooklyn Bridge to the first edition. From their windows, Evans and Crane could see the bridge and across the East River to Lower Manhattan and Coenties Slip. Crane had been thinking about this poem for almost ten years. He hoped it might be a "mystical synthesis of America," merging the symbolic power and engineering prowess of the bridge with a romantic sense of the country's pioneer history (where anything is possible and anyone can discover anything). The poem was also a homage to Whitman's "Crossing Brooklyn Ferry" and an ode to a Danish sailor, Emil Opffer, with whom Crane lived for a time in Brooklyn.

Much like the contemporaneous reception of his literary heroes Whitman and Melville, whose writing would be hailed as quintessential American masterpieces only after their deaths (with few exceptions), reviews of Crane's poem were negative: *The Bridge* was accused of not measuring up to its ambitions and of overreaching in its scope and language. Within two years, Crane jumped to his death from a ship at the age of thirty-two, as he was sailing back to New York with his new fiancée, allegedly after making a pass at a sailor.

Indiana stenciled lines from Crane's poem on each canvas, running in a kind of semicircular laurel pattern around the edge of the round painting of the Brooklyn Bridge in gray, white, and black tones: "And we have seen night lifted in thy arms / Silver-paced as if the sun took step of thee / Thy cables breathe the North Atlantic still / How could mere toil align thy choiring strings."

In his final months at 25 Coenties Slip, following the rush and inevitable letdown of the World's Fair, Indiana turned to a series around the theme of love that would become his best-known work, and, despite the word that launched it all, what most alienated him

from the New York art world. Of his *LOVE* art, Indiana later said, "It was a marvelous idea, but it was also a terrible mistake." The work came to overshadow all of his others, and fostered assumptions about his success and even selling out that did not align with reality.

···

AFTER KELLY AND INDIANA broke up, Indiana made a not very subtle painting, *FUCK*, in which the *U* is tilted, much like the *O* in his later *LOVE*. Kelly was horrified. Indiana started using other related words, including *FOUR* (another reference to love in its numerical makeup, and a departure, like *Mate*, from the three-letter imperatives of his earliest word paintings). In 1963, he began *Column Love*, one of his herm sculptures using found nineteenth-century columns from the neighborhood, with *LOVE* stenciled in white around its width and seven rows high, and *COENTIES SLIP* at its base. (He also made a pendant work, *Eat*, further connecting that term to a mother's love.) An unusual work from the same year, *Flagellant*, stands alone as a unique sculpture unrelated to his herms. The column, just over five feet tall, is painted tar black, with a red band from which ropes fall to the floor, and a white top on which is stenciled the work's title in black; the whole color scheme resembles the hull of a freshly painted tugboat. The thick ropes curl on the floor into loops that hold metal rings. In its resting state, it's ominous, with religious and sexual overtones of a punishing love, as well as the manacles of slavery that haunted the earliest days of the Slip.

Then, in December 1964, Indiana made a Christmas card he sent out to friends that stacked *LOVE* on two lines, *LO* (with a tilted *O*) on the top and *VE* below, to form a square. He used found stencils from the loft that he rubbed colored pencils over, using an old technique of frottage—itself a sensual process exploited even in the 1930s by the Surrealists as an erotic drawing action. One of the recipients of his

homemade holiday card was the MoMA curator Dorothy Miller. The next year, MoMA asked Indiana to design one of its annual artist-made Christmas cards, a successful program initiated at the museum in 1954 through its Junior Council. (Jack Youngerman had designed one in 1964.) Indiana took up the *LOVE* composition again, but in painting form, offering several options in different colors. The museum chose the combination of red letters against a green-and-blue background, a very Kelly combination, and it became one of its bestselling cards.

In May 1965, Miller wrote to Indiana thanking him for filling out the museum's questionnaire on his work *French Atomic Bomb*, and adding, "How terribly sad to think of you forced to leave Coenties Slip but I am relieved that you have another place and near Louise," meaning the sculptor Nevelson. Indiana had to leave in June 1965, as number 25 was getting demolished, and found a new loft in an old five-story luggage factory on the Bowery. He was soon occupying the whole building.

In November 1965, just a few months after his move, he agreed to a series of interviews with the psychologist Arthur C. Carr to explore the sources and origins of the creative process. Carr was himself an avid art collector and friend of Indiana's. In the summers, Indiana would visit Carr on Fire Island, and the wheel on his herm sculpture *Slip*, 1961, came from one such trip there.

Indiana would stay on the Bowery for thirteen years. It was here that he developed most of his LOVE works, for which he is best known, first shown in May 1966 at the Stable Gallery in an edition of six one-foot-high aluminum sculptures. Indiana did not believe in copyrighting a universal term, so he could not control the proliferation of posters, objects, and signs using his signature lettering. In 1973, Indiana's *LOVE* was chosen by the U.S. Postal Service for its eight-cent Valentine's Day stamp. He was paid $1,000.

Asked that decade if he felt like he'd received proper critical attention, Indiana answered vociferously no. He had many ideas about why his star had faded, including that "the very first person who took

my work seriously, and he happened to be the first American critic who took pop seriously, had to go and get himself killed."

Gene Swenson, the most important critic for Indiana and Rosenquist, died suddenly in 1969 in a car accident in his hometown in Kansas. He was thirty-five. Swenson had been going through a difficult time just before then. In the mid-1960s, Ann Wilson, who had not been living on the Slip for a few years but still visited Martin and Tawney downtown often, left her marriage for Swenson. It was a tumultuous affair, in part because Swenson also saw men and he and Wilson both struggled with mental illness. In 1968, he suffered a breakdown in New York following the death of Robert Kennedy, complained of hearing voices, and ended up in Bellevue.

Swenson picketed from eleven to two every day outside the Museum of Modern Art for several weeks in the bitter winter days of 1968–69, carrying a huge blue question mark, though only the year before he had curated an exhibition there. He was trying to draw attention to the connection between museum management and America's policy in the Vietnam War; while he marched alone (occasionally joined by Wilson), his actions presaged important political demonstrations and more organized protests by the Art Workers Coalition against MoMA the following year. Jill Johnston remembered picking Gene up from Bellevue Hospital and driving him across the bridge, "and he hung a hand out the window like a boy in a boat having never felt the drag of the water before." Rosenquist, who had visited Swenson in Bellevue, invited him out to East Hampton for some relaxation; from there, Swenson left to travel back to Kansas to see his family. At the time of his fatal crash, Wilson was on the remote Italian island of Ponza with her friend the artist Paul Thek. Thek's companion, the photographer Peter Hujar, traveled from New York to Italy to tell Wilson the news in person. As the critic Gregory Battcock wrote, "When Swenson died, many of us felt as though we had lost our conscience."

If Indiana had also lost his biggest champion in the press, he felt adrift without his Coenties Slip community, and in the following decade seemed to turn on some of his closest friends from that period. Perhaps unable to fathom the egoless Zen state that Martin was pursuing, he was quite blunt about her own career trajectory just a few years after he had helped rescue her from Bellevue, a trajectory that seemed diametrically opposite to his own quick rise and then fading. "By a strange irony it worked just the reverse for Agnes Martin. She had her early shows at Betty Parsons. It meant absolutely nothing. Nothing happened at all. It took her near-insanity and her moving away from New York and making herself into a myth to get *her* wagon moving."

After losing his lease on his Bowery studio in 1978—he had illegally occupied the building for three years before it was sold—Indiana moved permanently to Vinalhaven, an island in Maine, whose granite rocks were used in the building of the Brooklyn Bridge. He spent the final decades of his life with a direct material connection back to his Coenties Slip loft: "And since for eight years I used to look out of my window every day and see the Brooklyn Bridge, it's nice now to have a studio in the home of the Brooklyn Bridge." Two vans had made a dozen trips each to move all of the objects, artwork, and salvaged materials from Indiana's New York years to Maine.

He lived there until his death in 2018, sometimes in a seclusion that was at odds with his social presence in New York City in the 1960s, in what he called "self-imposed exile." He had an "Ellsworth Kelly room" at Vinalhaven with many of the artist's line drawings, including some of Indiana sleeping, and Kelly's painting *Orange Blue* (inscribed "FOR ROBERT AN ORANGE PEEL FROM PIER 7") remained in his personal collection. When asked in 2013 what it would take to get him back to New York, Indiana answered, "A very lovely loft on the waterfront for thirty bucks a month."

# 25

## AGNES

### 1964–67

MARTIN CONTINUED TO LIVE a little apart from the world. Unlike her fellow Slipmates Rosenquist, Indiana, and Youngerman, she didn't want her paintings to reflect anything from daily life, other than perhaps its material vestiges or passing weather. Or rather, influenced by her readings, she saw it as all connected in a seamless field that made any one piece of it equal to anything else. As she wrote in the conclusion to her 1973 text "The Untroubled Mind": "The wiggle of a worm is as important as the assassination of a president." This was certainly not how other artists at the Slip felt on news of Kennedy's death. But it reflected her Taoist interest in an egoless, unified field.

In 1964, the Whitney Museum of Art purchased her six-by-six-foot canvas *Milk River*, painted the previous year. The square of horizontal lines seen in *The Dark River* had now expanded almost to the edge of the canvas, and the ocher lines against a white background are much steadier, as if pulled more taut. The eye wants to see pink.

Jill Johnston visited Martin in her South Street loft in 1964. The two would sometimes go camping upstate as an escape from the city,

Agnes Martin working in her South Street studio, New York, May 1961.
Photograph by Fritz Goro.

*(Fritz Goro/The LIFE Picture Collection/Shutterstock.)*

with Martin "tearing off her clothes yelling at last one with nature,"
and jumping in the river. Ann Wilson also recalls going camping with
Martin and Tawney upstate and on the far side of Staten Island; Mar-
tin excelled at building campfires and they would cook coffee in a pot
directly over the flames.

Martin made Johnston tea (her loft was very cold), and hung paint-
ings on nails on the wall for Johnston to view in "a quiet concentrated
ceremonious ritual." As the critic wrote in *The Village Voice*, with her
Steinean syntax: "I knew she was one of the great women. It was a plea-
sure finding a great woman in new york city during the terrible times
of the 60s during every terrible decade it's a pleasure finding a great
woman . . . one way you knew agnes martin was great was because she

lived decisively alone and that this was an active irrevocable choice and because she put very little stock in people at all and another way you knew she was great was because her paintings were."

By 1964, Martin had been compared to her hero, Reinhardt, in a key review by the critic Barbara Rose, who felt that "they are related to the most important painting being done today." Both were looking for purity; both insisted on an extreme discipline in approach to composition. And a year later, Johnston would describe the "quiet intensity" of Martin's rectangles, revealing the critic and artist's bond over struggling with mental health in stating: "The pictures are, as the artist says, like tranquilizers."

In 1965–66, Martin took a trip to Pakistan and India, which had to be cut short due to a mental breakdown. But an airmail letter she sent to Tawney during her travels indicates how, beyond any other unknown or unresolved aspect of their relationship, they supported each other's ability to make art. "I hope everything is going well with you especially the work. It gives me great pleasure to think of your work from here," Martin wrote, and, hoping that Tawney's holiday at Jack Larsen's house on Long Island was restorative, she continued, "I have so much confidence in you that I cannot imagine your doing anything that is not just right in work or in play." She signed off "love and best wishes Agnes." A second letter ("please excuse the red ink") rekindled their shared "mad passion for the sea," and Martin told an anecdote that she no doubt thought Tawney would appreciate, about climbing up into the mountains outside of Genoa, Italy, to pick twenty-two varieties of wildflower that lasted a long time in water.

In October 1966, on the encouragement of Reinhardt, Martin was one of the artists included in the exhibition *Ten* at Virginia Dwan's New York gallery, organized by the artist Robert Smithson. Other artists included Carl Andre, Jo Baer (the only other woman, and also a painter), Dan Flavin, Donald Judd, Robert Morris, Sol LeWitt, and Michael Steiner. Her painting *Leaves* from that year was one of the

few canvases on view; all of the works were stripped down, simple geometries, mainly sculpture and wall reliefs, but the small space felt very full with a new energy, purpose, and look. As the art historian Christina Bryan Rosenberger put it, "Martin's work, so long in gestation, suddenly appeared relevant for a new group of artists and critics championing minimalism."

Martin was initially flattered to be included ("they were all so young") but increasingly felt uncomfortable being lumped in with "those boys"; she always insisted she was more of an Abstract Expressionist than a Minimalist, mainly because she did not want to lose the idea of "expression" as an element, however elusive, of the work. In any event, she was her own thing.

The show proved to be one of those pivotal moments in art history, seen in retrospect as helping define a generation of artists, even if at the time no one in the group could agree on what their work represented. The straightforwardly descriptive *Ten* was for the show's ten artworks by ten artists. Even then, Judd complained about Smithson suggesting any affinities among the cohort. As writer Nancy Princenthal has pointed out, Martin's inclusion in *Ten*, and several other major group exhibitions in New York at the time, created conflict for an artist who had fought to be seen and collected, but also fiercely protected her solitude and independence. "To feel confident and successful is not natural to the artist," Martin once said. "To feel insufficient, to experience disappointment and defeat in waiting for inspiration is the natural state of mind of an artist."

And yet: she loved to hold court. Johnston brought a group of five or so people over to 28 South Street in 1966, "and we sat around in a vague circle in a sort of a trance as though it was a seance although nobody mentioned it." Martin was leading them through various mind exercises, "and there was at one point this great overhead crash . . . whatever it was she didn't bat a lash she went right on talking."

...

IN JANUARY 1967, an old friend of Martin's from New Mexico, Mildred Kane, visited her in New York with her young niece Susan. Martin met them at her South Street studio wearing the thick quilted white jumpsuit that kept her warm in the drafty space. The day's itinerary included two museums. Martin took them to the Jewish Museum to see the Reinhardt retrospective just before it closed. And then they went to the Museum of Modern Art, where Martin's *The Tree*, 1964, was on view. Standing in front of the painting, Martin anxiously waited for the women to respond.

*The Tree* represented an important breakthrough for Martin, not just because of MoMA's quick interest in purchasing it in 1965 (the first of her art to enter the collection). Working on the canvas with horizontal and vertical bands of oil paint and pencil helped solidify her compositional strategy of the allover grid. "One day when I was waiting for inspiration I was thinking of innocence and a grid came into my mind and I thought, well, I guess I'm supposed to paint it—it didn't look like a painting to me, but I painted it, 6 by 6 feet tall and it looked like innocence very much. I called it a tree." Her title was possibly influenced by the early-twentieth-century painter Piet Mondrian, perhaps the most famous painter of grids, and a hero for Reinhardt and Kelly, who no doubt spoke with Martin about him. Mondrian had made an important series of paintings of a tree in 1908–13 in which the plant becomes increasingly abstracted in a kind of glorious reduction to line, form, and color. And here, just as the interior, unseen rings of a tree trunk mark its age, Martin's grid charts an understanding of something—not the representative whole in nature, but some reflection of it. As Frances Morris has written, Martin's description of creative inspiration for *The Tree*, freighted with Old Testament reference, can be seen

"as an allegory of arrival, referring to a moment of realization when things, much worked towards, fall into place." Yet just as Martin seemed to be "arriving" in New York and into her work, she was getting ready to leave.

The last painting that Martin made at the Slip, *Tundra*, was sold to the curator Sam Wagstaff. "I think my paintings will be around quite a while as I perceive now that they were all conceived in purest melancholy," she wrote to him. It is one of her most subtle paintings; barely perceptible graphite pencil lines separate a foggy canvas into six equal rectangles that extend to the edges of the canvas, freer than her initial, tight grids, and the final one of her series.

Martin walked right past Indiana on South Street without a glimmer of recognition. A few days later, she was found by a stranger wandering the streets of Manhattan utterly confused, and taken to Bellevue Hospital, where she was put with other anonymous patients in a dirty space that was as much a prison as it was a hospital room. There she underwent electroconvulsive therapy. (She told a friend that she had received more than one hundred rounds of electroshock therapy treatment.)

Orderlies found a scrap of crumpled paper in her pocket with Indiana's number jotted on it. The hospital contacted Indiana, who came with Tawney. Indiana was able to get Martin removed from state care through the intercession of his friend the psychologist Arthur Carr. When Carr and Indiana visited her at Bellevue, "a rat, or a mouse, ran across the floor." They had her transferred to Columbia Presbyterian Psychiatric Institute, on 168th Street in Manhattan, where Carr headed up the ward and she could read *The New York Times* and eat a good breakfast. (Carr implied that she hadn't been eating well down at the Slip; when she was caught up in her paintings she saw food as a "distraction." And yet this was also the same person who made her famous blueberry muffins every week there. She would later tell her dealer Arne Glimcher about her ex-

treme discipline and reduced diet, so that one winter she ate only cheese, tomatoes, and walnuts.) At Presbyterian, she was given antipsychotic drugs, most likely Thorazine, a heavy sedative. She told Youngerman when he visited, "They're taking good care of me, and I'm going to stay until I'm able to live on the outside." She went out for hours at a time, then eventually eased into going back to her loft to stay overnight before returning to the hospital, then finally was able to be released home.

...

A CASCADE OF difficult events happened quickly after that. Her building at 28 South Street was marked for demolition. And then, quite suddenly in late August, Reinhardt died of a heart attack in his studio at 732 Broadway. He was just fifty-three, two years younger than Martin. In the summer evening light of 1967, Martin made a bonfire outside her studio and threw many of her paintings into it. "The very day that I heard they were going to tear down my loft, I also got a letter that gave me a $5,000 award for painting." She took her grant money from the National Endowment for the Arts and bought a camper.

. She cut off her long hair, sold the few possessions from her loft except her Acorn stove, gave away her paintbrushes and supplies to Glimcher to redistribute to young artists, and set out west to wander around the country. It was a total purge, as her New Mexico friend Kristina Brown Wilson explained: "She knew, I think, that the only road to sanity was to get away from New York, get away from painting, give up everything." And so, "She gave up New York, she gave up coffee, she gave up smoking, she gave up reading, she gave up people." She claimed that she had to have time, and she no longer had that in New York, following newfound recognition from her appearance in several major shows. "In New York, I would stay in bed until the late

afternoon sometimes, waiting for inspiration so I could get up and paint. Then, I would start painting and be interrupted by a phone call or a visitor . . . you could say I wasn't up to the demands and everything, the life I had to live there . . . So I had to leave."

As Martin wrote to Tawney from the Grand Canyon in November 1967, "I must give independence a trial. I will have to have more time. I am thinking about you too with love, Agnes." And to the curator Sam Wagstaff, "I am staying unsettled and trying not to talk for three years." But Martin's self-imposed exile was hardly the hermetic retreat into silence that she, and others, often framed it as.

As she told Johnston a few years later of her time in New York, "I had ten one-man shows and I was discovered in every one of them. Finally when I left town I was discovered again—discovered to be missing." And in an interview in the 1990s, she told the writer Bettina Eisler that she could abandon New York because "I had established my market so I felt free to leave."

Like so many aspects of Martin's life and work, there's also a contradiction here. Even as she might have felt that she had established herself enough to leave New York and still be remembered, she was also overwhelmed by the ambition of a younger generation of artists just coming up in a newly lucrative and quickly metabolizing gallery system. She also claimed in a later interview that she was driven out of New York "by the lust of the young painters wanting to be so successful. I thought, I'll just go away and let them be successful in my place." It's difficult to square this statement with the artist marching her drawings into MoMA for consideration, and indeed, her "return" to art in 1973 with a major exhibition at the Institute of Contemporary Art in Philadelphia and a print portfolio that was prompted, in part, by her dissatisfaction with what the young painters were doing, and her need, therefore, to "start again."

...

MARTIN RETURNED BRIEFLY to New York during the '70s. She wanted to visit Kelly in his new studio and home in upstate New York. Kelly met her at the train station in Hudson. Martin stepped off the train and said, "I just came to say thanks. Now I can go back to New York." Kelly had to explain that the train wasn't headed back to the city and that she would have to at least stay the night. But as Kelly put it, "I understood that she didn't need to have a long visit. She just wanted to touch base, hold hands, as a way of hearing me say, 'Yes, you are working. You *are* going ahead.'"

# AFTERWORD

# COLLECTIVE SOLITUDE

"GO FROM CORLEARS HOOK to Coenties Slip, and from there, by Whitehall, northward. What do you see? Posted like distant sentinels all around the town, stand thousands upon thousands of mortal men fixed in ocean reveries." Though the poetics of Melville's famous passage that launches *Moby-Dick*, and that Indiana and Youngerman incorporated into their art workshop brochure, seems at odds with the bustle and business of the neighborhoods he maps, Melville knew that New York was a place divided between its bedrock foundation and its boundless surroundings, and that downtown brought out this tension between the ambitions of land and sea most openly. Nowhere is that bifurcation more prominent than a slip, which by definition is both land and water: a place that is also a displacement, something cut away, then filled in by another material.

Place is a tricky protagonist: fickle and, for too many uprooted or dispossessed, not guaranteed. It's all around us, its ubiquity rendering it almost invisible, structuring the way we live and get to work and who we get to be, now invading even the virtual realms of our screen lives. "Places are not inert containers. They are politicized, culturally relative, historically specific, local and multiple constructions," the anthropologist Margaret C. Rodman argued. A place is not just the setting for a narrative; it is the very narrative. And that narrative takes on a particular richness in art. "No great and beautiful building was ever built, no profound and eloquent picture ever painted, no

word of truth was ever spoken, without its being asked by the time and the place and the people," Swenson grandly proclaimed. Or, as the critic Thomas B. Hess put it, "Place is a precondition for work."

There's always a nostalgia for an era before one's own in a particular spot. "Why should [New York] be loved as a city? It is never the same city for a dozen years altogether. A man born in New York forty years ago finds nothing, absolutely nothing, of the New York he knew," *Harper's Magazine* lamented in 1856. The Slip carried its past into the contemporary moment in a unique way, its presence more apparent as a kind of living fossil of the United States' and the city's history. Crews of immigrants and people of color dug Coenties Slip out and built it up in the seventeenth century, and crews of immigrants and people of color bulldozed it down and rebuilt it as something else in the twentieth. Throughout, it was always a place hovering between two elemental boundaries that defined it. And therefore a site of itinerant communities: sailors on brief shore leave, journeymen sailmakers, squatting gamblers, drinkers, prostitutes, truck drivers idling while their wares got loaded onto their wagons, canal boaters, homeless children, artists who knew they were living and working there on borrowed time.

The artists' decade on Coenties Slip is about a suspended time within a liminal place, and what they could make of it. This setting fostered the development of what I've called here collective solitude—a model of creativity that is not about a movement and its manifestos, a set of ideals to work toward, or even a shared sense of what art needs to be. It is about being together in a very specific place at a very specific time, without denaturing each individual, locked-away story. It's about knowing that there are others around you—above and below, just down the block—who are also trying to work out how to make something compelling, and how to survive while doing that. But also knowing that you are alone and free.

This is a far cry from what has been defined as our virtual condition today, tethered to handheld technology, what Sherry Turkle has called being "alone together" on our devices. The artists of Coenties Slip benefited from their communal isolation—it was key (and for some, a mental necessity) to their being able to work. And they had their specific environment to ground them in a shared experience with specific parameters, unlike the infinite map of the Internet's solitary community. As Youngerman spoke of the lack of café culture in the United States versus Paris, everyone at the Slip "wanted to be alone and working alone, and so staying with your thoughts, and that's very important in the creative arts . . . But it can be crushing when there's no kind of outside alternative to it. You're there in this space alone. And I think it makes it very hard for artists in America without that." Youngerman saw this as an important urban issue; how artists want intellectual stimulation and exchange, rich and various culture, but also have "this great need for daily aloneness . . . There's no opposition there. They actually go together." Or, as Martin wrote (even if she broke her own credo): "A studio is not a place in which to talk to friends . . . [they] should be met in cafes."

Artists occupy two places: the physical studio or spot where they make their work, which they are often pillaging and stripping clean for material and details; and the interior space of their creation. It's the "two countries" that Gertrude Stein described for writers, who are "interested in living inside themselves in order to tell what is inside themselves." It's another way of understanding what "collective solitude" protects—the outer place that gives you an identity, a community, and the inner place that allows you to work. This was most central for Tawney's and Martin's understanding of creativity, and they were drawn to writers and thinkers—Stein, St. Teresa of Avila, Lao Tzu—who explore this inner space obsessively in their work. As Martin once put it, "Many artists live socially without disturbances

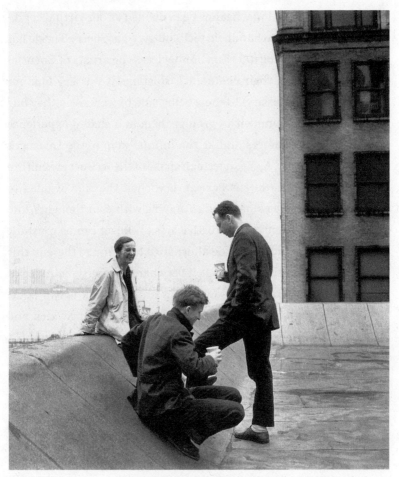

Agnes Martin, Jack Youngerman, and Ellsworth Kelly on the roof of
3–5 Coenties Slip, New York, 1958. Photograph by Hans Namuth.

*(Courtesy Duncan Youngerman/Jack Youngerman Archive. © 1991 Hans Namuth Estate.)*

to mind, but others"—and the implication here is that she means
herself—"must live the inner experiences of mind, a solitary way of
living."

The Slip artists looked out for one another's welfare and protected
one another from conditions that made it impossible to work. This
meant helping one another haul scavenged supplies from the street

up the narrow stairs to their studios, or aiding a neighbor in getting the best psychiatric treatment, or buying a fellow Slip artist's work at a crucial time for them, or letting a friend make a painting in your larger studio. It meant teaching a younger artist how to stretch a canvas, or lending your hot shower, or writing passionately about someone else's work.

They may not have all agreed on what they were doing to advance art, though they all had that ambition in their own way; they may have harbored jealousies about the different economic situations in which each of them was living, the seemingly arbitrary launches into success or continued obscurity that a specific studio visit might set off; they may not have had the operatic gestures of passion and betrayal, usually fueled by alcohol, that trailed the New York generation before them at the Cedar Bar and the generation after them at Max's Kansas City restaurant; they may not have thought of themselves as particularly connected, other than through this strange little street and the daily habits it forced one to share; but they all agreed on the need for a separate space to make art and the almost sacred need to protect that place from ever being a scene. Wilson was inspired by how her fellow Slip artists "created a gestalt about the total commitment to the work and the life there." Call it commitment, call it love. It's a kind of quiet generosity that is rarely noted in narratives of modernism, and certainly not celebrated in history's steady march of disruptive geniuses whose talents are stoked in their narcissistic drive.

"I think often of you and your work," Mitchell wrote to Kelly around 1957, "and how fine it is to know that the beauty of that part, very specifically that little set-apart area, villa Jeanetta and environs, is helping in its subtle influences to bring great art into being (even if I am no longer there)!" The blunt truth is that if these artists had never found their way to the Slip—via friends met overseas, word of mouth, accidental run-ins in art stores, and circumstantial necessity to locate the cheapest space possible in the city—American art and culture

would not be the same today. While working on the Slip, these artists changed how we understand major themes of twentieth-century art—whether abstraction, Pop, Minimalism, or textile art—even as those categories cannot properly contain the story of what happened there, and even if that story is not always about celebrated accomplishments but waiting and watching. We have to see their art apart from those neat categories, which never fully encompassed them, and root it instead in how and why it was made at a place like Coenties Slip. It's an origin story that has as much to do with what happened in New York City as it has to do with what happened in art history. And like the art made there, Coenties Slip is at once indispensable and invisible in the ways that that history has been written and understood.

Aside from the actual artworks, what came out of this place? Kelly revolutionized what abstraction could be; how it could come about and connect to one's environment. His exacting if playful sourcing of color and composition from nature—whether paving stones or stones from the beach—was an inspiration for Indiana, among many other younger artists searching for alternative approaches to relating to the world. Indiana also looked to the Slip's working-class environs to think about how labor and identity linked with a sweeping aesthetic history of the country. Like Martin, he was "at sea" before he landed at the Slip, and found his harbor and his calling there, in large part due to the influence of the other artists around him—inspired and challenged by what they were doing to find his own distinct voice, creating work that grows only more relevant in our meme-filled life, where "love" and "eat" and "die" are socialized with alarming inequality across the platforms of our daily scroll. Along with bringing his commercial skills and scale to picturing the United States as a kind of anti-advertisement of its virtues and vices, Rosenquist presaged digital art and postmodernism's mash-up of high and low imagery while constantly undermining the instant nostalgia that muffles our critical approach to the near past. Tawney's dedication to

her woven forms helped spur a turning point in textile art's reception as something central to a long tradition of art-making in the Americas. It would be a while before that position was fully realized: her work was still framed at the time as a domestic hobby and inspiration for readers of *House Beautiful* to pursue their own artistic potential. But even that kind of conflation offered an important new accessibility to high art—not as a hallowed, academic pursuit but as something you could do in your home. Martin came into her own at the Slip, in a city where she could draw from her expressionistic mentors and invent new rules for mapping the world onto abstraction via a simple precision that presaged a younger generation's obsession with preordained structure. In a period of both profound productivity and paralyzing breakdown, she laid the groundwork for an oeuvre whose singular path of ritualized painting reached into the twenty-first century. Youngerman's career embodied the arc of American abstract art: its indebtedness to Europe and the Middle East, its rebellion and independence, its refusal to stay the same, and its continual engagement with material experimentation, failure, and evolving forms. At the time of his death, in 2020 at the age of ninety-three, he had just shown new work and was still contemplating what it meant to be associated with artists who had gone on to a certain level of celebrity but to have remained somewhat under the radar himself. As he humbly put it in our last conversation, he'd like to think that his body of work contained "something there that didn't come from anybody else, and that has a certain interest beyond my life." In the films she chose to act in and make, the people she chose to work with, and the way she used her glamorous public persona to advocate for some of the most controversial and polarizing rights for women, Seyrig changed the template for a movie star in ways we take for granted today. Her time on the Slip among so many other artists, toggling between her roles as a wife and mother and actor, before she had much choice in her career, crystallized her aspirations.

The Slip artists not only forged alternative models for what art could be and what it could encompass; they also forged alternative models to conventional city life without any fanfare. The Slip came just before the explosion of "loft living" in SoHo and beyond, and real estate development strategies that understood artists as key gentrifying agents of abandoned or commercial neighborhoods. Unlike in SoHo, its inhabitants did not look to build new institutions or modes of showing their work (though Tawney's loft, and generous collecting, did double as a kind of exhibition space for the Slip artists), or even cooperatives for living. Theirs was a modest existence.

So how can we mark the importance of this breakthrough moment in American art, and even trace a model for future creative communities, while still preserving the Slip's anti-legacy? This is the stark conundrum of collective solitude. It's also the story of the place itself: not of singular genius but of little pathways of influence and intrigue— akin to the anecdote Youngerman tells of Indiana removing some bricks from the wall of his place at 25 Coenties Slip so that he could peek into Youngerman's adjacent studio at 27, to see what was going on with his art, but also just to gain a better vantage on his neighbor's separate world. Collective solitude brought protective cover to the struggle of coming into one's self, but also to the private joys within those limits: Kelly running down the street with outstretched arms, Orange at his heels, to welcome in the new year; Tawney's ecstasy as her weaving rolled off her loom at midnight.

We begin to see how many of the Slip's supporting characters fit into a way of understanding New York more fully through a certain periphery, a certain apartness of spirit bound to the ethos of collective solitude. Betty Parsons insisted that *how* art happens was far more important than *what* was produced, and among her impressive roster of modern artists, she supported many who were not easy to deal with or easily defined, whether because of the work they were making or their relative mental health or both. She turned down her

biggest named artists' proposal to solely represent them, sacrificing their success to take on much-less-known artists whose work she believed in. She relied on feeling and instinct and extreme independence; she barreled through life with an energy for making and finding art that had few equals (Dorothy Miller comes to mind). As Parsons put it, "I have no patience with people who don't know that every moment is filled with magic—can't they see? Can't they see?" Hers is not a gallery model that makes sense in late capitalism, but it was one of the few channels by which the artists on the Slip were able to move forward at this early stage of their career. For Kelly, Youngerman, and Martin, it was her invitation to come to New York that laid the foundation for their arrival in every sense of the word. Richard Bellamy was another outlier gallerist, as Judith E. Stein's recent biography recounts, and it's perhaps no surprise that he shows up at the Slip, too. Gene Swenson and Jill Johnston demonstrated how a new way of writing about art could bring the immediate environment, politics, and messy culture in, without losing the weird sublimity of experiencing something unique. For all its ambition, their writing has an intimate, honest bent: they admitted to astonishment and doubt, to anger and jealousy and the impact that art had not just on the intellect but on the body. We are still catching up to that other side of looking that they pursued, often under tremendous personal sacrifice and mental anguish. Jane Jacobs and Ada Louise Huxtable also worked against grand narratives of progress in their unique battles to preserve overlooked, modest corners of New York. As they argued, the eclecticism of everyday labor demonstrated in the architecture and artifacts of a place like the Slip was as much a monument to New York as any statue to a battle or political leader in Central Park. This legacy of how to think about place has only grown, finally starting to include the most displaced and erased stories of early New York, including communities of Indigenous and Black people.

...

CAN A SINGLE WORK hold the history of the place of its making, without combusting into a run-on metaphor? Maybe that's the other side of collective solitude—the most direct way to tell the story without resorting to the standard narratives it rejects. If one aspect describes a condition of working, the other describes the work the art is left alone to do when it is completed, having absorbed within itself the story of its making, which is always one of time and place, however sublimated.

One of the final paintings that Indiana made at the Slip comes full circle to his first days there. A large canvas with a bold blue background and an aquamarine sphere bordered in bright green, *Leaves* is made in what Indiana called his "summer palette," though we could also say it incorporates colors closely associated with Kelly (for instance, his *Blue Green* of 1962), and, within its reverent tondo, the subject and style of Kelly's plant drawings and the jagged, sometimes shocking boundaries of Youngerman's abstract botanical shapes.

Silhouetted inside the circle in the same green is the solid form of a common plant with drooping leaves found in many of the artists' lofts on the Slip, identified by the art historian Susan Elizabeth Ryan as a dracaena plant, though it also closely resembles Kelly's 1959 drawings of corn plants from the roof of 3–5, and Indiana himself called it "a corn plant or a dracaena." (It's hard not to conjure the photograph of Kelly grinning on the roof of 3–5 with his plants reaching to the sky behind him, or a slightly later image of the artist in his studio in a director's chair, delicately touching the leaf of one of his plants as he holds a broad paintbrush in the other hand.)

Along the bottom, *LEAVES* is painted in the same green, which has a kind of optical effect of shimmering or even disappearing, as it's so close to the register of the blue. The edges are all neat and perfect, as was Indiana's style, an approach described once by Swenson "as if

Ellsworth Kelly working in his Coenties Slip studio, New York, 1962.
Photograph by Onni Saari.
*(Courtesy Ellsworth Kelly Studio.)*

the artist were masked, or hiding behind a scrim of perfection and flippant irony."

*Leaves* commemorates Indiana's departure from the Slip. It's a stage direction (exit left) after a crucial act. It's a double portrait of place: a plant that was in his studio, and the end of living there, its colors representing the land and the sea. "I want to be under a leaf," Tawney had written just before arriving at the Slip, "to be quiet until I find my true self." For this group, Coenties Slip was where that discovery happened.

This work resonates with the earliest paintings that Indiana made at the Slip: his orbs, many of which he painted over after

seeing Martin's own circular grids, and his ginkgo leaf works on paper and cheap board and wood, when he didn't have money for a five-foot canvas. A photograph of Indiana in his Coenties Slip studio from 1959 shows him sitting between two tall orb plywood paintings with his cat on his lap; behind him is the very plant depicted in *Leaves*. Like his ginkgo paintings, these leaves channel propagation, sexuality, limp and alert fronds, as well as a neighborhood presence. The title also subtly references Whitman's *Leaves of Grass*, and the reedy calamus plant that grew along the East River waterfront and that figures in forty-five poems about male love in Whitman's collection. And there's another connection to an earlier, small Indiana work: a patch of bright monochrome green bordered by a white band on which is written the work's title, *Grass*.

*Leaves* also refers to the portrait still lifes that one of Indiana's great artist heroes, Charles Demuth, painted in the 1920s of his creative friends from his New York circle, both gay and straight. While they were more overt homages, often with names graphically included within the image (an early model for Indiana's own text-and-image paintings), there's a clear connection to *Leaves*. Several of Demuth's portraits even center on plants, which like Whitman's "Calamus poems" take on a metaphoric and even anthropomorphic presence.

The pun of *Leaves* is pure Indiana: a word that is both descriptive noun and action, not unlike other words he brought into his paintings during this period, including *TUG, DIE, PAIR, MATE*, and, of course, *SLIP* itself. (An avid journal writer his whole life, he once said that he kept a diary because "so much slips away.") The painting refuses to be nostalgic in these possible references, even as they are tied so closely to a specific neighborhood and its formative hold on how Indiana saw and commented on the world. It is also just a picture of a plant, helpfully inscribed as such.

You can take leave of a place, but it never fully leaves you.

# ACKNOWLEDGMENTS

This book began in 2016 as a spark of an idea struck over lemonade with my amazing agent, Elias Altman. I remember the lemonade detail because I was just pregnant with my first child and horribly nauseous; work on *The Slip* encapsulates the birth of two daughters and a son, which I mention because the joys and impossibilities of work and motherhood are too often sublimated. I am so grateful to Elias for finding me, helping me realize this dream of a book, and being a great reader, and for his incredible patience over half a decade of chaotic life, some of which no one could have imagined. Harper has been a generous home for this project. I could not have asked for better editors: Gail Winston believed in this story from the start, and her expert editing and guidance along the way made it that much better; Emily Graff shepherded it to its final publishing date with enthusiasm, energy, and grace. Hayley Salmon and Emma Kupor provided key assistance. *The Slip* looks so good thanks to Bonni Leon-Berman and Milan Bozic. The copyeditor is the unsung hero of any book, and I am indebted to John McGhee. Thanks also to Tom Hopke, Heather Drucker, Nikki Baldauf, Stephanie Evans, and to Jonathan Burnham, Doug Jones, Leah Wasielewski, and Tina Andreadis. Emily Lavelle helped this book find its right audience.

I am beholden to the scholars and writers who came before me whose work and research helped illuminate so many aspects of this book, including Glenn Adamson, Elissa Auther, Tiffany Bell, Yve-Alain Bois, Robert A. Caro, George Chauncey, Sarah Churchwell, Paul Cummings, Douglas Crimp, Barbaralee Diamonstein, Edward Robb Ellis, Mary Gabriel, Arne Glimcher, Mildred Glimcher, Judith Goldman, E. C. Goossen, Blake Gopnik, John Gruen, Barbara

Haskell, Suzanne Hudson, Sam Hunter, Brandon Joseph, Jonathan D. Katz, Michael Lobel, Henry Martin, Elaine Tyler May, Joseph Mitchell, Frances Morris, Eleanor Munro, Tricia Y. Paik, Joachim Pissarro, Nancy Princenthal, Leah Robinson Rousmaniere, Barbara Rose, Christine Bryan Rothenberger, Susan Elizabeth Ryan, Lucy Sante, Donna Seaman, Joshua Shannon, Judith E. Stein, Calvin Tomkins, Michelle White, Anthony C. Wood, among others. I am particularly grateful to Bois for his foundational work on Kelly and composition that as his student in graduate school I devoured like a great novel, and to Lobel for demonstrating that art history can be rigorous and fun, and for his constant cheerleading of this project.

I am grateful for the writings of Jill Johnston, Gene Swenson, and Ann Wilson that should be more broadly known in art history. I am grateful for those who took the time to speak to me about their experiences on and around the Slip, including Mary Lou Adams, Alice Adams, Charles Hinman, Bill Katz, William John Kennedy, Gerry Matthews, Larry Poons, Jeannette Seaver, Ann Wilson, Duncan Youngerman, and Jack Youngerman. I am grateful for those who spoke to me about knowing artists who lived on the Slip, including Barbara Rose, Deborah Kass, Philip Douglas Heilman, Mimi Thompson, and Kathleen Mangan, and to Deborah Solomon and Alicia Longwell who offered encouragement. I am grateful to my amazing colleagues at the Museum of Modern Art, and to colleagues at the Whitney Museum of American Art, the Museum of Arts and Design, and the Andy Warhol Museum, as well as former colleagues at *Artforum* and *Bookforum*. And to others I met along the way in researching and writing this book, including Janet Goleas, Alice Gregory, Hilary Helfant, Emily Goldstein, Elizabeth Smith, Michelle White, and Nicholas Dawidoff—that is the dream of how a book can connect a world of people, and I hope this is just the beginning of the many stories around the Slip that could not fit here. Thanks go to Alexander

Nagel, Charles Schultz, and the *Brooklyn Rail* team, for giving me the chance to share a part of this project as the inaugural Irving Sandler Essay in the *Brooklyn Rail.*

I am always overwhelmed by the generosity of archives and libraries, particularly during the difficult years of the pandemic when "normal" research was impossible. This book could not have happened without access to the Smithsonian Archives of American Art, the Beinecke Library at Yale University, Butler Library at Columbia University, the Seamen's Church Institute online archives, New-York Historical Society, the New York Public Library, the Brooklyn Public Library, the *New York Times*, the Museum of Modern Art, the Museum of Arts and Design, the Robert Indiana Catalogue Raisonné LLC, the Ellsworth Kelly Foundation, and the Lenore G. Tawney Foundation. Particular thanks to Kathleen Mangan at the Lenore G. Tawney Foundation for her generosity, openness, and extra efforts; Jack Shear, Mary Ann Lee, and Allison Wucher at the Ellsworth Kelly Studio and Foundation; Suzanne Geiss and Emeline Salama-Caro; Pat and Gerry Matthews; and Duncan Youngerman, for their generosity of spirit and archival materials. A book grant from the Andy Warhol Foundation Arts Writers Grant provided necessary financial support and intellectual encouragement at a crucial juncture in the project.

Isabel Flower gave key assistance with research and fact checking, as well as feedback on early chapters. Jessica Butler was an invaluable help with image research and rights. I am grateful to my friends—I haven't hung out with any of you in several years because every extra minute of the day went into this book, but your understanding and support means the world. I am forever grateful to my extended Peiffer and Fulford families. Particular thanks go to my parents for always prioritizing art even when that meant personal sacrifice, and more recently for their countless hours of childcare and wonderful

meals, and my sister, Siobhan Phillips, for being my ideal first reader: empathic and eagle-eyed.

This book is dedicated to Jack Youngerman and Charles Fulford. Jack's generosity of spirit over many Saturday morning conversations around his sunny table in Bridgehampton helped shape *The Slip*'s purpose and its heart; I am moved and forever changed by my time with him. I only wish he could have read it, but I hope it does his story justice, and celebrates his own aim to make every day a little more interesting through art. My husband, Charles, was my guide through this process. He kept reminding me that despite a global pandemic and all of its emotional, daily torpor, a full-time job, and having three kids during its tenure, this book would happen. I could not have written in the pre-dawns and weekends without his calming presence in our hectic, often-interrupted-by-sickness life, and thanks to the many, many excursions he took the kids on. Time is the most generous gift of love, even, maybe especially, when it is time alone to work. If Jack and the other artists of Coenties Slip showed me this, Charles brought it home.

# NOTES

## Introduction

xiv A 1960 tongue-in-cheek feature: "Robert Benton's & Harvey Schmidt's Map of New York: An Outlandish Guide for Intourists," *Esquire* 54, no. 3 (July 1960): 63–65.

xiv As Indiana would later insist: Andrew M. Goldstein, "Robert Indiana on 50 Years of Art, and the Fraught Life of 'LOVE,'" *ArtSpace*, September 24, 2013. It's difficult to trace the full roster of artists and creatives who passed through the Slip neighborhood; hopefully this book might tease out even more stories to come. Fred Mitchell drew a diagram of the neighborhood with names where he remembered people living; he included the Abstract Expressionist painter Anthe Zacharias, who lived around the corner at 66 Pearl Street, northwest of the Slip, in the 1960s. Deborah Kass remembered that her friend Alvin Dickstein, who knew Indiana from Chicago, stayed for a time on the Slip with him, and that Dickstein made some of his precise geometric paintings there. Indiana helped get Dickstein his only solo show at Stable Gallery, but he abandoned that career to pursue graphic design. Conversation with Deborah Kass, July 22, 2022.

xvi A detailed map of downtown Manhattan: Lionel Pincus and Princess Firyal Map Division, New York Public Library, "Plate 1: Map bounded by Bowling Green Row, Marketfield Street, Beaver Street, William Street, Old Slip, South Street, Whitehall, State Street; Including Moore Street, Broad Street, Coenties Alley, Coenties Slip, Mill Lane, Cuylers Alley, Bridge Street, Stone Street, South William Street, Pearl Street, Water Street, Front Street," New York Public Library Digital Collections. http://digitalcollections.nypl.org/items/5e66b3e8-b8fe-d471-e040-e00a180654d7.

xvii This, despite the fact: Edward Robb Ellis, *The Epic of New York City* (New York: Basic Books, 1966), 594.

xvii The writer Joseph Mitchell: Joseph Mitchell, *The Bottom of the Harbor*, in *Up in the Old Hotel* (New York: Vintage Books, 2008), 465.

xvii On the roof: Ellsworth Kelly letter to Henri Seyrig, October 17, 1954. Courtesy of the Ellsworth Kelly Studio. Also reprinted in *Calder/Kelly* (New York: Lévy Gorvy, 2019), 24. Exhibition catalogue.

xix Writing . . . in 1949: E. B. White, *Here Is New York* (New York: The Little Bookroom, 1999 [Originally published by Harper, 1949]), 22.

xix As Youngerman put it: Mildred Glimcher, *Indiana Kelly Martin Rosenquist Youngerman at Coenties Slip* (New York: Pace Gallery, 1993), 12. Exhibition catalogue.

xx "This was the first time": Interview with Jack Youngerman, November 3, 2018.

xx From Rosenquist's vantage point: Kline would die suddenly of heart failure in 1962, at the peak of his career. Judith Goldman, *James Rosenquist: The Early Pictures 1961–1964* (New York: Rizzoli, 1992), 94.

## 1. The Slip

3    In the water: Edward Robb Ellis, *The Epic of New York City*, 19.

3    Frogs create: Eric W. Sanderson, *Mannahatta: A Natural History of New York City* (New York: Abrams, 2009), 39.

3    The *Orange Tree*, the *Eagle*, and the *Love*: Russell Shorto, *The Island at the Center of the World* (New York: Vintage Books, 2005), 42.

3    They make their homes: Ellis, *The Epic of New York City*, 25.

3    One West India Company market report: Thomas Farrington De Voe, *The Market Book: Containing a Historical Account of the Public markets in the City of New York, Boston, Philadelphia, and Brooklyn, with a brief description of every article of human food sold therein, the introduction of cattle in America, and notices of many remarkable specimens*, Vol. 1 (New York: printed for the author, 1862), 16.

4    The enslaved people: Leslie M. Harris, *In the Shadow of Slavery: African Americans in New York City, 1626–1863* (Chicago: University of Chicago Press, 2003), 14.

4    The Dutch colonists' first order of business: Ellis, *The Epic of New York City*, 25.

4    They serve as guides: Shorto, *The Island at the Center of the World*, 60.

5    In the nineteenth century: Coenties Slip Collection, 1727–1808, New-York Historical Society.

5    According to a Dutch West India Company map: Lionel Pincus and Princess Firyal Map Division, New York Public Library, "Map of the original grants of village lots from the Dutch West India Company to the inhabitants of New-Amsterdam (now New-York) lying below the present line of Wall Street: Grants commencing A.D. 1642," New York Public Library Digital Collections. https://digitalcollections.nypl.org/items/510d47e3-b3c5-a3d9-e040-e00a18064a99.

5    Everyone pronounces it: Interview with Jack Youngerman, December 30, 2017.

5    Coenties is one of the deepest slips: Lionel Pincus and Princess Firyal Map Division, New York Public Library, "Map bounded by Front Street, Burling Slip, Pier-Line 1–20, Whitehall; Including South Street, Staten Island Ferry, Hamilton Ferry, Atlantic Ferry, Moore Street, Broad Street, Coenties Slip, Old Slip, Gouverneur Lane, Jones Lane, Coffee House Slip, Wall St Ferry, Pine Street, Depeyster Street, Maiden Lane, Fletcher Street," New York Public Library Digital Collections. http://digitalcollections.nypl.org/items/5e66b3e8-b210-d471-e040-e00a180654d7.

6    One can procure clams: De Voe, *The Market Book*, 118, 110, 114, and 122.

6    In 1691, the sheriff: Newspaper clipping from Coenties Slip Collection, 1727–1808, New-York Historical Society.

6    Twenty years after the market is established: Jill Lepore, *New York Burning: Liberty, Slavery, and Conspiracy in Eighteenth-Century Manhattan* (New York: Vintage, 2005), xii.

6    In *The New York Gazette*, May 25, 1778: De Voe, *The Market Book*, 115.

6    Badly beaten: Ellis, *The Epic of New York City*, 164.

6    In the new United States: Richard C. McKay, *South Street: A Maritime History of New York* (Riverside, CT: 7 C's Press, 1934), 15.

7    Coenties Marketplace becomes: De Voe, *The Market Book*, 125.

7    By the mid-nineteenth century: Leah Robinson Rousmaniere, *Anchored Within the Vail: A Pictorial History of the Seamen's Church Institute* (New York: SCI, 1995), 10.

7    This is the area: Ibid., quoting from Mathew Hale Smith, ed., *Wonders of a Great City* (Chicago: People's Publishing Co., 1887).

7    From this mire: Ibid., 21.

7    As Lucy Sante describes: Lucy Sante, *Low Life: Lures and Snares of Old New York* (New York: Farrar, Straus and Giroux, 2003), 49.

8    Ships are often quarantined: *The American Medical Recorder*, Vol. III (Philadelphia: William Brown, 1820), 203–204.

8    One bitter December night: *Autobiography of N. T. Hubbard, with personal reminiscences of New York City from 1789 to 1875* (Carlisle, MA: Applewood Books, first published 1875), 138.

8    John Henry Bufford's lithograph: Miriam and Ira D. Wallach Division of Art, Prints and Photographs: Print Collection, New York Public Library, *View of the great conflagration of Dec. 16th and 17th, 1835; from Coenties Slip*, New York Public Library Digital Collections. http://digitalcollections.nypl.org/items/5e66b3e8-7938-d471-e040-e00a180654d7.

8    The night is so cold: *Autobiography of N. T. Hubbard*, 139.

8    "So vast was the barren waste": R. M. Devens, *Our First Century*, as quoted in *Early Wall Street: 1830–1940* (Charleston, SC: Arcadia, 2014), 101.

8    The ruined merchandise is immense: McKay, *South Street*, 187–188.

9    Two years later: Sante, *Low Life*, 345.

10   With this collection: Edward Renehan, "Mannahatta—Walt Whitman in New York," *Medium*, December 15, 2018.

10   In Civil War New York: Philip Lopate, *South Street* (New York: Columbia University Press, 2007), 15.

10   Melville serves as a customs inspector: Herschel Parker, *Herman Melville: A Biography*, Vol. 2: *1851–1891* (Baltimore: Johns Hopkins University Press), 757.

10   He often walks the city: Ibid, 695.

10   At the end of the war: Ibid., 598.

11   In 1879, the journalist Charles H. Farnham: Ibid., 695, 693, and 692.

11   Pearl Street is dotted: Ellis, *The Epic of New York City*, 51.

11   "The houses are full": Parker, *Herman Melville*, 693, 692.

11   Seven years later: "Lagging in Time's March," *The New York Times*, Sunday, March 21, 1886, 4.

12   A year later: Rousmaniere, *Anchored Within the Vail*, 35.

12   By September, the institute accepts lodgers: Ibid., 35.

13   A seaman will: Ibid., 37.

13   *Harper's* article: Ibid., 34.

14   Letters arrive: Ibid., 51.

14   A saloon on the corner: Ibid., 60.

14   The figure of the sailor: George Chauncey, *Gay New York: Gender, Urban Culture, and the Making of the Gay Male World 1890–1940* (New York: Basic Books, 1994), 78, 145.

14   The "creators" he highlights: Paul Rosenfeld, *Port of New York* (New York: Harcourt, Brace and Co., 1924).

15   "Perhaps," Rosenfeld muses: Ibid., 295.

15   New York's port: *Federal Civil Defense Act of 1950: Hearings Before a Subcommittee of the Committee on Armed Services, United States Senate, Eighty-First Congress, Second Session* (Washington, D.C.: United States Government Printing Office, 1950), 185.

15   And then, on August 14, 1945: Sam Roberts, "New York 1945; the War Was Ending, Times Square Exploded. Change Was Coming," *The New York Times,* July 30, 1995, section 13, 1.

15   "Pennants flew from all the ships": Rousmaniere, *Anchored Within the Vail,* 78.

15   Just after the war: George Starbuck and Anthony Hecht, "Poetry: George Starbuck," *The Wilson Quarterly* 19, no. 3 (1995): 94. http://www.jstor.org /stable/40259031

15   Williams works on his own poems: "Oscar Williams, Poet, Dies at 64: Compiler of Anthologies That Sold in Millions," *The New York Times,* Sunday, October 11, 1964, 88.

16   he described Williams: "Dylan Thomas in America—Down and Up in New York and San Francisco," *The New York Times,* Sunday, April 13, 1986, 86.

16   though the poet James Merrill: James Merrill and Thomas Bolt, "James Merrill," *BOMB,* no. 36 (1991): 42. http://www.jstor.org/stable/40425020.

16   Ted Hughes and Sylvia Plath drink Drambuie at a party at 35 Water Street in 1958: Gail Crowther and Peter K. Steinberg, *These Ghostly Archives: The Unearthing of Sylvia Plath* (London: Fonthill Media, 2017), 52.

16   "Visiting the Williamses": John Gruen, *The Party's Over Now: Reminiscences of the Fifties—New York's Artists, Writers, Musicians, and Their Friends* (New York: Viking Press, 1967), 25.

17   Two years later: Glimcher, *Indiana Kelly Martin Rosenquist Youngerman at Coenties Slip,* 9; Fred Mitchell Papers, 1938–2007, Box 7, Folder 29, Archives of American Art, Smithsonian Institution.

17   After pining for Rome: *Nine Artists/Coenties Slip* (New York: Whitney Museum of American Art, Downtown Branch, January 10–February 14, 1974). Exhibition catalogue.

17   He loves the site's: Fred Mitchell Papers, 1938–2007, Box 7, Folder 28, Archives of American Art, Smithsonian Institution.

17   "On the edge of New York City": Ibid., 4.

## 2. The French Prelude

18   At the time he was: Richard Seaver, *The Tender Hour of Twilight* (New York: Farrar, Straus and Giroux, 2012), 101.

18   Or, as Youngerman described himself: Jack Youngerman and John Jonas Gruen, interview with Jack Youngerman, February 3, 1986, John Jonas Gruen and

Jane Wilson Papers, 1909–2016, Archives of American Art, Smithsonian Institution.

18   At eighteen, he'd chosen the navy: Ibid.

19   Parisians were suddenly grappling: Antony Beevor and Artemis Cooper, *Paris After the Liberation, 1944–1949* (New York: Penguin Books, 1994), 268.

19   The contradictions of Reconstruction Paris: Yve-Alain Bois, *Ellsworth Kelly: The Early Drawings 1948–1955* (Cambridge, MA: Harvard University Art Museums, 1999), 13. Exhibition catalogue.

20   Youngerman had grown up poor: Interview with Jack Youngerman, December 2, 2017.

20   As a kid: Among those, one that particularly stood out to young Jack was the regional painter Ivan Albright's *That Which I Should Have Done I Did Not Do (The Door)*, a large realist work in somber colors, depicting a door with a wreath and an old woman's hand reaching for the knob, painstakingly painted over ten years beginning in 1931 (now in the collection of the Art Institute of Chicago). Art books with lavish color reproductions were first published in France only in the late 1940s and '50s, when Youngerman was living there, able to visit the real things in person.

20   "Being an artist": Mark Segal, "For Jack Youngerman, It's Always New," *East Hampton Star,* April 15, 2014.

20   "I borrowed some money": Jack Youngerman, "Interview: Jack Youngerman Talks with Colette Roberts," *Archives of American Art Journal* 17, no. 4 (1977): 11.

20   Embarking from the train: Jack Youngerman and John Jonas Gruen, interview with Jack Youngerman, February 3, 1986, John Jonas Gruen and Jane Wilson Papers, 1909–2016, Archives of American Art, Smithsonian Institution.

21   In his first weeks of class: Interview with Jack Youngerman, February 2, 2019.

21   In 1948: Colette Roberts, "Jack Youngerman by Colette Roberts," *Archives of American Art Journal* 12, no. 2 (1972): 12.

21   One of the students: Interview with Jack Youngerman, February 2, 2019.

21   "They owned art": Agnès Poirier, *Left Bank: Art, Passion, and the Rebirth of Paris, 1940–50* (New York: Henry Holt and Co., 2018), 234.

21   "Thirty cents a day": Seaver, *The Tender Hour of Twilight,* 6.

21   "The choice in Paris": Poirier, *Left Bank,* 214.

21   Youngerman lived in the heart: Interview with Jack Youngerman, February 2, 2019.

22   His room, a former maid's quarters: Interview with Jack Youngerman, February 3, 2018.

22   He thought it was terrific: Ibid.

22   Many meals were served: Poirier, *Left Bank,* 232.

23   Youngerman's first impression: Interview with Jack Youngerman, June 2, 2018.

23   He spoke carefully, deliberately: E. C. Goossen, *Ellsworth Kelly* (New York: Museum of Modern Art, 1973), 10. Exhibition catalogue.

23   Youngerman found: Interview with Jack Youngerman, February 3, 2018.

23 "Part of Ellsworth's likeability": Interview with Jack Youngerman, February 2, 2019.

24 He had a nervous reaction: Rachel Cooke, "Ellsworth Kelly: 'I Want to Live Another 15 Years,'" *The Guardian*, November 18, 2015. https://www.theguardian.com/artanddesign/2015/nov/08/ellsworth-kelly-want-to-live-another-15-years-monograph-phaidon-tricia-paik.

24 "I didn't go to Paris to go to school": Ibid.

24 he came to France with a notebook: Andrew Russeth, "Ellsworth Kelly, Giant of Abstract Painting, Dies at 92," *ArtNews*, December 28, 2015. http://www.artnews.com/2015/12/28/ellsworth-kelly-giant-of-abstract-painting-dies-at-92/.

24 He liked "being a stranger": As quoted in Richard Shiff, "Making Your Own Choice," in *Ellsworth Kelly: New York Drawings 1954–1962* (New York: Matthew Marks/Prestel, 2014), 14. Exhibition catalogue.

24 His immediate thought on arrival: As quoted in Christoph Grunenberg, "Modern Icons: The Contradictions of Ellsworth Kelly," in *Ellsworth Kelly* (London: Tate St. Ives, 2007), 19. Exhibition catalogue.

24 In April 1949: Interview with Jack Youngerman, November 4, 2017.

24 Kelly's friend and fellow artist: Goossen, *Ellsworth Kelly*, 17.

25 The American writer Norman Mailer: Poirier, *Left Bank*, 214.

25 For the American playwright Arthur Miller: Beevor and Cooper, *Paris After the Liberation*, 349.

25 "Paris looks sadder and sadder": Poirier, *Left Bank*, 213.

25 Harvard's Byzantine Institute: Goossen, *Ellsworth Kelly*, 18.

26 That was the way that it was: Interview with Jack Youngerman, February 3, 2018.

27 Mark Rothko would also connect: As quoted in Diane Waldman, *Mark Rothko: A Retrospective* (New York: Solomon R. Guggenheim Museum, 1978), 62. Exhibition catalogue.

27 As early as 1946: Clement Greenberg, "Review of Exhibitions of the American Abstract Artists, Jacques Lipchitz, and Jackson Pollock," *The Nation*, April 13, 1946, as reprinted in *Clement Greenberg: The Collected Essays and Criticism*, Vol. 2: *Arrogant Purpose, 1945–1949*, ed. John O'Brian (Chicago: University of Chicago Press, 1986), 74–75.

28 When Youngerman started painting in Paris: Barbara Rose, "An Interview with Jack Youngerman," *Artforum* 4, no. 5 (January 1966): 27–30.

28 Both Youngerman and Kelly: Rose, "An Interview with Jack Youngerman."

28 He made many sketches: Tricia Y. Paik, *Ellsworth Kelly* (New York: Phaidon, 2015), 31.

28 "I think that if you can turn off the mind": As quoted in Roberta Bernstein, "Ellsworth Kelly's Multipanel Paintings," in Diane Waldman, *Ellsworth Kelly: A Retrospective* (New York: Guggenheim Museum), 40. Exhibition catalogue.

29 His education was on the streets: Seaver, *The Tender Hour of Twilight*, 102.

30 The two were "shocked": Goossen, *Ellsworth Kelly*, 47.

30 But Kelly was also shocked: William C. Seitz, *Claude Monet: Seasons and Moments* (New York: Museum of Modern Art, 1960), 50. Exhibition catalogue.

30   "On the first day after I went there": Iain Gale, "A Free Man in Paris," *The Independent*, August 5, 1993. https://www.independent.co.uk/arts-entertain ment/a-free-man-in-paris-he-couldnt-speak-french-but-post-war-paris-was -the-making-of-ellsworth-kelly-1459288.html.

30   "Anyone who has really looked": Rose, "An Interview with Jack Youngerman."

30   "I was open to everything": Interview with Jack Youngerman, February 2, 2019.

30   He was like a "child": Interview with Jack Youngerman, April 6, 2019.

30   "I saw the work before I read about it": Jack Youngerman and John Jonas Gruen, interview with Jack Youngerman, February 3, 1986, John Jonas Gruen and Jane Wilson Papers, 1909–2016, Archives of American Art, Smithsonian Institution.

30   Youngerman would later tell: Rose, "An Interview with Jack Youngerman."

30   He was in a state of perpetual wonder: In conversations with Youngerman, I often thought of his astonishment at his sudden privilege and good fortune in soaking up so much art through Frank O'Hara's poem "Autobiographia."

31   Vincent had written: Letter from Vincent van Gogh to Theo van Gogh and Jo van Gogh-Bonger, Auvers-sur-Oise, on or about Wednesday, May 21, 1890. http://vangoghletters.org/vg/letters/let874/letter.html.

31   And this pilgrimage underscored: Decades later, Yve-Alain Bois visited an exhibition of portraits by Van Gogh at the Museum of Fine Arts, Boston, with Kelly. Throughout the exhibition, Kelly kept "signaling shapes or color chords in the Dutch painter's works and noting how much they recalled some of his own—to the point that I felt compelled to joke that if one could be sure of anything, it was that Van Gogh had not copied him." Yve-Alain Bois on Ellsworth Kelly, *Artforum* 54, no. 8 (April 2016). https://www.artforum.com/print/201604/yve-alain-bois-58707.

32   For Youngerman, the hundreds of letters: Interview with Jack Youngerman, June 2, 2018.

32   Paris in the 1950s: Interview with Jack Youngerman, October 14, 2017.

32   Youngerman remembered: Interview with Jack Youngerman, May 5, 2018.

32   In Paris, "at any time": Interview with Jack Youngerman, June 15, 2019.

33   For Youngerman, it was Arp's woodcuts: Rose, "An Interview with Jack Youngerman."

33   Arp believed: *Arp* (New York: Museum of Modern Art, 1958), 9. Exhibition catalogue.

33   Despite the "horrors of those years": Ibid., 16.

33   In 1943: Carolyn Lanchner, *Sophie Taeuber-Arp* (New York: Museum of Modern Art, 1981), 18. Exhibition catalogue.

34   Youngerman remembers a studio: Interview with Jack Youngerman, March 9, 2019.

34   For Kelly, the visit: *Calder/Kelly*, 11.

34   Brancusi was otherwise occupied: Goossen, *Ellsworth Kelly*, 29.

34   During this period: Poirier, *Left Bank*, 200.

35   In 1951, Giacometti stopped: Gale, "A Free Man in Paris."

35  Visiting his big, drafty studio: Poirier, *Left Bank*, 201.

35  Kelly began making: Goossen, *Ellsworth Kelly*, 27.

35  Kelly and Youngerman went religiously: Interview with Jack Youngerman, April 6, 2019.

36  Youngerman was also struck: Rose, "An Interview with Jack Youngerman."

36  Seaver had met her: Seaver, *The Tender Hour of Twilight*, 32.

37  In 1969, the novelist Marguerite Duras: Marguerite Duras, "Delphine Seyrig, A Celebrated Unknown," in *Outside: Selected Writings* (Boston: Beacon Press, 1986), 162.

37  Born in Lebanon: Ibid., 160.

37  Henri had been sent there: Interview with Jack Youngerman, November 4, 2017.

37  As Youngerman later said: Interview with Jack Youngerman, May 5, 2018.

38  Henri Seyrig bought *Antibes*: *Calder/Kelly*, 16.

38  Kelly described Calder: Ibid.

38  perhaps a comment: Jed Perl, *Calder: The Conquest of Space; The Later Years, 1940–1976* (New York: Alfred A. Knopf, 2020), 313.

38  He would rent out whole restaurants: Paul Cummings, Oral history interview with Dorothy C. Miller, 1970 May 26–1971 Sept. 28, Archives of American Art, Smithsonian Institution.

39  "I loved him": *Calder/Kelly*, 11.

39  Seyrig was late: Interview with Jack Youngerman, June 19, 2019.

39  Looking back: Interview with Jack Youngerman, November 4, 2017.

39  The couple felt: Interview with Jack Youngerman, February 2, 2019.

39  Henri could be a commanding presence: Interview with Duncan Youngerman, July 25, 2019.

40  Youngerman remembers arriving late: Interview with Jack Youngerman, February 2, 2019.

40  Miette lent Kelly her Leica: Bois, *Ellsworth Kelly: The Early Drawings*, 13.

42  They weren't talking very much about art: Interview with Jack Youngerman, February 2, 2019.

42  Through this noticing: Bois, *Ellsworth Kelly: The Early Drawings*, 22.

42  It was here: Ibid., 14.

42  "I felt that my vision": *Calder/Kelly*, 13.

42  As Kelly put it: Goossen, *Ellsworth Kelly*, 19.

42  Or, as Youngerman framed it: Interview with Jack Youngerman, February 2, 2019.

42  "Everywhere I looked": Bois, *Ellsworth Kelly: The Early Drawings*, 20.

43  Kelly suddenly drew everying: "He drew the shadows cast on the wall by his balcony, and on a staircase by a railing; he drew the patterns on the striped canvas of the cabanas on the beach, the tree branches against the sky, and the twisted and rusting reinforcing rods exposed by the wartime shelling of German bunkers along the coast" (Goossen, *Ellsworth Kelly*, 32).

43 Writing to Kelly a few years later: Letter from the artist. Courtesy of Jack Youngerman. Also in the archives of the Ellsworth Kelly Studio.

43 Kelly dreamed: Bois, *Ellsworth Kelly: The Early Drawings*, 24.

44 Klein remembers Léger: Rachel Small, "A Lens on William Klein," *Interview* (March 1, 2013). https://www.interviewmagazine.com/art/william-klein.

45 Cage and Cunningham gave Kelly: Kay Larson, *Where the Heart Beats: John Cage, Zen Buddhism, and the Inner Life of Artists* (New York: Penguin Press, 2012), 405.

46 The show only brought him: Interview with Jack Youngerman, April 6, 2019.

47 Kelly returned to Meschers: Bois, *Ellsworth Kelly: The Early Drawings*, 255.

47 Writing to Kelly: Letters from the artist. Courtesy of Jack Youngerman.

47 He woke up early: Letters from the artist. Courtesy of Jack Youngerman.

47 "The war years": James Knowlson, *Damned to Fame: The Life of Samuel Beckett* (New York: Simon and Schuster, 1999), 344.

48 Youngerman didn't question: Interview with Jack Youngerman, March 9, 2019.

48 Opening night: Knowlson, *Damned to Fame*, 349. Kelly supposedly attended, though Youngerman, who *was* there, doesn't remember this.

48 it was a complete game changer: Knowlson, *Damned to Fame*, 350.

48 The "talk of theatrical Paris": Ibid.

48 He felt: Rose, "An Interview with Jack Youngerman."

48 "This," Bois writes: *Calder/Kelly*, 18.

49 "If I didn't have those years": Peter Schjeldahl, "Studio Visit," *The New Yorker* (February 6, 2012).

49 The Seyrigs' home: Perl, *Calder*, 258.

49 On September 17, 1955: *Calder/Kelly*, 42.

50 On November 18: Letters from the artist. Courtesy of Jack Youngerman. Also in the archives of the Ellsworth Kelly Studio.

## 3. Ellsworth Kelly

53 and a hot one, well into the eighties: https://www.farmersalmanac.com/weather-history.

53 with "button blue eyes": From an interview of Ann Wilson by Jonathan Katz. Oral history interview with Ann Wilson, 2009 April 19–2010 July 12, Archives of American Art, Smithsonian Institution. https://www.aaa.si.edu/collections/interviews/oral-history-interview-ann-wilson-15968#transcript.

53 His art was on board too: *Calder/Kelly*, 21.

53 "In France, they thought": Ibid.

54 munitions factories: Mary Gabriel, *Ninth Street Women: Lee Krasner, Elaine de Kooning, Grace Hartigan, Joan Mitchell, and Helen Frankenthaler; Five Painters and the Movement That Changed Modern Art* (Boston: Back Bay Books, 2019), 227.

54 Mitchell, who called him "Ellsworthy": As recounted by Philip Douglas Heilman, Mitchell's gallerist and friend, via email, August 17, 2022.

54  In a gesture typical: Yve-Alain Bois, *Ellsworth Kelly: Catalogue Raisonné of Paintings, Reliefs and Sculpture*, Vol. 2: *1954–1958*, ed. Staffan Ahrenberg (Paris: Cahiers d'Art, 2021), 74.

54  His stark white room: "There are several young painters living in the neighborhood with good American names like Roy Johnson + Fred Mitchell, Edmund Burke + yesterday whilst having the air on a deserted fish pier (it was Sunday), I met a boy from Denver who was drawing tugs, in a pair of 'Wranglers' named Robair (ert) Beauchamp, though he calls himself Bob Bocham, + we talked about Hans Hoffmann, whom he likes + about the mountains of Colorado, whether or whether they were not 13,000 feet." Ellsworth Kelly letter to Ralph Coburn, September 27, 1954. Courtesy of the Ellsworth Kelly Studio. Also reprinted in *Calder/ Kelly*, 23.

54  "Looking back": *Calder/Kelly*, 23.

55  "From each of the windows": Ibid.

55  "Later I discovered": As quoted in Holland Cotter, "A Giant of the New Surveys His Rich Past," *The New York Times*, October 13, 1996, section 2, 43.

55  The composer John Cage: Calvin Tomkins, *Off the Wall: A Portrait of Robert Rauschenberg* (New York: Picador, 1980), 89.

56  "It was comfortable there": Lopate, *South Street*, 32.

56  A hose and a bucket: Tomkins, *Off the Wall*, 75.

57  As he tried to read a paperback: Goossen, *Ellsworth Kelly*, 57.

57  As Kelly would later say: As quoted in Richard Schiff, *Ellsworth Kelly: New York Drawings 1954–1962* (New York: Matthew Marks Gallery), 18.

57  Rauschenberg also took the ferry: Tomkins, *Off the Wall*, 76.

57  His studio: Ibid., 124.

57  In place of the buildings: Joshua Shannon, *The Disappearance of Objects: New York Art and the Rise of the Postmodern City* (New Haven: Yale, 2009), 115.

57  Johns and Rauschenberg next moved: https://www.rauschenbergfounda tion.org/artist/chronology.

58  Rauschenberg moved out: *Interview*: Paul Taylor, "Robert Rauschenberg: I Can't Afford My Own Work," *Interview* 20, no. 12 (December 1990).

58  But their time together: Tomkins, *Off the Wall*, 108.

58  When Kelly finally knocked: Branden Joseph, *Random Order: Robert Rauschenberg and the Neo-Avant-Garde* (Cambridge, MA: MIT Press, 2003), 73–75.

58  No matter what happened: Goossen, *Ellsworth Kelly*, 52.

58  the importance of such social circles: Chauncey, *Gay New York*, 3.

59  Calder sent Kelly money: *Calder/Kelly*, 32.

59  Kelly continued to paint: https://matthewmarks.com/online/ellsworth -kelly/ek_47199-ek-d-54-109-01.

59  He wrote to Seyrig: Letter from Ellsworth Kelly to Henri Seyrig, October 17, 1954. Courtesy of the Ellsworth Kelly Studio. Also reprinted in *Calder/ Kelly*, 24.

59  "The violence done": Goossen, *Ellsworth Kelly*, 52.

59  Calder's wife, Louisa: *Calder/Kelly*, 189.

60  A year later, Kelly wrote: Ibid., 40.

60 And again, writing to Coburn: Bois, *Ellsworth Kelly: Catalogue Raisonné,* 42.

60 As she later claimed: Lee Hall, *Betty Parsons: Artist, Dealer, Collector* (New York: Harry N. Abrams, 1991), 144.

61 As the gallerist Leo Castelli: Carol Strickland, "Betty Parsons's 2 Lives: She Was Artist, Too," *The New York Times,* June 28, 1992, section L1, 13.

61 "I was born with a gift": Phyllis Linn, "Betty Parsons, Artist and Dealer Extraordinaire," *L'Officiel/USA,* October 1978, as quoted in Hall, 171.

61 Parsons once told Youngerman: Interview with Jack Youngerman, December 2, 2017.

61 She had a deep voice: As described in Edith Schloss, *The Loft Generation: From the De Koonings to Twombly, Portraits and Sketches 1942–2011* (New York: Farrar, Straus and Giroux, 2021), 135.

61 She carried her watercolors: As recounted in "Recollections of Betty," in Anne Cohen DePietro, *Shaping a Generation: The Art and Artists of Betty Parsons* (Huntington, NY: Heckscher Museum of Art, 1999), 54.

61 The critic Lawrence Alloway: Betty Parsons Gallery records and personal papers, 1916–1991, bulk 1946–1983: Alloway, typescript of "An American Gallery," circa 1961–1968, Box 42, Folder 24, Archives of American Art, Smithsonian Institution.

62 She let her artists hang: As recounted in Gruen, *The Party's Over Now,* 236.

62 She thought of her: Oral history interview with Betty Parsons, June 11, 1981, Archives of American Art, Smithsonian Institution.

63 She once described: Ibid.

63 Pollock had "exploded": Gabriel, *Ninth Street Women,* 206.

63 This was an "admirable" quality: Interview with Jack Youngerman, December 2, 2017.

63 Dorothy Miller once joked: As recounted in Calvin Tomkins, "Profiles: A Keeper of the Treasure," *The New Yorker,* June 8, 1975, 54.

63 Parsons herself admitted: Oral history interview with Betty Parsons, June 11, 1981, Archives of American Art, Smithsonian Institution.

63 Even so, Clement Greenberg: Clement Greenberg, "Foreword to the Tenth Anniversary Exhibition of the Betty Parsons Gallery," in *Clement Greenberg: The Collected Essays and Criticism,* Vol. 3: *Affirmations and Refusals,* ed. John O'Brian (Chicago: University of Chicago Press, 1993), 256.

63 She was not mechanically inclined: Gwen Metz quoted in "Recollections of Betty," in DePietro, *Shaping a Generation,* 52.

63 She had her own art career: As recounted in Gruen, *The Party's Over Now,* 242.

63 "Frankly, I think I could have": Interview with Jack Youngerman, December 2, 2017.

64 As Greenberg wrote at the time: Greenberg, "Foreword to the Tenth Anniversary Exhibition of the Betty Parsons Gallery," 256.

64 She had first seen: Oral history interview with Betty Parsons, June 11, 1981, Archives of American Art, Smithsonian Institution.

64 "Older, respected artists": Paik, 37.

64 Riding home on the subway: Bois, *Ellsworth Kelly: Catalogue Raisonné,* 225.

64  For Parsons: Hall, 110.

65  But work made: Bois, *Ellsworth Kelly: Catalogue Raisonné*, 84.

65  *Black and White I*, from 1956: Ibid., 95.

65  His total earnings: Ibid., 376

65  It wasn't until two years later: Ibid., 67. Kline also drew the East River and tugboats at Coenties Slip in the 1940s, as Fred Mitchell remembers in the catalogue for the 1977 exhibition he curated, *Franz Kline: The Early Works As Signals* (Binghamton, NY: University Art Gallery, State University of New York, 1977). With thanks to Philip Douglas Heilman for this reference.

66  Kinross describes Martin's crowd: Lord Kinross, *The Innocents at Home* (London: Readers Union, 1961), 31.

66  Kinross was at a loss: Ibid., 32.

66  To Kinross, Kelly: Ibid.

67  As if narrating a scene: Ibid., 36.

67  When Kelly and Harry Martin: Ibid., 199.

67  Youngerman described Kelly's space: Interview with Jack Youngerman, April 6, 2019.

67  Kelly was "drawn": Mildred Glimcher, *Indiana Kelly Martin Rosenquist Youngerman at Coenties Slip*, 9.

67  One hundred years earlier: McKay, *South Street*, 434.

68  where sailors could order: From an interview of Ann Wilson by Jonathan Katz. Oral history interview with Ann Wilson, 2009 April 19–2010 July 12, Archives of American Art, Smithsonian Institution.

## 4. Robert Indiana

69  He was still Robert Clark then: Richard Brown Baker, Oral history interview with Robert Indiana, tape recording and transcript, September 12–November 7, 1963, Archives of American Art, Smithsonian Institution. "It was three years of my life I would rather forget," from Joachim Pissarro, *Robert Indiana: Rare Works from 1959 on Coenties Slip* (Zurich: Galerie Gmurzynska, 2011), 61.

69  "They were still of that generation": Barbaralee Diamonstein, *Inside New York's Art World* (New York: Rizzoli, 1979), 159.

69  He'd needed to borrow money: Baker, Oral history interview with Robert Indiana.

70  he had moved: Indiana would return to Indianapolis in 1968 for an art project photographing all the houses or sites where he had lived.

70  even if he had announced: Baker, Oral history interview with Robert Indiana.

70  "who sometimes wore a third eye": Quoted in Barbara Haskell, "Robert Indiana: The American Dream," in *Robert Indiana: Beyond Love* (New York: Whitney Museum of American Art, 2013), 35. Exhibition catalogue.

70  Garcia Villa introduced: "Autochronology," also in Virginia M. Mecklenburg, *Wood Works: Constructions by Robert Indiana* (Washington,

D.C.: National Museum of American Art, 1984), 46n16. Exhibition catalogue.

70 One mid-June day: Goldstein, "Robert Indiana on 50 Years of Art."

70 "That fifteen dollars made quite a difference": Baker, Oral history interview with Robert Indiana.

71 In 1960, the average: Aaron Shkuda, *The Lofts of SoHo: Gentrification, Art, and Industry in New York, 1950–1980* (Chicago: University of Chicago Press, 2016), 49.

71 And since his departure: Baker, Oral history interview with Robert Indiana.

71 "having Ellsworth as a neighbor": Ibid.

71 Indiana's space was covered with tin: Ibid.

71 As he explained later: Ibid.

71 Twombly's "miserably small" apartment: Goldstein, "Robert Indiana on 50 Years of Art."

72 As Indiana remembered it: Ibid.

72 But when Youngerman arrived from Paris: Baker, Oral history interview with Robert Indiana.

72 Just months later: Ibid.

73 Wilson painted the floor: Interview with Ann Wilson, January 17, 2022.

73 Wilson's new maritime trade environment: "January," 1962, in Ann Wilson, *Patchworks: Painting Journal 1961 to 1966.* Document from Ann Wilson, *3–5 Coenties Slip, No. 1,* Museum of Arts and Design, New York, Collection File.

73 "Before Coenties Slip": Quoted in Haskell, *Beyond Love,* 18.

74 "The front of number 25": Susan Elizabeth Ryan, *Robert Indiana: Figures of Speech* (New Haven: Yale University Press, 2000), 38.

74 He got two cats: http://geraldlaing.org/memoirs/16_last_term_at_art _school_and_return_to_new_york.

74 A few years later: Baker, Oral history interview with Robert Indiana.

## 5. Delphine Seyrig and Jack Youngerman

75 This meant a great deal: Interviews with Jack Youngerman, October 14 and November 4, 2017.

76 Klein had described: Interview with Jack Youngerman, November 4, 2017.

76 Two days out: Diane Waldman, *Jack Youngerman* (New York: Solomon R. Guggenheim Museum, 1986), 23. Exhibition catalogue.

76 Later, when asked to explain: Ibid., 20.

77 "It was a time after the war": Interview with Jack Youngerman, May 5, 2018.

78 The Slip was "rough living": Interview with Jack Youngerman, November 4, 2017.

78 It was tar black: Delphine Seyrig, letter to her mother, end of October 1957, Youngerman/Seyrig Archives.

78 Duncan's main recollection: Interview with Jack and Duncan Youngerman, July 20, 2019.

79 "When one is young": Interview with Jack Youngerman, December 2, 2017.

79 In August 1957, he wrote a note to Parsons: Betty Parsons Gallery records and personal papers, Series 1, Box 18, Folder 2, Archives of American Art, Smithsonian Institution.

79 The place provided: Interview with Jack Youngerman, December 30, 2017.

79 The Youngermans later discovered: Delphine Seyrig, letter to her mother, December 23, 1957, Youngerman/Seyrig Archives.

79 Youngerman bought his art supplies: Interview with Jack Youngerman, December 2, 2017.

79 Youngerman traveled to the end: Interview with Jack Youngerman, December 8, 2018.

80 Shortly after their arrival: Delphine Seyrig, letter to her mother, fall 1957, Youngerman/Seyrig Archives.

81 Youngerman's brother: Interview with Jack Youngerman, March 14, 2020.

81 As Youngerman explained: Nancy Princenthal, *Agnes Martin: Her Life and Art* (London: Thames & Hudson, 2015), 72.

81 These artists had made it possible: Roberts, "Jack Youngerman by Colette Roberts," *Archives of American Art Journal* 12, no. 2 (1972): 5. www.jstor.org /stable/1556969.

82 But by the mid-1950s: Interview with Jack Youngerman, November 3, 2018.

82 Youngerman, like Kelly: Interview with Jack Youngerman, May 11, 2019.

82 "It was fairly easy": Agnes Martin hid her bed behind her work too: in one of her Slip studios, moving racks of paintings lined the end of the room. One of the racks held no paintings, and walking through, past a curtain, Martin arrived into her bedroom. Interview with Jack Youngerman, December 2, 2017.

82 For the first months: Delphine Seyrig, letter to her mother, September 3, 1957, Youngerman/Seyrig Archives.

82 He found some louver doors: Interview with Jack Youngerman, November 3, 2018.

82 He was shy and self-conscious: Interview with Jack Youngerman, September 14, 2019.

## 6. Agnes Martin

83 She carried a whole ham: Henry Martin, *Agnes Martin: Pioneer, Painter, Icon* (New York: Schaffner Press, 2018), 117.

84 "[Parsons] said she'd show": Christina Bryan Rosenberger, *Drawing the Line: The Early Work of Agnes Martin* (Berkeley: University of California Press, 2016), 90.

84 She occupied a vast loft: From an interview of Ann Wilson by Jonathan Katz. Oral history interview with Ann Wilson, 2009 April 19–2010 July 12, Archives of American Art, Smithsonian Institution.

84 Her space was unheated: Princenthal, *Agnes Martin*, 70.

84   She imagined the view: As quoted in Rosenberger, *Drawing the Line*, 119.

85   "There were a lot of drunken sailors": Princenthal, *Agnes Martin*, 72.

85   One day she knocked on Youngerman's door: Interview with Jack Youngerman, November 4, 2017.

85   Parsons was motivated: Oral history interview with Betty Parsons, June 11, 1981, Archives of American Art, Smithsonian Institution.

85   Newman warmed to Martin: From an interview of Ann Wilson by Jonathan Katz. Oral history interview with Ann Wilson, 2009 April 19–2010 July 12, Archives of American Art, Smithsonian Institution.

85   He also helped hang: Rosenberger, *Drawing the Line*, 106.

85   Kelly called her: Princenthal, *Agnes Martin*, 71.

85   She was known: From an interview of Ann Wilson by Jonathan Katz. Oral history interview with Ann Wilson, 2009 April 19–2010 July 12, Archives of American Art, Smithsonian Institution.

85   Martin proudly owned: Dore Ashton, "Art: Drawn from Nature," *The New York Times*, December 29, 1959, 23.

85   She would tell stories: Delphine Seyrig, letter to her mother, December 23, 1957, Youngerman/Seyrig Archives.

86   "When you're in your creative period": Princenthal, *Agnes Martin*, 72.

86   Wilson described the conversations: From an interview of Ann Wilson by Jonathan Katz. Oral history interview with Ann Wilson, 2009 April 19–2010 July 12, Archives of American Art, Smithsonian Institution.

86   As she put it: Rosenberger, *Drawing the Line*, 92.

## 7. Lenore Tawney

87   She was fifty: Lenore Tawney, *Autobiography of a Cloud*, unpublished manuscript, comp. Tristine Rainer and Valerie Constantino (New York: Lenore G. Tawney Foundation, 2002), 2. Courtesy of Lenore G. Tawney Foundation.

87   She imagined herself: Lenore Tawney to Marna Johnson, November 24, 1959. Courtesy of the Lenore G. Tawney Foundation. See also Glenn Adamson, "Student: 1945–1960," in *Lenore Tawney: Mirror of the Universe* (Chicago: University of Chicago Press, 2019), 67. Exhibition catalogue.

87   The loft at 27 Coenties Slip was the first of eight: Paul Smith, "A Tribute to Lenore," in *Lenore Tawney: A Retrospective*, ed. Kathleen Nugent Mangan (New York: American Craft Museum/Rizzoli, 1990), 15.

87   Critics noted how the place: See Karen Patterson, "Mirror of the Universe," in *Lenore Tawney: Mirror of the Universe*, 22.

87   "Lenore was a sprite": Donna Seaman, *Identity Unknown: Rediscovering Seven American Women Artists* (New York: Bloomsbury USA, 2017), 370.

88   Eleanor Munro described her: Eleanor Munro, *Originals: American Women Artists* (New York: Simon and Schuster, 1979), 325.

88   Recognizing her talent: Princenthal, *Agnes Martin*, 327.

89   She would go running: Paul Cummings, Oral history interview with Lenore Tawney, June 23, 1971, Archives of American Art, Smithsonian Institution.

89   She was renovating: Munro, *Originals*, 327.

89  "I'd never learned": As recounted in Tawney, *Autobiography of a Cloud*, 3. Courtesy of Lenore G. Tawney Foundation.

89  But she soon put this aside too: Arline M. Fitsch, Oral history interview with Merry Renk, January 18–19, 2001, by Arline M. Fitsch, Archives of American Art, Smithsonian Institution.

90  "I had a friend": Cummings, Oral history interview with Lenore Tawney, June 23, 1971, Archives of American Art, Smithsonian Institution.

90  Her move to New York was supported: Adamson, "Student: 1945 to 1960," 51.

90  She described her Coenties Slip loft: Cummings, Oral history interview with Lenore Tawney, June 23, 1971, Archives of American Art, Smithsonian Institution.

90  "on a street of the bums": Lenore Tawney's journal (30.10), December 4, 1967. Courtesy of the Lenore G. Tawney Foundation archives.

90  "Water is fertilizing": As quoted in Seaman, *Identity Unknown*, 367.

90  As she wrote in her journal: *Lenore Tawney: A Retrospective*, 21.

90  Just a few months before her move: Seaman, *Identity Unknown*, 383.

90  She left Chicago: Lenore Tawney's journal (30.10), December 4, 1967. Courtesy of the Lenore G. Tawney Foundation archives.

90  She wasn't sure: Cummings, Oral history interview with Lenore Tawney, June 23, 1971, Archives of American Art, Smithsonian Institution.

## 8. James Rosenquist

91  He had $300 in his pocket: Judith Goldman, *James Rosenquist: The Early Pictures, 1961–65* (New York: Gagosian, 1992), 93.

91  "I walked everywhere": James McElhinney, *Art Students League of New York on Painting*, foreword by James Rosenquist (New York: Watson-Guptill, 2015).

91  He sought out George Grosz: James Rosenquist, *Painting Below Zero: Notes on a Life in Art* (New York: Knopf, 2009), 34.

91  Later, in 1961: Ibid., 107.

91  As a kid: Goldman, *James Rosenquist*, 86.

91  So at the age of fifteen: Ibid., 88.

92  Rosenquist was always dreaming: Rosenquist, *Painting Below Zero*, 3.

92  When he was a teenager: Goldman, *James Rosenquist*, 90.

92  During his early days: Rosenquist, *Painting Below Zero*, 35.

93  "I looked at billboard painting": Ibid., 36.

93  "Life was precarious": McElhinney, *Art Students League of New York on Painting*.

93  "All the tools you need": Rosenquist, *Painting Below Zero*, 53.

93  "Down in what is now SoHo": Ibid., 36.

94  One day in 1956: Ibid., 308.

94  "We were like circus performers": James McElhinney, Interview with James Rosenquist, March 28, 2013, Archives of American Art, Smithsonian Institution.

94   By the late 1950s: See Michael Lobel, *James Rosenquist: Pop Art, Politics, and History in the 1960s* (Berkeley: University of California Press, 2009), 46.

94   Rosenquist would take: Walter Hopps, as quoted in Lobel, *James Rosenquist*, 55.

94   Rosenquist met the artist Ray Johnson: Jan van der Marck, "Reminiscing on the Gulf of Mexico: A Conversation with James Rosenquist," *American Art* 20, no. 3 (2006): 90.

94   Then, one day: Rosenquist, *Painting Below Zero*, 72.

96   The rent was still: Ibid., 75.

96   At first, he just used the space: McElhinney, Interview with James Rosenquist, March 28, 2013, Archives of American Art, Smithsonian Institution.

96   It wasn't a huge space: Rosenquist, *Painting Below Zero*, 81.

## 9. The Nature of It

99   Shirtless on a hot day: See ellsworthkelly.org/chronology.

99   On one occasion: Interview with Jack Youngerman, December 8, 2018. Interestingly, a trapeze in the loft of the artist Robert Weigand had a prominent cameo in the 1970 *Life* article "Living Big in a Loft," illustrating the amount of free space (and whimsical use of it) by artists at the time, another subtle way that the Slip artists were ahead of the curve when it came to the "loft" culture so celebrated in late 1960s and '70s SoHo. As discussed in Shkuda, *The Lofts of SoHo*, 62.

100   He later wrote: Fred Mitchell's letter to Ellsworth Kelly, dated Sunday, March 10 [1957]. Courtesy of the Ellsworth Kelly Studio.

100   As he put it: Bois, *Ellsworth Kelly: Catalogue Raisonné*, 361.

101   Indiana (still Clark at this point): Ryan, *Robert Indiana*, 121.

101   A 1951 article: "The Avocado," *The New York Times*, Sunday, October 21, 1951, 121.

101   His favorite course: Ryan, *Robert Indiana*, 23.

101   He drew from the avocado plants: Robert Indiana, "Autochronology," 1957, as published in *Robert Indiana: New Perspectives* (Ostfildern, Germany: Hatje Cantz, 2012), 232.

101   Even Seyrig wrote to her parents: Delphine Seyrig, correspondence to her parents, December 23, 1957, and February 1958, Youngerman/Seyrig Archives.

101   "I knew I could draw plants forever": "Old Masters: After 80, Some People Don't Retire. They Reign," *The New York Times Magazine*, October 23, 2014.

102   In damp February 1949: Marla Prather, "Interview with Ellsworth Kelly," *Ellsworth Kelly: Plant Drawings 1948–2010* (Munich: Schirmer/Mosel, 2011), 212. Exhibition catalogue.

102   He began to draw: Goossen, *Ellsworth Kelly*, 96.

102   Kelly called them "portraits": Karen Rosenberg, "Loving Flowers and Vines to Abstraction," *The New York Times*, June 8, 2012, section C, 34.

102   Friends were ready-made models: See Marianne Preger-Simon's memoir *Dancing with Merce Cunningham* (Gainesville: University Press of Florida, 2019),

in which she recollects how in Paris, Kelly and her friends were always drawing one another.

102 Kelly had, in Youngerman's words: Interview with Jack Youngerman, June 2, 2018.

102 This ever-present attention: https://www.nortonsimon.org/exhibitions/2010-2019/line-and-color-the-nature-of-ellsworth-kelly/.

103 In Paris, this might be: Diane Upright, *Ellsworth Kelly: Works on Paper* (New York: Harry N. Abrams, 1987), 9.

103 He was interested in things: Kelly in Henry Geldzahler, "Interview with Ellsworth Kelly," in *Paintings, Sculpture, and Drawings by Ellsworth Kelly* (Washington, D.C.: Washington Gallery of Modern Art, 1963). Exhibition catalogue.

103 On a return visit to Paris: Prather, "Interview with Ellsworth Kelly," 223.

103 "I want to work like nature works": "Old Masters."

103 "I want to paint": Gwyneth Paltrow, "Ellsworth Kelly," *Interview* (October issue, published online September 24, 2011).

103 He called his plant drawings: Michael Semff, "Ellsworth Kelly: Plant Drawings 1948–2010," in *Ellsworth Kelly: Plant Drawings 1948–2010* (Munich: Schirmer/Mosel, 2011), 8.

103 "I don't solve the painting": *Calder/Kelly*, 61.

103 When asked, as an atheist: Paltrow, "Ellsworth Kelly."

104 Kelly had spent his childhood: Ibid. Coincidentally, Fred Mitchell, who brought Kelly to the Slip, had also had a formative experience drawing birds as a boy in Mississippi; his local newspaper reprinted his drawing of a redbird when he was only six, and the idea of color and form in movement remained central to Mitchell's approach to art. "Artist Mitchell at Home in Manhattan," December 26, 1976, newspaper article in Fred Mitchell Papers, Archives of American Art, Smithsonian Institution.

104 His first year back in New York: Chronology, *Ellsworth Kelly* (Phaidon), 337. Use of collage in Audubon's illustrations is discussed here: Roberta J. M. Olson, "The 'Early Birds' of John James Audubon," *Master Drawings* 50, no. 4 (2012): 439–94.

105 "Drawings have memory": *Ellsworth Kelly: Red Green Blue* (San Diego: Museum of Contemporary Art San Diego, 2003), 17. Exhibition catalogue.

105 And Indiana in turn: Pissarro, *Robert Indiana: Rare Works from 1959 on Coenties Slip*, 13.

105 The beer sign became: Goossen, *Ellsworth Kelly*, 67.

105 Kelly would later make a drawing: Rosenquist, *Painting Below Zero*, 87.

105 The pier was at the end: "Thrown Overboard Manacled in a Box," *The New York Times*, July 8, 1912, 6.

106 "With Ellsworth": Robert Indiana quoted in Haskell, *Beyond Love*, 18.

106 Indiana "could feel": Ryan, *Robert Indiana*, 29.

106 Returning to his studio: Bois, *Ellsworth Kelly: Catalogue Raisonné*, 220.

106 There's no one-to-one equivalence: Kelly, as quoted in Shiff, *Ellsworth Kelly*, 19.

107 The work's original title: Bois, *Ellsworth Kelly: Catalogue Raisonné*, 221.

107 "I could take from everything": Kelly, as quoted in Shiff, *Ellsworth Kelly*, 20.

107 In 1881: "Open Air Movies for Sailors: Little Breathing Space in Coenties Slip Will Soon Rise from Its Ruins," *The Nautical Gazette* 99 (July 24, 1920): 108. For more on this see Hampton Sides, *In the Kingdom of Ice: The Grand and Terrible Polar Voyage of the USS Jeannette* (New York: Doubleday, 2014).

107 People had to walk: "Lagging in Time's March," 4.

107 A park would fix this problem: *Scribner's Magazine*, 1892, 108.

107 In 1886, an article: "Lagging in Time's March," 4.

109 "The proper place to see Jeannette Park": *Scribner's Magazine*, 1892, 114.

109 For Kelly: Lucy Rees, "10 Fascinating Insights into the Creative Mind of Ellsworth Kelly," *Galerie*, January 15, 2019.

109 Indiana never thought much: Interview with Donald B. Goodall, 1976–77, in Haskell, *Beyond Love*, 229.

109 He worked on these paintings: Artist statements, Institute of Contemporary Art, University of Pennsylvania, 1968, as quoted in Haskell, *Beyond Love*, 224.

110 Indiana noted: Ibid.

110 In his journal: Ryan, *Robert Indiana*, 77.

**10. Money**

111 His first months in New York: Interview with Jack Youngerman, November 4, 2017.

112 She saw how: Delphine Seyrig, letter to her mother, July 1957, Youngerman/Seyrig Archives.

112 She was certain: Delphine Seyrig, letter to her mother, March 3, 1958, Youngerman/Seyrig Archives.

112 A couple of years later: Colette Roberts, Interview with Jack Youngerman, February 1968, 19 of transcript. Archives of American Art, Smithsonian Institution.

113 He charged a dollar an hour: Fred Mitchell Papers, 1938–2007, Box 7, Folder 29, Coenties Slip studio 1955–1976, Archives of American Art, Smithsonian Institution.

115 Coenties Slip has a less famous cameo: Herman Melville, *Redburn, His First Voyage* (New York: Harper and Brothers, 1849), 2.

115 In the eighteenth and nineteenth centuries: "Lagging in Time's March," 4.

116 From 5:35 a.m.: Ellis, *The Epic of New York City*, 341.

116 And in another account: John H. White and William D. Edson, "Spunky Little Devils: Locomotives of the New York Elevated," *Railroad History*, no. 162 (1990): 43.

117 The Slip was also: Sante, *Low Life*, 308.

117 All this, and yet: "Lagging in Time's March," 4.

117 His description of the market: Lopate, 26–27.

118 Some of the artists: Interview with Larry Poons, January 30, 2021.

118 Hinman called it: Princenthal, *Agnes Martin*, 67.

118  The writer Mary Cantwell: Mary Cantwell, "Manhattan, When I Was Young," in *Manhattan Memoir* (New York: Penguin Books, 2000), 192.

118  When writing to her mother: Delphine Seyrig, letter to her mother, mid-January 1958, Youngerman/Seyrig Archives.

118  Mitchell reminded Kelly: Fred Mitchell, letter to Ellsworth Kelly, labeled "Friday," undated, circa 1957. Courtesy of the Ellsworth Kelly Studio.

118  "There's a kind of end-of-the-world feeling": *The Lookout*, December 1957, 5.

119  Coenties Slip was: Mildred Glimcher, *Indiana Kelly Martin Rosenquist Youngerman*, 12.

119  Wilson remembers: *Nine Artists/Coenties Slip*.

119  Rosenquist recalled: Van der Marck, "Reminiscing on the Gulf of Mexico," 90.

119  One of the most distinct: Cromwell Childe, "The Canalers in Coenties Slip," *The New York Times*, March 5, 1899, 39, 40.

120  From the early nineteenth century: Tracy Trisch, "A Short History of Wheat," *Valley Table* 44 (2008). https://www.valleytable.com/vt-article/short-history-wheat.

121  The canalers and their families: Childe, "The Canalers in Coenties Slip."

121  Toddlers were tethered: "Children on Canalboats: Means Taken to Prevent the Little Ones from Falling Overboard," *The New York Times*, Saturday, November 9, 1889, 3.

121  Even thirty years later: M. B. Levick, "The Canal Boats' Winter Sleep Is Over: Soon the Elephantine Fleet Will Leave Coenties Slip for Ports North," *The New York Times Magazine*, April 13, 1924, 135, 139.

121  And in 1939, a journalist: Meyer Berger, "About New York," *The New York Times*, October 19, 1939, 20.

121  *The New Yorker* chronicled: Burke Boyce, "Downtown Lyrics: Coenties Slip," *The New Yorker*, November 28, 1926, 56.

122  Cantwell again: Cantwell, *Manhattan Memoir*, 192.

124  Indiana and Youngerman's main clientele: Interview with Jack Youngerman, December 30, 2017.

124  Slideshows happened: Princenthal, *Agnes Martin*, 70.

124  James Rosenquist remembered: Rosenquist, *Painting Below Zero*, 71.

124  More often: Baker, Oral history interview with Robert Indiana.

124  "New Yorkers didn't know that area:" Interview with Jack Youngerman, December 30, 2017.

125  Twatchtman's depiction: Michael J. Chiarappa, "New York City's Oyster Barges: Architecture's Threshold Role Along the Urban Waterfront," *Buildings & Landscapes: Journal of the Vernacular Architecture Forum* 14 (2007): 84–108.

126  commemorated by a plaque: Ryan, *Robert Indiana*, 272, note 2.

126  Looking back in 1913: Mike Wallace, *Greater Gotham: A History of New York City from 1898 to 1919* (New York and London: Oxford University Press, 2017), 364.

126 Besides art, he took his inspiration: As quoted in Lowery Stokes Sims, *Stuart Davis: American Painter* (New York: Metropolitan Museum of Art, 1991), 151. Exhibition catalogue.

126 For Davis, the United States was: Stuart Davis, "The Cube Root," *Art News* 12 (February 1943): 34.

127 Abbott's *Shelter on the Water Front*: Miriam and Ira D. Wallach Division of Art, Prints and Photographs: Photography Collection, New York Public Library, *Shelter on the Water Front, Coenties Slip, Pier 5, East River, Manhattan*, New York Public Library Digital Collections. https://digitalcollections.nypl.org/ items/510d47d9-4f99-a3d9-e040-e00a18064a99.

127 On this early May day: Julia Van Haaften, *Berenice Abbott: A Life in Photography* (New York: Norton, 2018), 223.

127 Abbott became fascinated: Ibid.

129 If "New York is an exercise": Barnett Newman, "New York" in *Barnett Newman: Selected Writings and Interviews*, ed. John P. O'Neill (Berkeley, CA: University of California Press, 1990), 30–34.

129 "When I came back": Segal, "For Jack Youngerman."

130 Indiana and Youngerman couldn't afford: http://robertindiana.com /chronology/.

130 "somewhat aromatic": From an interview of Ann Wilson by Jonathan Katz. Oral history interview with Ann Wilson, 2009 April 19–2010 July 12, Archives of American Art, Smithsonian Institution.

130 "Painters must live together": Faye Hammel, "Bohemia on the Waterfront: Serious Writers and Painters Are Creating New Shangri-La at the East River's Edge Near the Tip of Manhattan," *Cue*, March 22, 1958, 17.

## 11. Structure

131 "When I got to New York": Henry Martin, *Agnes Martin*, 121.

132 It was a twenty-year process: Benita Eisler, "Life Lines," *The New Yorker* (January 25, 1993), 74.

132 "I just painted": Henry Martin, *Agnes Martin*, 121.

132 One of the first works: Artist's questionnaire, Museum Collection Files, Agnes Martin, *Harbor 1*, Department of Painting and Sculpture, The Museum of Modern Art, New York.

132 In the early half: See, for example, Paulina Bren, *The Barbizon: The Hotel That Set Women Free* (New York: Simon & Schuster, 2021).

133 Chauncey outlines a parallel pattern: Chauncey, *Gay New York*, 3, 9, 27.

133 She also regaled Indiana: Henry Martin, *Agnes Martin*, 152.

134 He followed in a long line: Chauncey, *Gay New York*, 104–105.

134 she also told a friend: Rosenberger, *Drawing the Line*, 72.

134 The artist Chryssa: Eisler, "Life Lines," 77.

134 Johnston wrote: Jill Johnston, "Agnes Martin: Surrender & Solitude," in *Gullibles Travels* (New York: Links Books, 1974), 283.

134 Youngerman remembered: Interview with Jack Youngerman, June 2, 2018.

134 And Martin herself: Arne Glimcher, *Agnes Martin: Paintings, Writings, Remembrances* (New York: Phaidon Press, 2012), 71.

134 She had, in her own description: ibid.

135 In a review: Rosenberger, *Drawing the Line*, 117.

135 And Dore Ashton: Dore Ashon, "Premiere Exhibition for Agnes Martin," *The New York Times*, December 6, 1958, 28.

135 Martin required specific conditions: Agnes Martin, "What Is Real?" lecture given at Yale University, New Haven, Connecticut, April 5, 1976, in Arne Glimcher, *Agnes Martin*, 81.

135 Her second Coenties Slip studio: Rosenberger, *Drawing the Line*, 132.

135 Entering it was like: Ann Wilson, "Agnes Martin," essay in Betty Parsons Papers, Series 1, Box 11, Folder 5, Archives of American Art, Smithsonian Institution.

135 "You must be clean": Agnes Martin, "I want to talk to you about the work," in Arne Glimcher, *Agnes Martin*, 16.

135 And she wrote in her journal once: Agnes Martin, "The silence on the floor of my house . . ." in ibid., 24.

135 The artist needed to get past: "Beauty Is the Mystery of Life," first published in *El Palacio* 95 (Fall-Winter 1989): 9–23, reprinted in Barbara Haskell, *Agnes Martin* (New York: Whitney Museum of American Art and Harry N. Abrams, 1992), 10–12. Exhibition catalogue.

135 She would go into trances: Arne Glimcher, *Agnes Martin*, 102.

136 "The best thing to do": Princenthal, *Agnes Martin*, 69.

136 "Unless you were in a park": Cantwell, *Manhattan Memoir*, 186.

136 "We all did the same thing": Princenthal, *Agnes Martin*, 68.

136 not unlike the cascading currents: I am grateful to Kathleen Mangan at the Lenore G. Tawney Foundation for this observation.

137 The poet "had a passion for ferries": Walt Whitman, *Complete Poetry and Collected Prose*, ed. Justin Kaplan (New York: Library of America, 1982), 700.

137 "I paint to make friends": Agnes Martin, A Personal Statement, Betty Parsons Papers, Series 1, Box 11, Folder 5, Archives of American Art, Smithsonian Institution. Handwritten notation: "This statement is as Ray Izbecki remembers it, Taos, New Mexico."

138 "Marisol, you're a snob": Interview with Jack Youngerman, December 2, 2017. Marisol was born into a wealthy Venezuelan family in Paris, and was not naturally warm, but as Youngerman said, "When I learned that her mother committed suicide when she was twelve years old [actually, eleven], I realized it wasn't snobbism, it was a kind of protective removal." Marisol stopped speaking after her mother's death and began conversing again only in her late twenties; her sculptural figures, like Indiana's, have their own bold presence. See Gabriel, *Ninth Street Women*, 509.

138 For Martin, there was "something ecological": Ashton, "Art: Drawn from Nature."

139 They visited Jacob Riis Park: Princenthal, 72.

139 Many years later, she would say: Skowhegan lecture 1987, as quoted in Henry Martin, *Agnes Martin*, 307.

139 Musing that someone: *The American Whig Review* 2 (November 1845): 537–38.

140 Or as one author put it: McKay, *South Street*, 122.

140 The year 1957 was a record one: Thomas W. Ennis, "'57 Set a Record for New Office Space, and '58 Will Top That," *The New York Times*, Sunday, January 5, 1958, 1.

140 One night, he invited Youngerman: Interview with Jack Youngerman, May 11, 2019. Matthews does not recall this particular episode, though Youngerman had recounted it vividly.

141 Martin and Kelly were eating breakfast: Goossen, *Ellsworth Kelly*, 67.

141 Kelly remembered those moments: Geldzahler, "Interview with Ellsworth Kelly."

142 "I never could have imagined": Robert Storr and Ellsworth Kelly, "Interview with Ellsworth Kelly," *MoMA* 2, no. 5 (1999): 2–7. http://www.jstor.org/stable/4420360.

142 As Kelly wrote in his diary: Bois, *Ellsworth Kelly: Catalogue Raisonné*, 178.

142 And a few years later: Detail of the artist's journal, Friday, January 15, 1960, reprinted in *Robert Indiana: New Perspectives*, 108.

143 Even Tawney returned to sculpture: Rosenberger, *Drawing the Line*, 153.

143 In 1960, she also acquired: Lenore Tawney's handwritten record of acquired artworks. Courtesy of the Lenore G. Tawney Foundation, and with thanks to Kathleen Mangan for this resource.

143 Though the relationship: Edgar Negret, as quoted in Ana Maria Franco, "The Magic of a Traffic Light: Edgar Negret's *Magic Machines*" paper, presented at "Transational Latin American Art from 1950 to the Present Day: the 1st International Research Forum of Graduate Students and Emerging Scholars" at the University of Texas at Austin, November 6–8, 2009.

143 Her first construction: Rosenberger, *Drawing the Line*, 124.

143 He continued to tinker: Robert Indiana journal entry, February 15, 1962, as reproduced in Mecklenburg, *Wood Works: Constructions by Robert Indiana*, 27. Exhibition catalogue.

143 Around this time: Henry Martin, *Agnes Martin*, 148.

144 Chryssa wrote to Parsons: Betty Parsons Gallery records and personal papers, 1916–1991, bulk 1946–1983, Series 1, Box 2, Folder 41: Chryssa Correspondence, 1958–1964, Archives of American Art, Smithsonian Institution.

144 By almost everyone's description: Sam Hunter, *Chryssa* (New York: Harry N. Abrams, 1974), 5.

144 Like Martin, she suffered: Arne Glimcher, *Agnes Martin*, 8.

144 She cast off Europe: Ann Geracimos, "Greek Artist Finds Times Square Poetic," Archives of American Art, Smithsonian Institution (January 29, 1962), Betty Parsons Gallery records and personal papers, 1916–1991, bulk 1946–1983, Series 1, Box 2, Folder 43: Chryssa Correspondence, 1958–1964.

145 Her *Gate to Times Square—Analysis of the Letter A*: John Canady, "Art: A Pleasure, Headache, and a Delicate Balm," *The New York Times*, March 19, 1966, 25.

145 Hunter proclaimed: Sam Hunter, *Chryssa*, 10.

145 In the September 14, 1962, issue of *Life*: "A Red-Hot Hundred: Introducing the Generation: A Foldout Gallery: Young Leaders of the Big Breakthrough," *Life*, September 14, 1962, 5.

147 She was, in her own description: Teri Wehn, "Interview with Chryssa, June 26, 1967," Archives of American Art, Smithsonian Institution.

147 She would go days: Ibid.

147 In a letter sent to Parsons in March 1961: Betty Parsons Gallery records and personal papers, 1916–1991, bulk 1946–1983, Series 1, Box 2, Folder 41: Chryssa Correspondence, 1958–1964, Archives of American Art, Smithsonian Institution.

147 And a year later, in March 1962: Ibid.

147 "She resembles her work": Hunter, *Chryssa*, 22.

148 It wasn't a notebook: Frances Morris, "Agnes Martin: Innocence and Experience," in *Agnes Martin*, ed. Frances Morris and Tiffany Bell (London: Tate/New York: D.A.P., 2015), 60.

148 "When things are spelled out": Margalit Fox, "Chryssa, Artist Who Saw Neon's Potential as a Medium, Dies at 79," *The New York Times*, January 19, 2014, section A, 28.

149 Chryssa mentions once: Hunter, *Chryssa*, 9.

149 Indiana noted seeing Martin and Chryssa: Robert Indiana journal entry, May 16, 1961. Courtesy RI Catalogue Raisonné LLC.

## 12. Auditions

151 On one such walk: Delphine Seyrig, letter to her mother, December 23, 1957, Youngerman/Seyrig Archives.

151 "The dog stayed and I stayed": Interview with Jack Youngerman, November 4, 2017.

152 In the morning: Ibid.

153 In the middle of one night: Lenore Tawney, *Autobiography of a Cloud*, 49. Courtesy of the Lenore G. Tawney Foundation.

153 "Even if we were very rich": Delphine Seyrig, letter to her mother, September 9, 1959, Youngerman/Seyrig Archives.

153 While she waited: Delphine Seyrig, letter to her mother, mid-April 1958, Youngerman/Seyrig Archives.

154 She wrote to her mother: Delphine Seyrig, letter to her mother, June 15, 1958, Youngerman/Seyrig Archives.

155 Kelly wrote in his journal: *Calder/Kelly*, 184.

155 Calder devised: Interview with Gerry Matthews, July 16, 2020.

155 Their first Christmas at the Slip: Delphine Seyrig, letter to her mother, December 23, 1957, Youngerman/Seyrig Archives.

155 Seyrig was unsuccessful: Perl, *Calder*, 316.

156 Plainclothes police officers: Delphine Seyrig, letter to her mother, December 23, 1957, Youngerman/Seyrig Archives.

156 On April 30, 1870: "Descent on Gambling-Houses," *The New York Times*, Saturday, April 30, 1870, 10.

156 And in 1886: "He Had Lost $500 at Faro," *The New York Times*, Sunday, January 24, 1886, 5.

157 The next day: Delphine Seyrig, letter to her mother, December 23, 1957, Youngerman/Seyrig Archives.

157 Seyrig considered buying a guitar: Delphine Seyrig, letter to her mother, December 1958, Youngerman/Seyrig Archives.

157 She did not get the part: Delphine Seyrig, letter to her mother, December 3, 1958, Youngerman/Seyrig Archives.

158 Seaver remembered this time: Seaver, *The Tender Hour of Twilight*, 281.

158 She and Jeannette: Ibid.

158 And Duncan would ride: Interview with Jack Youngerman, December 28, 2019.

159 She had been married so young: Delphine Seyrig, letter to her mother, end of October 1959, Youngerman/Seyrig Archives.

159 "I know myself well enough": Ibid.

159 This next project: *Pull My Daisy* (Germany: Steidl, 2008; first published by Grove Press, 1961), unpaginated.

160 As the composer: David Amram, *Vibrations: The Adventures and Musical Times of David Amram* (New York: Macmillan, 1968), 313.

160 The thirty-minute film is overlaid: R. J. Smith, *American Witness: The Art and Life of Robert Frank* (Boston: Da Capo Press, 2017), 134.

160 Leslie described: Judith E. Stein, *Eye of the Sixties: Richard Bellamy and the Transformation of Modern Art* (New York: Farrar, Straus and Giroux, 2016), 83.

161 As Leslie reportedly told: David Amram, *Offbeat: Collaborating with Kerouac* (New York: Routledge, 2008), 49.

161 And Orlovsky wrote: *Peter Orlovsky: A Life in Words* (New York: Routledge, 2014), 101.

161 "Most of us were drinking wine": Amram, *Vibrations*, 313.

161 She wanted to understand: Ellis Abrum, *Subterranean Kerouac: The Hidden Life of Jack Kerouac* (New York: St. Martin's Griffin, 1999), 304.

161 "Poor Delphine would pace": Amram, *Vibrations*, 314.

162 As her son explained: Interview with Jack and Duncan Youngerman, July 20, 2019.

162 Youngerman, who took many of her early headshots: Interview with Jack Youngerman, March 14, 2020.

163  She thought of the superficial aspect: Delphine Seyrig, letter to her father, May 5, 1959, Youngerman/Seyrig Archives.

163  It was not until a year later: Delphine Seyrig, letter to her mother, April 12, 1960, Youngerman/Seyrig Archives.

### 13. First Words

166  "I could feel that something": Diamonstein, *Inside New York's Art World*, 156.

166  There were a few other artists around: Baker, Oral history interview with Robert Indiana.

166  "It was just like going": Diamonstein, *Inside New York's Art World*, 156.

166  Kelly quipped: Interview with Jack Youngerman, June 2, 2018.

166  For his inaugural solo show: Robert Indiana, Biographical notes on Robert Indiana, 1962, Stable Gallery records, 1916–1999, Archives of American Art, Smithsonian Institution. https://www.aaa.si.edu/collections/items/detail/biographical-notes-robert-indiana-12950.

167  "Is an artist talking to himself": Donald B. Goodall, "Conversations with Robert Indiana," in *Robert Indiana* (Austin, TX: University Art Museum, 1977), 26. Exhibition catalogue.

168  He tore down his studio partition: See Pissarro, *Rare Works*. Indiana mentioned that he would have preferred to work on canvas, but he couldn't afford it, and therefore had to use Homasote, which was a cheap building material not intended for artistic use. (See page 60.)

168  An unexpected anecdote: Mark Rosenthal, "Experiencing Presence," in Waldman, *Ellsworth Kelly*, 63.

169  Martin described the hanging: Rosenberger, *Drawing the Line*, 136.

169  Their shared motif: Ibid., 144.

169  Four years of Latin: Diamonstein, *Inside New York's Art World*, 157.

170  Excitement mounted: As quoted in Ryan, *Robert Indiana*, 58. There was "excitement in the studio."

170  He felt like he was doing something new: Diamonstein, *Inside New York's Art World*, 157.

170  Indiana good-naturedly competed: Baker, Oral history interview with Robert Indiana.

170  "With so many prospectors": http://robertindiana.com/works/french-atomic-bomb/.

170  Indiana was overwhelmed: Daniel E. O'Leary, "The Journals of Robert Indiana," in *Love and the American Dream*, (Portland, Maine: Portland Museum of Art, 1999), 11. Exhibition catalogue.

170  A profile in *The New York Times*: Jeanne Molli, "Designer Works in Loft Amid Art and Greenery," *The New York Times*, March 19, 1962, 35.

172  He wrote in his diary: O'Leary, "The Journals of Robert Indiana," 10.

172  The herms stood silent: "[Indiana] later confessed that they were a source of physic comfort during lonely times in the absence of family." Haskell, *Beyond Love*, 36.

172  And then Indiana realized: Baker, Oral history interview with Robert Indiana. "The work became harder and more geometric and then when I did start using words in 1960 and these were as I said, forced on the constructions, because the constructions just needed the words; they did not look complete without them. And they were only decorative until they had their words. This was the beginning of my present work."

173  Indiana found a printer's calendar: Ryan, *Robert Indiana*, 154.

173  "I lived in an Indiana": Goldstein, "Robert Indiana on 50 Years of Art."

173  she would walk around her shows: As recounted by John Gruen in *The Party's Over Now*, 123.

173  Indiana's debut: "Robert Indiana," *Flash Art*, June 17, 2013. https://flash
---art.com/2013/06/oral-history-interview-with-robert-indiana/.

173  He later called this work: As quoted in Kalliopi Minioudaki, "From His Story to History: Robert Indiana's Patriotic Art of Social Engagement," in *Robert Indiana: New Perspectives*, 110.

174  Indiana found a "choice piece": Artist questionnaire: *Mate* (1960–62), February 17, 1966, Object Files, Whitney Museum of American Art, New York, as reproduced in Haskell, *Beyond Love*, 223.

174  He found there was suddenly: Ryan, *Robert Indiana*, 83.

175  As art historian Jonathan Katz has written: See Jonathan D. Katz, "Two Faced Truths: Robert Indiana's Queer Semiotic," in *Robert Indiana: New Perspectives*.

176  He was after an absolute truth in art: "Barnett Newman, Painter, 65, Dies," *The New York Times*, July 5, 1970, 45.

176  Newman's strong vertical zips: Ryan, *Robert Indiana*, 48.

176  Indiana continued to search: O'Leary, "The Journals of Robert Indiana," 10. Visit was on April 22, 1960.

177  "That's where my relationship": Pissarro, *Rare Works from 1959 on Coenties Slip*, 56.

177  And much later: O'Leary, "The Journals of Robert Indiana," 26.

177  Not wanting to give: Goodall, "Conversations with Robert Indiana," 25–41.

178  The curator Diane Waldman: Waldman, *Ellsworth Kelly: A Retrospective*, 29.

178  A few years later: From an interview of Ann Wilson by Jonathan Katz. Oral history interview with Ann Wilson, 2009 April 19–2010 July 12, Archives of American Art, Smithsonian Institution.

178  Kelly mentions Johnson: See his letter to Ralph Coburn, September 27, 1954. The Ellsworth Kelly Studio lists the meeting in 1955 on his official chronology.

179  "But then the postman": Paik, "In New York City," *Ellsworth Kelly*, 116.

179  Rosenquist always insisted: Rosenquist, *Painting Below Zero*, 87. Kelly showed Rosenquist three diamond-shaped paintings with one small shape in the corner and described them as "the James Dean road sign going backward at a hundred and ten miles an hour." Of another large abstract painting with black shapes, Kelly explained: "That's clothes on a line hanging across Wall Street."

180  The letters themselves: For this anecdote, see Bois, *Ellsworth Kelly: Catalogue Raisonné*, 225 n6.

180  Speaking of the Expressionist painter: Ibid., 224.

180  "Making art has first of all to do with honesty": Ellsworth Kelly, "Notes from 1969," in *Ellsworth Kelly: Schilderijen en beelden 1963–1979* (Amsterdam: Stedelijk Museum, 1979), 34. Exhibition catalogue.

180  Maybe, as Indiana defensively put it: Excerpts from Goodall, "Conversations with Robert Indiana," as quoted in Haskell, *Beyond Love*, 231.

181  Indiana was still thinking about the ginkgo: Robert Indiana's journal, April 8, 1962, as reproduced in Joe Lin-Hill, *Robert Indiana: A Sculpture Retrospective* (Buffalo, NY: Albright Knox Art Gallery and Kerber Verlag, 2019), 10. Exhibition catalogue.

181  The critic Douglas Crimp has pointed out: Douglas Crimp, *Before Pictures* (New York: Dancing Foxes Press, 2016), 142.

**14. Sixteen Americans and Two Frenchmen**

182  He called these studies: Roberts, Interview with Jack Youngerman, February 1968, 71 of transcript. Archives of American Art, Smithsonian Institution.

183  Crouched in that claustrophobic space: Ibid., 41.

183  Speaking in 1958: Rosenberger, *Drawing the Line*, 109.

184  She exhibited *Study for Black Ripe*: The actual painting *Black Ripe* was exhibited, under a different title, *Source*, in Kelly's first Parsons show in New York. And while, as Yve-Alain Bois has indicated, the title seems to allude to the work's surprisingly biomorphic shape and potential, it might also be a hat tip to Kelly's first American patron: *Black Ripe* was the brand of cigars smoked by Alexander Calder. Bois, *Ellsworth Kelly: Catalogue Raisonné*, 85.

184  "The 'Americans' shows set the tone": Michael Kimmelman, "Dorothy Miller Is Dead at 99; Discovered American Artists," *The New York Times*, July 13, 2003, section B, 16.

184  *New York Times* critic John Canaday: Dorothy Miller, Oral history interview with Paul Cummings, April 8, 1972, tape 7, side 1, page 174 of transcript, Archives of American Art, Smithsonian Institution.

184  Barr felt that: Oral history interview with Dorothy Miller, May 14, 1981, Archives of American Art, Smithsonian Institution.

185  For the artist: Interview with Jack Youngerman, December 2, 2017.

185  His living in an "out-of-the-way place": As quoted in Lindsay Pollock, "Mama MoMA," *New York*, October 31, 2003. https://nymag.com/nymetro/arts/features/n_9461/.

185  In one correspondence: Dorothy Miller correspondence to artist. February 1, 1962, Museum Collection Files, Robert Indiana, *The American Dream 1*, Department of Painting and Sculpture, The Museum of Modern Art, New York.

185  "If I hadn't known any artists": Pollock, "Mama MoMA."

185  Youngerman only half joked: Interview with Jack Youngerman, December 2, 2017.

187  "I feel comfortable": Delphine Seyrig, letter to her mother, end of October 1959, Youngerman/Seyrig Archives.

187 In Paris, Youngerman and Seyrig had their education in film: Interview with Jack Youngerman, May 5, 2018.

187 He took pictures of her: Delphine Seyrig, letter to her mother, end of November 1959, Youngerman/Seyrig Archives.

188 "I have always needed to have someone on the horizon who enlightens me . . . because otherwise I feel alone and helpless to make that light myself": Delphine Seyrig, letter to her mother, beginning of December 1959, Youngerman/Seyrig Archives.

188 Seyrig wrote to her mother: Delphine Seyrig, letter to her mother, mid-December 1959, Youngerman/Seyrig Archives.

188 At the time, there was no critical text: Interview with Jack Youngerman, December 2, 2017.

188 Kelly included excerpts: *Sixteen Americans*, ed. Dorothy C. Miller, with statements by the artists and others (New York: Museum of Modern Art; Doubleday), 31. Exhibition catalogue.

188 Other powerful statements: *Sixteen Americans*, 22 and 58.

189 In a review: Clement Greenberg, "Louis and Noland," *Art International* (May 1960), republished in *The Collected Essays and Criticism, Modernism with a Vengeance, 1957–1969* (Chicago: University of Chicago Press, 1993), 95.

190 he kept a reproduction: Walter Hopps, *The Dream Colony: A Life in Art*, ed. Deborah Treisman from interviews with Anne Doran (New York: Bloomsbury, 2017), 118.

190 As Stella famously explained: Tomkins, *Off the Wall*, 153.

190 The composer Philip Glass: Philip Glass, *Words Without Music* (New York: W. W. Norton, 2015) 80.

190 At the opening of *Sixteen Americans*: Interview with Jack Youngerman, December 2, 2017. Detail of the white orchid from Laurie Wilson, *Louise Nevelson: Light and Shadow* (London: Thames & Hudson, 2016), 195.

191 MoMA's conservators: Ann Temkin, *Claude Monet: Water Lilies* (New York: Museum of Modern Art, 2009), 37. Exhibition catalogue. Mitchell's use, as recounted by Philip Douglas Heilman, Mitchell's gallerist and friend, via email, August 17, 2022.

## 15. Dark River

192 Every month: *Lenore Tawney: A Personal World* (Brookfield, CT: Brookfield Craft Center), preface and interview with Lenore Tawney by Jean d'Autilia. Also Jack Lenor Larsen, "Lenore Tawney—Inspiration to Those Who Want to Develop Their Artistic Potential," *House Beautiful* 104 (March 1962): 177; and George O'Brien, "Weaver Departs from Tradition to Create an Art Form," *The New York Times*, April 29, 1963, 47.

192 She had painted: As quoted in Mona Schieren, "'Every Moment Is a Moment of Learning': Lenore Tawney, New Bauhaus and Amerindian Impulses," *Bauhaus Imaginista*. http://www.bauhaus-imaginista.org/articles/2623/every-moment-is-a-moment-of-learning.

192 The writer Anaïs Nin: Deirdre Bair, *Anaïs Nin: A Biography* (New York: Penguin, 1995), 430.

192 Tawney was "brilliant": From an interview of Ann Wilson by Jonathan Katz. Oral history interview with Ann Wilson, 2009 April 19–2010 July 12, Archives of American Art, Smithsonian Institution.

193 During the Depression: Harry Partch, *Bitter Music: Collected Journals, Essays, Introductions, and Librettos* (Champaign: University of Illinois Press, 2000), 5.

193 Nin, herself a daughter: *The Diary of Anaïs Nin, 1955–1966,* ed. and with a preface by Gunther Stuhlmann (New York and London: Harcourt Brace Jovanovich, 1976), 123.

193 She felt the need: Ibid., 201.

193 Nin was always paying her: Tawney, as quoted in an interview with the artist in Bair, *Anaïs Nin*, 430.

194 "interior landscapes": Schieren, "'Every Moment Is a Moment of Learning.'"

194 In the winter: Cummings, Oral history interview with Lenore Tawney, June 23, 1971, Archives of American Art, Smithsonian Institution.

194 Like Martin, she felt the East River: *Lenore Tawney: A Personal World.*

194 In the second half of the nineteenth century: Mark R. Wilson, "The Extensive Side of Nineteenth-Century Military Economy: The Tent Industry in the Northern United States during the Civil War," *Enterprise & Society* 2, no. 2 (2001): 297–337. See pp. 304–305.

194 In Nantucket: James Franklin Briggs, *Sails and Sailmakers: Paper Read at the Meeting of the Old Dartmouth Historical Society, April 27, 1937,* unpaginated.

194 A master sailmaker: Wilson, "The Extensive Side of Nineteenth-Century Military Economy," 304–305.

195 There are stories: Briggs, *Sails and Sailmakers.*

195 Outfitted in homemade clothes: Julie Winch, *A Gentleman of Color: The Life of James Forten* (Oxford: Oxford University Press, 2002), 20.

196 One account of sails: Briggs, *Sails and Sailmakers.*

196 The height of business: Wilson, "The Extensive Side of Nineteenth-Century Military Economy," 309.

196 By the end of the war: Ibid., 331.

196 Sailmakers in New York: "Arrest of a New-York Merchant for Fitting Out Slavers," *The New York Times,* December 6, 1861, 5.

198 This renewed focus: Elaine Tyler May, *Homeward Bound: American Families in the Cold War Era* (New York: Basic Books, 1988), 9.

198 And this extended: Ibid., 13.

199 Rosenquist remembers her: Rosenquist, *Painting Below Zero,* 126.

199 Tawney and Martin were captivated: A metaphor that the queer writer Carson McCullers would rework into the "inner room" of one's self where your most precious memories and people live inside you in her 1940 novel *The Heart Is a Lonely Hunter.*

199 In her clear, descriptive writing: St. Teresa, translated from the Spanish by Rev. John Dalton, *The Interior Castle or The Mansions* (London: T. Jones, 63 Paternoster Row, 1852), 46. Ann Wilson talks about their interest in Teresa. From an interview of Ann Wilson by Jonathan Katz. Oral history interview with Ann Wilson, 2009 April 19–2010 July 12, Archives of American Art, Smithsonian Institution.

199 Tawney and Martin both meditated: Barbara Haskell, "Agnes Martin: The Awareness of Perfection," in Haskell, *Agnes Martin*, 95.

199 With Youngerman: Tawney often served as a library and source for Indiana in his work; one hot April morning in 1962 he called her up to check in her unabridged dictionary for the colors of Cuba's flag when he was working on his wooden construction *Cuba*. See Mecklenburg, *Wood Works*, 25.

199 Back in Urbana: Seaman, *Identity Unknown*, 404.

200 Critics compared Tawney's weavings: A seventy-two-inch-square canvas, *The Islands*, in which a grid is drawn in pencil onto the natural linen, and pale paint is inscribed in rectangular daubs or dashes inscribing another square that seems to be threaded into the grid. As the artist Donald Judd wrote in describing this work, "The field is woven." *Agnes Martin* (New York: D.A.P., 2015), 79.

200 A woman working in textiles: Elissa Auther, *String, Felt, Thread: The Hierarchy of Art and Craft in American Art* (Minneapolis: University of Minnesota Press, 2010), 23.

201 Occasionally, Tawney had to ask Johnson: As quoted in Adamson, "Student: 1945 to 1960," 67n74.

201 Martin intervened: As quoted in Ibid., 76.

201 Tawney took this in stride: As quoted in Glenn Adamson, "Sculptor: 1961 to 1970," in *Lenore Tawney: Mirror of the Universe*, 106, and author's visit to the Lenore G. Tawney Foundation archives.

201 Tawney's exhibition: Kathleen Nugent Mangan, "Messages from a Journey," in *Lenore Tawney: A Retrospective*, 22. Exhibition catalogue.

202 Adams remembers: Interview with Alice Adams, January 22, 2021.

202 Her review in *Craft Horizons*: Alice Adams, "Lenore Tawney," *Craft Horizons* 22, no. 1 (January/February 1962): 39.

202 Martin contributed a statement: *Lenore Tawney* (Staten Island, NY: Staten Island Museum, November 19, 1961–January 7, 1962). Exhibition catalogue.

203 Parsons would send statements: Princenthal, *Agnes Martin*, 126.

203 Every morning for two and a half years: Ibid., 127.

203 She called it: Ibid., 147.

203 She was working on: Munro, *Originals*, 329.

204 Its open delicacy: Adamson, "Student: 1945 to 1960," 59.

204 She saw that it: Auther, *String, Felt, Thread*, 29.

204 As Youngerman later noted: Quoted in Adamson, "Student: 1945 to 1960," 72.

205 Her invention was not: *Lenore Tawney: A Personal World*, 1978.

206 The new shapes: Kathleeen Nugent Mangan, "Remembering Lenore Tawney," *New York Arts* 13 (March/April 2008): 70.

206 "It's not patience": *Lenore Tawney: A Personal World*.

206 Larsen and Tawney spoke: Larsen, "Lenore Tawney," 177.

206 Tawney ordered "a great deal of black and white linen thread": Munro, *Originals*, 329.

206 Martin would later write: Agnes Martin, "The current of the river of life moves us," prepared for a lecture at the University of New Mexico, Santa Fe, 1979, from Arne Glimcher, *Agnes Martin*, 169.

207 Here, too, we see: St. Teresa, *The Interior Castle or The Mansions*, 49.

207 and she wrote, in sensual terms: https://www.theculturium.com/teresa-of-avila-the-ecstasy-of-love/.

207 The "great noise": St. Teresa, 46.

207 She had "all this work ready": *Lenore Tawney: A Personal World*.

207 It was a "thrilling" time: Rose Slivka, "The New Tapestry," *Craft Horizons* 23, no. 2 (March/April 1963): 18; and Maureen Orth, "The Cosmic Creations of Lenore Tawney," *New York Woman* (May/June 1987): 66; both quoted in *Lenore Tawney: Mirror of the Universe*, 118.

207 Her work poured out: Munro, *Originals*, 330.

207 One day when she called: Ibid.

208 As she was making it: Orth, "The Cosmic Creations of Lenore Tawney," 66.

208 Tawney described the piece: Slivka, "The New Tapestry," 18.

208 Mildred Constantine, curator of textiles: Lenore Tawney, *Dark River*, Collection File, Department of Architecture and Design, Museum of Modern Art, New York.

209 In retrospect, Constantine and Larsen: Mildred Constantine and Jack Lenor Larsen, *Beyond Craft: The Art Fabric* (New York: Van Nostrand Reinhold, 1973).

209 At one point: Adamson, "Sculptor: 1961–1970," 106.

209 Just a few months: Lenore Tawney postcard to Marna Johnson, January 15, 1963, Lenore G. Tawney Foundation. Also published in *Lenore Tawney: Mirror of the Universe*, 73.

209 Or she rode: Seaman, *Identity Unknown*, 380.

210 Martin once said: Agnes Martin, as quoted by Ann Wilson, "Linear Webs," *Art and Artists* (London), October 1966, 48.

210 Smith took the title: *Lenore Tawney: A Retrospective*, 26.

211 Tawney's friend and former Slipmate: Ann Wilson, "Lenore Tawney," in *Woven Forms* (New York: Museum of Contemporary Crafts of the American Craftsmen's Council, March 22–May 12, 1963), 33. Exhibition catalogue.

211 Underscoring the hierarchal role: O'Brien, "Weaver Departs from Tradition," 47.

211 In retrospect, *Woven Forms* has been called: Adamson, "Sculptor: 1961–1970," 119.

211 "Next day": Lenore Tawney letter to Marna Johnson, April 12, 1963. Courtesy of the Lenore G. Tawney Foundation. Also published in *Lenore Tawney: Mirror of the Universe*, 125.

211 On April 24, 1961: Betty Parsons Gallery records and personal papers, Series 1, Box 11, Folder 7, Archives of American Art, Smithsonian Institution.

212 It was one of two works: Princenthal, *Agnes Martin*, 126.

212  *Dear Lenore*: Agnes Martin to Lenore Tawney, October 25, 1963. Courtesy of the Lenore G. Tawney Foundation.

## 16. Simple Things

214  He thought of his life: James Rosenquist, Interview with Mary Ann Staniszewsk, *Bomb*, October 1, 1987.

214  As he later explained: Rosenquist, *Painting Below Zero*, 78.

214  As the *New Yorker* writer: Lopate, *Waterfront*, 242.

214  "Buildings to the left": "Autochronology," *Robert Indiana* (Philadelphia: Institute of Contemporary Art with Falcon Press, 1968). Exhibition catalogue.

215  A later work: Gene Swenson, "James Rosenquist: The Figure a Man Makes," in *Gene Swenson: Retrospective for a Critic* (Lawrence: Register of the Museum of Art, University of Kansas, 1971), 58.

215  Painting and seeing and hearing: "Painting, Working, Talking: Michael Amy Interviews James Rosenquist," *Art in America*, February 2004, 104–109, 143.

215  "On Coenties Slip": Rosenquist, *Painting Below Zero*, 90.

215  "The brain itself": Ibid.

215  At the same time: Ibid., 98.

215  "With collage, there is a glint": Ibid., 101.

216  "Something happened in painting": Leo Steinberg, "Other Criteria," in *Other Criteria: Confrontations with Twentieth-Century Art* (Chicago: University of Chicago Press, 2007), 84.

216  "It occurred to me": Rosenquist, *Painting Below Zero*, 83.

217  "I was always close up": Rosenquist, Interview with Mary Ann Staniszewsk, *Bomb*, October 1, 1987.

217  "It was a process": Rosenquist, *Painting Below Zero*, 91.

217  *Zone* flirts: Goldman, *James Rosenquist*, 16.

217  "I thought maybe I could make": Rosenquist, *Painting Below Zero*, 88.

217  He connected this back: Ibid., 89.

218  What, he wondered: Ibid., 95.

218  In another early work: Van der Marck, "Reminiscing on the Gulf of Mexico: A Conversation with James Rosenquist," 84–107.

219  Rosenquist had not met: Robert C. Scull, "Re the F-111: A Collector's Notes," in *The Metropolitan Museum of Art Bulletin* 26, no. 7 (March 1968): 8.

219  "The room was knee-deep": Goldman, *James Rosenquist*, 100.

219  Paul Cummings described: Ibid., 14.

220  The paintings he was working on: Ivan Karp, Interview with Paul Cummings, March 12, 1969, Archives of American Art, Smithsonian Institution.

220  Gene Swenson, the critic: Swenson, "James Rosenquist: The Figure a Man Makes," 59.

220  During a huge blizzard: Rosenquist, *Painting Below Zero*, 86.

221  Just after Christmas that year: Ibid., 85.

221 "Part of the reason the art scene": Ibid., 128.

221 Living near him: Ibid., 84.

221 Rosenquist started to throw: Ibid., 128.

**17. The American Dream**

223 As he was working: Interview with Charles Hinman, November 6, 2020.

223 Rosenquist was struck: Rosenquist, *Painting Below Zero*, 113.

223 Rosenquist painted the oversaturated: Ibid.

225 He was still working on it: O'Leary, "The Journals of Robert Indiana," 17.

225 what one TV critic called: Michael Beschloss, "No Concession, No Sleep: Glued to the TV on Election Night 1960," *The New York Times*, October 30, 2016, section BU, 3.

226 Indiana may be referencing: Thomas Crow, "The Insistence of the Letter in the Art of Robert Indiana," in *Robert Indiana: New Perspectives*, 50.

227 He found it "spellbinding": Haskell, "Robert Indiana: The American Dream," in *Beyond Love*, 76.

229 Indiana was annoyed: From Indiana's notebooks, as quoted in O'Leary, "The Journals of Robert Indiana," 22.

229 Indiana would later say: Martin Dibner, "Introduction," *Indiana's Indianas: A 20-Year Retrospective of Paintings and Sculpture from the Collection of Robert Indiana* (Rockland, ME: William A. Fransworth Library and Art Museum, 1982), 1–10, as reprinted in Haskell, *Beyond Love*, 235.

229 "I thought of them": Rosenquist, *Painting Below Zero*, 116.

229 When Jasper Johns: Ibid., 134.

230 A few other friends: Ibid., 116.

230 Castelli remained skeptical: Stein, *Eye of the Sixties*, 145; and James Rosenquist, Interview with Mary Ann Staniszewsk, *Bomb*, October 1, 1987.

230 Swenson was, in the critic Lucy Lippard's description from 1959: Lucy Lippard's reflection on Gene Swenson in *Gene Swenson: Retrospective for an Art Critic*, 16.

230 He had a bad stutter: Jill Johnston, "Like a Boy in a Boat," *Marmalade Me* (New York: E.P. Dutton & Co., Inc., 1971), 301.

231 On his first visit to the Slip: Swenson, "James Rosenquist: The Figure a Man Makes," 57.

231 As Rosenquist remembered: James Rosenquist on Gene Swenson in *Gene Swenson: Retrospective for an Art Critic*, 24.

231 Swenson went back: Swenson, "James Rosenquist: The Figure a Man Makes," 57.

231 He saw a "ruthless clarity": Goldman, *James Rosenquist*, 9.

231 Swenson's response to art: Lucy Lippard on Gene Swenson in *Gene Swenson: Retrospective for an Art Critic*, 16.

231 For his part, Barr: Oral History Program, Interview with James Rosenquist, April 17, 2012, 2, The Museum of Modern Art Archives, New York.

232 One Sunday in early fall: Stein, *Eye of the Sixties*, 144.

232 Karp was chattering away: Rosenquist, *Painting Below Zero*, 118.

232 As he once described his process: Stein, *Eye of the Sixties*, 159.

232 Bellamy thought of himself: Ibid, 162.

232 Or, as Rosenquist described him: Rosenquist, *Painting Below Zero*, 324.

232 On this particular occasion: Rosenquist, *Painting Below Zero*, 118, and Stein, *Eye of the Sixties*, 145.

232 "You think you're the only artist": Rosenquist, *Painting Below Zero*, 132.

233 Rosenquist and his friend Ray Danarski: Alexi Worth, "First Break: James Rosenquist," *Artforum*, March 2002. https://www.artforum.com/print/200203/james-rosenquist-2448.

233 In fact, eleven works: Rosenquist, *Painting Below Zero*, 119.

233 (who incidentally was color blind): Stein, *Eye of the Sixties*, 115.

233 Tremaine showed up: Ibid., 156.

233 As Rosenquist remembered: Rosenquist, *Painting Below Zero*, 166.

233 In the pages: James E. Breslin, *Mark Rothko: A Biography* (Chicago: University of Chicago Press, 1993), 429.

234 Swenson's important article: G. R. Swenson, "The New American 'Sign Painters,'" *ArtNews* 61, no. 5 (September 1962): 45.

234 His 1963 follow-up article: Ibid., 46.

235 Warhol's and Rosenquist's work: G. R. Swenson, "The Personality of the Artist," 1965. Unpublished draft of a lecture delivered on the occasion of the exhibition *Andy Warhol: Works from 1961–1965*, Institute of Contemporary Art, University of Pennsylvania (September 10–December 8, 1965). As quoted in Jennifer Sichel, "'Do You Think Pop Art's Queer?' Gene Swenson and Andy Warhol," *Oxford Art Journal* 41, issue 1 (March 2018): 59–83.

235 If Abstract Expressionism: Breslin, *Rothko*, 429.

235 The opening was "insane": Stein, *Eye of the Sixties*, 174.

235 "Instead, he stared in from outside": Mark Stevens and Annalyn Swan, *De Kooning: An American Master* (New York: Alfred A. Knopf, 2004), 441.

236 The critic Thomas B. Hess: Goldman, *James Rosenquist*, 9.

236 Rosenquist would take offense: Ibid., 103.

236 Even if Pop: Gene Swenson, "What Is Pop Art?" *Art News* 62, no. 7 (November 1963): 63–64.

237 Indiana couldn't remember: Baker, Oral history interview with Robert Indiana.

237 But it was "brought into focus": See Robert Indiana's journal, January 15, 1961. Courtesy RI Catalogue Raisonné LLC.

237 Albee's satire: Mel Gussow, *Edward Albee: A Singular Journey* (New York: Applause, 2001), 150.

237 Later he described: Goodall, "Conversations with Robert Indiana," as reprinted in Haskell, *Beyond Love*, 230.

237 He worked for Phillips: Artist statements, Institute of Contemporary Art, University of Pennsylvania, 1968, in Haskell, *Beyond Love*, 225.

238 In his journals: Haskell, "Robert Indiana: The American Dream," 41.

238 or as the artist put it: As quoted in Joe Lin-Hill, "Figuring Robert Indiana," in *Robert Indiana: A Sculpture Retrospective*, 18.

238 But it really was a modern invention: The phrase's first known appearance, according to Sarah Churchwell's extraordinary book *Behold, America*, was in the 1880s as a Republican slogan; in the following years it crops up in a 1914 treatise on social democracy in which it's framed as a danger in society's too-trusting empowerment of individualism. It was officially coined in James Truslow Adams's 1931 book *The Epic of America*, which analyzed the Great Depression and referred to "the American Dream" as an ideal social order, based in dignity and equity. Sarah Churchwell, *Behold, America: A History of America First and the American Dream* (London: Bloomsbury Publishing, 2018). See also the artist O. Louis Guglielmi's fascinating *The American Dream* painting of 1935, which lampoons the promise of a better life.

238 It wasn't until the 1950s: Churchwell, *Behold, America*, 285–286.

239 Boorstin finds it ironic: Daniel J. Boorstin, *The Image, or What Happened to the American Dream* (New York: Atheneum, 1962), 245.

239 Rosenquist wrote that in the early 1960s: Rosenquist, *Painting Below Zero*, 101.

242 The novelist and art collector: Van der Marck, "Reminiscing on the Gulf of Mexico," 100.

242 More than anything: Swenson, "James Rosenquist: The Figure a Man Makes," 58.

243 Ruscha hitchhiked: Ed Ruscha, in "Sign Language: James Rosenquist in Retrospect," *Artforum* 42, no. 2 (October 2003): 131.

243 On Palm Sunday, 1963: Hollis Frampton, *On the Camera Arts and Consecutive Matters: The Writings of Hollis Frampton*, ed. and with an introduction by Bruce Jenkins (Cambridge, MA: MIT Press, 2009), 206.

243 Upstairs in Rosenquist's studio: Ibid.

244 Frampton later wrote: Ibid.

245 Just as Kloss was leaving the Slip: http://geraldlaing.org/memoirs/13_first_visit_to_new_york.

246 Directly following Laing's show: https://www.washburngallery.com/exhibitions/charles-hinman2/press-release.

247 Swenson remembered weeping: Swenson, "James Rosenquist: The Figure a Man Makes," 77.

247 This, too, took on a new significance: Aprile Gallant, "An American's Dream," in *Love and the American Dream*, 49.

248 As he put it: Rosenquist, *Painting Below Zero*, 308.

## 18. Pop Will Eat Itself

249 Warhol was bothered: J. J. Murphy, *The Black Hole of the Camera: The Films of Andy Warhol* (Berkeley: University of California Press, 2012), 141.

249 unless you count: Blake Gopnik, *Warhol* (New York: Ecco, 2020), 348.

249 Warhol scheduled Indiana: Ibid., 349.

250 Name once said: Eric Shiner interviews Billy Name, "I was natural, but Andy, he was purely synthetic," in *Thirteen Most Wanted Men: Andy Warhol and the 1964 World's Fair* (Queens, NY: Queens Museum, 2014), 85. Exhibition catalogue.

252 Film was a natural extension: J. Hoberman, "Across the Movi-verse," *Film Comment* 48 no. 2 (2012): 34–39.

252 Indiana is present: Gopnik, *Warhol*, 315.

252 When Warhol arrived to film: Hoberman, "Across the Movi-verse," 36.

252 The night before: "*Tom Jones* Film Opens Here Oct. 7," *The New York Times*, September 17, 1963, 31.

253 But from the large selection: Steven Watson, *Factory Made: Warhol and the Sixties* (New York: Pantheon, 2003), 138.

253 Had he seen Craig Claiborne's: Craig Claiborne, "Agaricus Campestris," *The New York Times*, February 12, 1964, 258.

253 He set his camera up: Dan Duray, "On the Horn with a Hoosier: A Fun Little Telephone Q&A with Robert Indiana," *The Observer*, September 18, 2013, Fall Arts Preview. https://observer.com/2013/09/on-the-horn-with-a-hoosier-a -fun-little-telephone-qa-with-robert-indiana-2/. Indiana's cat is called Pachiki here, Parcheesi in his 1963 interview with Robert Brown Baker, and Particci in his March 8, 1964, *New York Times* profile.

253 Warhol's camera kept falling apart: Paul Taylor, "Love Story," *Connoisseur* 221, no. 955 (August 1991): 95.

253 They also "cheated": Anny Shaw, "From the Archive: How New York Fell Back in Love with Robert Indiana," *The Art Newspaper* (May 21, 2019). https:// www.theartnewspaper.com/feature/how-new-york-fell-back-in-love-with-rob-ert-indiana.

255 He was on speed: Larissa Harris and Nicholas Chambers interview John Giorno, "He was a commercial artist. It was the kiss of death," in *Thirteen Most Wanted Men: Andy Warhol and the 1964 World's Fair*, 24.

255 And while Warhol probably didn't know this: "She was very pleased, and she picked the mushroom, took it, and cooked it for my lunch," Arthur C. Carr, "The Reminiscences of Robert Indiana," November 1965, 109, Arthur C. Carr Papers, Rare Book and Manuscript Library, Butler Library, Columbia University, New York.

256 Within the art world: Warhol had expressed his admiration for Cage in 1963 ("He really is great") and had seen the composer's presentation of Erik Satie's *Vexations*, which repeated a one-minute phrase of Satie's music for more than eighteen hours (Branden W. Joseph, "The Play of Repetition: Andy Warhol's 'Sleep,'" *Grey Room*, no. 19 [2005]: 22–53). Cage famously quoted the Zen saying "If something is boring after two minutes, try it for four. If still boring, try it for eight, sixteen, thirty-two, and so on. Eventually one discovers that it's not boring at all but very interesting" (Larson, *Where the Heart Beats*, 385). *Sleep* was compared by some critics to Cage's aesthetics of duration and repetition—an association that delighted Warhol.

257 For Indiana, *EAT* as a word: As quoted in Carr, "The Reminiscences of Robert Indiana," November 1965, 98, Arthur C. Carr Papers, Rare Book and Manuscript Library, Butler Library, Columbia University, New York.

257 Some were standalone works: Baker, Oral history interview with Robert Indiana.

257 He claimed he liked: Clare Henry, "Interview: James Rosenquist: Painting Up in the Air," *Financial Times*, November 15/16, 2003, W5.

257 But it was also a frequent meal: Oral History Program, Interview with James Rosenquist, April 17, 2012, 60, The Museum of Modern Art Archives, New York.

257 "No drips or splashes": Henry, "Painting Up in the Air," W5.

258 To support the family: Artist statement, *Sao Paulo 9* (Sao Paulo: Museu de Arte Moderna, 1967), exhibition catalog, as republished in Haskell, *Beyond Love*, 226–227. Exhibition catalogue.

258 The EAT signs: Excerpt from Richard Stankiewicz and Robert Indiana, interview by Jan van der Marck, Walker Art Center, Minneapolis, October 21, 1963.

258 "It is pretty hard to swallow": Gallant, "An American's Dreams," 38.

258 "Everybody eats": Excerpt from Stankiewicz and Indiana, interview by Jan van der Marck, Walker Art Center, Minneapolis, October 21, 1963.

258 Indiana claimed: Robert Indiana, Artist statement, Stedelijk/Van Abbemuseum, 1966, as reprinted in Haskell, *Beyond Love*, 224.

259 later, his father dropped dead: Robert Indiana, Artist statement, Institute of Contemporary Art, University of Pennsylvania, 1968, as reprinted in Haskell, *Beyond Love*, 226.

259 As the mushroom expert: Larson, *Where the Heart Beats*, 326.

259 Or, as one critic in 1964 wrote: Carl I. Belz, "Pop Art and the American Experience," *Chicago Review* 17, no. 1 (1964): 112.

260 One artist commented: "Avant-Garde Art Going to the Fair," *The New York Times*, October 5, 1963, 17.

261 Michelangelo's famous *Pieta*: Robert A. M. Stern, Thomas Mellins, and David Fishman, *New York 1960: Architecture and Urbanism Between the Second World War and the Bicentennial* (New York: Monacelli Press, 1995), 1049.

261 He had the piece fabricated: Baker, Oral history interview with Robert Indiana.

261 He imagined the work: Indiana, Artist statement, Stedelijk/Van Abbemuseum, 1966, republished in Haskell, *Beyond Love*, 224.

261 He had written to Cage from Paris: As quoted in Ann Temkin, *Color Chart: Reinventing Color 1950 to Today* (New York: Museum of Modern Art, 2008), 47.

261 Here was his wish: Geldzahler, "Interview with Ellsworth Kelly."

262 In a September 1963 interview: Gopnik, *Warhol*, 376.

262 The opening dinner: Rosenquist, *Painting Below Zero*, 142.

263 If it was not activated: Indiana, Artist statement, Stedelijk/Van Abbemuseum, 1966, republished in Haskell, *Beyond Love*, 224.

263 This followed a major crackdown: George Chauncey, "A Gay World, Vibrant and Forgotten," *The New York Times*, June 26, 1994, section 4, 17.

263 The poet Frank O'Hara: Douglas Crimp and Richard Meyer, "Imagine the police raiding a film called Blow Job and finding a forty-minute silent portrait of a man's face!" in *Thirteen Most Wanted Men: Andy Warhol and the 1964 World's Fair*, 66.

264 This "cleanup" coincided: Robert C. Doty, "Growth of Overt Homosexuality in City Provokes Wide Concern," *The New York Times*, December 17, 1963, 1, 33.

265 "It's amazing": Ninette Lyon, "Robert Indiana, Andy Warhol, a Second Fame: Good Food," *Vogue*, March 1965, 185.

265 Here, Indiana: Ibid., 186.

265 For Warhol, the concept: Branden W. Joseph, "The Play of Repetition: Andy Warhol's 'Sleep,'" *Grey Room*, no. 19 (2005): 22–53. http://www.jstor.org /stable/20442678. 27.

265 Of course, the ultimate form: As Branden Joseph has argued, "Warhol's own deployment of eroticism . . . was always densely mediated through the tropes of death and commodification." Joseph, "The Play of Repetition," 46–47.

265 *Eat* was Warhol's first: The first known mention of the series is in January 1964, when Kelly Edey wrote in his diary that Warhol "made a movie . . . a series of portraits of a number of beautiful boys."

266 The French food journalist Ninette Lyon: Lyon, "Robert Indiana, Andy Warhol," 185.

266 Lyon had herself: Craig Clairborne, "Food News: French View Given on Dining in U.S." *The New York Times*, June 27, 1964, 13.

266 Warhol meanwhile: Lyon, "Robert Indiana, Andy Warhol," 185.

268 The preponderance of corporate: Cecile Whiting, "Philip Johnson: The Whence and Whither of Art in Architecture," *Journal of the Society of Architectural Historians* 75, no. 3 (2016): 318–338.

268 "The World's Fair": From *Jubilee*, August 1964, as quoted in Joseph Tirella, *Tomorrow-Land: The 1964–65 World's Fair and the Transformation of America* (Guilford, CT: Lyons Press, 2014), 265.

268 And another critic lamented: Lobel, *James Rosenquist*, 119.

268 The Kodak tower: Ibid.

268 A September 1964 article: Tirella, *Tomorrow-Land*, 261.

269 The author attached: Ibid., 262.

269 In the words: Robert Caro, *The Power Broker: Robert Moses and the Fall of New York* (New York: Vintage Books, 1974), 1114.

**19. A Delicate City**

273 More than twenty-one acres: Kurt C. Schlichting, *Waterfront Manhattan: From Henry Hudson to the High Line* (Baltimore: Johns Hopkins University Press, 2018), 29.

273 Here is F. Scott Fitzgerald's initial vision: https://www.laphamsquarterly.org/ city/blowing-town.

274 Immigration through: Schlichting, *Waterfront Manhattan*, 90.

274 The neighborhoods around: Ibid., 93.

274 the newly coined term: Wallace, *Greater Gotham*, 147.

274 "Industry was leaving": Interview with Jack Youngerman, May 5, 2018.

274 By 1955: Rousmaniere, *The Anchor in the Vail*, 83.

275 Ironically, this was also the concern: David Rockefeller, *Memoirs* (New York: Random House, 2002), 161.

275 "The key to getting the plan approved": Caro, *The Power Broker*, 734.

275 "Much to my relief": Rockefeller, *Memoirs*, 166.

275 A photograph of the Mutual Benefit Life building: Walker Evans, "Downtown: A Last Look Backward," *Fortune*, October 1956, 157–62.

276 In the same issue: Joshua Shannon, *The Disappearance of Objects: New York Art and the Rise of the Postmodern City* (New Haven: Yale, 2009), 69.

277 At the start of construction: Rockefeller, *Memoirs*, 166.

277 "The big, broad-shouldered Chase": As quoted in Michael Johns, *Moment of Grace: The American City in the 1950s* (Berkeley: University of California Press, 2003), 30.

277 Rockefeller set aside: Bunshaft also served on the original design committee for the 1964 World's Fair, but resigned when Robert Moses stifled any sense of contemporaneity in their plan.

277 The irony of this support: Delphine Seyrig, letter to her mother, beginning of October 1959, Youngerman/Seyrig Archives.

277 Miller pointed out to him: Dorothy Miller, Interviewed by Paul Cummings, February 12, 1971, tape 6, side 2, page 165 in transcript, Archives of American Art, Smithsonian Institution. Also recalled in her essay "Art for Work Places," in *Art at Work: The Chase Manhattan Collection* (New York: E. P. Dutton, 1984), 38.

277 As Youngerman would later put it: Interview with Jack Youngerman, May 5, 2018.

278 Miller had another view: Peter Morrin, "The First Ten Years of the Chase Art Committee: An Interview with Dorothy Miller," in *Chase Manhattan: The First Ten Years of Collecting, 1959–1969* (Atlanta: Preston Rose Company for the High Museum of Art, 1982), 14.

278 Indiana described the beam: Artist's questionnaire, Museum Collection Files, Robert Indiana, *Moon*. Department of Painting and Sculpture, The Museum of Modern Art, New York.

278 As Rockefeller wrote: Rockefeller, *Memoirs*, 388.

278 As part of the Downtown-Lower Manhattan Association's vision: Stern, Mellins, and Fishman, 198.

279 "The district": Ibid., 207.

279 Walker Evans returned to Coenties Slip: Walker Evans, "On the Waterfront," *Fortune*, November 1960, 144–50.

280 A year later: Anthony C. Wood, *Preserving New York* (New York: Routledge, 2008), 51.

280 One of the most intriguing aspects: Ibid., 141.

281 Already in 1958: Ibid., 251.

281 In early 1960: Seaver, *The Tender Hour of Twilight*, 335.

282 She was an "unaccredited journalist-mother, with no college education": Wilfred M. McClay, "The Space Was Ours Before We Were the Place's," in *Why*

*Place Matters: Geography, Identity, and Civic Life in Modern America*, eds. Wilfred M. McClay and Ted V. McAllister (Encounter Books, 2014), 244.

282 Among her arguments: Jane Jacobs, *The Death and Life of Great American Cities* (New York: Vintage, 1961), 195.

282 A *New York Times* editorial in March 1962: Wood, *Preserving New York*, 286.

283 An editorial in *The New York Times* in February 1964: "South of Brooklyn Bridge," *The New York Times*, February 10, 1964, 26.

283 Ivan Karp's Anonymous Arts Recovery Society: Ada Louise Huxtable, "Arts Group Saves Bits of Landmark," *The New York Times*, October 6, 1964, 41.

283 Huxtable kicked off a series: Ada Louise Huxtable, *Classic New York: Georgian Gentility to Greek Elegance* (New York: Anchor Editions, 1964).

283 "Before urban renewal was scheduled": Ibid., xiv.

283 Huxtable walked the city streets: Ibid., 111–13.

284 For brief interludes: Ibid., 111.

284 Huxtable wrote: Ibid., 110.

284 Echoing many accounts, Lyon remembers: Danny Lyon, *The Destruction of Lower Manhattan* (New York: Macmillan, 1969; facsimile published by Aperture Foundation, New York, 2020), 2.

285 It was, in his description: Eric Banks, "When a Neighborhood Fell, and Barely Made a Sound," *The New York Times*, June 19, 2005, section 2, 32.

285 "The metropolis is peculiar to rapid changes": Rousmaniere, *The Anchor in the Vail*, 94.

286 In 1968, the place that had been: Robert Indiana's Autochronology, quoted in Mecklenburg, *Wood Works*, 42.

286 In August 1968, a feature in *New York*: Patricia Lahrmer, "Bargains in Gargoyles," *New York*, August 18, 1968, 59.

287 The crew was later issued: Mark Perigut, "Collectors Reap the Fruits of Demolition," *The New York Times*, February 1, 1979, section R, 1.

## 20. Delphine and Jack

288 Christmas 1959 was a warm affair: Delphine Seyrig, letter to her parents, February 3, 1960, Youngerman/Seyrig Archives.

288 They were terrified they'd have to leave: Ibid.

289 Alain Robbe-Grillet, who had emerged: Roland Barthes, *Writing Degree Zero*, trans. Annette Lavers and Colin Smith (New York: Hill and Wang, 1977), 77.

290 The haircut became a trend: Charlotte Curtis, "The Movies Are Staging Comeback as Influence on Fashion and Hairdos," *The New York Times*, July 13, 1962, 26.

290 Seyrig told him she had changed: ("Elle lui a annoncé qu'elle avait hange et embelli depuis son depart.") Mireille Brangé, *Delphine Seyrig: un vie* (Paris: Nouveau Monde Editions, 2019), 157.

290 Realizing that he had lost her: Ibid., 163.

291 As the critic and theorist bell hooks: bell hooks, "Women Artists: The Creative Process," in *Art on My Mind* (New York: New York Press, 1995), 130.

291 "Delphine was tormented": Interview with Jack Youngerman, May 5, 2018.

291 *Last Year at Marienbad* was shot: James Monaco, *Alain Resnais* (New York: Oxford University Press, 1979), 59, and Brangé, *Delphine Seyrig*, 163.

292 Seyrig later said: Alexandre Moussa, "'Undoing the Diva': Delphine Seyrig as an Actress, or the Deconstruction of a Myth," in Nataša Petrešin-Bachelez and Giovanna Zapperi, *Defiant Muses: Delphine Seyrig and the Feminist Video Collectives in France in the 1970s and 1980s* (Madrid: Museo Nacional Centro de Arte Reina Sofia, 2019), 78.

292 "We even went so far": As quoted in Roy Armes, *The Cinema of Alain Resnais* (London: A. Zwemmer, 1968), 105.

292 He remembered seeing Seyrig: Rosenquist, *Painting Below Zero*, 96.

293 As Resnais said: Armes, *The Cinema of Alain Resnais*, 107.

293 Resnais never fully said: Ibid., 103.

293 Resnais's first assistant on the film: Brangé, *Delphine Seyrig*, 163.

293 In January 1961: Ibid., 165.

293 In April 1961, Youngerman was again in Paris: Betty Parsons Gallery records and personal papers, Series 1, Box 18, Folder 2, Archives of American Art, Smithsonian Institution.

293 He wrote a month later: Ibid.

294 "It mirrors my inside/outside life then": Artist's questionnaire, Museum Collection Files, Jack Youngerman, *Naxos,* Department of Painting and Sculpture, The Museum of Modern Art, New York.

294 Youngerman returned to New York: Betty Parsons Gallery records and personal papers, Series 1, Box 18, Folder 2, Archives of American Art, Smithsonian Institution.

294 Seyrig predicted the film's critical reception: Delphine Seyrig, letter to her mother, September 28, 1960, Munich, Youngerman/Seyrig Archives.

294 In France, it was a surprise box office smash: Cynthia Grenier, "Notes on 'Marienbad' and the Paris Scene," *The New York Times*, November 12, 1961, 543.

294 Six months after its premiere: "Paris Still Stirred by 'Marienbad' Film," *The New York Times*, January 4, 1962, 26.

294 For its New York premiere in 1962: Bosley Crowther, "The Screen: Last Year at Marienbad," *The New York Times*, March 8, 1962, 26.

295 As Resnais's fellow French director François Truffaut said: Eugene Archer, "Director of Enigmas," *The New York Times*, March 18, 1962, 257.

295 And Seyrig joined her fellow Slip artists: The Museum of Modern Art, New York, press release, Thursday, February 15, 1962.

295 Indiana noted in his journal: Journal entry for February 15, 1962, as reproduced in Mecklenburg, *Wood Works*, 27.

295 It was hard to attend: Archer, "Director of Enigmas," 232.

296 He called these works "a bridge": From the painting files at the Buffalo AKG Art Museum, in a letter by Jack Youngerman dated October 17, 1968.

296 They were his "homage": Interview with Jack Youngerman, September 14, 2019.

296 Marguerite Duras described Seyrig: Marguerite Duras, "Delphine Seyrig, a Celebrated Unknown," *Vogue*, 1969, in Duras, *Outside*, 163.

297 By 1970: Interview with Jack Youngerman, November 3, 2018.

297 In the 1970s, she met: Ros Murray, "Cutting Up Men? Delphine Seyrig and Carole Roussopoulos's Playful Forms of Video Activism," in Petrešin-Bachelez and Zapperi, *Defiant Muses*, 107.

297 The three produced a series of videos: Petrešin-Bachelez and Zapperi, *Defiant Muses*.

297 It was "a revelation": Petrešin-Bachelez and Zapperi, "Defiant Muses: An Introduction," in *Defiant Muses*, 20.

298 These directors, Seyrig explained: Ibid., 19.

298 Akerman had traveled: Gary Indiana, "Getting Ready for the Golden Eighties: A Conversation with Chantal Akerman," *Artforum*, Summer 1983. https://www.artforum.com/print/198306/getting-ready-for-the-golden-eighties-a-conversation-with-chantal-akerman-35484.

298 Among those "other things": Petrešin-Bachelez and Zapperi, "Defiant Muses," 12.

299 "One of the last, best memories": Interview with Jack Youngerman, May 5, 2018.

## 21. Lenore

300 "I fought in the courts": Seaman, *Identity Unknown*, 380.

300 As the novelist Deborah Levy writes: Deborah Levy, *Real Estate: A Living Autobiography* (New York: Bloomsbury Publishing, 2021), 97.

300 "Often the place where an artist lives": James Schuyler, "Lenore Tawney," *Craft Horizons* 27, no. 6 (November/December 1967): 20.

301 "There is a play": Ibid.

301 After doing extensive research: Mangan, "Messages from a Journey," 27.

301 She visited a label factory: Cummings, Oral history interview with Lenore Tawney, June 23, 1971, Archives of American Art, Smithsonian Institution.

301 "I went symbolically down": Tawney, *Autobiography of a Cloud*, 7. Courtesy of the Lenore G. Tawney Foundation.

302 Indiana noted: Robert Indiana to Rolf Nelson, August 18, 1964, Robert Indiana Catalogue Raisonné Project, as quoted in *Lenore Tawney: Mirror of the Universe*, 130.

302 She had a solo show: Adamson, "Sculptor: 1961–1970," 137.

303 Constantine was furious: Auther, *String, Felt, Thread*, 136.

303 In 1968: Ibid., 23.

303 During this trip: Adamson, "Student 1945 to 1960," 73.

303 In its pages: Constantine and Larsen, *Beyond Craft*, 272.

304 In one journal entry from 1978: Lenore Tawney, *Autobiography of a Cloud*, 49. Courtesy of the Lenore G. Tawney Foundation.

304 In a commencement address: *Lenore Tawney: Mirror of the Universe*, 280, and Tawney, *Autobiography of a Cloud*, 66. Courtesy of the Lenore G. Tawney Foundation.

### 22. Ellsworth

305 In his last months: Receipt from Alan-Clarke Co., 75 Chambers Street, New York, dated April 24, 1963. Courtesy of the Ellsworth Kelly Studio.

305 Parallel to Martin's own experience: *Ellsworth Kelly: Red Green Blue*, 27.

306 Many were shown: William Rubin, "Ellsworth Kelly: The Big Form," *ART-news*, November 1963, republished online. https://www.artnews.com/art-news/retrospective/converting-painting-into-sculpture-william-rubin-on-ellsworth-kellys-signature-style-in-1963-4352/.

306 For Kelly, the edges: *The Metropolitan Museum of Art: Masterpiece Paintings*, ed. Kathryn Calley Galitz (New York: Rizzoli, 2016), 531.

306 When he was twelve and out trick-or-treating: *Ellsworth Kelly: Red Green Blue*, 7.

306 Another more recent reading: Ibid., 36.

306 The first time: Ibid., 17.

307 Kelly took Orange: Interview with Jack Youngerman, November 4, 2017.

308 In September 1964: Betty Parsons Gallery records and personal papers, 1916–1991, bulk 1946–1983, Series 731, Box 40, Folder 44: K, circa 1940–1982, Archives of American Art, Smithsonian Institution.

308 Parsons was extremely upset: As recounted in Gruen, *The Party's Over Now*, 239.

308 While he was walking in Central Park: As recounted in Goossen, *Ellsworth Kelly*, 88.

309 For several days, Kelly drew: Marla Prather and Michael Semff, *Ellsworth Kelly: Plant Drawings 1948–2010*, 214.

309 His paintings didn't fit: Louise Nicholson, "Ellsworth Kelly," *Apollo*, October 2013, as republished online on the occasion of his death. https://www.apollo-magazine.com/ellsworth-kelly-1923-2015/.

309 Hilton Kramer wrote: Hilton Kramer, "Kelly: Extremely Individual and Extremely Traditional," *The New York Times*, September 23, 1973, D25.

310 "In a sense": Holland Cotter, "A Giant of the New Surveys His Rich Past," *The New York Times*, October 13, 1996, H43.

### 23. James

312 Upon its completion: Excerpt of fall 1965 interview between Gene Swenson and James Rosenquist in *Partisan Review*, as reprinted in *The Metropolitan Museum of Art Bulletin* (March 1968), 285.

313 "Whenever you are near water": Van der Marck, "Reminiscing on the Gulf of Mexico," 94.

## 24. Robert

315 In 1959, Indiana started work: http://robertindiana.com/works/marine-works/.

317 Gerry Matthews remembers Indiana: Interview with Gerry Matthews, July 17, 2020.

317 The irony of this: Morrin, in *Chase Manhattan*, 28.

317 But a visit to the Whitney Museum: Crane was also a favorite writer of Johns, who used to read his verses out loud to Rauschenberg (Tomkins, *Off the Wall*, 109) and who made several works in a gray register that reference Crane, after his breakup with Rauschenberg in 1961, including *Passage* (1962), the very beautiful charcoal-and-pastel *Diver* (1962–63), and *Periscope (Hart Crane)* in 1963.

318 Though *Brooklyn Bridge VII* appears: Goossen, *Ellsworth Kelly*, 59.

318 Crane published: Langdon Hammer, "Hart Crane's View from the Bridge," *New York Review of Books Daily*, November 24, 2017. https://www.nybooks.com/daily/2017/11/24/hart-cranes-view-from-the-bridge/.

319 Of his *LOVE* art: Kelly Richman-Abdou, "The Surprisingly Heart-Wrenching Story of Robert Indiana's 'Love' Sculptures," *My Modern Met* (March 15, 2019). https://mymodernmet.com/love-sculpture-robert-indiana/.

319 After Kelly and Indiana broke up: Ryan, *Robert Indiana*, 203.

320 In May 1965, Miller wrote: Artist's questionnaire, Museum Collection Files, Robert Indiana, *French Atomic Bomb*, Department of Painting and Sculpture, The Museum of Modern Art, New York.

320 In November 1965: Ryan, *Robert Indiana*, 19.

320 In the summers: http://robertindiana.com/works/slip-2/.

320 He had many ideas: Diamonstein, *Inside New York's Art World*, 165.

321 In the mid-1960s: From an interview of Ann Wilson by Jonathan Katz. Oral history interview with Ann Wilson, 2009 April 19–2010 July 12, Archives of American Art, Smithsonian Institution.

321 Jill Johnston remembered: Jill Johnston, "Like a Boy in a Boat," 301.

321 Rosenquist, who had visited Swenson in Bellevue: Rosenquist, *Painting Below Zero*, 205.

321 At the time of his fatal crash: Interview with Ann Wilson, January 17, 2022.

321 As the critic Gregory Battcock wrote: Gregory Battcock on Gene Swenson in *Gene Swenson: Retrospective for a Critic*, 15.

322 "By a strange irony": Diamonstein, *Inside New York's Art World*, 165–166.

322 "And since for eight years": Ibid., 163.

322 Two vans had made a dozen trips: Haskell, *Beyond Love*, 133.

322 He lived there until his death: Ibid.

322 He had an "Ellsworth Kelly room": Paul Taylor, "Love Story," *Connoisseur* 221, no. 955 (August 1991): 94.

322 When asked in 2013: Duray, "On the Horn with a Hoosier."

## 25. Agnes

323 As she wrote: Agnes Martin, "The Untroubled Mind," first published in *Agnes Martin* (Philadelphia: Institute of Contemporary Art, University of Pennsylvania, 1973), 17–24, and republished in Haskell, *Agnes Martin*, 21.

323 The two would sometimes go camping: Jill Johnston, "Agnes Martin [2]: Of Deserts and Shores," *The Disintegration of a Critic* (New York: Sternberg Press, 2019), 134.

324 Ann Wilson also recalls: Interview with Ann Wilson, January 17, 2022.

324 Martin made Johnston tea: Johnston, "Agnes Martin: Surrender & Solitude," *The Disintegration of a Critic*, 125.

324 As the critic wrote in *The Village Voice*: Ibid., 124.

325 By 1964, Martin had been compared to her hero: Princenthal, *Agnes Martin*, 129.

325 And a year later, Johnston would describe: Ibid.

325 But an airmail letter she sent: Lenore G. Tawney Foundation archives.

326 As the art historian Christina Bryan Rosenberger put it: Rosenberger, *Drawing the Line*, 165.

326 Martin was initially flattered: Princenthal, *Agnes Martin*, 139.

326 As writer Nancy Princenthal has pointed out: Ibid.

326 "To feel confident and successful": Agnes Martin, "Reflections," transcribed and edited by Lizzie Borden, December 1972, in *Artforum* 11, no. 8 (April 1973): 38.

326 Johnston brought a group: Johnston, "Agnes Martin: Surrender & Solitude," 274.

327 Standing in front of the painting: Henry Martin, *Agnes Martin*, 175.

327 As Frances Morris: Morris, "Agnes Martin: Innocence and Experience," 65.

328 "I think my paintings": Henry Martin, *Agnes Martin*, 177.

328 Martin walked right past: Princenthal, *Agnes Martin*, 152.

328 She told a friend: Henry Martin, *Agnes Martin*, 159.

328 When Carr and Indiana: Princenthal, *Agnes Martin*, 153.

328 Carr implied: Ibid.; Arne Glimcher, *Agnes Martin*, 77.

329 At Presbyterian: Henry Martin, *Agnes Martin*, 160.

329 She told Youngerman: Interview with Jack Youngerman, June 2, 2018.

329 In the summer evening light: Rosenberger, *Drawing the Line*, 1.

329 It was a total purge: Henry Martin, *Agnes Martin*, 191

330 "In New York, I would stay in bed": As quoted in Haskell, "Agnes Martin: The Awareness of Perfection," 111.

330 As Martin wrote to Tawney: Agnes Martin, letter to Lenore Tawney, November 17, 1967, from the Grand Canyon, Arizona. Lenore G. Tawney Foundation archives.

330 As she told Johnston: Princenthal, *Agnes Martin*, 140.

330 She also claimed: Henry Martin, *Agnes Martin*, 217.

330 her need, therefore, to "start again": Ibid.

331 She wanted to visit Kelly: Eisler, "Life Lines," 81.

## Afterword: Collective Solitude

333  They are politicized: Margaret C. Rodman, "Empowering Place: Multilocal-
ity and Multivocality," *American Anthropologist* 94, no. 3 (1992): 640–656. http://
www.jstor.org/stable/680566.

333  "No great and beautiful building:" Swenson, "The Figure a Man Makes," 79.

334  Or, as the critic: Thomas B. Hess, "A Tale of Two Cities," *Location*, Summer
1964, 40.

334  "Why should [New York] be loved": As quoted in Ellis, *The Epic of New York
City*, 273.

335  As Youngerman spoke: Interview with Jack Youngerman, June 19, 2019.

335  Or, as Martin wrote: Agnes Martin, "I want to talk to you about the work . . ."
handwritten insert in Arne Glimcher, *Agnes Martin*, 16.

335  It's the "two countries": Gertrude Stein, *Paris France* (New York: Charles
Scribner's Sons, 1940); as quoted in Levy, *Real Estate*, 100.

335  As Martin once put it: Agnes Martin, "Reflections," 38.

337  Wilson was inspired: *Nine Artists/Coenties Slip*.

337  "I think often of you": Fred Mitchell, letter to Ellsworth Kelly, "Tuesday,
Cranberry," undated, circa 1957. Ellsworth Kelly Studio archives.

339  It would be a while before: See Larsen, "Lenore Tawney," 160–161, 175–177.

339  As he humbly put it: Interview with Jack Youngerman, December 28, 2019.

340  It's also the story: Interview with Jack Youngerman, June 2, 2018.

341  As Parsons put it: Quoted in Anne Cohen DePietro, "The Art of Betty Par-
sons: Carpenters' Throwaways and the Expanding World," in *Shaping a Genera-
tion*, 40.

342  One of the final paintings: Baker, Oral history interview with Robert Indiana.

342  Indiana himself called it: "Although it is a silhouette study of a plant which
is right here in my studio, a corn plant or a dracaena, the point of the thing, of
course, is that I was leaving Coenties Slip." Carr, "The Reminiscences of Robert
Indiana," November 1965, Arthur C. Carr Papers.

342  an approach described once: Gene Swenson, "Robert Indiana," Summer 1964, in
*Gene Swenson: Retrospective for a Critic*, 35.

344  The title also subtly references: See Hugh Ryan, *When Brooklyn Was Queer*
(New York: St. Martin's Press, 2010), 24–25.

344  Several of Demuth's portraits: *Poster Portrait: O'Keeffe*, 1923–24, for in-
stance, has the first initials of Georgia O'Keeffe's name running in a parallel hor-
izontal line across the composition, while the rest of her name stacks vertically
above the *O* like a blazing candle. The effect is that the work seems to read "Go
O'Keeffe," a kind of affirmative and terse command we find so often in Indiana's
work. And Demuth's "portrait" is a potted plant and some fruit, with the main
emphasis on the tall, straining leaves of the common sansevieria or snake plant.
*Calla Lilies* (Bert Savory), 1926, does not include its subject's name, but is a tribute
to a vaudeville theater personality famous for his female impersonations, who was
struck by lightning on Long Beach and died at the age of thirty-five in 1923. (Robin
Jaffe Frank, *Charles Demuth: Poster Portraits 1923–29*, New Haven: Yale Univer-
sity Art Gallery, 1994, 54.) The pale white flowers stretch out from their green
stalks and curled leaves, which emerge from a kind of cloth shroud that also has
the stiffness of a shell born aloft in a wave, against a rich, blue velvety background.

As the scholar Sasha Nicholas has argued, in both Indiana's *Leaves* and Demuth's *Calla Lillies*, the "allusions to homosexual creativity are subtle and coded; like visual puzzles, they disrupt a clear relationship between seeing and knowing." (Sasha Nicholas in Haskell, *Beyond Love*, 187.)

344 An avid journal writer: Baker, Oral history interview with Robert Indiana.

# INDEX

Note: Page references in *italics* refer to illustrations

## ABOUT THE AUTHOR

PRUDENCE PEIFFER is an art historian, a writer, and an editor, specializing in modern and contemporary art. She is the managing editor of the creative team at the Museum of Modern Art, New York. She received her PhD from Harvard University. Following a post-doctoral fellowship at Columbia University, she was a senior editor at *Artforum* from 2012 to 2017, and then the digital content director at David Zwirner. Her writing has appeared in the *New York Times*, the *New York Review of Books* online, *Artforum*, and *Bookforum*, among other publications. She lives in Brooklyn.